D0114044

*The Writings of a Savage*

# The Writings of a Savage
## PAUL GAUGUIN

Edited by **DANIEL GUÉRIN**
*With an Introduction by Wayne Andersen*

*Translated by Eleanor Levieux*

The Viking Press • New York

*Oviri Écrits d'un sauvage*
© Éditions Gallimard, 1974
Introduction Copyright © Wayne Andersen, 1978
English-language translation Copyright © Viking Penguin Inc., 1978
All rights reserved

First published in 1978 by The Viking Press
625 Madison Avenue, New York, N.Y. 10022
Published simultaneously in Canada by
Penguin Books Canada Limited

LIBRARY OF CONGRESS CATALOGING IN PUBLICATION DATA
Gauguin, Paul, 1848–1903.
  The writings of a savage.
  Translation of Oviri.
  Includes index.
  1. Gauguin, Paul, 1848–1906.
2. Painters—France—Biography.  I. Title.
ND553.G27A4813      759.4  [B]      76–53574
ISBN 0–670–79173–3

Printed in the United States of America
Set in Videocomp Baskerville

61080

# Contents

# Introduction

by Wayne Andersen

Gauguin had literary pretensions, I suspect. Like Delacroix and van Gogh, he wrote a great deal, but unlike them he tended to package his writings as books. And he adapted himself to each different genre of literature that he undertook: he wrote as a critic when writing criticism, as a savant when writing art theory; as a journalist when composing journalistic copy. He enhanced his journals with illustrations, cover designs, and elaborate end-papers; he gave them book titles. Even in his personal letters, he sounds at times as if he were addressing a world audience.

He did not, however, work at developing a fine hand. His public attitude toward "finish" in the execution of his art—a cultured phobia that functioned as a self-esteemed naïveté— was transferred to his writing in which he recognized a sacredness or inviolability of that which stimulated it. Most precious to Gauguin was his self-image, his *originalité* (in the nineteenth-century meaning of the word). Literary style, like the finish of fine art (the "finish of fools," as Cézanne described it) was for Gauguin like the dressing up of a savage, displaying superficial taste while disguising the naturalness of primary creation. In Gauguin's construction the perfection of talent disassociates the artist from originality—the defining uniqueness and integrity of the creative being. Believing this, Gauguin held doggedly to the connotation of primitiveness as essential to ward off the least suggestion that he was capable of displaying any aspect of the perfection of the breed. His atavistic instincts were not

subject to repression by such civilizing forces as the need for technical perfection and a fine hand.

Yet, for all the success that he achieved in avoiding technical perfection in his personal art, he wavered and finally capitulated to talent in the production of his first literary work, *Noa Noa*. Gauguin returned from his first Tahitian sojourn in 1893 with enough canvases and carvings to constitute a one-man show; but he knew that the strangeness of his Tahitian imagery would require some stage-managing if it was to be a success. He had in mind the idea of producing a book that would introduce and explain his imagery to a Parisian audience. Perhaps he was even more concerned about the reaction of critics and fellow artists, whose opinions on his Tahitian canvases, if not supported by a contextual understanding of their valiant, yet errant, colleague, might well be as agitated and severe as the public's. Realizing that he was not a professional writer, Gauguin sought collaboration with the sympathetic Charles Morice and submitted to Morice's cultivated hand the roughhewn notes that embodied the essence of *Noa Noa*. A Symbolist poet and friend of Verlaine and Mallarmé, Morice was, in complementary fashion, a mirror-image of Gauguin. He had literary skill but he lacked both generative inspiration and thematic substance. In collaborating they could each offer what was most wanting in the other while sharing the traits that bonded them. Morice, like Gauguin, was a theorist of Symbolism; both held that thematic constructions in either art or literature should be veiled rather than clearly stated in expository fashion.

The collaboration was only one among Gauguin's many regrettable ventures. It was a disaster for Morice as well; for his residual fame came to bear less on his erstwhile poetry than on the ignominy of having flattened Gauguin's original text into a popular novelette. But the onus of the collaboration must fall on his client, Gauguin, who distrusted his own literary talent. He was not, as he once confessed to Morice's wife, "a professional writer." He lacked style, vocabulary, the skill of metaphor, the manipulative verbal expertise of the professional. He *chose* Morice, and the misgivings he would later have rever-

berated throughout the balance of his life. Even on a pragmatic level the book did not materialize as planned at the moment of need; the whole public-relations scheme never came off.

In 1899, five years after Gauguin's return to Tahiti, as his and Morice's agony over the ill-fated venture wore on, he wrote to Morice's wife: "The book, *Noa Noa.* I beg of you, credit me with a little experience and the instinct of the civilized savage that I am. The storyteller must not disappear behind the poet. A book is what it is, incomplete . . . yet, by means of a few narratives, one manages to say everything one wants to say or have the reader guess, and that is a great deal." For both Gauguin and Morice it was an investment that might still yield returns. Gauguin wanted his story told; Morice was desperate to publish it, because he was up against hard times. In 1896, perhaps to the chagrin of Gauguin, Morice published excerpts from the text in *La Revue blanche;* and in 1901, under his and Gauguin's names, he published the entire manuscript, elaborated with appendices of his own poetry, as a book. Gauguin could only cry from his Paradisical wilderness: "The storyteller must not disappear behind the poet"—the plaintive call of the savage that Morice's talent had so thoroughly civilized. "I know," he had pleaded in his letter to Morice's wife, "that Morice is expected to write verse, but, if there is a lot of verse in this book, all of the storyteller's naïveté disappears and the savor of *Noa Noa* will lose its *originalité.* "

Gauguin's part in the *Noa Noa* venture has been excused as an ingenuous and regrettable mistake, the result of an underestimation of his own ability to write. Typically, no excuse has been allowed the wretched Morice. Accused of mangling Gauguin's text, of professionalizing the rugged simplicity that was the artist's style, he has been harshly and unjustly sentenced by Gauguin infatuates. Eagerly ignored is that Gauguin returned to Tahiti with a hand-copy of Morice's text; his own text he left behind. Was this just because Morice might still have need of Gauguin's draft, or was the storyteller so powerfully touched by Morice's poetic rendering that he had no further thoughts about his own words? The answer, I suggest, is the opening

paragraph of the handwritten version that Gauguin so elabo-
rately constructed after his return to Tahiti. Had he not been
thoroughly pleased at that moment with the product of the
collaboration, he would surely have purged *Noa Noa* of this
Preface:

"The memory and imagination of a painter and a poet have
produced this, through the concerted will of two minds enam-
ored of the same goal and in the profound belief that in the
beginning art was one, and that the future of the arts lies in
regaining, through some convoluted charm, the instant of that
triumphal harmony and so gathering into a single bouquet the
compounded and marvelous glories of all gardens, at once
unutterable and undeniable—of which this book to be seen and
read may be only a hint! Or as prayer, the two hands joined
together pointing the way to paradise, opens up that way in the
souls of the saints."

The existence of three versions of *Noa Noa* has wreaked
havoc with Gauguin scholarship. A quarter of a century inter-
vened between their appearances. The painter's aggrandized,
beautifully illustrated version came to light only in 1926; Gau-
guin's draft, which Morice had retained in his files and sold to
a print merchant in 1908, was not published until 1954. More
recent yet was the discovery that much of Gauguin's raw mate-
rial for *Noa Noa* and the whole of his little book "Ancient Maori
Religion," which the French scholar René Huyghe has called
"the key to *Noa Noa,*" was copied from Moerenhout's *Voyages
aux îles du grand océan.* So yet a third author was involved in the
enterprise!

Jacques-Antoine Moerenhout, once the United States Con-
sul-General to Oceania, published his account of South Seas
religions and customs in 1837. Gauguin encountered Moe-
renhout's book in 1892, while in Tahiti. He copied whole sec-
tions from it into a notebook, added drawings and watercolors,
and decorated the cover with elaborate penstrokes and a title:
"Ancien Culte Mahorie" (Ancient Maori Religion). Organized
in ten chapters, Gauguin's notebook details the pantheon of

Maori deities, the myths of creation, and the great legends of a race that was rapidly losing its native theology, even when Moerenhout was fathering the material of his volume in the early 1830s. By the time of Gauguin's arrival in Tahiti the old legends were dead; no one knew the ancient gods, as the Christian missionaries had long since exorcized them. One can imagine Gauguin's distress upon arriving there with preconceptions of Paradise to find that, amidst the detritus of a Paradise Lost, the whole population was suffering at last its share of the wages of sin. Gauguin might be condoned for his indiscretion—he was not a scholar. One can understand his need to hide from his European fellows the humiliation that his knowledge of Maori religion came from a book—worse yet, a book written by a Belgian, published in Paris, and available in the Bibliothèque Nationale. In *Noa Noa*, Gauguin acknowledged as his source, rather, a "full course in Tahitian theology" given him on starry nights by his thirteen-year-old bedmate, Teha'amana. But certainly, as the anthropologist Bengt Danielsson assures us, this girl knew no deities other than the gods of the missionary school. (Pierre Loti, twenty years earlier and similarly situated with a young *vahine*, admitted that his mistress had no knowledge at all of the characters in Polynesian lore or mythology.)

The plagiarism has destroyed what anthropological or literary values Gauguin's "Ancient Maori Religion" was thought to have had; it discredited as well the chapter in *Noa Noa* that was carelessly excerpted from Moerenhout's book. There are other portions of *Noa Noa* that are of questionable verity, but which perhaps can be approached as dramatic constructions that pose Gauguin in the lead role of an elaborate stage play. His affair with the half-caste Titi—did he really encounter her in Papeete, take her with him to Mataiéa, and then expel her when her European taintedness offended him at last? As I have discovered from early travel books, Titi was as notorious as Gauguin described her and had to her credit the downfall of many lovers. Was Gauguin one of them, or was Titi simply inserted into his recurrent fantasy of the fateful woman as a device to define his innocent Eve? On one of the blank pages

of the aggrandized version of *Noa Noa* he wrote: "My God, what childish things will be found in these pages, written either for personal entertainment or for the sake of classifying favorite if somewhat foolish ideas."

Gauguin's extracts from Moerenhout's book coincided with concerns about his own origins, which could not be satisfied by either the mystical accounts of Genesis or those of Darwin's naturalism. In Polynesia he encountered a more suitable theogony and a pantheon of deities to displace for a time the sinners and saints of a theology that during his upbringing had, in the manner of isomorphic generation, become aligned with his psychical sense of self: at last he had at hand a more compatible structure to house his fantasies. It matters little that he found it in a book.

Gauguin's position was now reversed: in Paris, he was a real person embedded in fantasy; in Tahiti, his new environment was real, and if anything was now fantasy, it was himself. In spite of financial and other practical difficulties—in spite, even, of the need to dissolve many of his most guiding pre-visions of Tahiti —he seemed, in fact, more spiritually whole during his first few weeks there, as if the landscape alone were providing a cushion for his anxieties. In a letter to his wife, Mette, he spoke of the "night silence" that was permeating him and said that he was beginning to apprehend all those things that would soon invade his being. It is perhaps harsh to imply that the disappointments on arrival had eroded his spirit. If his Promised Land disconcerted him, he had at least achieved it, and his desire to succeed within its boundaries was great. He had confronted the fantasy of his own origins, and no longer could he afford to believe that his inclinations might, after all, be aberrational. Nor could he plead natural causes or put the blame for his chronicle of disasters on his Peruvian blood, which, to hear him tell it, pulsed with primitivism undiminished by time, distance, or years of French upbringing.

Even before departing for Tahiti, Gauguin had begun to redefine origins by setting up his mother as the resident Eve in a tropical Paradise. In a painting of Eve about to succumb to the

serpent's tongue, he used a photograph of his mother to fashion Eve's head; her body was modeled on the androgynous Buddha. Typically, Gauguin was thinking not only of mankind's origins but of his own as well. His mother was part Peruvian—she had a share of savage blood—and this was sufficient to establish Gauguin, even in his European existence, as a savage. The return to a tropical paradise was his inevitable destination— there he could re-enact the whole syndrome in his terms. His migration to Tahiti, where he could "love, sing, and die" at peace with the life cycle at last, was a journey backward to the era of his Peruvian childhood. Shortly after arriving, he made a portrait of his mother as a Tahitian native, more beautiful than any other of the native women he painted.

Moerenhout's book was no doubt a welcome substitute for the only other explanation of primary creation that Gauguin harbored. During 1891–92, he had painted many versions of Eve before and after the fall; in each, the pall of Original Sin comes over Eve, either as intimations of guilt or a naïve heedlessness of the urgings of the Devil. In substituting for a while the creation myths of the Maori, Gauguin was himself relieved of the sinful syndrome and of the anxieties that welled up from the mystery-depths of his own origin. It may have also established for him a narrative that coincided with his fantasies of royal descent. He once wrote: "Memories! That means history. That means a date. . . . And you have to tell who you are and where you are from. . . . If I tell you that by the female line I descend from a Borgia of Aragon, Viceroy of Peru, you will say that it is not true, and I am pretentious. But if I tell you that my family is a family of sewer cleaners, you will hold me in contempt. If I tell you that on my father's side they were all named Gauguin, you will say that that is unbelievably naïve; and if I try to explain what I mean, myself wanting to say that I am not a bastard, you smile skeptically."

Dreams of royal lineage die hard. "Tomorrow I am going to see all the Royal Family," Gauguin wrote Mette shortly after his arrival at Papeete. But, as fate would have it, the Maori king, Pomare V, died on the very morning of Gauguin's appointment

with him. His death was due to acute alcoholism, but Gauguin chose to interpret it as the knell of the old native civilization, which had maintained itself, natural and primitive, beneath the sordid layer of colonial and Christian habitation: "With him," Gauguin concluded, "disappeared the last vestiges of ancient customs and grandeur. With him died the Maori tradition. . . . Civilization, alas, triumphed."

"Ancient Maori Religion" was more, therefore, than merely a copy. The words were Moerenhout's; but to the extent that they were assimilated into Gauguin's evolving sense of self, they became his own property. Most important, however, is that the book released Gauguin from the Genesis myth of creation with which he had barely coped on a troubled and even traumatic level. In assimilating the Maori myths, he was able to objectify the life cycle and render it more powerfully and persuasively than when it was governed by forces so deep as to be surfaceable only by violent eruptions that might fatally impede his progress as an artist. Gauguin based several of his most marvelous paintings—*Hina and Tefatou, Hina Tefatou, Matamua*—upon the legends recorded by Moerenhout. Perhaps the question of authenticity raised by "Ancient Maori Religion" should be allowed graciously to fade out.

Gauguin's adoption of the Maori theology also acted, for a time, as an antidote for the disease of Christolatry that had infested his imagery as early as 1889. The awkward, ambiguous involvement with Eve, in which he was both mother-protector and mother-seducer, ran down the mother-son syndrome to its absolute base upon which, through metaphorical constructions, he objectified his celebrated dual nature, most explicitly in *Self-Portrait with Halo and Snake*. There, his devil's-capped head, annotated with virginal green apples—one just beginning to redden—is surmounted by a golden halo, suspended in midair as if wired over a child-angel in a catechism pageant. In this arresting portrayal of his precious duality, Gauguin is at his best. His arrogance is neatly ordered. He is surrounded by the tools of his trade: his devil's cap, his halo, dangling apples, a

small snake held debonairly between the two fingers of a priest's blessing—his weighty malevolence is less expressed than proffered. As Satan in Milton's *Paradise Lost,* having revolted against God in an attempt to control the heavenly spheres, rejected from heaven, he now marshals the forces of evil to make an assault upon the Garden of Eden.

The intensity of Gauguin's rancor was never set loose in his paintings, however; perhaps there was too much Eve and too much Christ in him to allow the Devil his play. But in the final 140 or so pages of the extended version of *Noa Nôa,* he at last vented his passion against the Church, and, in logical sequence, against the State and against marriage. This text was added to *Noa Noa* in 1896–97, and the larger portion of it was later somewhat rearranged and copied into a booklet that Gauguin titled "The Catholic Church and Modern Times."

Perhaps by this time, thoroughly disillusioned with his Paradise Found and wracked with all the diseases of his fall, he could no longer be succored by a primitive theology that reality had so wastefully used up. In his paintings, he returned once again to the theme of the Biblical Fall, but now Eve is accompanied by an ineffectual, guilty Adam-in-back-view. Bereft of his quest to redeem her—her Tahitian surrogate having lost her innocent sting—Gauguin's Eve, by 1897, had become as anomalous in Tahiti as an apple on a palm tree. In one final and desperate effort to claim divine right, Gauguin attempted suicide by ingesting arsenic, but he was foiled by his remarkable consistency in failure. His recovery might earlier in life have been taken as the miracle of Lazarus, but on this page of Gauguin's logbook of disasters, it was just another piece of bad luck —an unwanted fish thrown back by Saint Peter. He would complete his attack on the Church at his final retreat, Atuona in the Marquesas, where he went in 1901 in search of cannibals, sailing one more Freudian step backward to ebb at the breast of his mother, just short of the fatal womb from which he had once been ejected—and now twice.

Gauguin's vitriolic attack on Catholicism was fueled by readings from the English poet Gerald Massey, whose little

book, *Le Jésus historique,* was published in San Francisco in 1896. The translator's notes led Gauguin to the earlier and more extensive of Massey's diatribes against the Church, housed in four volumes, which included *A Book of The Beginnings, containing an attempt to recover and reconstitute the lost origins and the myths and mysteries, types and symbols, religion and language, with Egypt for the mouthpiece and Africa at the birthplace* (1881), and also *The Natural Genesis* (1883). Both were available to Gauguin in translations by the French philosopher Jules Soury.

Gauguin had had some theological studies during his youth as a pupil in Orléans, where his Bible teacher was the district bishop. But Massey's ideas were taken over literally—and, in substantial passages, word for word—by Gauguin, who had the inclinations and passions to do battle with dogma but lacked the essential strategies of rhetoric that could argue his views on a level above the pessimistic and disgruntled. His stony image of self-sufficiency had, in reality, a tufalike sponginess which, depending upon one's choice of perspectives, could be seen as nonetheless implacable, or mimically flexible, and in its paradoxical porosity, self-absorbing. Gauguin had cultivated a remarkable ability to animate himself into displays of suffering and absorb the underdog in any contest when injustice or persecution were certain to prevail.

In the opening lines of his manuscript, he asks the eternal questions: *"Where do we come from? What are we? Where are we going?"* He opens with such flourishes, as if the text that follows will now rule with sufficient majesty to proclaim the eternal answers. His abjectness is raised to magnificence; he never questions the reality of the siege he is about to lay against the fortified walls that guard the foolishness of philosophical verities. He proceeds, however, with reflexive contempt. Assured of failure, the formidableness of his enemy is of no importance. His first assault is designed to rush straight to the heart of the citadel and kill God. He spares nothing in his way: "Every form of government seems to me absurd, every creed idolatry. . . . What must be attacked is not the fabled Christ but, higher up, further back in history: God." And on his way to kill God,

Gauguin indignantly pushes aside the fool: "While man is free to be a complete fool, his duty is to stop being one. In the name of reason, and being a tyrant, I refuse to grant him the right to be a fool. . . ."

The fool's role in Gauguin's construction is the creator of God; it was fools who replaced the unfathomable by a specific being, tiny and mean, wicked and unjust, in the fool's own image, "concerned with the asshole of each one of his little productions. . . . What must be killed so it will never be reborn? God. Our souls today, gradually shaped and taught by other souls that have come before, no longer want a God-creator who is tangible. . . . The unfathomable mystery remains *what it was, what it is, what it will be*—unfathomable."

The eternal questions, then, must remain unanswered. Their significance is in the verity of their fathomless depth. Gauguin asks only that the fable and legend—the "ever-present riddle: *Where do we come from? What are we? Where are we going?*" —continue as they are, in natural truth and simplicity and of utmost beauty. He calls for an end to the literal translations of the parables, the dogma of Jesus' immaculate conception, the miracles of the relics, the stultifying and theocratic reign of the Church, the sacerdotal guild of priests, the infallible authority of the pope. But all of this, and much more, is direct from Massey's text. Gauguin's book is more a repository for his own instinctively spiritual convictions than the treatise on philosophy that he described in a letter to Morice as the best expression of his life views. As in the example of "Ancient Maori Religion," Gauguin allowed himself to be absorbed into the source of his borrowings rather than to extract anything in particular from them. In the same way he invariably entered into his fantasies, and in doing so, he inadvertently destroyed them, one after the other. Like myths and legends rendered literal, they became, ironically, as real as the reality he so ardently despised.

Gauguin's literary sources supported his painted imagery, but, in absorbing him, they also passed him through filters so finely textured as to separate his essences from his aggregate wholeness. The filtering served only to expose his impurities

and amplify his ambiguities. His understanding of Jesus was as tender as a child's prayer at bedtime, but his behavior at the time he was writing about the "dirty stick" of Catholicism was as sordid and basically sin-ridden as any monk's in debauch. In the sequel to the diatribes on religion, he praises the virtues of a true democracy, but at heart he was a selfish, pig-headed anarchist who admired potentates. As for marriage, he extols the right of any woman to sleep with whomever she pleases, to have a child without the contract of marriage, but he can still warn his husbandless wife that adultery is a sin, and praise the issuance of bastard children because they thrive on air and don't inherit. There was much of Gauguin which couldn't pass through the filter to join with his essence. "I have sinned a little . . ." he confesses in his journal, but his self-absolution comes as quickly and gently as a mother in the night: "I don't regret it." A full confession would surely have broken all his teeth.

Gauguin's "Cahier pour Aline" (Notebook for Aline) is the most accessible of his writings. Its poignancy in the tender intersection of Gauguin with his daughter Aline and his mother, after whom his daughter was named, coincides with some of the artist's most cogent statements about the process of art. He wrote it in the spring of 1893, in a simple *cahier,* a sketchbook of twenty-six leaves. He decorated the covers with watercolor, and on each of the endpapers he pasted reproductions he had clipped from somewhere: at the front, Corot's *Young Woman with Mandolin*; at the back, Delacroix's *Arab Warrior Mounting a Horse.* Positioned at either end of this waif of a diary, like bookends, the reproductions act as poles between which the contradictions within the artist's essential duality are framed. The motif of girl with mandolin dates back to those years when Gauguin, though miserable, was still whole with wife and children. In a painting of 1885, a young girl, who is perhaps Aline, grasps the neck of a mandolin and extends it toward a vase of peonies; a seascape of beach, water, and sky compose the backdrop, a prefigurement, perhaps, of Tahiti. The mandolin in this picture, as in the

one by Corot, echoes the form of the young girl while defining her state of idyllic innocence (or is she proffering herself to the flowers?); it stimulates instinct as opposed to intellect, induces reverie, a spatiality of feeling which soothes but can also arouse, can dissipate anxieties even as it evokes potent visions. The reproduction of Delacroix's picture completes the contrast: the Arab warrior, his sword prominently positioned, prepares to mount his side-stepping steed; and in a fashion characteristic of Delacroix, both man and horse are charged with the virility of violence. Feminine/masculine, passive/active, gentleman/savage—the conflicting forces of Gauguin's dual nature are the endpapers of the text.

His dedication to Aline opens the first page:

> To my daughter Aline, this book is dedicated. . . .
>     Sparse notes, lacking continuity,
> Like dreams, as like everything else in life,
>     made of pieces.

The lines suddenly disappear under the clippings of a chronicle on Gauguin by Jean Dolent, dedicated to Morice, which, after the death of Aline, Gauguin pasted right over the body of his dedication. Beneath Dolent's redundant extolments on Gauguin's virtues, the writing continues: "These meditations are a reflection of myself. She, too, is a savage, she will understand me. . . . Will my thoughts be useful to her? I know she loves her father, whom she respects. I give her a remembrance. The death that I have to accept today is an insult to my fate. Who is right? My words or myself? Who knows. In any event, Aline has, thank God, a heart and mind lofty enough not to be frightened and corrupted by contact with the demonic brain that nature gave me. Faith and Love are Oxygen. They alone sustain life."

Aline died suddenly at the age of twenty in Copenhagen in 1897. Gauguin had last seen her in 1891; she was then fourteen. At this last meeting with his family, it would seem that she alone responded to him with warmth. He recalled her response in a letter three years later: "Mademoiselle is off to the ball. Do you

dance well? I hope the answer is a graceful Yes, and that young men talk to you a great deal about me, your father. That's an indirect way of courting you. Do you remember three years ago when you said you would be my wife? I sometimes smile when I recall your simplicity. . . ."

The irony that his young Mademoiselle had died of pneumonia contracted on coming home from a ball must have struck hard. The circumstances of her death were now inextricable from his tenderest wishes for the transition to womanhood that would withdraw her from him. The thinly veiled motives in his hope that her young suitors would keep him indirectly in the process of courtship are laced with quantities of incestuous guilt. He reminds her that she once said she would be his wife, and in recalling the innocence of her remark, is perhaps pleading as well his own innocence in the courtship of his first Aline, his mother. In her image, he had first seen the imprint of the savagery which by now had become the validation of his own nature, just as it was the only tie he had to his daughter. Within the limitations of his vision (as between the endpapers of the book), bound by ego, he loved the two Alines in the way he loved himself ("She, too, is a savage. She will understand me") and it seemed that death alone would facilitate whatever degree of love was capable of forcing its way through his grit: "I have just lost my daughter. I no longer love God. Like my mother, she was called Aline. . . . Some love exalts even into the sepulcher. Others—I do not know. And her tomb is over there with flowers—it is only an illusion. Her tomb is here near me; my tears are her flowers; they are living things."

Aline's death was taken by her father as less a tragedy for her than for him. He logged it as another example of divine malice against him and a stroke of bad luck. After hearing the news, he wrote in anguish to a friend, the composer William Molard: "Bad luck has dogged me since childhood. Never any luck, never any joy. Always adversity. And so I cry: *God if you exist, I charge you with injustice and malice.*" The fact that Aline had lost her life may never have entered his head.

Perhaps his daughter was the last of his Eves, and with her

died the last vestiges of Gauguin's romantic longings for emu-
lating, in the process of being an artist-creator, the primary
creation of a sinless woman by removing the venom from the
sting of sin. Shortly after Aline's death, he undertook his attack
on the Church, the State, and the institution of marriage; and
perhaps by mutual decision, correspondence ceased between
him and his wife. Then, as if ritualistically, he buried those lines
of the dedication to his daughter beneath the weight of a paean
to himself, written by a sentimentalist whose paper ardor would
wilt paper flowers: "As soon as I encountered him, I recognized
him. I had already seen him in Bruges, in Ghent, in London, at
the Louvre, in paintings of saints. He is not the kneeling man
whose hands are clasped in prayer; he is the faithful knight, who
ecstatically contemplates the saint. Like a faithful knight, he
adores and worships."

It is doubtful that Gauguin ever intended to present this
little book to his daughter; it was more likely reserved for the
daughter within himself. On the cover, wispily written and now
faded by time, Gauguin added what might be a subtitle: "Diary
of a Young Girl." Was the reference to Aline or to himself? And
is it not sufficiently puzzling to point out that the head on the
body of the strange young girl that Gauguin drew on the cover
beneath his patented monogram, PGO (pronounced "pego" no
doubt; a piece of slang, meaning "prick," picked up from Gau-
guin's merchant marine years) that this head, its profile, the
almond eye with small iris located like a setting sun below an
arched eyebrow, seems almost uncannily familiar from those
Eves-after-the-Fall that Gauguin rendered that same year? In
each of them, and especially potent in a woodcut of 1893—
where the artist's monogram is implicating in the ingeniousness
of its design: PG within the O—the head is on line with Eve's
now-hidden genitalia. And symmetrically placed on the same
line there is a semitumescent member with flames of pubic hair
at its root; a mongoose, the killer of snakes whose bite came too
late, is perched on its fading arch. Above it, the monogram
identifies the phallus as the signet of the crime. Eve is bounded
on the one side by the retreat of Sin's ugly head, on the other

by the stare of Death. In her state of temptation, the fear of both
is overcome by inchoate desire, and at the climax of her fall they
become fatally incorporated into her being.

The formula is persistent in Gauguin's oeuvre: the eye
appears first as a fox-eye in 1890, in a painting entitled *The Loss
of Virginity,* wherein a wily fox presides over a Breton maiden's
deflowering; then, in the visage of the fox-devil Meyer de Haan,
who moderates between Eve's state of hysterical resistance and
that of her inevitable desecration; also, and still among his pre-
Tahitian works, there is a painting of a young girl gazing over
a display of still-life fruit; her eyes and mouth are tucked at the
corners by desire, her hitched-up innocence and inevitable guilt
emanate as coexistent qualities within her. As within Gauguin
himself, they seem to nurture rather than to negate each other.
Finally, on the tenth leaf of the "Notebook," Gauguin illus-
trated a section titled "The Genesis of a Painting" with a water-
color of his great canvas of 1892, *Manao Tupapaü* (The Spirit of
the Dead Watches). There, a head which is analogous to the
visage on the cover occurs behind a native girl, who lies nude
and belly down on a bed, bathed in artificial light. Gauguin
describes the girl on the bed as somewhat indecent and also
frightened; he uses her terror to signify the character of the
Maori women, who experience such horror at apparitions of the
dead that they cannot sleep in the dark without anticipating
death: "Finally, the ghost . . . a simple, ordinary woman. Be-
cause the young girl, unacquainted with the theatrics of the
French stage, can only conceive of a spirit as embodied in the
corpse itself. That is to say, a person, like herself. . . . The soul
of the living woman united with the spirit of the dead. The
opposites of night and day." On the cover of the "Notebook,"
therefore, the young girl may already display, in the ambiguity
of her visage, the specter of her death.

The "Notebook" contains much that Gauguin would re-
peat or had already written elsewhere: in *Noa Noa,* in letters to
Mette and to his friend Daniel de Monfreid. Yet, on the whole,
it may be his most illuminating text, containing as it does refer-
ences to Poe and Wagner; and citations from Verlaine, Rim-

baud, Swedenborg, Balzac, and Péladan whose ideas supported Gauguin in the formulation of his basic way of thinking and painting. Art becomes "the reproduction of what one sensibly grasps in nature but which is seen through the veil of the soul" —a reiteration of Zola's famous line: "Art is a corner of nature seen through a temperament." But Gauguin's adopted version seems more compelling, perhaps because "the veil of the soul" is more deeply recessed than "temperament." In obscuring reality, it permits one to perceive obscurity itself—the unknown, the mysterious. It clarifies basics, differentiates between poet and storyteller, artist from illustrator. Gauguin writes, quoting Cézanne, that a full kilo of green paint is greener than a half-kilo. Simplicity itself is uttered with the weight of a philosophical truth. And the question of art and of life finds its summation in the most ingenuous of observations: "In Europe, human coupling is a consequence of love; in Oceania, love is the consequence of coitus." And then, the question: "Who is right?"

On one level, Gauguin's theories of art, which are scattered throughout his writings, seem inextricable from the configurations of sexual union and divine creation—the musky and exotic level upon which creative nourishment is at times serenely and at other times savagely drawn from unconscious founts. On another level, Gauguin occasionally permits the intellect to hold sway, not at the expense of instinct but rather as a way of keeping it in constructive abeyance. He is hardly original, however, when he verbally formulates theoretical ideas. As in constructing his paintings, he borrows from everywhere: the writings of Delacroix, Charles Blanc, E. Péron; from the ideas of van Gogh and the whole array of Romantic and Symbolist writers: Aurier, Rimbaud, Huysmans, Fénéon, Remy de Gourmont, Mallarmé, Baudelaire. That they became synthesized, however, was Gauguin's achievement; no other painter more effectively embodied in the workings of his mind and craft the intellectual machinations of a whole generation of poets. His capacity for assimilation was omnivorous to the extreme. As he once re-

marked, his artistic center was in his brain, and it seems that whatever entered that volcanic cauldron became chemically transformed. His selecting, however, was not on the conscious level, so even though elements of his theories were drawn magnetically and with remarkable proficiency from various sources, it could hardly be called an eclectic process. Nor should the ecumenical commerce by which ideas entered his head be looked upon as an exploitation of others by which values are received without recompense. Pissarro, on viewing Gauguin's first exhibition of Tahitian canvases, concluded that his former pupil, always in difficulty finding his way, always poaching on someone else's ground, was now pillaging the savages of Oceania. He could not grasp the generic unity of Gauguin's imagery because he, and others, simply could not substitute such egotistical idiosyncrasies for orderly arrangements of ordinary reality. But if such residual naturalists as Pissarro failed to connect with Gauguin in the 1890s, there were others who found in his method confirmation of the kind of ideational realism that among the avant-garde was rapidly displacing the realism of natural appearances. Aurier was the principal spokesman for Gauguin and for the new sensibility. It was he who helped foment the formal split between the Impressionists and Gauguin's circle when, in 1889, he suggested the title Exposition du Groupe Impressioniste et Synthétiste for the Café Volpini exhibition which Gauguin organized.

Though in usage as early as 1885, the term *synthétiste,* with all its broad implications of simplicity, rhythmicality, ease of comprehension, and its assertion of mnemonic priorities, in which memory images fuse the unconscious with the cognitive aspects of perception, became the essential catalyst for Gauguin's thoughts only in 1888. But then, unhitched from Pissarro and Cézanne, he was quick to take hold on the stylistic potentialities of *synthétisme,* and certain of his paintings began to show the level of linear and surface-pattern simplicity to which natural appearances could be subjected if one wanted to force into being the synthetic essence of an idea, either pictorial or more strictly ideational. But whereas this was also adopted as a work-

ing hypothesis by other artists—Emile Bernard, Maurice Denis, Paul Sérusier, Charles Filiger, Eugène Fromentin, even Georges Seurat—Gauguin was the only one who really grasped the underbelly of the emerging theory, its essential primitivism, and pulled it down, as had Baudelaire many years earlier, to the depths of savagery where genius is unfettered and where perceptions and dreams are meshed with the fabric of nature. Aurier also spoke of this level where the synthesis of two souls, the souls of nature and the artist, occurs, but perhaps only the likes of a Baudelaire or a Gauguin were able to achieve it.

The divining of Gauguin's contribution to art theory and criticism is a task of scholarship on a level out of context here. Gauguin's writings on art, as distinct from his paintings, are interesting because he is interesting; their genealogy seems at times no less important to us to know than the names of every casual antecedent to his genetic make-up. The eyes of his mother, "so kind, so imperious, so pure, and so caressing"; her little hand, "as supple as India rubber," would have figured in his art as importantly as the ideas of Swedenborg or Poe. "My art goes way back," Gauguin admitted, "further back than the horses on the Parthenon—all the way back to the dear old wooden horsie of my childhood."

Gauguin wrote sporadically, but with sustained interest, until his death in May 1903. After 1897 he continued adding entries on the blank pages of *Noa Noa,* and in 1899, when he was so thoroughly bedeviled by the chicaneries of the colonial settlement, he undertook journalism and published a polemical little newspaper titled *Le Sourire* (The Smile), which appeared in nine issues. He wrote occasionally under the pseudonym Tit-Oil, which translates as "breast"—a remarkable change of identity from Pego! And in his first issue, reporting on a stage play written by a native woman on the theme of incestuous love and sexual liberation of women, Tit-Oil blurts out: "I must confess that I too am a woman and that I am always prepared to applaud a woman who is more daring than I, and is equal to a man in fighting for freedom of behavior."

This too is an old theme in Gauguin's repertoire. Shortly after his separation, and while still in Paris, he wrote excitedly to his wife in Copenhagen that he had heard of a newly published Danish book in which the author claims the right for a woman to sleep with whomever she pleases. The businessman's instinct still pressing him, Gauguin proposed to his wife that they might profitably collaborate on a French translation. One wonders how Mette replied, if she did at all, having been reminded by her absent husband a few letters earlier that the greatest sin of all was adultery. And in the "Notebook for Aline" (Diary of a Young Girl), Gauguin's commentaries on the rights of the artist are so tightly interwoven with those on the rights of the woman as to lead one to suspect that creation and procreation had never undergone separation in his maturity. "Women want to be free . . . the day a woman's honor is no longer located below the navel, she will be free." But Gauguin's own behavior with regard to native women would soon thoroughly undercut what degree of virtue he had summoned on behalf of the feminine from the implanted spirit of his maternal grandmother, the workers' and women's liberationist, Flora Tristan. He was operating now with boyish eagerness, as if his Paradise had suddenly become a playpen in which he could act out pranksterly fantasies under the protection of free press. He wrote diatribes and libelous attacks. In his assault on the public prosecutor for not having brought to trial natives who were robbing him blind, he openly invited either a duel or a lawsuit, but was not counterattacked; the officials knew better than to fuel his rage. Ironically, however, his efforts paid off. His acid style and satirical humor soon won him a client, the officialdom of the Catholic Church, no less, which financed him in editing a newspaper that was to undermine the Protestant stronghold in French Polynesia. Gauguin, his treatise against Catholicism conveniently forgotten, undertook the task with flair and professional acumen. His newspaper was titled *Les Guêpes* (The Wasps).

Gauguin's service to his silent partner, Catholicism, coincided sufficiently with his own critical views on colonial mal-

adroitness and misbehavior to relieve him from total puppetry; but, in truth he became again the stockbroker he once was, investing himself in what might yield the most profitable returns. And as if in a state of full recapitulation, he strikes back at Morice by printing in *Les Guêpes* several paragraphs from the introduction the poet had written for *Noa Noa*. Composed under the title *Terre Délicieuse* (Fragrant Earth), and, without mention of Morice, the piece ends with the by-line "Noanoa." Gauguin stopped short of signing his own name.

In June 1901, Georges Dormoy, a schoolmaster and compiler of the standard Tahitian-French dictionary, wrote an open letter to Gauguin as editor of *Les Guêpes*. Among the paragraphs which detail Gauguin's maliciousness, and which by law Gauguin was required to print, there is this:

These days, it is customary, in the so-called opposition press, to insult and disqualify those who occupy or have occupied public office. *Les Guêpes* is not exempt from this impediment. It is up to you, Monsieur Gauguin, to earn the money you receive to spread lies and slander. Strange occupation for an artist, to exploit human credulity with so little regard for truth and to trade so despicably in public naïveté!

One final word: the so-called Tit-Oil in your journal finds my face stupid; tell him for me that his face has always seemed to me too basically dumb to be moronic; I find it bestial.

Gauguin's reply follows directly:

As far as I am concerned, I will respond to the epithet of despicable only in proportion to your miserable personality; that is to say, with the utmost disdain, my reputation until this very day putting me beyond your reach. One day the world will laugh at this epithet, and the ridicule will fall back on you.

The same goes for your comment on Monsieur Tit-Oil.

I have heard indeed that he had mentioned a stupid-faced bureaucrat in a satirical article, and you rightfully recognized yourself. Admit, then, that Tit-Oil really showed great forbearance by describing only the face. Well, here you stand, condemned by one for having a bestial face, by the other for having a stupid one. Alas! It is a great pity.

Gauguin's stint as a yellow journalist was as much a misadventure as misadventure was the theme of his vituperative columns.

Perhaps his latent flair for rhetoric had gained him a small following. His reinstatement as an active member of society, the involvement in local politics—or even the fact that he had joined the Catholic party, incredible as it may seem—may have given him a remedial dose of reality when he needed it most. Perhaps also it threw him back in time with such force as to renew the old dream of seeking mystery and solitude in an exotic land—the dose of reality having been thoroughly effective. He had lost his love of the Tahitian natives, and what degree of respect they may have had for him was now turned to contempt. Gauguin was no longer their white brother and magical man-who-makes-things. In *Les Guêpes,* Gauguin had insulted the natives in his editorial proposal to station a gendarme in every village in order to control the native thieves; and in countering the Protestant proposal to cancel the liquor licenses of barkeepers in native villages, he was not sympathetic to the natives, but predicted that a dangerous congestion would develop on the roads into Papeete should the sale of spirits be centralized there. Gauguin had once again become a Frenchman. Speaking as a representative of the Catholic party, on a dais in the Papeete park—speaking, incidentally on the problems of the interbreeding going on between the Chinese and the Tahitians—Gauguin opened his address: "Before me, I see no ordinary gathering, but a united family of friends who have met here together, far from our homeland, to enforce the welfare of ourselves and of our colony, each of us proud to be French."

In September 1901 he made the decision to sail to the Marquesas, motivated by the germ of savagery still alive in him, this fealty to an old dream. To continue was his only remaining option—all else had failed. To de Monfreid, he confided his plan: "I think that in the Marquesas . . . with new and more savage subject matter . . . I shall do beautiful things. . . . My Brittany pictures are now rose water because of Tahiti; Tahiti will become *eau de Cologne* because of the Marquesas." And to Morice he added that his choice of retreat was now Fatu Hiva, which he believed was still almost entirely in the cannibal stage:

"I believe that there the savage atmosphere and complete solitude will give me a last burst of enthusiasm before dying—will rejuvenate my imagination and bring my talent to its conclusion."

Gauguin's voyage, like his dreams, fell short. He never reached the voracious paradise of Fatu Hiva, choosing to settle instead at Atuona on Hiva Oa, where the ship happened to dock. He purchased a lot in the center of the village and hired carpenters to build him a studio-home. Above the door he inscribed the legend "House of Pleasure"—the writing on the wall that would editorialize the sad state of the master's affairs. The house soon became the scene of raucous all-night parties. The public carousing aroused the ire of the nearby Catholic mission, whose favor Gauguin cultivated only long enough to effect the purchase of the land.

Gauguin had also purchased a young *vahine,* but she soon became pregnant, and left to have her baby at her own home. Gauguin's sexual appetite remained satisfied by the comings and goings of native girls who flocked to his door: "A chicken had come along. . . . When I say a chicken, I am modest, for all the chickens arrived, and without my invitation." On his bed he had carved an erotic scene, and the walls of his bedroom were decorated with obscene photographs. He adopted as a partner a little dog, which, appropriately, he named Pego. In his chamber the deathbed was an arena of sexual energy, and from Sardanapalus he borrowed another prerogative: in his decline, like that king, he destroyed all the beauty around him to take it with him in his own death. He might have achieved in the Marquesas the savagery that had always been beyond him, but he was not up to it. He might have found yet a new Eve worthy of reverence and redemption, but he no longer possessed the grace to honor her. If in the end he was to fail, he would force the world to commend him nonetheless for the magnificence of the failure.

In August 1902 Gauguin wrote to de Monfreid expressing a wish to return to France. De Monfreid, his most faithful and level-headed friend, wrote back to dissuade him: "It is to be

feared that your return would only derange the growing and slowly conceived ideas with which public opinion has surrounded you. . . . *You must not return! Now you are as are the great dead. You have passed into the history of art!"*

In his native land he was considered dead, and better so—his premature passing into art history had enshrined him. The final phase of his life was mottled by battles with the Catholic mission and with colonial officials. He would not die in peace but railed against authority to the last, as if his hard-won pariah-hood were at stake. Infirm though he was, he proved a formidable adversary. He wrote inflammatory letters, set himself up as public defender for natives under charges, preached to keep girls out of mission schools, and exhorted natives not to pay their taxes. Finally, he succumbed to a libel suit and was heavily fined and sentenced to three months in prison. He would die while the sentence was under appeal, on May 8, 1903.

In the interstices of his routine of encounters and disasters over his final years, Gauguin managed to find time to paint and to write. He continued with his work on "Catholicism and Modern Times," compiled his recollections and reflections in journal form, and wrote the most remarkable of his treatises on art: "Racontars de Rapin" (Dauber's gossip), a blast against criticism that he sent to André Fontainas for submission to the *Mercure de France.* His journal, *Avant et Après,* sums up the aspirations and the vicissitudes of his life. He described it in a letter to Fontainas in February 1903, shortly before his death:

I have just written a whole volume of childhood memories, the reasons for my instincts, for my intellectual development; also what I have seen and heard (including criticism of men and of things), my art, other people's art, the things and people I admire, also those I hate. This is no literary work deliberately cast in a chosen mold. It is something else: the civilized man and the barbarian face to face. The style has to be in keeping, laid bare, showing the whole man, often shocking. That is easy enough for me. I am not a writer.

# Foreword

### by Daniel Guérin

To put it briefly, why this book? Why this selection of writings by a painter?

Above all, because Gauguin was two people at once: an artist, and a revolutionary one for his time, who used many means of expression (painting, drawing, engraving, sculpture, ceramics), and at the same time a versatile writer who used any and all means available. As an autobiographer, art critic, and theoretician, he bullied academicism, wrote nonconformist tracts, and, as he grew older, became anticlerical, anticolonialist, pacifist, antimilitaristic, antibourgeois, praised free love and women's emancipation and even, at times, androgyny and bisexuality; an anarchist by temperament, he combated the establishment and so, on that score, he would be a revolutionary even now.

His powerful personality greatly exceeded the resources of his art, prodigious though his palette, pencil, knife, and chisel were. It is impossible to grasp him fully without having some acquaintance with his written work.

Let me quote his biographer, the late Henri Perruchot, whose books have either been remaindered or gone out of print:

Gauguin wrote a great deal. On the one hand, he maintained a continuous or episodic correspondence with a great number of his contemporaries; on the other, he occasionally wrote articles for periodicals; and, **xxxiii**

finally, he wrote some long manuscripts, indeed whole books. Altogether these total some fifteen hundred pages. Unfortunately, there is no collected edition of his writings.[1]

So much for the amount he wrote. And now, let us see its quality:

Gauguin left some writings, personal confessions, and comments on his art, and the least that can be said of them is that they are of utmost interest. In his writings, Gauguin did not attempt to formalize his thoughts, memories, and dreams. But without trying he achieved style, a result, perhaps, of his haughty disdain for style. His language is rugged, harsh, highly colored; its movement is swift and incisive. Through it the artist's personality asserts itself forcefully.[2]

Perruchot could have added that (aside from a few stunning exceptions) many of Gauguin's Symbolist or other contemporaries now seem out-of-date, or even unreadable, when their affected, mannered, and pompous style is compared to his.

After all, what are Gauguin's written works if not a long cry of misery, rebellion, anguished searching, pride and joy in artistic creation, the contemplation and interpretation of the Beautiful, a certainty of genius amid incomprehension and solitude. They are the cry of an artist whom the French bourgeoisie and the art speculators allowed to starve to death—whereas today his works fetch astronomical sums—only to let the greater part of his immense artistic heritage later slip out of France.

Virtually none of the texts which make up that body of writings can be found in the bookstores. Certain books or volumes of letters are out-of-print and have not yet been republished. In the case of other manuscripts, facsimiles have been published in very limited editions that only fortunate collectors or libraries can afford. The complete correspondence, in three volumes, as planned by John Rewald, Bengt Danielsson, and Merete Bodelsen, has not yet been published. A great many articles or interviews are scattered throughout various periodicals dating from the 1890s or later, some of them extremely

1. *Gauguin*, tr. Humphrey Hare (Cleveland, 1963), Bibliography, p. 371.
2. *Gauguin, sa vie ardente et misérable* (1948), Bibliography, pp. 329–32.

difficult to obtain. Private or public collections jealously guard their treasures (manuscripts or mere autographs), while other people, not of French nationality, deliberately overlook the fact that Gauguin's written work has now fallen into the public domain and intend to reserve their "right" to decide on the subsequent and, in fact, long- overdue publication of hitherto unpublished matter. Moreover, since Charles Morice, that evildoer of the written word, had truncated Gauguin's essential literary work, his Tahitian narrative *Noa Noa,* the pure savor of the original text remained unknown until 1966, when Jean Loize re-established it. But even that scholarly edition is already out-of-print.

Within the editorial framework of this anthology, which is a work of vulgarization in the best sense of the word, no available text has been omitted, although it has been possible to publish only extensive excerpts of the longest texts and correspondence. At the same time, this has relieved them of much dross. But the reader may trust me: the texts published here are the quintessence, the finest flower of Paul Gauguin's writings.

The precocious artist-writer had thorough secondary schooling behind him and was by no means self-taught, although he started out as a "coarse sailor," in his own words. Nor, contrary to what has been maintained, was he inferior as a writer and art theoretician to certain painters who were his contemporaries, friends, or disciples, such as Paul Sérusier, Emile Bernard, and, later on, Maurice Denis. From that viewpoint alone, this volume is revealing: a great painter explains his painting and reveals his secrets. But as we read Gauguin we cannot help being struck by aspects that go beyond painting— the richness of his thinking and curiosity, the extent and diversity of his culture, the sureness of his judgment and taste. The Biographical Index at the end of this book, listing the many names mentioned by Gauguin throughout these writings, along with a brief identification of each person, attest to his wide knowledge.

Throughout his writings this outstandingly civilized man, a man of culture in its utmost refinement, proclaimed that he did

not "disdain its beauties"; yet there is a ceaseless leitmotiv—revealing a contradiction at the very core of his being—which is his desire to be a savage.

On his Peruvian origins on his mother's side: "A savage from Peru."

In Brittany: "I am living there like a peasant, known as the savage."

"I go about like a savage, with long hair."

In America: "I'm going to Panama to live like a savage."

In Tahiti: "In their eyes too I was the savage. Rightly perhaps."

"Give me credit for a little . . . of the instinct of a civilized savage, which I am."

In the Marquesas (shortly before his death): "I am and shall remain a savage."

"You were mistaken in telling me one day that I was wrong to say that I am a savage. The fact is that I *am* a savage. And civilized people have a presentiment of this: for there is nothing surprising, disconcerting in my works if not this 'savage-in-spite-of-myself' aspect. That is why what I do is inimitable."

In Gauguin, there is a fundamental duality: "civilized savage," plebeian and aristocrat at the same time, "so hard, so loving," "sensitive" and sometimes coarse of speech.

But in his voluntary exile in Oceania, we can also see an artist's deliberate reasoning: by becoming an expatriate, Gauguin was not only deserting culture but also looking for original pictorial themes—those that might release his art from what was *déjà vu*—and would ultimately enrich culture.

By going to the ends of the earth to seek new inspiration, Gauguin was to become prisoner of a stunning contradiction. He had wanted to flee from Paris, yet was unable to cut the umbilical cord which bound him to the city. He constantly had all sorts of urgent material problems to settle with people in the distant capital—his buyers, dealers, prospective publishers of his writings, organizers of his exhibitions, and so on. And since the absent are always in the wrong, he was so far away that sheer distance hampered his friends' efforts to act as intermediaries

for him. The airplane had not yet been invented. Shipping services and mail were heartbreakingly slow. Even the mechanics of sending canvases to France involved awkward problems and heavy risks; and so did the shipment, in the opposite direction, of works that he had left in Paris and wanted to recover. He sought solitude and suffered from solitude. He missed, at times wretchedly, not only his children, whom he had given up seeing again, but also the company of artists and writers whom he esteemed and who had formed his entourage in France, and whom the thirteen-year-old Polynesian girls that he took to bed did not replace. He wanted to turn his back on the artificiality of Parisian life, yet every month he gobbled up the *Mercure de France,* a subtle Symbolist review. He adored living like a "savage" and, at the same time, fumed at not being on the spot, to handle personally the business matters that were going on without him in Paris.

On the other hand, the fact of having gone away, so far away, certainly gave him a perspective that allowed him to judge more lucidly and profoundly the changes between past and present culture, and his writings certainly owe a great deal to his existence-at-one-remove.

Of all the contradictions in which he had let himself become bogged down, the philistines chose to perceive but one other contradiction, just one, and they all chortled over it. In the *Bulletin de la Société d'études océaniennes,* [3] published in Tahiti, a *popaa* (European) named Jacquier, publishing Gauguin's final exchange of letters with his lawyer, dared to comment: "In fact there is something both painful and grotesque in Gauguin's flight from civilization and in his attempts to return to nature." Then, in an effort to justify his sarcasm, this scribbler added: "Just as he believed he had reached the end of the world, he found himself face to face with two characteristic representatives of civilization—the parish priest and the gendarme!"

But what made Gauguin, to an astonishing extent, the precursor of today's challengers of the established order was the

3. *Bulletin de la Société d'études océaniennes,* March–June 1961, pp. 213–34.

fact that he did not deliberately desert the "consumer society" and then abdicate, fall silent, succumb to disappointment, and yield to despair. Doubtless he was not a "hero"; at times he was weak and inconsistent; there were cruel hours of discouragement and poverty; and once he had a brush with suicide. But despite the illness that ultimately killed him he did battle, down to his last breath, on behalf of the natives and the humbler colonials, not only against governors, magistrates, and capitalist leeches but also against those two "characteristic" representatives, in the Marquesas, of a form of society which was intolerable to him: "the parish priest and the gendarme."

Governor Edouard Petit quite understood this. In a report to the French Minister for the Colonies (which Bengt Danielsson found in the Archives of Overseas France), he wrote (referring to Gauguin by name) that the islands should be swept clean of the "bad Frenchmen" who had come "to the ends of the earth in order to conceal there the turpitudes of their existence" and were "fomentors of disorder."

I have not always stuck to the exact wording of Gauguin's manuscripts, as has been done by editors with religious faithfulness and possibly excessive scruples. Aside from the inevitable cuts I have had to make, I have taken the liberty, in order to make the texts more easily understandable, of correcting a few spelling lapses, improving punctuation, restoring (in square brackets) words which the writer skipped or which have been difficult to read or even misread, of re-establishing proper names that had been deformed, and, where the excerpts from *Avant et Après* are concerned, of arranging those "scattered notes" in a less disconcerting order than Gauguin, who was pressed for time, had done. Sometimes I have inserted passages from one manuscript in another, when the one completed the other or was in the same vein. I have also had to avoid repetitions, for Gauguin would insert one and the same fragment in several of his manuscripts or comment on one of his canvases more than once.

Last, following a chronological order, I have combined

excerpts from the correspondence with excerpts from contemporary articles, essays, or books to which the letters often refer. By using this method I hope to give the book a somewhat biographical cast. The explanatory footnotes should illuminate or clarify certain passages; the most important works are preceded by brief introductions.

# Gauguin in France

# *Gauguin's Beginnings*

*Editor's note: In Paris, at the age of twenty-five, Paul Gauguin, who had been in the merchant marine and the navy, met a Danish girl of twenty-three, Mette Gad, who was visiting the city. On November 22, 1873, they were married. Since 1871 he had been plying the lucrative trade of agent for a stockbroker, Paul Bertin (later succeeded by Galichon). The office at number 1 Rue Laffitte was managed by Adolphe Calzado, son-in-law of Paul's godfather and guardian, Gustave Arosa, an old friend and neighbor of Paul's mother in Saint-Cloud, a photographer and a knowledgeable collector of paintings.*

*In 1880 Gauguin played the stockmarket successfully enough to be able to buy, at low cost, paintings by Monet, Renoir, Degas, Sisley, Cézanne, Pissarro, and Guillaumin. And he himself began to succumb to the demon of painting. His first canvas dates from the summer of 1873, and in 1875 he began to study under Camille Pissarro. In 1876 one of his paintings was accepted by the Salon. He became married to painting at the same time that he married Mette, and later on he was to abandon Mette and his children for its sake.*

*In January 1883 he cut his ties with the stock-market speculators in order to devote himself to his new passion. But this abruptly stopped his source of income, and in August 1884 his wife returned to Denmark with the five children she had borne him. At the end of that year Gauguin reluctantly joined her, but he did not like Denmark. In June 1885 he did not hesitate to leave his family and go back to France, taking Clovis, one of his sons, with him for a time.*

3

*The first letter in this book, a fragment of which is given, was written from Copenhagen to Emile Schuffenecker, whom Gauguin had known at Bertin's brokerage house and who had also given up the stock market to devote himself to painting.*

**TO EMILE SCHUFFENECKER**    . . . Sometimes I wonder if I am crazy, and yet the more I think things over at night, in my bed, the more I think I am right. For a long time the philosophers have been reasoning about phenomena which seem supernatural to us and which we nonetheless feel. That word is the key to everything. The Raphaels and others, people in whom feeling was formulated long before thought, were unable, even while studying, to destroy that feeling and so could remain artists. In my opinion the great artist is the embodiment of the greatest intelligence. The sentiments and renderings which occur to him are the most delicate and, consequently, the most invisible products of the human brain.

. . . Colors are still more eloquent than lines, although less dominant, because of their power over the eye. There are tones that are noble, others that are common, harmonies that are calm and consoling, others that excite you by their boldness. . . . Look at Cézanne, the misunderstood, the essential mystic nature of the Orient (his face is like the face of an ancient from the Levant); he prefers forms imbued with the mystery and weighty tranquillity of a man lying down so as to dream; his colors are grave like the character of an Oriental; a man from the Midi, he spends whole days on the mountaintops reading Virgil and gazing at the sky. And his horizons are high, his blues very intense, and his reds vibrate astonishingly. . . . The literature of his paintings is meaningful, like a parable teaching a double lesson; his backgrounds are as imaginative as they are real. In short, when you see a painting by Cézanne, you cry, "How strange!"

. . . Here [in Copenhagen], I am more than ever tormented by art, and although I have to worry about money and look for business, nothing can deter me. You say I would do well to join

your Société d'Indépendants;[1] shall I tell you what will happen?
There are about a hundred of you now; tomorrow there will be
two hundred. Two-thirds [of] these artist-merchants are in-
triguers; in a short while you will see the Gervexes and others
becoming more important. What will we do—[we] the dream-
ers, the misunderstood? This year the press is favorable to you;
next year the schemers (there are Raffaellis everywhere) will
have stirred up all the mud in order to cover you with it and
make themselves look clean.

Work freely and madly; you will make progress and sooner
or later people will learn to recognize your worth—if you have
any. Above all, don't sweat over a painting; a great sentiment
can be rendered immediately. Dream on it and look for the
simplest form in which you can express it. . . .

*—January 14, 1885, Copenhagen*

TO SCHUFFENECKER   . . . I am taken with your idea of going to Du-
rand-Ruel's, but the fellow has terrible difficulty staying afloat
and the very little that he does do for the Pissarros and others
is done not out of friendship but actually because he has in-
vested close to a million [francs] and he is afraid that the Im-
pressionist painters will depreciate the goods by selling at any
price. Get it into your head that that damned Jesuit couldn't
care less whether I am broke.

   . . . Here I have been underhandedly sapped by a few
bigoted Protestant females. They know I am blasphemous and
so they want to bring about my downfall. Jesuits are milksops
compared with churchy Protestants. To begin with, the Count-
ess Moltke, who had been paying my son Emile's boarding-
school fees, immediately stopped paying because of the reli-
gious question. No reproach to be made, you understand. Many
French lessons have not found takers for the same reason, etc.
I'm beginning to get fed up[2] and am thinking of giving up

1. Schuffenecker had been a founder of the Salon des Indépendants.
2. See p. 17, and passages from *Avant et Après*, pp. 241–44, for the bitter
memories Gauguin was to have of his stay in Denmark.

everything to go to Paris, to work, to make just enough to keep myself alive—but even as a sculptor's assistant in Bouillot's studio I'm free. Duty! Well, let someone else just come and try; I have done my duty as best I could, and it is material impossibility that will have made me give up. Thanks once again for all the interest you take in us. There aren't many people who have any consideration for you when you're hard up!

If you see Guillaumin tell him that I would be pleased to have a letter from him at this point; when I receive a letter from France I always breathe a little better. For six months now I haven't talked. The most complete isolation. Of course the family considers me a monster because I'm not making money. Nowadays only the successful man gets any respect.

Send me a photograph of Delacroix's *Wreck of Don Juan*—if it doesn't cost too much. I must admit that at this point my only good moments are when I can shut myself into the world of art. Have you noticed to what extent that man had the temperament of the wild beasts? That's why he painted them so well. Delacroix's drawing always reminds me of the strong, supple movements of a tiger. When you look at that superb animal you never know where the muscles are attached, and the contortions of a paw are an image of the impossible, yet they are real. Similarly the way Delacroix draws arms and shoulders, they always turn around in the most extravagant way, which reasoning tells us is impossible, yet they express the reality of passion.

The draperies coil around like a snake, and the effect is so tigerish! However that may be, and whatever you may think of it, in his *Wreck of Don Juan* the boat is the breath of a mighty monster and I would really like to feast my eyes on the sight of it. All those starving people in the middle of that sinister ocean. . . . Everything disappears behind their hunger. Nothing but painting, no trompe l'oeil. The boat is a plaything that was never built in any seaport. No sailor, Monsieur Delacroix, but at the same time what a poet, and upon my word he is quite right in not imitating Gérôme's archaeological accuracy.

And to think of what Monsieur Wolff wrote, in *Le Figaro*: that not one of Delacroix's paintings was a masterpiece; always

incomplete, says he. Now that Delacroix is dead, he has the temperament of a genius, but his paintings are not perfect. Look at Bastien-Lepage; there's a conscientious man, burrowing into nature in his studio. Mr. Wolff does not stop to think that Delacroix is not only gifted at rendering forms but is also an innovator. . . .

I held a show of my works here. One day I'll tell you how they closed my exhibition after five days, on the orders of academe, and how serious articles, favorable to me, were kept out of the newspapers. All this contemptible plotting! The whole old academic clan trembled as if I'd been a sort of Rochefort in the field of art. It's flattering for an artist but the effect is disastrous.

In Copenhagen I have to get a carpenter to make frames; the framers would lose their customers if they worked for me. This, in the nineteenth century! But if we're so insignificant, then why all this fuss? . . . To feel that you're an element, imperfect perhaps but still an element, and yet doors are closed to you everywhere . . . There is no denying that we are the martyrs of painting . . .        —*May 24, 1885, Copenhagen*

TO METTE GAUGUIN    . . . You ask me what I'll do this winter. I have no idea. It will all depend on my resources. You cannot establish something with nothing. I have no money; no house; no furniture; no work, except a promise at Bouillot's if there is any work. In which case I'll rent a small studio at his place and sleep there. As for food, I'll eat what I can afford to buy. If I sell a few pictures, next summer I'll go to an inn in some little out-of-the-way place in Brittany and paint and live economically. The cheapest place of all to live is still Brittany. Once this bad period is over, if business picks up[3] and my talent increases and brings in money as well, then I'll consider settling down for good somewhere. . . .        —*August 19, 1885, Paris*

3. Allusion to the acute economic and financial crisis which had begun in January 1882, with the collapse of l'Union Générale, a Catholic bank, which had made Gauguin lose a good deal of money.

# "Notes Synthétiques"

**(1884–85) (Excerpts)**

*Editor's note: There is disagreement over the date of these "Notes." Some scholars situate them "circa 1890," others as early as 1884, during Gauguin's stay in Rouen, or at some point in the winter of 1885, during his trip to Denmark. The latter dates would seem the most probable, since the "Notes" were written in the front of a notebook that Gauguin had bought in Rouen in 1884. Furthermore, by 1886 the artist had publicly announced his allegiance to "synthétisme." These "Notes" were first published in 1910 by Henri Mahaut in a review called* Vers et Prose *published by Paul Fort, the poet.*

. . . "This work is to my taste and done exactly as I would have conceived it." There you have the whole of art criticism[4]—being in agreement with the public, looking for a work in its image. Yes, gentlemen of letters, you are incapable of criticizing a work of art, even a book, because you are already corrupted as judges. You have a preconceived idea, that of a *littérateur,* and you are too imbued with your own importance to look at somebody else's thinking. You do not like blue, for you reprove all blue paintings. Sensitive and melancholy poets, you want all pieces to be in a minor key. So-and-so likes what is graceful, and for him everything has to be done gracefully. Another man likes gaiety and cannot imagine a sonata.

---

4. See pp. 215–27, for Gauguin's tract against art criticism, "Racontars de Rapin," 1902.

To judge a book, you must be intelligent and well educated. To judge painting and music, you need—in addition to possessing intelligence and artistic knowledge—special feelings which are not in everyone's nature. In a word you must be a born artist; and though many are called, few are chosen.

. . . Literature is human thought described by words. No matter how talented you may be at telling me how Othello, his heart eaten up with jealousy, comes to kill Desdemona, my soul will never be so impressed as when, with my own eyes, I have seen the stormy-browed Othello coming toward her in the bedchamber.[5] Which is why you need the theater to make your work complete. You can give me a talented description of a tempest, but you will never succeed in making me feel it.

Like numbers, instrumental music is based on a unit . . . Using an instrument, you start with one tone; in painting you start with several. Thus, you start with black and divide it up until you reach white: there's your first unit; it is the easiest, and accordingly the most widely used and, therefore, the best understood. But take as many units as there are colors in the rainbow, add to those the units made by the composite colors, and you arrive at a respectable number of units. What an accumulation of numbers, a regular Chinese puzzle, and it is not surprising that the colorist's science is so little developed by painters and so little understood by the public. But still, what a wealth of means by which to enter into intimate contact with nature!

We are criticized for using colors without mixing them, placing them next to each other. On that ground, we are necessarily the winners, being mightily helped by nature, which proceeds in just the same way. A green next to a red does not yield a reddish brown as would the mixture of the two, but gives two vibrant notes instead. Next to that red put a chrome yellow; you have three notes each enriched by the others and increasing the intensity of the first tone, the green. Instead of the yellow put

5. Gauguin had seen Delacroix's painting *Desdemona* in the collection of Gustave Arosa, his guardian.

a blue, and you'll find three different tones but all vibrating because of each other. Instead of the blue put a purple, and you'll be back in a single composite tone, merging into the reds.

The combinations are unlimited. Mixing colors gives you a muddy tone. A color by itself has a raw quality that does not exist in nature. Colors exist only in a visible rainbow; but how right rich nature was in carefully showing them to you next to each other in a deliberate and immutable order, as if each color was born of the other!

Now, you have fewer means at your disposal than nature and you decide to deprive yourself of all the means that nature offers you. Will you ever have as much light as nature has, as much heat as the sun? And you talk about exaggeration! But how can one exaggerate, since one can't go all the way, as nature does?

Oh! If by "exaggerated" you mean any work that is badly balanced, then, in that sense, you would be right; but I would like to point out that however timid and pale one's work may be, it will be accused of exaggeration whenever there is a mistake in harmony. Is there really a science [of] harmony? Yes.

And it happens that the sense the colorist possesses is, in fact, natural harmony. Like singers, painters sometimes sing off-key; their eye does not have harmony. Later on, through study, a whole method of harmony appears of itself unless—as in the academies and most of the studios—they pay no attention to it. As a matter of fact, they have broken up the study of painting into two categories. First, you learn to draw; then you learn to paint—which amounts to saying that you come back and color within prepared contour lines, more or less like painting a statue after it's been carved. I must say that so far the only thing I've understood in that exercise is that color is nothing more than an accessory. "Sir, you must be able to draw properly, before you can paint," and this is said in a pedantic tone of voice—for that matter, that is the way the stupidest things are always said.

Does anyone wear shoes on his hands, confusing them with gloves? Can you really make me believe that drawing does not

derive from color, and vice versa? And to prove it, I propose to make any drawing look larger or smaller, depending on the color with which I fill it in. Just try to draw a Rembrandt head in exactly the same proportions as he did and then use Rubens' color: you'll see what a shapeless thing you end up with and the color will have become disharmonious.

For a century enormous sums have been spent to propagate drawing and the mass of painters has grown larger; but not the least progress has been made. Who are the painters whom we admire at this time? All those who found fault with the schools, all those who have derived their knowledge from a personal observation of nature.

# On Decorative Art

*Editor's note: The following are excerpts from a torn, untitled, unpublished manuscript. Lengthy passages appeared in the journal* Arts *(July 8, 1949). As there is no way of assigning a date, I am inserting them here, although the chronology may be incorrect. I have also added the title.*

Must we take pride because our country, which gave birth to [Clouet], has placed so much importance on the Dutch school, including [Il Bamboccio], who created so many little paintings, minute but precious?[6] I know of course that Holland was the leader in diamond cutting and that rich merchants, back from the Indies, had to accommodate as many paintings as they did tulips in tiny town houses.

It was only a step from that infatuation to losing the notion of great decorative art. And what role does nature play, or a copy of nature (I have in mind visible nature)? In decorative art, none or almost none; only the role that the painter with little creative imagination (creative, I repeat, not the type that arranges and manages) decides to give it.

In that art, color becomes essentially musical. In the cathedral we like to hear the orderly, auditory translation of our thoughts; to the same extent, color is music, polyphony, symphony, whatever you want to call it. . . .

---

6. Jean Clouet II is a suggested reading here, for *Arts* had printed "Chloé." Similarly, *Arts* had also printed "Le . . ." which may be "Le Bamboche," known to us as Il Bamboccio.

Let us go inside the cathedral, let's make the sign of the cross, a sign which it really deserves. Its windows are decorated with stained glass to which colored light is fundamental. For it is indeed there that the light should arrive in richly colored beams borne by angels, heavenly persons coming from the heavenly vault. But the walls are and should remain walls, all lengthened by series of interlinked columns, all united to hold up the edifice; strength and elegance. And in these walls you will come and make new windows opening onto nature. We believe we can establish a principle of decoration: on those walls, if there is decoration, see to it that not one centimeter of the surface of your painting stands out from its mural surroundings.

In commissioning works, the government and the City of Paris have both lost sight of their genuine aim—preserving the monuments that belong to them. And in so doing they have become a branch of the Public Welfare Office, assisting as much as possible the majority of faithfully submissive artists. Since then the notions of monumental decoration seem to have been lost.

. . . Since everything in nature, the organic and visual as well as the imaginative and mysterious, has certain laws of relative size, it is necessary, in the field of decorative art, to establish clearly the size of the surfaces to be filled. The dwarf and the giant are both beings under and over the supposed average size, and through an absurd understanding of things, it [decorative art] seems to see dwarves on gigantic walls and [at the] same time giants in tiny apartments.

So-and-so decorates opera houses of gigantic stature with little columns and mantelpiece busts or statuettes, while another man carves the Trojan war on a hazelnut or depicts one ploughman in [a] field on a ten-meter canvas. . . .

It would take a long study to go into this, and [it] is not yet our goal. . . . We have simply aimed to bring attention [to] an art that is disappearing and, without laying down the law, to indicate in a few words the causes of that disappearance.

—Arts, *July 8, 1949*

LETTERS    **TO METTE**    . . . I am not surprised that my paintings were refused amid daubings of Christmas scenes and I am not upset by it, but if you don't try to exhibit, how can you express yourself? You just have to note the ill-will that prevails, that's all, and not make a secret of it. If you can even get the press to say so, that will be publicity and one day people will see which is the right side.

In March, along with some of the talented new Impressionists, we are going to put on a very complete show.[7] For several years now all the schools and the studios have been paying attention to them, and it is expected that this show will be talked about all over town; maybe it will be the starting point of success for us. Let's wait. More than any other, the picture trade is completely dead here and it is impossible to sell any painting, especially the official kind. . . . A very good sign in our favor, but that's in the future. . . .        —*December 29, 1885, Paris*

**TO METTE**    . . . Necessity is the mother of invention; sometimes too it makes man go beyond the limits that society places on him. When our son came down with smallpox, I had twenty centimes in my pocket and for three days [we] had been eating dry bread, on credit.

Panic-stricken, I thought of asking a company that puts up posters in railway stations to hire me as a billposter. My bourgeois look made the manager laugh. But I told him very seriously that I had a sick child and that I wanted to work. So I posted bills for five francs a day; meanwhile, Clovis was confined to bed with fever, and in the evening I came home to take care of him.

. . . Your Danish woman's pride will flinch at having a billposter for a husband. What can I do, not everyone has talent. Don't worry about the boy; he's getting better and better and I am not thinking of sending him to you; on the contrary, as and when my billposting brings in more money, I intend to take some of the other children back. It's my right, you know.

7. This was the eighth exhibit of painting put on by the Société anonyme des artistes peintres, sculpteurs, graveurs (May 15–June 15, 1886).

You ask me to answer you gently, the way you do, so it is with a great deal of calm that I pore over all your letters which tell me very coolly, and rightly for that matter, that I once loved you but that you are now merely a mother and not a wife, etc.; this brings me very pleasant memories but they have the very great disadvantage of leaving me not the slightest illusion as to the future. And therefore you must not be surprised if one day, once my situation has improved, I find a woman who will be more than a mother, etc., to me.

I know that you consider me devoid of any charm, but that spurs me on to prove to you the opposite. . . . Meanwhile, with your head held high, as you do now, keep facing the world imbued with your sense of duty, your conscience clear; after all, there is only one crime and that is adultery. Except for that, everything else is moral. It is unjust that you be driven out of your home but it is reasonable that I be driven out of mine. So don't disapprove if I make myself another home. And in that one I'll be able to post bills. Everyone blushes in his own way. . . .                    —*Approximately April 25, 1886, Paris*

TO METTE   . . . Our show brought the whole question of impressionism out into the open again, and in a way that was favorable. I was much appreciated by the artists. Monsieur Bracquemond, the engraver, enthusiastically bought one of my paintings for 250 francs and introduced me to a ceramicist[8] who plans to make hand-decorated vases. Delighted by my sculpture, he asked me to make things for him this winter, whatever I want to make, and if they sold, we would share the profits half and half. Perhaps this will be a great source of income in the future.

. . . I have been offered a job as farm laborer in Oceania, but that means abandoning all hope for a future, and I dare not resign myself to doing it when I feel that, with patience and a little help, art can still hold out some good times for me. . . .
                    —*Undated, late May 1886, Paris*

---

8. Ernest Chaplet (see Biographical Index).

TO METTE . . . I've just come from Schuffenecker's. He's still a good fellow and grateful to me for having helped him make progress. Unfortunately he is more and more exasperated by his wife, who, clearly not suited to being his life's companion, is becoming more and more of a shrew. It's odd how marriage turns out: it leads to either ruin or suicide. But *Pot Bouille*[9] is merely a softened version of the truth. . . .

*—Undated, early June 1886, Paris*

TO METTE    I have finally found the money for my trip to Brittany and I am living here on credit.[10] . . . My painting arouses a lot of discussion and I must say that Americans rather like it. That's some hope for the future. It is true that I do a lot of sketches and you will hardly recognize my painting. . . . You picture us as being isolated. Not at all. There are painters winter and summer. . . . Later on if I succeed in finding an assured and steady little outlet for my paintings, I'll come and settle here all year round. . . . I'll take a small studio near the Vaugirard church and I'll work at ceramics, sculpting pots the way Aubé used to do. Monsieur Bracquemond, who has been friendly with me because of my talent, has found me this work and told me it could become lucrative.

Let us hope that I will have a talent for sculpture as I do for painting, as I plan to work on both at the same time.

*—Undated, late June 1886, Pont-Aven*

TO METTE    . . . I am working a lot here and successfully too, I am respected as the best painter in Pont-Aven;[11] it is true that that does not bring me a sou more than before. But it may be paving the way for the future. At any rate I am acquiring a respectable

9. The novel by Emile Zola.

10. Félix Jobbé-Duval, the painter, who patronized Marie-Jeanne Gloanec's inn in Pont-Aven, had told Gauguin that he could live very cheaply there and that she would give him credit.

11. Emile Bernard, the young painter, who was also at Pont-Aven, wrote to his parents, in a letter dated August 19, 1886, that Gauguin the painter was "a very impressive fellow."

reputation and everyone here . . . vies for my advice, which I am stupid enough to give, since after all one is used by other people, without just recognition.

This life is not making me fatter; I now weigh less than you. I'm becoming dry as a herring again but on the other hand I am getting younger. The more worries I have the more my strength comes back, but that does not encourage me. I don't know where I'm going and I'm living on credit here. Money problems discourage me completely and I would like to see the end of them.

Well, one must resign oneself, and let come what may and perhaps one day, when my art will have become as plain as can be to everyone, some enthusiastic man will pick me up out of the gutter.                    —*Undated, July 1886, Pont-Aven*

TO METTE   . . . You can ask Schuffenecker what other painters think of my painting, and yet nothing happens. And people turn their backs on a man who has nothing!

I am doing ceramic sculpture. Schuffenecker says that they're masterpieces and so does the ceramicist, but it's probably too artistic to sell. Yet he says that within a given period of time, at the industrial arts exhibition, this idea will be wildly successful. May the Devil answer his prayers! Meanwhile my entire wardrobe is at the pawnbroker's and I can't even go calling.                    —*December 26, 1886, Paris*

TO METTE   . . . My reputation as an artist grows bigger every day but meanwhile I sometimes go three days at a stretch without eating, which destroys not only my health but also my energy. The latter I want to recover and then I'm going to Panama to live like a savage. I know a little island (Taboga) in the Pacific, a league out to sea from Panama; it is almost uninhabited, free and fertile. I'll take along my colors and my brushes and find new strength far away from people.

I will still have to suffer from the absence of my family but I will no longer have to live this beggarly life which disgusts me.

You needn't fear for my health, the air there is very healthful, and as for food, fish and fruit are to be had for nothing. . . .

—*Undated, early April 1887, Paris*

TO METTE   . . . I've many things to tell you; it's a jumble in my mind. The trip was as stupidly carried out as could be and we[12] are "wiped out," as the saying goes. The devil take all the people who give you misleading information. The ship called at Guadeloupe and Martinique, a marvelous country where there is plenty to keep an artist busy and life is cheap, easy, and the people are affable. That's where we should have gone, the trip would have cost us half as much and we wouldn't have wasted any time. Unfortunately we went on to Panama. . . . Since the canal was dug, these idiotic Colombians won't let you have a meter of land at under 6 francs the [square] meter. It's completely uncultivated and yet everything grows; despite which, it is impossible to build yourself a hut and live on fruit; if you try it they go for you and call you a thief. Because I had peed in some filthy hole filled with broken bottle ends and shit, they had two gendarmes march me through all of Panama for a half an hour, and finally they made me pay a fine of one piaster. No way of getting out of it. I felt like giving the gendarme a taste of my fists but here justice is expeditious: they follow you five paces behind, and if you move they send a bullet through your head.

Well, now the mistake has been made; it has to be corrected. I'm off into the isthmus tomorrow to wield a pick for the digging of the canal which will bring me 150 piasters a month, and once I've saved up 150 piasters, that is 600 francs (it will take two months), I'll leave for Martinique.

. . . Don't you complain about working. Here, I have to move the earth around from half past five in the morning to six in the evening, under the tropical sun, and with rain every day. At night, I'm eaten alive by mosquitoes.

As for the death rate, it is not so frightening as it is made

12. Gauguin was traveling with Charles Laval, a painter friend from Pont-Aven.

out to be in Europe; the Negroes who do the nasty work die at the rate of nine out of twelve, but the others die only half as often.

Speaking of Martinique, there's a nice life. If I could only have an outlet in France for 8000 francs' worth of paintings, then we could live here, the whole family, as happily as could be, and I believe you could even find pupils. The people are so affable and gay. . . .          —*Undated, early May 1887, Panama*

TO METTE   . . . This time I'm writing to you, from Martinique, and I had intended to get here much later. For a long time now luck has been against me and I don't do what I would like to. I had been working for the [canal] company for two weeks when orders arrived from Paris to hold up much of the work and that very day ninety employees were laid off, and so on. Naturally I was on that list as I was a newcomer. I took my trunk and came here.

. . . Right now we are living in a Negro hut and it's a paradise compared to the isthmus. Below us is the sea, bordered by coconut palms; above us, all kinds of fruit trees, and only twenty-five minutes from the town.

Negroes and Negresses go about all day with their creole songs and their endless chatter. Don't get the idea it's monotonous; on the contrary, it's very varied. . . . Nature is at its richest, the climate is warm but there is intermittent coolness.

. . . We have begun to work and in time I hope to send you some interesting paintings. . . . Believe you me, a white man here has trouble keeping his virtue intact, for there is no lack of Potiphar's wives. Almost all of them are colored, ranging from ebony to the mat white of the black races, and they even go as far as casting charms on fruits that they then give you so as to snare you. The day before yesterday a young Negress of sixteen, and quite pretty I must say, came to offer me a guava that was split and squeezed at one end. I was going to eat it after the girl had gone but a yellowish lawyer who happened to be there takes the fruit out of my hands and throws it away. "You are European, sir, and don't know the country," he says. "You

must not eat a fruit without knowing where it comes from. This fruit, for instance, has had a spell cast on it; the Negress has crushed it against her breast and you would assuredly be in her power afterward." I thought it was a joke. Nothing of the sort. Educated though he was, this unfortunate mulatto believed what he was saying. . . .

—*June 20, 1887, Saint-Pierre, Martinique*

TO METTE   . . . I have just returned from the dead, almost, and have got up from my straw mattress to write to you. Today I received news from you for the first time; all your letters had gone wandering about everywhere.

While I was staying in Colón, I caught [a] disease, a poisoning caused by the swampy miasmas of the canal. I had had enough energy to withstand it, but once I reached Martinique I began to get weaker every day. To make a long story short, a month ago I came down with dysentery and malaria and couldn't get up. At this point my body is nothing but a skeleton and my voice is faint in my gullet; after being so ill that I nearly succumbed every night I finally got the better of it but my stomach made me suffer horribly. Now the little I eat gives me terrible liver pains and I have to make an effort to write to you: my mind is unhinged. You must understand that the last funds I had went to pay the pharmacist and several doctor's calls. He says it's absolutely necessary for me to go back to France, otherwise I'll have liver trouble and fevers for the rest of my life.

Ah, my poor Mette, how sorry I am [I] didn't die! It would be all over. Your letters gave me pleasure and at the same time they caused me grief and I am overwhelmed by it now. If only we at least detested each other (hate gives strength), but you are beginning to feel the need of a husband just at a time when that is impossible. And distracted with work, poor Mette, you ask me to help you.

Can I? Right now I am lying exhausted on a pallet made of seaweed in a Negro hut and I haven't any money to get me back to France. . . . I'll stop this letter because my head is spinning,

my forehead is covered with perspiration, and I have shivers
down my spine. . . .

—*Undated, August 1887, Saint-Pierre, Martinique*

TO METTE   . . . If I had just come out of prison I'd be able to find
work more easily, but after all I can't go and get myself sen-
tenced in order to make people take an interest in what happens
to me. An artist's duty is to work to become a good artist; I have
done that duty. Everything I've brought back from out there
finds nothing but admirers; and yet I can't seem to make a
breakthrough. . . .           —*November 24, 1887, Paris*

TO METTE   . . . I see from your letter that you are a wall that still
stands intact, just like any bourgeois woman. There are two
classes in society: one possesses some capital from birth, en-
abling the individual to live on unearned income, to be a work-
ing shareholder or owner of a business. The other class, having
no capital, is to live on what? On the fruit of its labor. . . . In
what way do the children in an artist's family have to suffer more
than in a workingman's family? Where are the workingmen who
do not have to suffer from poverty (at least for a while)?

And what is the finest segment of the living nation, fructify-
ing, promoting progress, enriching the country? The artist. You
don't like art, then what do you like? Money. And when an artist
makes money, you're on his side. It's a game involving both
profit and loss, and you should not take part in the joy if you
do not take part in the sorrows.

. . . Since I left I have little by little closed my heart to
sensitive feelings, so as to preserve my moral strength. Every-
thing is numb in that department and it would be dangerous for
me to see my children beside me and then have to go away. You
must remember that there are two types of temperament within
me: the Indian and the sensitive. The sensitive has disappeared,
and this allows the Indian to walk resolutely straight ahead.

Recently in *Le Figaro* there was a long article on the small
revolution that is taking place in Norway and Sweden: Björnson
and consort have just published a book in which they ask for a

woman's right to sleep with whomever she likes. Marriage is done away with and becomes no more than a partnership, etc. Have you seen it? What do people say about it in Denmark? See if the book has been translated into French; if not, it would be a good idea for you to translate it and send it to me, and I'd have it checked over and published. . . .

*—February 1888, Paris*

TO SCHUFFENECKER   I've been here almost a month without having written you. It is true that three days out of every six I am in bed, suffering horribly, without respite, and so have little inclination to work. I drift along and silently contemplate nature, completely absorbed in my art. There is no other way to salvation and it's also the best way of overcoming physical pain. . . . You are a Parisian. The country life for me. I like Brittany; here I find a savage, primitive quality. When my wooden shoes echo on this granite ground, I hear the dull, muted, powerful sound I am looking for in painting. . . .    *—February 1888, Pont-Aven*

TO SCHUFFENECKER   . . . My strength has returned; I have just done several nudes that you will like. And they're not Degas at all. The last one, though done by a savage from Peru, is altogether Japanese: two boys fighting near the river, the idea barely elaborated, green grass and the upper part white. . . .

*—July 8, 1888, Pont-Aven*

TO SCHUFFENECKER   . . . A bit of advice, don't copy nature too closely. Art is an abstraction; as you dream amid nature, extrapolate art from it and concentrate on what you will create as a result.

. . . My latest things are coming along well and I think you'll find they have a particular touch, or, rather, the affirmation of my earlier searchings. . . . The self-esteem one acquires and a well-earned feeling of one's own strength are the only consolation—in this world. Income, after all—most brutes have that.

*—August 14, 1888, Pont-Aven*

TO SCHUFFENECKER . . . What beautiful thoughts one can invoke with form and color! How down-to-earth they are, those *pompiers,*[13] with their trompe l'oeil rendering of nature. We alone can sail on our phantom vessels with all our whimsical imperfections. How much more tangible the infinite appears to us, when we are faced with some undefined thing. Musicians experience sensual enjoyment through the ear, but we, with our insatiable eye always in heat, savor endless pleasures. This evening, when I have my dinner, the animal in me will be sated but my thirst for art will never be quenched. . . .

*—September 1888, Pont-Aven*

TO SCHUFFENECKER . . . I did a painting for a church; naturally it was refused, so I am sending it back to [Théo] van Gogh. No point in describing it, you'll see it.[14]

This year I have sacrificed everything—execution, color— for style, wishing to impose on myself something other than what I know how to do. This, I believe, is a transformation which has not yet borne fruit but will one day.

I did a portrait of myself for Vincent [van Gogh], who had asked me for one. I think it's one of my best things: thoroughly incomprehensible—it is so abstract! A bandit's head at first glance, a Jean Valjean *(Les Misérables),* also personifying an Impressionist painter who is frowned upon and, in the eyes of the world, always carries a [ball and] chain. The way it's drawn is altogether special, complete abstraction. The eyes, the mouth, and the nose are like flowers in a Persian rug, also personifying the Symbolist side. The colors are colors remote from nature; just picture a vague memory of pottery twisted by a fierce fire! All the reds, the purples, streaked by flashes of fire, like a furnace blazing before the painter's eyes, where the struggle among his thoughts takes place. All this on a chrome yellow

13. Nineteenth-century neo-Classicist painters. (Translator's note.)
14. *Jacob Wrestling with the Angel,* or *The Vision after the Sermon,* which Gauguin, helped by Charles Laval and Emile Bernard, had carried to Nizon, near Pont-Aven, so that it could hang in the church. But the priest declared, according to Bernard, that "the interpretation was irreligious and of no interest to the faithful," and he refused the gift of this masterpiece.

background strewn with childish nosegays. Bedroom of a pure young girl. An Impressionist is pure, not yet sullied by the putrid kiss of the [Ecole]des Beaux-Arts.

. . . [Théo] van Gogh has just bought 300 francs' worth of pottery from me. So at the end of the month I leave for Arles, where I think I'll stay a long time, since the purpose of my stay there is to make it easier for me to work without worrying about money until he has managed to launch me.

*—October 8, 1888, Quimperlé*

TO VINCENT VAN GOGH . . . I believe that in my figures I have achieved a great simplicity, which is both rustic and superstitious. The whole thing [is] very severe. As far as I'm concerned, in this picture the landscape and the struggle [between Jacob and the angel] exist only in the imagination of the people whom the sermon has moved to prayer. That's why there is a contrast between the people, depicted naturally, and the struggle in its unnatural and disproportioned landscape.

*—Undated, September–October 1888, Pont-Aven*

TO EMILE BERNARD . . . [Théo] van Gogh has written a very peculiar thing to Vincent [van Gogh]. He says I was at Seurat's, who did some good studies, denoting a good workman happy over what he's doing. Signac as cold as ever: he seems to me like a salesman of little dots.[15] They are to begin a campaign (since they have *La Revue indépendante* as headquarters for their propaganda) against the rest of us. In it they will depict Degas, Gauguin above all, Bernard, etc., as worse than devils, to be avoided as if they had the plague. That is roughly what is being said. Keep it in mind and don't say anything about it to [Théo] van Gogh, otherwise you'll get me a reputation as a gossip.

I am as satisfied as possible with the results of my studies at Pont-Aven. Degas is supposed to buy the study for *Deux Bretonnes aux Avins* from me.[16] This is the utmost flattery for me;

15. Allusion to the so-called "pointilliste" type of painting.
16. Listed as *Les premières fleurs*, no. 249 in the George Wildenstein Catalogue.

as you know, I have the greatest faith in Degas's judgment. Moreover, commercially speaking, this is a very good starting point. All Degas's friends have faith in him.

[Théo] van Gogh hopes to sell all my paintings. If I am that lucky I'll go to Martinique, where I am certain that I now could do fine things. And if I could get a larger sum of money together, I'd buy a house there so that I could establish a studio where my friends would find everything ready for them and they could live on almost nothing. I rather agree with Vincent, the future belongs to the painters of the tropics, which have not yet been painted, and new subjects always have to be found for the public, that stupid buyer. . . .        —*October 1888, Pont-Aven*

TO SCHUFFENECKER  . . . What do you mean when you talk about my terrifying mysticism? Be an Impressionist all the way and don't let anything frighten you! Of course that appealing path is full of dangers, and so far I have only just begun to follow it, but as a matter of fact it suits my true being, and you must always go where your temperament leads you. I know that people will understand me less and less. What does it matter if I become remote from other people; for most of them I'll be a riddle, for a few I'll be a poet, and sooner or later what is good comes into its own.

Never mind; be that as it may, I tell you that I will succeed in producing first-class things—I know it and we'll see. You know very well that on questions of art I'm always basically right. Pay close attention: right now among artists a very strong wind is blowing in my favor; I know this from certain things that have slipped out and, believe me, no matter how fond of me [Théo] van Gogh is, he wouldn't go to the expense of supporting me in the Midi just for my good looks. Being a cold Dutchman he has appraised the lay of the land and intends to push things as far as they can go and exclusively. . . .
        —*October 16, 1888, Quimperlé*

TO EMILE BERNARD  . . . Look closely at the Japanese; they draw admirably and yet in them you will see life outdoors and in the

sun without shadows. . . . I will move as far away as possible from whatever gives the illusion of a thing, and as shadow is the trompe l'oeil of the sun, I am inclined to do away with it.

. . . Seeing how [Théo] van Gogh is paving the way, I think it is possible for all the talented artists in our group to pull through; which means that all you have to do is go on straight ahead. I talked to the Zouave[17] about you and I think that in Africa you will lead a life that will be very useful to your art and quite easy.

. . . It's funny, here Vincent sees Daumier-type work to do, but I, on the contrary, see another type: colored Puvis [de Chavannes] mixed with Japan. The women here have their elegant coiffures, their Greek beauty. Their shawls forming folds like the primitives are, I find, Greek processions. A girl who goes by in the street is as much of a lady as any other and in appearance is as virginal as Juno. . . .    —*December 1888, Arles*

TO EMILE BERNARD    . . . I am like a fish out of water in Arles; everything—landscape and people alike—seems so small, shabby. Vincent and I don't agree on much, and especially not on painting. He admires Daumier, Daubigny, Ziem, and the great Théodore Rousseau—all of whom I can't stand. And, on the other hand, he detests Ingres, Raphael, Degas—all of whom I admire. I answer, "Sergeant, you're right," just to have some peace and quiet. He likes my paintings very much, but while I'm painting he always feels that this is wrong and that is wrong. He is romantic, whereas I, I am more inclined to a primitive state. . . .    —*Undated, December 1888, Arles*

TO SCHUFFENECKER    You are waiting for me with open arms. I thank you but unfortunately I am not coming yet. I am in a very awkward position here; I owe a great deal to [Théo] van Gogh and Vincent, and although there is a certain amount of discord, I can't hold a grudge against an excellent heart that is ill, that

17. An officer in the Zouaves whose portrait van Gogh had painted. Gauguin had spoken with him in Arles to obtain information about Africa for Emile Bernard, who was intending to go there.

is suffering, and that needs me. Remember the life of Edgar Poe, whose troubles and state of nerves led him to become an alcoholic. One day I'll explain to you in detail. At any rate I am staying here, but my departure is always latent. . . . Vincent sometimes calls me the man who comes from afar and who will go far. . . .    —*Late December 1888, before the twenty-fourth*[18]

TO METTE   . . . Despite the certainty which my conscience gave me, I wanted to consult the others (men who also count) to find out whether I was doing my duty. All of them agree with me that what concerns me is art, it is my capital, my children's future, the honor of the name I have given them, all things which one day will be of use to them. When the time comes, an honorable father, known to everyone, can come forward to get them decently settled in life. Consequently I work at my art, which is nothing, for the moment, in terms of money (times are hard), but which is taking shape for the future.

   . . . I am by the seaside in a fishermen's inn near a village that has a hundred and fifty inhabitants; there I live like a peasant, and am known as a savage. And I have worked every day wearing [a] pair of duck trousers (all those I had five years ago are worn out). I spend a franc a day on my food and two sous on tobacco. So I can't be accused of enjoying life. I talk to no one and receive no news of the children. On my own, altogether on my own, I exhibit my works at Goupil's in Paris, and they cause a real sensation but people are very reluctant to buy them. When that will come I can't say, but what I can say is that today I am one of the artists who astonish people the most. . . .

   —*Undated, late June 1889, Le Pouldu*

18. A few days later, on December 24, a dramatic scene occurred between Vincent van Gogh and Gauguin, causing Gauguin to leave Arles suddenly for Paris. (See *Avant et Après.*, pp. 254–56)

*Editor's note: The following is the first text by Gauguin to appear in print.*

# "Notes on Art at the Universal Exhibition"

**(Excerpts)**

Of course this exhibition is the triumph of iron, not only with regard to machines but also with regard to architecture. And yet architecture is at its beginnings, in that, as an art, it lacks a style of decoration consistent with the material which architecture uses. Why, alongside this severe, rugged iron, are there such flabby substances as underfired clay; why, alongside these geometric lines of a new type, is there all this old stock of old ornaments modernized by naturalism? To the architect-engineer belongs a new decorative art, such as ornamental bolts, iron corners extending beyond the main line, a sort of gothic lacework of iron. We find this to some extent in the Eiffel Tower.[19]

Imitation bronze statues clash alongside iron. Always imitations! Better to have monsters of bolted iron.

Also, why repaint iron so it looks like butter, why this gilding as if in the Opera [house]? No, that is not good taste. Iron, iron, and more iron! Colors as serious as the material used and you'll have an imposing construction, suggestive of molten metal.

We are stubborn in our search for art and when we enter the space given to the Beaux-Arts school, which the State, that

19. Much later, in an article published in the Tahitian newspaper *Les Guêpes* in February 1901, Gauguin was to be less certain of the tower's merits, asking: "Is the Eiffel Tower by any chance an improvement when compared to the Temple of Jerusalem?"

28

is, all of us, pays for so dearly, we are nauseated rather than astonished. I really mean astonished, because for a long time we have known what to expect—poor quality for which low prices are little consolation. All these vain creatures wantonly display their daubings with an unspeakable offhandedness.

. . . Happy were the painters of ancient times who had no academy. For the past fifty years things have been different: the State increasingly protects mediocrity and professors who suit everyone have had to be invented. Yet alongside those pedants, courageous fighters have come along and dared to show: painting without recipes. Rousseau, whom they jeered at, is now in the Louvre in spite of them; Millet too, and what insults didn't they heap on that great poet who nearly died of hunger. Remember the Exhibition of 1867: Courbet and Manet put on a show at their own expense on the Champs-Elysées. Again it is they who are the winners, always they who stand tall alongside the Institute. Where are the artistic glories on which France can pride itself? Among that Pleiades of unsung thinkers with royal instinct: Rousseau, Delacroix, Millet, Corot, Courbet, Manet— all of them scorned in their own day.

What's to be done about it? Nothing! Except to be indignant. In 1889 as well, there is doubtless, like the artists we have just named, a whole Pleiades of independent artists whom the official painters have anxiously been keeping track of for fifteen years, and whom all the sensitive people, thirsting for pure art, true art, watch with interest. And this movement is in everything: in literature just as it is in painting. All of twentieth-century art will derive from them. And you, gentlemen of the Institute, you want to ignore them. We would have liked to see these independent artists in a separate section at the Exhibition. We are surprised that the State and the City of Paris continue to obey Monsieur Bouguereau and his associates so abjectly.

Since they invite all the various branches of French and foreign industry to the Exhibition, their duty, it seems to me, was to make a little room for a class of independent artists whom they know as well as I do. The foreigner looks around, and, less superficial than the French, tries to understand. For instance,

one foreigner told me recently that the Luxembourg Museum was a disgrace to France. "Money is represented there," he said, "by a watercolor by Madame de Rothschild, but nowhere is there any talent!" How does it happen that Manet is not there? Heaven and earth had to be moved before a Puvis de Chavannes could be placed there.

. . . Why real roses, real leaves? Decoration involves so much poetry. Yes, gentlemen, it takes a tremendous imagination to decorate any surface tastefully, and it is a far more abstract art than the servile imitation of nature. In the Dieulafoy Gallery at the Louvre, have a close look at the bas-reliefs of the lions. I maintain that enormous genius was required to imagine flowers that are the muscles of animals or muscles that are flowers. All of the dreamy, mystical Orient is to be found there.

Decoration, which is appropriate to the material and to the place where that material is to be used, is an art which seems to be disappearing and requires study over a long period of time, a special genius. It is true that here too the official manner has distorted taste. Sèvres, not to name names, has killed ceramics. No one wants them, and when some Kanaka ambassador comes along, bang, they stick a vase in his arms, the way a mother-in-law would fling her daughter at you, to get rid of her. Everybody knows this, but Sèvres is inviolable: it's the glory of France.

Ceramics are not futile things. In the remotest times, among the American Indians, the art of pottery making was always popular. God made man out of a little clay. With a little clay you can make metal, precious stones—with a little clay, and also a little genius! So isn't it a worthwhile material? Nonetheless, nine out of ten educated people pass by this section without giving it so much as a glance. What can you do? There's nothing to be said: they don't know.

Let's take a look at the question. Let's take a little piece of clay. In its plain, raw state, there's nothing very interesting about it; but put it in a kiln, and like a cooked lobster it changes color. A little firing transforms it, but not much. Not until a very high temperature is reached does the metal it contains become

molten. I am certainly not about to give a scientific lecture on this, but by giving you a glimpse we are trying to make it clear that the quality of a piece of pottery lies in the firing. A connoisseur will say: this is badly fired or well fired.

So the substance that emerges from the fire takes on the character of the kiln and thus becomes graver, more serious the longer it stays in Hell. Hence all the junk on exhibit—because a brief firing is more stylish and easier to do. It follows that any ceramic decoration must be done in a character analogous to its firing. Because the vital element of beauty is harmony. Consequently pottery pieces with coy, insipid lines are not homogeneous with an austere material. Hollow colors alongside full colors are not in harmony. And look how artistic nature is. The colors obtained during the same firing are always in harmony. That is why no ceramics artist will apply colored enamels one on top of another in different firings. At the Universal Exposition this is true of most of the ceramics artists. One of them has even gone too far, applying distemper or oil paint to a substance that has been fired.[20] Carrying his impudence further, he entitles this lemon "High-Fired Fresco." And the State commissions these horrors from the factory at Longwy. A fresco is a fresco only if the color combines naturally with the fresh plaster. The term "fresco" therefore does not apply to ceramics. "High Fired" is a lie since not one color has been fired. And the State authorizes these lies.

Let's get back to our subject. In ceramics, both the shaping and the drawing must be adapted "harmoniously to the material used." I will ask sculptors to give careful thought to this question of adaptation. Plaster, wood, marble, bronze, and fired clay must not all be modeled the same way, since each of these substances has a different type of solidity, of hardness, of aspect. All this just amounts to so much refinement, you may say; but in art, refinement is necessary, otherwise you no longer have a complete art, you no longer have art. Clay contracts as it fires, and, in fact, the hotter the fire, the more it contracts; this tends

20. Doubtless Adrien-Pierre Dalpayrat, who painted on earthenware.

to make the surfaces subside. Consequently, an arm, a piece of fabric must be excessively rigid.

At this exhibition we see only two genuine ceramics artists, Messrs. Chaplet and Delaherche. The former, with his porcelains, the latter with his stoneware. We will make the same reproach to both of them. Since they want to make beautiful things, modern things, let them do so completely and, aside from the fine colors they manage to produce, let them find shapes for their vases other than the familiar shapes made on the wheel. Let them work with an artist.

*Post-Scriptum.* I was mistaken when I wrote that there was no more pictorial art at the Universal Exposition. Now that the Centennial Exhibition is open, I think differently. And yet, it amounts perhaps to the same thing, for that exhibition is the triumph of the artists I mentioned as having been reproved and scorned: Corot, Millet, Daumier, and, above all, Manet. The *Olympia* which caused such an outcry is there like a morsel fit for a king and is already prized by more than one viewer.

The conclusion: Monsieur Huysmans drew it a long time ago. The talent of the independents and the example they set suffice to show the uselessness of a budget and the futility of an official Department of the Arts. Courier's words are still true: "What the State encourages languishes, what it protects dies." —Le Moderniste illustré, *July 4 and 11, 1889*

LETTERS    TO EMILE BERNARD   . . . I feel pleasure, not in going further ahead in what I had once planned, but in finding something more. I feel it and am not expressing it yet. I am sure of getting there, but slowly, despite my impatience. Under these conditions my groping studies lead only to a very clumsy and ignorant result. However, I hope that this winter you will see things done by an almost new Gauguin; I say "almost" because everything is connected and I'm not pretentious enough to claim I've invented anything new. What I want is a corner of myself that is still unexplored.

. . . In three days I'm going back to Pont-Aven because my

money is gone and I can live on credit there. I plan to stay there until winter and then if I can obtain anything at all in Tonkin I'll be off to study the Annamites. Terrible itch for the unknown that makes me commit follies. . . .

*—Undated, August 1889, Le Pouldu*

TO EMILE BERNARD    From reading your letter I can see that we're all pretty much in the same boat. The moments of doubt, the results that are always inferior to what we dream of, the scant encouragement from other people—all these things combined seem to flay us with thorns. Well, what can we do about it except fume over it, fight against all these difficulties; even if we're down, we can still go on saying: again, and again. When you come right down to it, painting is like man, mortal but always living in conflict with matter.

. . . You know how much I admire what Degas does and yet I sometimes feel that he lacks a sense of the "beyond," a feeling heart.

. . . I have not been very spoiled by other people and in fact I intend to become more and more incomprehensible.

I've done . . . a large (size 30) panel, to be carved later in wood, once I have money to buy the wood. Not a sou to my name. It's also the best and the strangest sculpture I've done. Gauguin (like a monster) taking the hand of a woman who resists and saying to her, *Be in love, you will be happy.* A fox, the Indian symbol of perversion, and little figures in the interstices. The wood will be painted. . . .

*—Undated, early September 1889, Pont-Aven*

*Editor's note: This is Paul Gauguin's second published article:*

# "Who Is Being Deceived Here?"

(Excerpts)

It is no secret that the State likes to bid at auction for Millet paintings, at very sweet prices, over five hundred thousand francs. Such a purchase reflects very honorably on the high commission of the Beaux-Arts; everyone has said so and we must believe it. But there is a dilemma here which perplexes me: either Millet has absolutely no talent, and in that case it is idiotic to clutter up museums with his output at exorbitant prices; or else his masterpieces have always been masterpieces, and in that case what was the Beaux-Arts Commission—represented by the honorable predecessors of the present members who perpetuate their activity—thinking of in earlier days? Why didn't it buy a painting like the *Angelus* from its author while he was alive, for two or three thousand francs, instead of leaving it up to us to pay half a million much later to a speculator who pockets the difference? Wouldn't this have been to everyone's benefit—the painter's, his family's, the State's, and that of the public, which could have had the joy of contemplating this canvas so much earlier in one of our museums? I don't even need to look at the matter from the standpoint of art, although it certainly is important in this instance.

In a speech delivered to the Beaux-Arts on the day the Millet Exhibition opened, Monsieur Bouguereau . . . dared to say: "Millet was not altogether lacking in talent, but be careful not to look at his works. He was so ignorant of the elementary

principles of drawing that if he submitted something to the Salon today we would have to refuse him!"

Although the real painters have eluded your grasp, gentlemen, on the other hand you have created the official mediocrities who have their places in the museums, at the taxpayers' expense. Why be surprised that France has to pay enormous prices in order to hold on to the works of the masters after having let them starve to death! This brings us straight back to the High Commission of the Beaux-Arts. Its role is very useful, so useful that we couldn't do without it. First of all it is composed of the best, the subtlest, and most scholarly critics. It is the elite among critics; is it not sworn like any true expert? It has wit, by way of competence, and it even has duties. Stationed outside the State museums like a squad of quarantine officials, it keeps a sharp lookout (as we have seen) for contraband talent. It is the customs office of Aesthetics.

. . . You are in charge of official patronage. Is your mission to discover artists and sustain them in their task, or is it, when the general public ignores their merit, to legalize posthumous success by fancy deals and much fuss while you take shelter under a halo of high-sounding words that read like an advertising slogan?

Wicked people mutter about bribes; we will not be so cruel with honorable officials. We quite simply believe that the High Commission of the Beaux-Arts has been and always will be half-witted and ignorant.

If only these gentlemen would listen at last to the complaints that countless voices repeatedly utter within their hearing. Aloof from all these base transactions there is always a party of young people that constantly renews itself and wants its masters to be respected. Any artist who wants to become a master, who hopes for so remote an ideal, necessarily respects that ideal and grows indignant when it is trampled on. Every day you hear the names of men who are also great painters but who have made the immense mistake, to your way of thinking, of having carved out a strong position for themselves in art. But this

fortress of theirs does not lie within the official city. Your duty is to go and look for them, not to dig them up out of their graves later, at a price of five hundred thousand francs.

Above all, don't come and tell us that you are not aware of the great men hidden in the fray. Haven't the cries of the mediocre stirred up against genius always been there to alert you? In the last analysis, we must come back to those famous old words of Beaumarchais: Who is being deceived here?

—Le Moderniste illustré, *September 21, 1889*

LETTERS    **TO EMILE BERNARD**   . . . I have put in many applications to go to Tonkin but the replies at this time are almost all negative. The people who are sent out to the colonies are generally those who have got into trouble, embezzled, etc. But for me, an Impressionist painter, in other words an insurgent, it is impossible. What is more, all this bile and spleen that I accumulate, under the redoubled blows of the misfortune that weighs upon me, makes me ill and at this point I hardly have strength or will enough to work. And work used to make me forget. In the long run this isolation, this concentration within myself—whereas all the principal joys of life are outside and intimate satisfaction is lacking, crying famine as it were, like an empty stomach—in the long run this isolation is an empty illusion, as far as happiness goes, unless you are made of ice, absolutely insensitive. Despite all my efforts to become that way, I am simply not like that, my innermost nature constantly gets the upper hand. Like the Gauguin of the vase, the hand choking in the furnace, the cry that strives for utterance. Well, I will say no more about it. What is man in the immensity of all creation? Who am I to make demands? Am I better than any other man?

. . . Did you send me that issue [of] *Art et Critique?* . . . The good thing about stupidity is that it isn't offensive. Fénéon actually wrote that I was imitating Anquetin, whom I do not even know. . . .[21]       —*Undated, November 1889, Le Pouldu*

21. In his newspaper, *La Cravache,* Félix Fénéon, the art critic, had written: "It is probable that Mr. Anquetin's manner . . . has influenced Mr. Gauguin somewhat, in a purely formal way."

TO EMILE BERNARD  . . . Attacks against originality are natural on the part of those who haven't the power to create and the strength of character to shrug their shoulders. . . . All that remains of all my efforts this past year are the howls in Paris that can be heard here, and they discourage me so, that I don't dare paint any more and I take my old body out for walks in the icy north wind along the banks of the Pouldu! Mechanically I do a few sketches (if you can call sketches some brushstrokes guided by the eye). But my soul is missing and looks sadly at the gaping hole in front of it.

. . . As for doing commercial painting, even the Impressionist kind: no. Very deep inside myself I glimpse a higher meaning.

. . . Degas does not find . . . in my canvases what *he* sees (the model's bad smell). He feels that in us there is a movement contrary to his. Ah, if only I, like Cézanne, had the means to take up the struggle, I would certainly do so with pleasure! Degas is getting old and he is furious at not having had the last word.[22] We are not the only ones to have struggled; you can see that Corot, etc., have won recognition with the passing of time. But what poverty today, what difficulties. Personally, I admit that I am beaten—by events, by people, by the family—but not by public opinion. I don't give a damn about public opinion and I can do without admirers. . . . Let them look closely at my last paintings (if they have a heart that can feel) and they'll see what resignation to suffering is contained in them. Is a human cry nothing, then? . . . What can I do, my friend, I am going through such a phase of disillusionment that I cannot help yelling out loud. . . .                —*Undated, November 1889, Le Pouldu*

22. See pp. 257–61 for Gauguin's tribute to Degas.

*Editor's note: Here is an unpublished article, brought to light by* **Les Nouvelles littéraires** *of May 7, 1953.*

# Huysmans and Redon

**(Excerpts)**

Huysmans is an artist. Many painters would like to be musicians or men of letters. He would like to be a painter, he loves painting. Having been a naturalist, he praised naturalists, chiefly Raffaelli, and criticized the others. Since then a great change has taken place in him, for he thirsts after art and is not afraid of admitting his mistakes. In his book *Certains,* he shows us still another series of pictures. As always, he wants to do a painting himself.

That *Bianchi* painting of his is very oddly described. Like all painters in the old days, Bianchi found around him, in nature, a particular type in which he depicted himself or which, I would even say, he must have made in his own image. Was it God who made man in His image or man who made Him in his image? I am strongly inclined to think it was the latter. Look at Rembrandt's work; see what an intimate relationship there is between all his models, men and women, and his own portrait. The same is true of Raphael, and many others.

No, Bianchi did not deliberately put so much vicious mischief into the painting as Huysmans describes.[23] The three figures are the same model, regardless of their sex or age. All

---

23. In his book, published in 1889, Huysmans had described a painting in these terms: "*The Virgin and the Infant Jesus,* by Francesco Bianchi, in the Louvre; on either side, an old man, Saint Benedict, and a young man, Saint Quentin, 'ephebus of indeterminate sex,' 'hybrid with the body of a boyish girl,' 'androgynous creature of insinuating beauty.' "

three convey the same mood, which is that of the painter. Huysmans, criticizing this painting, was creating a Huysmans.

By the way, I strongly doubt that two men of talent, both with strong personalities, can work together: a painter and a man of letters. By this I mean that a painter cannot illustrate a book, and vice versa. He can decorate his book, yes, add to it other, related sensations.

I do not see why it is said that Odilon Redon paints monsters. They are imaginary beings. He is a dreamer, an imaginative spirit. Ugliness: a burning issue; it is the touchstone of modern art and of its criticism. If we look carefully at Redon's profound art, we find little trace of "monsters" in it—no more than in the statues of Notre-Dame. Of course animals that we are not used to seeing look like monsters, but that is because we tend to recognize as true and normal only what is customary, what constitutes the majority.

Nature has mysterious infinites, and imaginative power. It is always varying the productions it offers to us. The artist himself is one of nature's means and, in my opinion, Odilon Redon is one of those it has chosen for this continuation of creation. In his work, dreams become reality because of the believability he gives them. All of his plants, his embryonic and essentially human creatures have lived with us; beyond a doubt, they have their share of suffering.

Amid a black atmosphere, we finally make out one tree trunk, then two; one of them is surmounted by something, probably a man's head. With utmost logic he leaves us in doubt as to that existence. Is it truly a man or, rather, a vague resemblance? However that may be, they both live on this page and, inseparable from one another, they weather the same storms.

And that man's head with its hair standing on end, the skull split open, an enormous eye in the opening—is this a monster? No! In the silence, the night, the darkness, our eye sees, our ear hears. . . . In all his work I see only a language of the heart, altogether human, not monstrous.

In contrast to this criticism, Huysmans speaks of Gustave Moreau with very great esteem. Fine; we admire him too—but to what extent? Here is a spirit that is basically not very literary but wants to be. Thus Gustave Moreau can speak only a language already written by men of letters; the illustration, as it were, of old stories. His impulse is very far from the heart, so that he loves the richness of material goods. He crams them in everywhere. Of every human being he makes a jewel covered with jewels. In short, Gustave Moreau does finely tooled work. . . .                                                    *Late 1889*

LETTERS    TO METTE   . . . May the day come (soon perhaps) when I'll flee to the woods on an island in Oceania, there to live on ecstasy, calm, and art. With a new family by my side, far from this European scramble for money. There, in Tahiti, in the silence of the beautiful tropical nights, I will be able to listen to the soft murmuring music of the movements of my heart in amorous harmony with the mysterious beings around me. Free at last, without financial worries and able to love, sing, and die. . . .
                                          *—Undated, February 1890, Paris*

TO EMILE BERNARD   . . . My mind is made up: I am going to Madagascar. Out in the country I shall buy a mud house that I'll enlarge myself, and there I shall plant and live simply. I'll have models and everything I need in order to study. Then I'll found the Studio of the Tropics. Anyone who wants to may come and join me. . . . Life doesn't cost a thing for a person who wants to live like the natives. Hunting suffices to supply you easily with food. Consequently, if I can close a deal, I am going to found what I have just said and live free and create art. . . .
                                          *—Undated, April 1890, Paris*

TO EMILE BERNARD   . . . I am not going out there to look for a job or to offer you one. What I want to do there is found the Studio of the Tropics. With the money I'll have I can buy a native hut, like the ones you saw at the Universal Exposition. Made of wood and clay, thatched over (near a town, yet in the country). That

costs next to nothing; I'll make it bigger by cutting wood and turn it into a comfortable residence. We'll have a cow, hens, and fruit—the main items in our diet—and after a while we'll be living without any expenses at all. We'll be free. . . .

Do you think I am incapable of loving and that my forty-two years are an obstacle to my youthful impulses?

. . . I'll go out there and live withdrawn from the so-called civilized world and frequent only the so-called savages.

. . . Out there, having a woman is compulsory, so to speak, which will give me a model every day. And I guarantee you that a Madagascan woman has just as much heart as any French-woman and is far less calculating. . . .

*—Undated, June 1890, Le Pouldu*

TO EMILE BERNARD   . . . All these things that are close to my heart hurt me more than I can say, in spite of all the trouble I take to harden my heart. The coteries that howl in front of my can-vases don't affect me much, particularly since I myself know that my painting at this point is incomplete, more of a preparation for something similar. In art, these sacrifices have to be made, stage by stage—groping efforts, half-formed thoughts lacking direct and definitive expression. Bah! for a minute you touch the sky and then it slips away afterward; yet this glimpse of a dream is something more powerful than any matter. Yes, we (the innovators and thinkers among artists) are doomed to per-ish under the blows dealt by the world, but to perish as matter. Stone will perish, the word will remain. We are really in a fix but we are not yet dead. They won't get me for a while yet. Yes, I think I will obtain what I am applying for now, a good position in Tonkin, where I will work on my painting and save up money. All of the Far East, the great philosophy written in letters of gold in all their art, all that is worth studying and I think I will be reinvigorated out there. The West is rotten today and any Hercules can, like any Antaeus, draw new strength from the ground in that part of the world. And you come back a year or two later, strong and healthy. . . .

*—June 1890, Le Pouldu*

TO EMILE BERNARD . . . I have heard about Vincent's death[24] and I am glad you went to his funeral.

Sad though this death may be, I am not very grieved, for I knew it was coming and I knew how the poor fellow suffered in his struggles with madness. To die at this time is a great happiness for him, for it puts an end to his suffering, and if he returns in another life he will harvest the fruit of his fine conduct in this world (according to the law of Buddha). He took with him the consolation of not having been abandoned by his brother and of having been understood by a few artists. . . .

Right now I am letting all my artistic intelligence lie fallow and I doze, I am not . . . disposed to understand anything.

—*Undated, August 1890, Le Pouldu*

TO ODILON REDON . . . The reasons you give me for staying in Europe are more flattering than they are likely to convince me. My mind is made up, and since I've been in Brittany I've altered my decision somewhat. Even Madagascar is too near the civilized world; I shall go to Tahiti and I hope to end my days there. I judge that my art, which you like, is only a seedling thus far, and out there I hope to cultivate it for my own pleasure in its primitive and savage state. In order to do that I must have peace and quiet. Never mind if other people reap glory!

Here, Gauguin is finished, and nothing more will be seen of him. I am selfish, as you can see. I am taking along photographs and drawings, a whole little world of friends who will speak to me every day; as for yourself, in my head I carry the memory of just about everything you have done, and one star; when I see it, in my hut in Tahiti, I will not think of death, I promise you, but, on the contrary, of eternal life. . . . In Europe depicting death with a snake's tail[25] is plausible, but in Tahiti it must be shown with roots that grow back bearing flowers. I have not said good-by forever to the artists who are

24. Vincent van Gogh had committed suicide on July 27, 1889.
25. An allusion to Plate III in Odilon Redon's album, *A Gustave Flaubert,* published in 1888.

in harmony with me. . . . So, my dear Redon, we will see each
other again.                                        —*September 1890, Le Pouldu*

TO METTE   . . . You say that Schuffenecker undoubtedly heaps
too much praise on me, and yet he is repeating pretty nearly
what many others are saying [about me], even Degas: "He may
be a buccaneer, but he's sacred. He is art incarnate. . . ."
                                        —*December 1890, Paris*

# Letter to J. F. Willumsen [26]

. . . I have had to suffer so much from Denmark and the Danes that I have mistrusted them instinctively ever since. Accordingly, in Pont-Aven, I was amiable with you because you are an artist but not with the Dane in you, which I mistrusted. The letter I have received from you changes everything, and it is a great pleasure to admit that I was mistaken and to make an exception to my decision to hate the inhabitants of Denmark. Now that we have established this, let's talk like good friends. You are happy about your trip to Holland, and I have nothing to say about any of your judgments of the Dutch masters, except for Rembrandt and Hals. Of the two, you prefer Hals. We French are not very familiar with him; yet it seems to me that his portraits show life too vividly through cleverly (perhaps too cleverly) handled external things. I would advise you to go to the Louvre and have a close look at old Ingres's portraits. In the work of this French master, you find inner life; the seeming coldness that puts people off hides intense heat, violent passion. In addition, Ingres has a love for the lines of the whole which is grandiose, and he seeks beauty in its veritable essence, which is form. And what should we say about Velázquez? Velázquez, the tiger. There's portraiture for you, with a full measure of regal character written plain across the face. And by what means

26. Not Willemsen, as spelled by Gauguin (*Les Marges* magazine, March 15, 1918).

does he achieve this? By the simplest type of execution, a few touches of color.

Rembrandt, now—him I know thoroughly. Rembrandt, an awesome lion who dared everything. *The Night Watch,* reputed to be a masterpiece, is indeed on an inferior level, and I can see why you judge him badly after having seen it. All the masters have their weak points and it is precisely those weak points that are called masterpieces; and besides, they do them as crowd pleasers—to prove that they know how. Sacrifice to science! . . . I don't think there is any such thing as a single masterpiece; it is the entire body of work. A rough sketch reveals a master. And that master is of the first or second rank. In the Louvre you'll see very small Rembrandts, such as *The Good Samaritan* and *Tobias.* Have you seen Rembrandt's etchings, such as the *Saint Jerome,* which is unfinished, deliberately, I believe, a landscape such as one sees in a dream, a lion, not a stuffed lion but a real one who roars and exudes authority? In a white corner, a glimpse of Saint Jerome reading. Rembrandt left a personal, powerful imprint on everything he did, investing it with a mysticism which attains the highest pinnacles of the human imagination. And I admire his great intelligence.

In my opinion, an inferior artist always falls into the trap of the so-called science of workmanship. . . . All the supplest gestures of the brush merely take away from an imaginative work by reminding us of the matter of which it is made. The truly great artist is the one who can successfully, and in the simplest way, apply his most abstract precepts. Listen to Handel's music! . . . As for me, my mind is made up; in a little while I shall go to Tahiti, a small island in Oceania, where material life can be lived without money. There I want to forget all the bad things in the past and die unbeknownst to people here, free to paint without any glory for other people. . . . In Europe, terrible times are in store for the next generation: gold will be king. Everything is rotten, men and the arts alike. People are constantly being torn apart. Out there at least, beneath a winterless sky, on marvelously fertile soil, the Tahitian need only lift up his arms to pick his food; for that reason, he never works. In Europe,

however, men and women can satisfy their needs only by toiling without respite, while they suffer the pangs of cold and hunger, a prey to poverty; the Tahitians, on the contrary, are the happy inhabitants of the unknown paradises of Oceania and experience only the sweet things of life. For them, living means singing and loving.[27] Therefore once I've arranged things so that my daily needs out there are met, I'll be able to devote myself to the grand business of art as such, free of all artistic jealousies, without any need to engage in low dealings. In matters of art, one's state of mind is three-quarters of what counts, so it has to be carefully nurtured if you want to do something great and lasting. . . .                          —*Brittany, late 1890*

27. Gauguin is referring to an 1894 lecture on Tahiti given in Paris by a man named van der Veene (see Biographical Index).

# *"Paul Gauguin Discussing His Paintings"*

by Jules Huret

The article which our eminent colleague, Octave Mirbeau, published the other day on Paul Gauguin[28] made me extremely curious about the man and his work. He had been pointed out to me a month ago at the Symbolist banquet, and I retained a very vivid recollection of the fine tanned head, framed by long curling hair, lighted by the gentle, warm, limpid clarity of those deep eyes, a sailor's eyes, brimming with dreams. But I wanted to meet him, speak with him, and especially to become familiar with his painting.

. . . And yesterday, luck being with me, I met Paul Gauguin in front of the paintings he is displaying today, Sunday, at the Hôtel Drouot, for Monday's sale. . . . A mutual friend introduced me to him. We were standing before a painting done in the artist's latest style, one of those which I kept coming back to, whose meaning I was trying, with the utmost attention, to discover. It showed a figure wearing a red hood and seated at the base of a tree in an attitude of dejection; behind him, trees under a blue sky; in a ravine, two vague human shapes fleeing; I had been told it was Christ in Gethsemane. I could indeed see that the head was suffering horribly but it seemed to me unal-

---

28. Before leaving for Tahiti, Gauguin exhibited and put on auction some thirty of his canvases at the Hôtel des Ventes. The writer Octave Mirbeau wrote an article in which he noted "the case of a man fleeing from civilization" (*L'Echo de Paris*, February 19, 1891). That article was to provide the preface to the catalogué.

lowably ugly for a Jesus, and the beard seemed to me too red, and why these greens, these reds, these raw blues, and why these weird trees? And what did those fleeing people represent? And also, why this oppressive sensation of terror that pierced me to the marrow?

Gauguin answered me in that simple, modest, and caressing tone that goes so well with the dream in his eyes and the evangelical, unutterable gentleness of his physiognomy:

"What I've done there is my own portrait. . . . But it is also meant to convey the crushing of an ideal, pain that is as divine as it is human, Jesus abandoned by all, his disciples deserting him, a setting as sad as his soul."

. . . "You are leaving for Tahiti," I said to Monsieur Paul Gauguin, "in order to paint?"

"I am leaving in order to have peace and quiet, to be rid of the influence of civilization. I only want to do simple, very simple art, and to be able to do that, I have to immerse myself in virgin nature, see no one but savages, live their life, with no other thought in mind but to render, the way a child would, the concepts formed in my brain and to do this with the aid of nothing but the primitive means of art, the only means that are good and true. . . ."    —L'Echo de Paris, *February 23, 1891*

# First Stay in Tahiti

TO METTE   . . . Yesterday a dinner was given for me[1] with forty-five people present, painters and writers, and Mallarmé was chairman. Poems, toasts, and the warmest kind of tribute to me. I assure you that in three years I'll have won a battle that will enable us—you and me—to live securely. You will rest and I'll work. Maybe one day you'll understand what kind of a man fathered your children. I am proud of my name. . . .

—*March 24, 1891, Paris*

TO METTE   . . . In two days I'll be in Nouméa, where the boat for Tahiti will pick me up. The crossing was very smooth and rapid, with glorious weather—just for my benefit. But what a lot of extraordinary passengers on these voyages. I am the only one to pay for his passage. All of them are government employees —and the good, kind government pays for little jaunts for all these useless people, their wives and children, which add up. Basically they are very decent people who have only one fault, quite a common one for that matter, that of being altogether mediocre.

   . . . On our ship's deck, amid all these stiff-collared civil servants, their children, etc., I am really oddly alone, me with my long hair. I too have a family, it seems (although you would

1. Dinner in Gauguin's honor shortly before his first departure for Tahiti, on March 23, 1891, at the Café Voltaire, at 1 Place de l'Odéon.

never guess it). Is my family thinking of me? I hope so. Will I, now and then, receive some news out there in Tahiti? Not necessarily on a letter-for-letter basis. But I hope that I will not always be a pariah. I am eager to get settled and start working.

For more than thirty days now I have been gazing stupidly at the horizon while eating, drinking, and so on. Sometimes the porpoises leap out of the waves to say hello to us, and that's all. Fortunately, I sometimes think of you and the children. . . . I have been in Nouméa for two days and on the twenty-first I leave for Tahiti aboard a warship. The government gave me a very good reception and has given me passage on the ship in the officers' quarters; the official letter stating my mission opens many doors. . . .

—*May 4, 1891, Oceania, 250 miles from Sydney*

TO METTE   . . . Twenty days have already gone by since I arrived, and I have already seen so many new things that my mind is in a whirl. It will be some time yet before I can do a good painting. I am going about it gradually by studying a little each day. . . . I am writing you in the evening. This silence at night in Tahiti is even stranger than the other things. It can be found only here, with not even a birdcall to disturb it. Here and there, a large dry leaf falls but does not give an impression of noise. It's more like a rustling in the mind. The natives often go about at night, but barefoot and silent. Always this silence. I understand why those individuals can remain seated for hours, days at a time, without saying a word, and look melancholically at the sky. I feel all of this is going to overwhelm me and I am now wonderfully at rest.

It seems to me that all the turmoil that is life in Europe no longer exists and that tomorrow will always be the same, and so on until the end. Don't let this make you think that I am selfish and that I'm abandoning you. But let me live like this for a while. Those who heap blame o.1 me don't know everything there is in an artist's innermost being, and why should they try to impose on us duties similar to theirs. We don't impose ours on them.

What a beautiful night it is. Thousands of people are doing what I'm doing tonight, taking life as it comes, and their children bring themselves up. All these people go everywhere, in any village, on any road, sleep in a house, eat, etc., without even saying thank you—prepared to return the favor at any time. And they are called savages? They sing, they never steal, my door is never closed, they don't commit murder. Two Tahitian words characterize them: *Ia orana* (hello, good-by, thank you, etc.), and *Onatu* (I don't care, what does it matter, etc.), and they are called savages?

The Tahitian territory is becoming altogether French and little by little all this ancient way of life will disappear. Our missionaries had already brought a great deal of Protestant hypocrisy and they take away part of the poetry, not to mention the smallpox that has spread to the entire race (although without spoiling it too badly, I must say). You who like handsome men, there is no lack of them here, much taller than I am and strong-limbed as Hercules.

How I wish I had your memory so that I could learn the language quickly, for very few [people] here speak French. And often I say to myself, If Mette were here, it wouldn't take her long to speak Tahitian—which is fairly easy, for that matter. . . .                              *July [1891, Tahiti]*

TO METTE   For the first time I have received a letter from France; I was beginning to think that everyone had forgotten me. Yes, I am a little lonely, especially now that I am forty-five kilometers from town, by the sea. I have begun to work. It is not easy and I always have trouble getting the engine started in a new country. Little by little I'll get used to the personality of each thing and each individual. Unfortunately life here is very expensive, even though I am horribly stingy and I eat as badly as possible. However, nothing can be achieved without effort, and if I can succeed in doing what I want in my work, that will console me.

You must be in Paris now. You will hear many good things and many bad things said about me. All that is of no importance;

you can't live to please other people and I don't care a fig about them. . . .                                                              *—Summer 1891*

TO PAUL SÉRUSIER    . . . Thank you for having written. When you are far from your native land, alone out in the country, letters give much pleasure, so write to me often. For two months I have had no news. . . . All these worries (the only ones that have a grip on me) bother me in my work. In spite of them, I am working hard and earnestly. I can't tell if it's good, for I'm doing a lot and at the same time it amounts to nothing. Not one painting as yet, but a great deal of research that can lead to something, many notes that will be of use to me for a long time, I hope, in France. For instance, I've simplified so much that by now I don't know how to judge the result. It seems disgusting to me. Once I'm back, with carefully dried canvases, frames, etc., all the eloquent accoutrements, then I'll judge.

Yes, my dear Séruse, I am quite alone in the country, forty-five kilometers from town; no one with whom to talk art, nor even French, and I'm still not very good at the local language, despite all my efforts. You see, I can't memorize, and, above all, I'm always lost in something else, plunged into endless dreams.

. . . You are making progress: that must mean you had some to make.

. . . Now back to work. It's a good thing I brought along a mandolin and some music—they give me some entertainment. I am indebted to Filiger for the idea of playing this instrument. I think that by now I am much more of a virtuoso than he is.
                                                              *—November 1891, Tahiti*

TO METTE    . . . I am an artist and you are right, you're not crazy, I am a great artist and I know it. It's because of what I am that I have endured so much suffering, so as to pursue my vocation, otherwise I would consider myself a rogue—which is what many people think I am, for that matter. Oh well, what difference does it make. What upsets me the most is not so much the poverty as the things that perpetually get in the way of my art, which I cannot carry out the way I feel it and which I could carry out if

it weren't for the poverty that is like a straitjacket. You tell me I am wrong to stay far away from the artist[ic] center. No, I am right; I've known for a long time what I am doing and why I am doing it. My artistic center is in my brain and nowhere else, and I am strong because I am never thrown off-course by other people and because I do what is in me.

Beethoven was deaf and blind, he was cut off from everything, which is why in his work you get the impression of a musician living on his own planet. Look what has happened to Pissarro: by dint of always wanting to be in the forefront, up-to-date on everything, he has lost every scrap of personality and his entire body of work lacks unity. He always plays follow-the-leader, from Courbet and Millet right down to the petty young chemists who accumulate little dots.

No, I have a goal, and I am still pursuing it, accumulating studies and sketches. True, there are transformations every year, but they always go in the same direction. I alone am logical. Accordingly, I can find very few people who follow me for long.

Poor Schuffenecker who reproaches me with being headstrong in my determination. But if I didn't act that way, would I be able to stand, even for one year, the out-and-out struggle I have undertaken? My acts, my painting, etc., are always contradicted when they are first seen, but in the end people admit that I am right. I am always beginning all over again. I believe I am doing my duty and, strong in that conviction, I do not accept any advice or brook any reproach. The conditions I am working under are unfavorable and anyone who does what I am doing under these circumstances has to be a colossus. . . .

. . . I have a lot of worries, and if it weren't necessary for my art (I am sure it is), I would leave immediately. . . .

—*March 1892, Tahiti*

TO DANIEL DE MONFREID    . . . Your letter gave me more pleasure than you realize. Letters are like a rare fruit for me; I have received so few since I've been here. . . . You are right, my friend, I am a strong man who knows how to bend providence to suit my

tastes; believe me, doing what I have done in the past five years is quite a feat. I am not talking about the struggle as a painter, though that certainly counts, but the struggle to keep alive, without ever a stroke of luck! Sometimes I marvel that everything doesn't fall apart, I so often hear it creaking. Well, let's keep going, at the end there's always the great remedy.

I am going to let you in on a part of my secret. It consists of being very logical, and I am very methodical in my actions. From the outset I knew my existence would be on a day-to-day basis, so logically I accustomed my temperament to that. Instead of squandering my strength on work and on worries about tomorrow, I invested it all in each day as it came. Just like a wrestler who moves his body only when he is fighting. When I go to bed at night I say to myself, That's another day gained, tomorrow maybe I'll be dead.

In my work as a painter, ditto. I take care of only one day at a time. But, and this is where method comes in, you have to arrange it so that everything follows in sequence and so you don't do on the fifth of the month what should be done on the twentieth. That's exactly what the madrepores[2] do. After a while they manage to cover quite a lot of ground. If only men did not waste their time on useless, unconnected tasks and feats of strength! Each day, one link. That's the big thing.

. . . My life is now that of a savage, my body bare, except for the essential part, which women don't like to see (so they say). I am working more and more, but so far [have done] studies only or rather notes, which are piling up. . . .

—*March 11, 1892, Tahiti*

TO SÉRUSIER   . . . I don't dare talk about what I'm doing here, my canvases terrify me so; the public will never accept them. It's ugly from every point of view and I will not really know what it is until all of you have seen it, in Paris. . . . What I'm doing now

2. Stony coral colonies said to be of polypary tissue, which, in Oceania, produce immense reefs, some of them around islands of volcanic origin, others creating ring-shaped atolls.

is quite ugly, quite mad. My God, why did you make me this
way? I am cursed.

What a religion the ancient Oceanian religion is. What a
marvel! My brain is bursting with it and all it suggests to me will
certainly frighten people. If they are afraid to have my old
paintings in an exhibition, then what will they say about the new
ones?                                                  *—March 25, 1892, Papeete*

TO METTE  . . . I am fairly pleased with the most recent things I
have done and I feel that I am beginning to grasp the Oceanian
character; and I can guarantee that what I am doing here has not
yet been done by anyone else and that it is not known in France.
I hope this newness will tip the balance in my favor. Tahiti is not
devoid of charm, and the women—though they lack beauty as
such—have an indescribable something which is infinitely pene-
trating and mysterious.                               *—[June 1892], Tahiti*

TO METTE  . . . I am hard at work, now I know the soil, its odor,
and although I portray the Tahitians in a very enigmatic way,
they are Maoris nonetheless and not Orientals from the Bati-
gnolles.[3] It took me nearly a year before I managed to under-
stand that. . . .                                     *—[July 1892], Tahiti*

3. Lower-middle-class district in northwestern part of Paris.

# "Ancient Maori Religion"
(Excerpts)

*Gauguin was stimulated to keep this notebook, exquisitely illustrated with watercolors, by reading* Voyages aux Iles du grand océan *(1837) by Jacques-Antoine Moerenhout, who was first United States consul and then French consul in Oceania. In 1942, the publisher Adrien Maisonneuve brought out a reproduction of the first edition of Moerenhout's book. A facsimile edition of Gauguin's notebook was brought out in 1951 by La Palme (now known as Editions Hermann), with an introduction by René Huyghe.*

. . . LEGEND OF RUA HATU

This god, a sort of Neptune, was sleeping at the bottom of the sea in a place dedicated to him. A fisherman committed the imprudence of going fishing there, and as his hook caught in the god's hair, the god was awakened. Furious, he rose to the surface to see who had been so bold as to disturb his sleep; and when he saw that the guilty party was a man, he immediately decided that the entire human race would perish as punishment for this insult. Thanks to that spirit of justice which rather commonly distinguishes the gods from a great many peoples, the innocent were punished and the only guilty man was also the only man to be spared.

The god told him to go, with all his family, to the *toa marama*, which, according to some people, is a canoe and, according to others, is an island or a mountain, but which I will call an ark, merely pointing out that *toa marama* means moon

58

warrior, which leads me to suppose that whatever this ark is and the entire event of the cataclysm are in some way related to the moon. When the fisherman and his family had gone to the place that had been stipulated, the waters of the sea began to rise and, covering even the highest mountains, made all creatures perish, except those who were on or in the *toa marama* and who later repopulated the islands or the earth.

### . . . BIRTH OF THE STARS

They must have had fairly extensive knowledge of astronomy. To prove it one could recall the periodic feasts of the Ariois; I could say that they were not ignorant of the cause of the moon's light; they in fact believed the moon to be a globe approximately like ours, inhabited like our globe, and rich in plant and animal species analogous to those of the earth, not to mention the idea they seem to have had of the distance between this satellite and earth. (They said that the seeds of the Ora tree had been brought to them from the moon by a white pigeon. It had taken it two moons to go there, and two to come back, and when it fell back onto earth it had no more feathers.) Of all the birds they know, this one is believed to fly the most swiftly.

The most convincing proof of what I claim here would be the following fragment, found in Polynesia, which I believe shows a rational system of astronomy and could lead one to suppose that the regular movement of the heavenly bodies was known to them.

This fragment is very puzzling.

I will confine myself to quoting some sentences from it which will give an idea both of the difficulties involved in explaining it and of what is to be made of it, once it has been demonstrated by further discoveries that such a conception cannot be the mere fruit of an excited imagination and must be linked to a set of ideas, the sequence of which points to a certain degree of thought and aptitude for the loftiest types of scientific speculation:

Rua (great is his origin) . . . slept with his wife, the somber earth; she gave birth to her king, the sun; then to dusk, then to darkness; but then Rua repudiated this wife. Rua (great is his origin) slept with the woman known as great reunion. She gave birth to the queens of the heavens, the stars, then to the star Faïti, the evening star. The king of the golden skies, the only king, slept with his wife Fanui. Of her was born the star Faurua, Venus (the morning star), the king Faurua, who gives laws to the night and the day, to the stars, to the moon and to the sun, and guides sailors. He set sail to the left, northward; and there, sleeping with his wife, the sailors' guide, he gave birth to the red star, that red star that shines in the evening on two sides. Red star, this god, who flies in the west, prepares his canoe, canoe of broad daylight, that steers toward the skies. He set sail at sunrise.

. . . There is a singular connection between this system of astronomy and that of several other nations.

It is certain, for instance, that their *Hui tarara,* or Gemini, are the same as our Castor and Pollux. Here is what is told about these two children:

They were from Bora-Bora and having heard their parents talk about separating them, they left their father's house and went together to Raiatéa, then Uhamé, to Eimeo,[4] and to Otaheite.[5] Their anxious mother began to search for them as soon as they had left; but she always arrived too late on each successive island. In Otaheite, however, she learned that they were still there and were hiding in the mountains. Finally she found them, but they fled before her to the summit of the highest mountain and from there, just as she, weeping, thought she had caught up with them at last, they flew away into the sky, where they still are among the constellations.

It is also certain that their *Atuahi,* which comes in the fleecy clouds, is our evening star, and that their *Naunu-ura,* which in the evening shines on both sides, is our Sagittarius, which the ancients sometimes depicted in that form.

. . . APPOINTING A KING

The new chief emerged from his house covered with rich garments, surrounded by all the dignitaries of the island and

4. Another name for Mooréa.
5. Former name of Tahiti.

preceded by the principal Ariois, their heads decorated with the rarest feathers. He went to the *maraé.*[6]

As soon as the priests who had given the signal for the ceremony by sounding trumpets and drums had gone back into the temple, a dead human victim was placed before the image of the god. Whereupon the king and the priests began prayers and chants, after which the high priest stood over the human victim and tore out both its eyes; the right eye he placed before the image of the gods and the left he offered to the king, who opened his mouth as if to swallow it, but the priest withdrew it immediately to place it with the rest of the body, as has already been said elsewhere. After these ceremonies, the image of the god was placed on a carved bier and, preceded by this image, carried by priests, the new chief, himself sitting on the shoulders of some other chiefs, led the procession to the shore where the sacred canoe awaited, accompanied by the chiefs and the Ariois as he had been when he left his house, and followed by a throng of people; and all were preceded by the priests who sounded their trumpets, beat their drums, and danced before the divinity.

When they had come to the sacred canoe, which was decorated for the occasion with flowers and green branches, they placed the idol in it; then they removed the clothing of the new chief, whom the high priest led naked into the sea, where the people believed that the *Atouas-mao,* the shark gods, came to caress and wash him. A short while later he came back to the high priest, who helped him to climb into the sacred canoe, placed about his loins the *Maro-ourou* and about his head the *Taoumata,* signs of sovereignty, and conducted him to the prow of the canoe to show him to the people who, at sight of him, broke their long silence, so that countless cries of *Maeva Arii!* (Long live the king!) were heard from all sides.

When the tumult of this first joyous impulse had died down, the king was placed on the sacred bed on which the image

---

6. *Maraé,* open-air place of worship, rectangular, with low walls on three sides and, at the back, a sort of altar in the form of a tiered pyramid.

of the god had been placed when they had come from the *maraé* and a procession formed, in much the same order as when they had come from it, to bring him back to the *maraé*.

The priests carried the image of the god, some of the chiefs carried the king. As they had when coming, the priests led the way with their music and their dances and the people followed, but this time giving full vent to their joy and never ceasing to shout, *Maeva Arii! Maeva Arii!*

When they had returned to the *maraé,* the idol was placed on the altar again and the celebration ended with a scene which must have reduced its solemnity to a singular extent. The chief, or king, placed on mats near the image of the god, there received what they called the people's final tribute. This consisted of the most shockingly filthy, coarsely obscene dances and representations, in which several entirely naked men and women surrounded the king and they strove so hard to touch him with the various parts of their body that he had difficulty avoiding their urine and their excrement, with which they sought to cover him. This went on until the priests began once again to sound their trumpets and beat their drums, which was the signal to withdraw. The celebration was ended. The king then returned to his residence, accompanied by his attendants. . . .

*1892, Tahiti*

LETTERS    **TO METTE** . . . These days I am constantly on the alert, making every effort to get hold of a 1000-franc note. In that case I will go to the Marquesas, to the little island of Dominica which has only three Europeans living on it and where the Oceanians have been less damaged by European civilization. Here, life is very expensive and I am ruining my health by not eating. In the Marquesas, I'll eat—an ox can be had for 3 francs, or the trouble of hunting it. And I'll work.

. . . Soon I'll be old and I've done precious little in this world for lack of time. I am always afraid I'll become senile before I've finished what I've undertaken. Not that I feel weakened, morally; on the contrary, my mind feels good and strong at this point. Who can predict what the morrow will bring? I

must certainly have a badly made heart, every day I can feel it getting worse. The slightest surprise or excitement shakes me up completely. If I ride horseback and the horse shies the least bit, I feel frightened for four or five minutes; I am furious, and the poor beast is severely ill-treated. Here people are constantly riding horseback, and it is an amusement which costs nothing. When I get back, if I have a little peace, I'm going to take care of myself a little. . . .                    —*September 1892, Tahiti*

TO METTE   . . . I feel myself aging, and fast too. From having to go hungry, my stomach is being atrociously ruined and I become thinner every day. But I must keep up the struggle, always, always. And the fault lies with Society. You have no faith in the future, but I have faith because I want to. Otherwise I'd have blown my brains out long ago. Hoping is almost living. I have to live in order to do my duty to the end, and I can't do it unless I force my illusions, dreaming up hopes for myself. Every day, when I have my dry bread and a glass of water, I manage to will myself into believing that it is a steak. . . .
                    —*November 5, 1892, Tahiti*

TO METTE   . . . I have had an opportunity to send eight canvases to France. Naturally many of them are incomprehensible and you're going to have work on your hands. So that you will understand and be able to show off, as they say, I am going to give you the explanation of the most difficult one, which, in fact, is the one I want to keep—or sell for a very good price: the *Manao Tupapaü.*[7] I did a nude of a young girl. In that position, a mere hint, and it is indecent. Yet that is the way I want it, the lines and the movement interest me. So when I do the head I put in a little fear. For this fear I have to give a pretext, if not an explanation, and it has to be in keeping with the character of the person, a Maori girl. The Maoris have a very great, traditional fear of the spirit of the dead. A girl from our own part of

7. *Manao Tupapaü (She Is Thinking of the Spirit of the Dead)*, no. 457 in the Wildenstein Catalogue.

the world would be afraid of being caught in that position (women here not at all). I have to explain this fright with the fewest possible literary devices, as in olden times. So this is what I do. Dark, sad, terrifying general harmony that rings in the eye like a funeral bell. Purple, dark blue, and orangey yellow. I make the cloth greenish yellow (1) because the linen that this savage wears is different from our linen (beaten treebark), (2) because it creates, suggests artificial light (a Kanaka woman never sleeps in the dark) and yet I do not want any suggestion of lamplight (that's ordinary), and (3) because this yellow linking the orangey yellow and the blue completes the musical chord. There are a few flowers in the background but they mustn't be real, since they are imagined. I make them look like sparks. The Kanakas think that the phosphorescences of the night are the souls of the dead and they believe in this and are afraid. To finish up, I do the ghost very simply, a small figure of a woman; because the girl, not being familiar with the French spiritist theaters, can't help seeing the actual dead person, that is, a person like herself, linked to the spirit of the dead. This little text will make you look very scholarly when the critics start to fire their mischievous questions at you. And finally, the painting has to be done very simply since the subject matter is primitive, childlike. . . .

—*December 8, 1892, Tahiti*

# "Notebook for Aline"

*Editor's note: In 1892, in Tahiti, Gauguin acquired a plain notebook, whose cover and endpapers he embellished with watercolors done in delightful tones, and he enjoyed writing down in it a certain number of thoughts, notes, and copies of other people's writings which he valued. Some of these entries were not exactly what a girl of those days was usually permitted to read. Gauguin didn't care. He tenderly dedicated this notebook to his daughter.*

*Of his five children, Aline, born in 1877, was his favorite. He had seen her for the last time during a brief visit to Copenhagen in March 1891; she was fourteen at the time. He thought her very pretty, and like him both physically and morally. "Later, I'll be your wife," she had told her father. At the end of December 1893 he was to write her: "Very dear Aline, how grown-up you are. . . . You don't remember it, of course, but I saw you when you very small, very calm, you opened very beautiful light eyes. So you have remained, I believe, forever. Mademoiselle is off to the ball. Do you dance well? I hope the answer is a graceful Yes, and that young men talk to you a great deal about me, your father. That's an indirect way of courting you. Do you remember, three years ago, when you said you would be my wife? I sometimes smile when I recall your naïve idea. . . ."*

*Aline never saw the notebook that was dedicated to her; she died in Copenhagen early in the winter of 1897, three days after catching pneumonia—upon leaving a ball, in fact. The news plunged Gauguin, who was then in Tahiti, into despair. He wrote Mette: "I have just lost my*

*daughter, I no longer love God. . . . Her tomb is here near me, my tears
are her flowers, they are living things."*

*The "Cahier pour Aline" was never printed. But the manuscript is
kept in Paris in the Bibliothèque d'Art et d'Archéologie, founded by
Jacques Doucet. This enabled Suzanne Damiron, the curator, to publish,
in 1963, a limited facsimile edition, for which she wrote an introduction.*

DEDICATION
(EXCERPT )

To my daughter Aline, this notebook is dedicated. These medi-
tations are a reflection of myself. She, too, is a savage, she will
understand me. . . . Will my thoughts be useful to her? I know
she loves her father, whom she respects. I give her a remem-
brance. The death that I have to accept today is an insult to my
fate. Who is right, my words or myself? Who knows. In any
event, Aline has, thank God, a heart and mind lofty enough not
to be frightened and corrupted by contact with the demonic
brain that nature gave me. Faith and Love are Oxygen. They
alone sustain life.

. . . Is it not a miscalculation to sacrifice everything for the
children, and doesn't that deprive the nation of the genius of its
most active members? You sacrifice yourself for your child who,
in turn, becomes an adult, and will sacrifice himself. And so on.
There will be nothing but sacrificed people. And this stupidity
will go on for a long time.

. . . It is good for young people to have a model, but they
should forgo looking at the model while they paint.

. . . Women want to be free. That's their right. And it is
certainly not men who stand in their way. The day a woman's
honor is no longer located below the navel, she will be free. And
perhaps healthier too.

. . . I have known what absolute poverty means—being
hungry, being cold—and everything that it implies. That's noth-
ing, or next to nothing; eventually you get used to it and with
a little will power you laugh it off. But the terrible thing about

poverty is the way it prevents you from working, prevents development of your intellectual faculties. In big cities, and in Paris especially, you spend three quarters of your time and half your energy chasing after money. On the other hand, it is true that suffering sharpens genius. Yet too much suffering kills you.

Along with a great deal of pride, I ended up having a great deal of energy and was determined to exert my will! Is pride a defect, and should it be developed? I think it should. It's still the best way of combating the human animal that is within us.

. . . Nobility used to be hereditary, and we had our 1793 to abolish that custom. Today wealth is hereditary, isn't it the same privilege?

. . . The great monuments were built during the reign of the potentates. I believe that, likewise, the great things yet to come will be done only under potentates.

. . . It is said that God took a little clay in his hands and made every known thing. An artist, in turn (if he really wants to produce a divine creative work), must not copy nature but take the natural elements and create a new element.

. . . When Napoleon I was a young man, he had seen an excitable crowd overflow like a swollen river and thereafter he wanted to confine it once again to its bed. He worked all his life to create kings. The kings formed coalitions to destroy Napoleon. The idiots worked against themselves. And the great despot was right when he said bitterly, at Saint Helena: "The kings will regret me."

The public wants to understand and learn in a single day, a single minute, what the artist has spent years learning.

My political views? I haven't any, but because of universal suffrage, I am supposed to have some.

I am a republican because I believe that society should live

in peace. The majority of people in France are strict republicans; therefore I am republican, and, besides, so few people like what is great and noble that a democratic government is necessary.

Long live democracy! That's all there is. Philosophically speaking, I think the Republic is a trompe l'oeil (to borrow a term used in painting) and I hate trompe l'oeil. I become antirepublican again (philosophically speaking), intuitively, instinctively, without thinking about it. I like nobility, beauty, delicate tastes, and this motto of yesteryear: *"Noblesse oblige."* I like good manners, politeness, even that of Louis XIV. So (instinctively and without knowing why) I am a snob—as an artist. Art is only for the minority, therefore it has to be noble itself. Only the great lords have protected art, out of instinct, out of duty (out of pride perhaps). It doesn't matter; they caused great and beautiful things to be made. The kings and the popes dealt with artists as equals, so to speak.

The democrats, bankers, ministers, and art critics masquerade as protectors and don't protect anything; they haggle like fish buyers at the market. And you would like artists to be republicans!

There you have all my political views. I believe that in a society every man has the right to live, and to live well in proportion to his work. Since an artist cannot live, it follows that society is criminal and badly organized.

. . . A young man who is unable to commit a folly is already an old man.

. . . Can we say that the man who wrote *Seraphitüs Seraphita* and *Louis Lambert* is a naturalist? No, Balzac[8] is not a naturalist.

---

8. In his book *La Littérature de tout à l'heure* (1889), Gauguin's friend Charles Morice, the apostle of Symbolism, had railed against naturalism in these terms: "What do the naturalists make of the philosophical works [Balzac's *Etudes philosophiques*]? *Louis Lambert,* what do they think of that? What do they think of *Seraphita?*"

. . . In the art of literature there are two opposing factions.

The one that wants to tell more or less well-contrived stories. And the one that wants fine language, pure forms. The argument could go on for a very long time with each side having an even chance. Only the poets can rightly demand that lines of poetry be beautiful lines and nothing else.

A musician is a privileged being. Sounds, harmonies. Nothing else. He is in a special world. Painting too should be a separate world; sister to music, it lives on forms and colors. Those who have thought differently are very close to going down in defeat.

. . . Freedom of the flesh should exist, otherwise it is revolting slavery. In Europe, the coupling of two human beings is a consequence of Love; in Oceania, Love is the consequence of copulation.

. . . You will always find vital sap coursing through the primitive arts. In the arts of an elaborate civilization, I doubt it!

. . . Is there a man who can claim that he has never, not for a minute, not for a second, wanted to commit a crime?

Back in France

TO METTE  . . . I am overwhelmed by the expenses involved in settling down here and in organizing my exhibition, which will open on November 4 at Durand-Ruel's. In addition, I am preparing a book on Tahiti which should be very useful in helping people to understand my painting. What a lot of work. At last I will soon know whether it was folly to go away to Tahiti. . . .  *—Undated, October 1893, Paris*

TO METTE  . . . My exhibition did not actually achieve the result that was expected of it. . . . Never mind. The main thing is that my show was a very great success, artistically speaking—it even aroused fury and jealousy. The press treated me in a way it had never yet treated anyone, that is, reasonably and with praise. For the moment, many people consider me the greatest modern painter.

Thanks for your suggestion that I come to Denmark, but I will be tied down here all winter with a great deal of work. Many receptions. Visitors who want to see my paintings. Buyers, I hope. A book on my trip that is causing me a lot of work.

*—December 1893* [*Paris*]

# Noa Noa

**(end of 1893) (Excerpts)**

*Editor's note: On August 3, 1893, Gauguin came back to France from Tahiti. Toward the end of that year, he began to write down his recollections of his first Oceanic adventure. The result was the text which is reproduced here virtually in full.*

*But the painter had the unfortunate idea of entrusting the manuscript to his friend Charles Morice, the Symbolist poet, doubtless because Gauguin, very mistakenly, underestimated his own literary capabilities. "Writing is not my line of work," he was to confide to Daniel de Monfreid in May 1902 (see p. 212). Morice hastened to begin writing a new version of Noa Noa, much less authentic and more turgid than the initial version, and he inserted in it some redundant poems of his own. In 1894 Gauguin felt it his duty to endorse this new version, mangled by Morice, by recopying it in his own hand in order to take it with ,him when he returned to Oceania. This is the manuscript that Monfreid held in safekeeping and which, thanks to him, was acquired by the Cabinet des Dessins in the Louvre. Luckily, the text is redeemed by Gauguin's admirable illustrations — watercolors, monotypes, and woodcuts colored by himself.*

*Later, at the end of 1897, Morice published excerpts from Noa Noa in two issues of the Revue blanche, and in vain Gauguin begged Mme. Morice to urge her husband not to continue weighing down the narrative and not to spoil the savor of the original further by adding more poetry (letter of February 1899, see pp. 182–83). Morice ignored this and in 1901, at his own expense, he had a publishing house called la Plume publish, under his name and Gauguin's, a Noa Noa that did not please Gauguin at all.*

*As a man of letters, Morice had at least kept Gauguin's original manuscript in his files. Being hard up in 1908, long after Gauguin's death, Morice brought himself to sell it to Edmond Sagot, who sold prints, and whose daughter, Berthe Le Garrec, eventually produced a limited facsimile edition of it in 1954.*

*It was not until 1966 that Jean Loize published a printed edition of the original Noa Noa, which he followed with very abundant and valuable scholarly comments. It is that text (minus a few passages which are to be found in "Ancient Maori Religion" and an appendix which was of no interest, at least from the literary standpoint) that the reader will find here.*

For sixty-three days I have been on the way and I am aflame with eagerness to set foot on the desired land. On June 8 we sighted some strange, zigzagging lights: fishermen. A black jagged-edged cone stood out against a somber sky. We were rounding Mooréa and coming in sight of Tahiti. A few hours later the day dawned and slowly we drew near the reefs of Tahiti, entered the channel, and moored in the anchorage without damage. For someone who has traveled a good deal, this little island, unlike the bay of Rio de Janeiro, has nothing enchanting about it. A few mountain peaks where, long after the deluge, a family climbed and settled down; the coral also climbed, and surrounded the new island.

On arrival in Papeete, my duty (as I had been given a mission) was to call on the governor, the Negro Lacascade, renowned for his color, for his *bad morals,* for his previous exploits at the Guadeloupe bank, and more recently for his exploits in the Leeward Islands.[1] Despite all of King Pomare's recriminations and the protests by the French colony in Tahiti, that inept and harmful man could not be removed. Everywhere throughout the ministry the inevitable answer was: "Debts to pay." Only a man who had a wife or a daughter to offer him could obtain a job from the sovereign dispenser of favors. What corruption on both sides!

1. See pp. 121–22.

So it was sadly, and perhaps with the arrogance of disgust on my face, that I called upon the governor, the Negro Lascade.

I was received with courtesy and—having been announced by the Ministry of the Colonies as a painter—with mistrust. That profession being rare and improbable in Tahiti, it was easier to assume that I was a political spy.

[*Variation:* At ten in the morning I presented myself before Governor Lacascade, who received me as a man of importance to whom the government had entrusted a mission, purportedly artistic, but really one of political espionage. I did everything I could to convince all the political people it was not so, but in vain. They thought I was being paid off, I vowed I was not.]

I withdrew. That was all. But everyone vied with everyone else in believing I was something I was not. And yet I had long hair, no white helmet, and, most important, no black suit. Even though I said that I was not receiving any government subsidies, that I was poor, only an artist, everyone was on the alert. That is because in a city like Papeete there are a great many factions: governor, mayor, Protestant bishop, Catholic missionaries, and the Ladies.

Things went so far that one July 14 holiday two magistrates' wives pulled each other's hair in the public square, each boasting that she was receiving the governor's favors, and their husbands, honorable colonial magistrates, sided with their wives and hit each other with their canes. As always, it ended by a dismissal from the colony and each gentleman was given a promotion.

One will easily understand how eager I was to flee from the city of Papeete, its officials and its soldiers, to go study and prove at last that I was nothing in this world: a free man, an artist. Finally people gave in to the obvious and the bowing and scraping stopped.[2]

At that time the king was deathly ill and each day a catastro-

2. Gauguin had placed the foregoing passage, starting with "On arrival in Papeete," in an appendix. I have taken the liberty of inserting it here since, chronologically, it belongs with his arrival in Tahiti.

phe was expected. The city had a singular look to it: on the one hand, the Europeans, shopkeepers, officials, officers, and soldiers continued to laugh and sing in the streets; while the natives took on a serious air and stood near the palace talking in low voices.

And out in the harbor there was an unaccustomed movement of boats with orange sails on the blue sea, often traversed by silvery waves from the line of reefs. The inhabitants of the neighboring islands were arriving each day to witness their king's last moments and the final takeover of their islands by the French. Their voices from on high had just warned them. (Every time a king is about to die, dark patches appear at sunset, they say, on some of their mountain slopes.)

The king died and in his palace, in an admiral's dress uniform, [he was] laid out for all to see.

There I saw the queen, whose name was Marau, decorating the royal chamber with flowers and draperies. As the director of public works was asking me for artistic advice on how to adorn the hall, I motioned to him to watch the queen who, with the fine instinct of the Maori race, gracefully embellishes everything she touches and makes of it an art object.

"Let them do it," I answered.

Having arrived only recently, feeling rather disillusioned because things were so different from what I had wished for and especially imagined, sickened by all this European triviality, I was blind, so to speak. Thus, when I looked at the queen, who was already middle-aged, all I could see was a heavy, ordinary woman who must once have been beautiful. That day, her Jewish blood had absorbed everything. I was thoroughly mistaken.

When I saw her again later, I understood her Maori charm; the Tahitian blood had gotten the upper hand again, and the recollection of her ancestor, the great chief Tati, gave her, her brother, and the whole family a really imposing aspect. Her eyes held hints of passion that flames in an instant.

An island rising out of the ocean and in the early sunlight the plants that begin to sprout.

For two days *hyménés* (choirs) sang. Everyone wore black.

Funeral hymns. I thought I heard Beethoven's Pathétique sonata.

Pomare's funeral: at six o'clock, the procession leaves the palace. The soldiers, the authorities, black clothes, white helmets. All the districts marched in order, the chief carrying the French flag. Great black mass. All the way to the district of Arué. There, an indescribable monument, incongruous amid natural beauty, a shapeless heap of coral stones bound together by cement. Speech by Lacascade, trite cliché translated afterward by the interpreter. Speech by the Protestant pastor; then reply by Tati, brother to the queen.

That was all. Officials piling into horse-drawn carts, as if going home after the races.

On the road back, helter-skelter, the indifference of the French sets the tone, and all these people who had been so serious for days began to laugh, the *vahines* took the arm of their *tanés*[3] again, wagging their buttocks while their broad bare feet stepped heavily in the dust along the way. When they came near the river of Fataua, everyone dispersed. Here and there some of the women, hidden by stones, squatted in the water, their skirts lifted to their waists, cleansing their hips soiled by the dust of the road, refreshing the joints that had become irritated by the walk and the heat. Feeling in good shape again they resumed their way to Papeete, bosom to the fore, the tips of the breasts like two pointed shells protruding under their muslin dresses, with all the suppleness and grace of healthy animals, giving off all around them a blend of animal odor and perfumes of sandalwood and *tiaré*:[4] *Teine merahi noa noa* ("Now very fragrant"), they said.

That was all. Everything went back to normal. There was one king fewer and with him had disappeared the last vestiges of Maori customs. It was really over: nothing but civilized people. I was sad: to have come so far for . . .

3. *Tanés,* men.
4. Fragrant white flower which the Tahitians, of both sexes, wear behind their ears.

Would I be able to find any trace of that remote, mysterious past? The present did not appeal to me at all. I wanted to find the ancient hearth, revive the fire in the midst of all these ashes. And there was no one to help me; I was all alone.

No matter how down-hearted I am, I am not in the habit of giving up without having tried absolutely everything. My mind was soon made up: I would get out of Papeete as fast as possible, move away from the European center. I felt, as by intuition, that by living completely in the brush with the Tahitian natives and being patient, I would eventually overcome their mistrust, and that I would know what I wanted to know.

An officer in the gendarmerie kindly offered me his carriage and his horse. One morning I went off looking for my hut. My *vahine* went with me (she was called Titi); she was almost English but spoke a little French. She had put on her best dress that day, with a flower behind her ear, and her sugar-cane-stalk hat, which she had woven herself, was trimmed with orange-colored shells on top of the band of straw flowers. With her black hair hanging down on her shoulders, she was really pretty. She was proud to be in a carriage, she was proud to be elegant, she was proud to be the *vahine* of a man who, she thought, was important and had a big salary. There was nothing ridiculous about this pride—their faces are so suited to dignity. Old memories of great chiefs (a race that had such a feudal system).

I knew very well that her self-seeking love encompassed things which, to our European eyes, make her a whore, but anyone looking at her could see there was more to her. Such eyes and such a mouth could not lie. In all of these women love is so inborn that bought or not, it is always love.

The ride was rather short; some idle chatter and a landscape that was always rich but varied little. To our right, always the sea, the coral reefs, and expanses of water sometimes rising in smoke when they crashed too swiftly on the rock.

At noon we came to the forty-fifth kilometer, the district of

Mataiéa. I looked over the whole district and eventually found a rather fine native hut that the owner let me rent; he was building another one for himself nearby.

Coming back the next evening, Titi asked me if I was willing to take her along.

"Later, in a few days, once I've settled in."

I was aware that this half-white girl, with the gloss she had acquired from contact with all these Europeans, would not serve the purpose I had in mind. I would find dozens of them, I told myself. But the country is not the town. And they would have to be taken in Maori style (*mau* = to seize). And I didn't know their language.

The few girls of Mataiéa who do not live with a *tané* look at you so frankly—dignity without any fear—that I was really intimidated. And also it was said that many of them had a disease, that disease which the civilized Europeans had brought them in exchange for their so ample hospitality.

After some time I let Titi know that I would be happy if she came back; yet in Papeete she had a terrible reputation. She had buried several lovers in succession.

[On] one side, the sea. On the other side, the mango tree leaning against the mountain, blocking the fearsome cavern.

Near my house was another house (*Fare amu,* house to eat). Near that a canoe. And an ailing coconut tree looked like a huge parrot trailing its golden tail and holding an enormous bunch of coconuts in its claws.

With both arms, the near-naked man lifted up the heavy ax, leaving on high its blue imprint on the silvery sky, and, below, its incision on the dead tree which, shortly afterward, would relive an instant of flame, centuries-old heat accumulated day by day. On the crimson ground, long serpentine metallic-yellow leaves, a whole Oriental vocabulary, the alphabet (it seemed to me) of some unknown mysterious language. It seemed to me they spelled that word of Oceanian origin, *Atua,* "God". . . . A woman was putting some nets away in the canoe and the hori-

zon of the blue sea was often interrupted by the green of the
cresting waves on the coral reefs.[5]

Tonight I went to smoke a cigarette on the sand at the edge
of the sea. The sun was rapidly nearing the horizon, beginning
to hide behind the island [of] Mooréa that was to my right. The
mountains were silhouetted black and powerful against the
flaming sky. All those peaks like old crenelated castles.
. . . Quickly night fell. Mooréa slept once again. I fell asleep
later in my bed. Silence of a Tahitian night. Only the beating
of my heart could be heard. Seen from my bed, by the moon-
light that filtered through them, the lines of reeds some distance
from my hut looked like a musical instrument. "Pipo" for our
ancestors, here they call it *vivo*—but it is silent (out of memories
it speaks at night). I fell asleep to the sound of that music. Above
me the great lofty roof of pandanus leaves, with lizards living in
them. In my sleep I could picture the space above my head, the
heavenly vault, not a stifling prison. My hut was space, freedom.

I was quite alone there. We watched each other.
Two days later I had exhausted my provisions; I had as-
sumed that with money I would find all the food I needed.
Food can certainly be found—in the trees, in the mountains,
in the sea; but you have to know how to climb up a tall tree,
how to go into the mountains and come back bearing heavy
burdens, how to catch the fish, how to dive to the bottom of
the sea and there wrest shellfish from the stones to which they
are sturdily attached. So there I was, I, the civilized man, for
the time being far inferior to the savage, and while, on an
empty stomach, I was thinking sadly of my predicament, a na-
tive made signs to me, calling in his language, "Come and
eat." I understood. But I was ashamed and shook my head in
refusal. A few minutes later a child silently placed on the top

5. Gauguin adds in a note: "Description of landscape, toward the sea" and
"Painting of the woodcutter." (*The Man with the Ax*, no. 430 in the Wildenstein
Catalogue.)

edge of my door some food neatly wrapped in freshly picked green leaves, then went away. I was hungry; silently too, I accepted. A little while later the kind-faced man came by and without stopping spoke a single word: *"Paia?"* I understood vaguely: Are you satisfied?

On the ground, beneath tufts of broad pumpkin leaves, I spied a little brown head with calm eyes. A small child was examining me; he ran away, frightened, when my eyes met his. These black creatures, those cannibal's teeth brought to my lips the word "savages." For them too I was the savage. Perhaps they were right.

I began to work—notes, sketches of all sorts. Everything in the landscape blinded and dazzled me. Coming from Europe I was always uncertain of a color, unable to see the obvious: yet it was so easy to put a red and a blue on my canvas, naturally. In the streams, golden shapes enchanted me. Why did I hesitate to make all that gold and all that sunny rejoicing flow on my canvas? Probably old habits from Europe, all that timidity of expression of our old degenerate races.

In order to understand the secret in a Tahitian face, all the charm of a Maori smile, I had been wanting for a long time to do the portrait of a neighboring woman of pure Tahitian race. One day, when she had been bold enough to come into my hut to look at some pictures and photographs of paintings, I asked her if I could do it.

She was specially interested in the photograph of Manet's *Olympia*. Using the few words I had learned in her language (for two months I'd not spoken a word of French) I questioned her. She told me that this Olympia was very beautiful; I smiled at this opinion and was moved by it. She had a sense of the beautiful (whereas the Ecole des Beaux-Arts finds it horrible).

Suddenly, breaking the silence which precedes a thought, she added: "Is she your wife?"

"Yes."

I told that lie. I! the *tané* of Olympia!

While she was looking with great interest at some religious

paintings, Italian primitives, I tried to sketch some of her features, especially her smile, so enigmatic.

I asked if I could do her portrait. She made an unpleasant face:

*"Aita"* ("No"), she said, her tone close to anger, and then ran away.

This refusal saddened me deeply. An hour later she came back wearing a pretty dress. Was it an internal struggle, or a whim (a very Maori trait), or a coquettish impulse, not wanting to capitulate until she had resisted?

Caprice, desire for forbidden fruit. She smelled good, she was dressed in her best. I was aware that at the same time as I, as a painter, was examining her, it was as if I was tacitly asking her to surrender, surrender forever without being able to take herself back; my scrutiny was a shrewd search for what was within. Not very pretty really, according to European standards, yet beautiful. There was a harmony worthy of Raphael in the encounter of curves in every one of her features, the mouth, as if shaped by a sculptor, speaking all the tongues of language and of kissing, of joy and suffering; the melancholy of bitterness mingled with pleasure, passivity residing in domination. A whole fear of the unknown.

I set to work hastily; I was sure that her determination would not last. Portrait of a woman: *Vahine no te tiare.*[6] I worked quickly, with passion. It was a portrait resembling what my veiled eyes had, through my heart, perceived. Above all I believe it was a good inner resemblance. The steady flame of controlled strength. She had a flower at her ear which listened to her perfume. And the majesty and uplifted lines of her forehead recalled these lines by Poe: "There is no exquisite beauty without some *strangeness* in the proportion."[7]

A period of work. Alone. I saw many young women with untroubled eyes; I guessed that they wanted to be taken word-

6. *Woman with Flower*, no. 420 in the Wildenstein Catalogue.
7. "Ligeia," 1838. Poe is quoting Bacon, Lord Verulam.

lessly, brutally. A desire for rape, as it were. The old men said to me, speaking about one of them: *"Mau tera"* ("Take this one"). But I was timid and could not bring myself to do it.

I let Titi know that I wanted her to come. She came. But being already civilized, accustomed to an official's luxury, she did not suit me for long. I sent her away.

Alone again. . . . Every day I became a little more of a savage, my neighbors were almost my friends, I dressed like them, ate like them. In the evening I went to the house where the natives from the district gathered. There, after a prayer spoken conscientiously by an old man, with everyone repeating in chorus, the chants began. Strange music without instruments. In the intervals, funny stories or wise proposals. One of them surprised me. The old man said:

"Here and there in our village we can see houses that are falling into ruin, rotting roofs that gape open and let in the water when it happens to rain. Why? Everyone should have shelter. Wood and foliage for the roof are not lacking. I ask that large houses be rebuilt to replace these; everyone will take turns working on them (unity is strength)."

And everyone, without exception, applauded: that is a good thing. Unanimously approved.

I went to bed that night full of admiration for this wise people, and the next day I went out to see how work had begun on those houses. Nobody was thinking of them any more. I questioned a few people. No answer, just a few meaningful smiles and those broad musing foreheads.

There's many a slip 'twixt cup and lip. Why this work? Haven't the gods given us our daily sustenance? The sun rises, serene, every day. Tomorrow. Perhaps. Don't know. Is this levity? heedlessness? or, on second thought, is it philosophy: do not acquire a taste for luxury, etc.? I withdrew. Pangloss,[8] everything is for the best in the best of all possible worlds.

---

8. A smug, unshakable optimist in Voltaire's *Candide.*

Every day things get better for me. I have finally come to understand the language fairly well. My neighbors—three close by, the others at varying distances—look upon me almost [as one of] themselves. My bare feet, through daily contact with stones, are now familiar with the ground; my body, almost always naked, no longer fears the sun; civilization is slipping away from me little by little and I am beginning to think simply, to harbor only a little hatred for my neighbor, and I function in an animal way, freely, certain that tomorrow will be like today; every morning the sun rises for me as it does for everyone, serene; I become carefree, tranquil, and loving.

I have a native friend;[9] who comes every day, quite naturally, not looking for anything special. My colored pictures, my wood carvings surprised him and my answers to his questions have taught him something. He comes to watch me whenever I work. One day, when I handed him my tools and asked him to try doing a sculpture, he looked at me with astonishment and said to me simply and sincerely that I was not like other men and —maybe the first person in the community to do so—he told me that I was useful to the other members. Child! You have to be a child to think that an artist is something useful.

This young man was thoroughly handsome and we were very friendly. Sometimes in the evening, when I was resting from my day, he questioned me as a young savage wanting to know many things about love in Europe, and I was often at a loss to know how to answer him.

One day I wanted to obtain a rosewood trunk, fairly large and not hollow, from which to make a sculpture.

"For that," he told me, "you have to go into the mountains, to a certain place where I know several fine trees that might suit you. If you like, I'll take you there and we'll bring it back together."

We left early in the morning. The Indian paths in Tahiti are

---

9. Cf. my commentary on this singular passage: "Gauguin et les jeunes Maoris," *Arcadie* (February 1973).

difficult for a European: between two mountains that cannot be climbed is a cleft where water emerges through rocks that the current has rolled along and that lie there loose until they are swept away again one day by the rushing stream, which tumbles them lower and lower, down to the sea.

On either side of the cascading stream, the semblance of a path, trees pell-mell, monstrous ferns, all of the vegetation growing wilder, becoming more and more impenetrable as we climbed toward the center of the island.

Both of us were naked with a loincloth about our waists and an ax in our hands, crossing and recrossing the river to rejoin a bit of path that my companion seemed to follow by scent alone, it was so shady and hard to see. Total silence, only the sound of water groaning over the rocks, monotonous as the silence. And there we two were, two friends, he a very young man and I almost an old one, in both body and soul, made old by the vices of civilization, and lost illusions. His supple animal body was gracefully shaped, he walked ahead of me sexless.[10]

From all this youthfulness, from this perfect harmony with the natural surroundings, emanated a beauty, a perfume (noa noa) which enchanted my artistic soul. From this friendship, which was so well cemented by the mutual attraction between the simple and the compound, love was blossoming within me.

And there were only the two of us.

I had a sort of presentiment of crime, desire for the unknown, awakening of evil. Then too, a weariness of the role of the male who must always be strong, the protector having to bear the weight of his own heavy shoulders. To be for one minute the weaker being, who loves and obeys.

I drew nearer, unafraid of laws, my temples pounding.

---

10. Doubtless with a view to reworking this passage and what comes immediately after it, Gauguin made these notes, separately from the text:

"1. The androgynous side to the savage, the little differentiation of sex among animals.

"2. The purity brought about by sight of the nude and the freedom between the two sexes.

"The way vice is unknown among savages.

"Desire, for one instant, to be weak, a woman."

The path had come to an end, we had to cross the river; my companion turned just then, his chest facing me.

The hermaphrodite had disappeared; this was definitely a young man; his innocent eyes were as limpid as clear waters. Suddenly my soul was calm again, and this time I found the coolness of the stream exquisite, reveling in the feel of it.

*"Toe toe"* ("It's cold"), he said to me.

"Oh, no!" I replied, and that negation, answering my earlier desire, resounded in the mountain like a sharp echo.

I plunged eagerly into the bush, which had become increasingly wild; the child continued on his way, with that limpid gaze. He hadn't understood a thing; I alone bore the burden of an evil thought, an entire civilization had preceded and had instructed me in it.

We reached our goal. There, the steep mountain widened out on either side and behind a screen of tangled trees was the semblance of a plateau, yet known to him.

Several trees (rosewood) spread their enormous boughs. The two of us, both savages, began to chop at a magnificent tree that had to be destroyed so that I could have a branch such as I desired. I wielded the ax furiously and my hands were covered with blood as I cut with the pleasure of brutality appeased, of the destruction of I know not what.

> In time with the sound of the ax I sang:
> Cut down the entire forest (of desires) at the base
> Cut out love of self from within you, just as
>     with the hand, in autumn,
> one would cut the Lotus.

All the old residue of my civilized emotions utterly destroyed. I came back serene, feeling myself another man from now on, a Maori. Together we carried our heavy burden gaily, and again but calmly this time, I could admire the graceful lines of my young friend as he walked ahead of me, lines as robust as the tree we were carrying. The tree smelled like a rose; *noa noa.*

By afternoon we had returned, tired.

He asked me: "Are you content?"

"Yes." And inside myself I said again: Yes. No doubt about it, I was at peace with myself from then on.

Every stroke of my chisel on this piece of wood brought back memories of a sweet tranquillity, a fragrance, a victory, and a rejuvenation.

Via the valley of the Punaru, the great cleft in the island, you come to the plateau of Tamanou. From there you can see the Diademe, Orohena, and Arorai.[11] The center of the island. Many people had spoken to me about it and I had decided to spend several days there alone.

"But what will you do at night? You will be tormented by the *tupapaü*. You have to be either crazy or very bold, to go and disturb the spirits of the mountain."

All of which was just what I needed to arouse my curiosity.

So one fine morning I set out. For nearly two hours I followed a path that went along the river of the Punaru, then I crossed the river again and again. The walls became more and more sheer on either side; enormous stones in the river. In order to continue, I was obliged to stay in the river almost all the time, with water sometimes up to my knees and sometimes up to my shoulders.

Between two extremely high walls the sun was hardly visible. The blue sky. You could almost make out the stars in broad daylight.

Five o'clock. The light was growing dimmer, and I was at last beginning to consider where I could spend the night when, off to one side, I saw a couple of acres of almost flat land where ferns, wild banana trees, and *bourao*.[12] grew pell-mell. Luckily a few ripe bananas.

Hastily I made a wood fire and cooked my meal, the bananas. And I lay down as best I could at the foot of a tree whose

11. The three highest Tahitian mountain peaks.

12. *Bourao*, or actually *puraü* in Tahitian, which has no letter *b*, means hibiscus, whose flowers are one of Tahiti's natural beauties.

branches, in which I had entwined banana leaves, made a shelter in case of rain.

It was cold, I was soaking wet from having made my way all day long through the cold water: I slept badly. I was afraid that wild pigs would come and chafe my legs, so I tied the rope of my ax around my wrist.

Pitch-black: impossible to see anything. Near my head a phosphorescent powder intrigued me greatly, and I smiled as I thought of those good Maoris who had earlier told me those *tupapaü* stories. Later I learned that the luminous powder was a little mushroom that grows in damp places, on dead branches like those I had used to build my fire.

At dawn the next day I got up and continued on my way.

The river, wilder and wilder, becomes more and more of a waterfall, twists more and more. Enormous crayfish look at me, seeming to say: "What are you doing here? Who are you?"

Age-old eels.

Often I am compelled to climb from branch to branch.

I reached a bend of the river I had glimpsed: description of the *Pape Moe* painting.[13]

. . . I had not made any noise. When she had finished drinking she took some water in her hands and let it run down between her breasts; then alert as an antelope [which] instinctively senses the presence of a stranger, she scanned the thicket in which I was hiding. Swiftly she dived, crying: *"Taehae!"* (ferocious). . . .

I looked quickly down to the water's bottom: she had disappeared. Only a huge eel slithered among the little stones on the bottom.

For some time I had been growing gloomy. My work suffered as a result, I hadn't enough notes and sketches. True, I had been divorced for several months. I no longer had to listen to the prattle of the *vahine* constantly asking me about the same

13. *Pape Moe (Mysterious Water),* no. 498 in the Wildenstein Catalogue.

things and myself invariably giving the same answer. I decided to spend some time taking a trip around the island.

While I was making a few light bundles of things I would need on the way and arranging all my studies in orderly fashion, my neighbor and friend Anani watched me anxiously. Finally he made up his mind to ask me if I wanted to go away. I told him no, that I was simply going to travel around for a while, that I would come back. He did not believe me and wept. His wife came to join him and told me that she loved me, that I did not need money to live there, that one day I could rest there, and, on her land near her house, she showed me a place adorned with a shrubby tree. I felt the desire to rest there forever, certain that in eternity no one would ever again bother me.

"You Europeans always promise to stay, and when we have finally grown to love you, you go away and intend to come back, you say, but you never return."

I dared not lie: "But I promise you I will be back in a few days. Later on, I'll see."

Finally I left.

TRIP AROUND THE ISLAND    Leaving the road that goes along the sea, I plunged into a thicket which goes quite far back into the mountain. Came to a little valley. There, a few inhabitants who want to live in the old way. Paintings *Matamua* and *Hina maruru*.[14]

. . . I continue on my way. When I reach Taravao (end of the island), the gendarme lends me his horse. I head for the east coast, little frequented by Europeans. When I arrive in Faaone, a little district that comes before the district of Hitia, a native hails me: "Hey, man who makes men" (he knows I am a painter), "come and eat with us!" (the hospitable phrase *"Haere mai ta maha"*).

I accept readily, his face is so gentle. I get down from the horse; he takes it and, simply and skillfully, without any servility, ties it to a branch.

14. *Matamua (In the Old Days)*, no. 467 in the Wildenstein Catalogue, and *Hina maruru (Giving Thanks to Hina)*, no. 500.

I enter a house where several men, women, and children are gathered, sitting on the ground, talking and smoking.

"Where are you going?" asked a fine-looking Maori woman of about forty.

"I am going to Hitia."

"What for?"

I don't know what idea crossed my mind. I answered: "To look for a wife. In Hitia there are a lot of women, and pretty too."

"You want a wife?"

"Yes."

"If you like I'll give you one. She is my daughter."

"Is she young?"

"*Eha* [Yes]."

"Is she pretty?

"*Eha.*"

"Is she healthy?"

"*Eha.*"

"All right, go and fetch her."

She was gone for a quarter of an hour, and while they were bringing in the meal of *maioré*, [15] wild bananas, and some shrimp, the old woman came back, followed by a tall girl carrying a little bundle in her hand.

Through the astonishingly transparent pink muslin dress, the golden skin of her shoulders and arms was visible; two swelling buds protruded from her breasts. Her charming face seemed to me different from the faces of the other girls I had seen on the island so far, and her hair grew thick as the bush and slightly frizzy. In the sunlight an orgy of chromes. I learned that she came from the Tonga Islands. [16]

When she had sat down near me I asked her some questions.

"You're not afraid of me?"

"*Aita* [No]."

15. Fruit of the breadfruit tree; it is eaten cooked and has a mealy consistency and a rather bland taste.
16. Archipelago in the Pacific Ocean, in Polynesia, colonized by England.

"Do you want to live in my hut forever?"

"*Eha.*"

"You've never been sick?"

"*Aita.*"

That was all. And my heart was pounding as she, impassively on the floor at my feet, arranged the food which had been offered me on a large banana leaf. I ate hungrily but timidly. This girl, a child of about thirteen, charmed me and frightened me: what was going on in her soul? In mine, blushing and hesitation, for this contract had been so hastily concluded and signed, and I was almost an old man.

Perhaps the mother had ordered her to come, had discussed the deal at home. And yet this tall child displayed the proud independence of the whole race, the serenity of a praiseworthy thing. The tender but mocking expression of her lips clearly showed that the danger was for me, not for her. I will not say [that] I left the house without feeling afraid. I took my horse and mounted.

The girl followed behind; the mother, a man, and two young women, her aunts, she said, also followed. We came back to Taravao, nine kilometers from Faaone.

A kilometer farther I was told: "*Parahi teie* [Live here]."

I dismounted and entered a large, very cleanly kept house, in fact, almost opulent. The opulence of earthly goods, pretty mats placed on hay on the ground. . . . A rather young couple, graceful as could be, lived there, and the girl sat down next to her mother, whom she introduced to me. Silence. We took turns drinking cool water as if it was an offering, then the young mother, moved, with tears in her eyes, asked me: "Are you good?"

Having examined my conscience, I answered, somewhat disturbed: "Yes."

"You will make my daughter happy?"

"Yes."

"In one week she must come back. If she is not happy she will leave you."

A long silence. We went out and again I rode away. The

women followed behind. On the way we met several people.

"So, you are now the *vahine* of a Frenchman? Be happy."

"Good luck."

This matter of the two mothers worried me. I asked the old woman who had offered me her daughter: "Why did you lie to me?"

The mother of Tehamana (for that was my wife's name) answered me: "The other woman also is her mother, her foster mother."

We arrived in Taravao. I returned the horse to the gendarme. His wife (a Frenchwoman) said to me (not maliciously, in fact, but without tact): "Oho! You've brought back a trollop. . . ."

And her wrathful eyes undressed the impassive girl, who had become haughty. Decrepitude looked at the new blossom, the virtue of the law blew impurely on the innate but pure immodesty of confidence and faith. And it was painful for me to see that dirty cloud of smoke on such a lovely sky. I was ashamed of my race; my eyes turned away from that filth— quickly I forgot it—to gaze on that gold that I already loved. That, I remember.

The good-bys to the family took place at Taravao, in the Chinaman's shop that sells everything, even men and beasts. My fiancée and I rode together in the public conveyance, which took us to my house in Mataiéa, twenty-five kilometers away.

My new wife was not talkative; she was melancholy and mocking. We observed each other; she was unfathomable; in this struggle I was quickly defeated. Despite all the promises I'd made to myself, my nerves rapidly got the better of me, and in no time she was able to read me like a book.[17]

. . . During the week that followed, I was "childlike" as I had never known myself to be. I loved her, and I told her so, which made her smile (she knew I did!). She seemed to love me and

---

17. Here Gauguin noted, as a theme to be expanded further: "Maori character (takes a long time to come to know it). French character."

did not tell me so. Sometimes at night flashes of light streaked the gold of Tehamana's skin. That was all. It was a great deal.

In what seemed a day, an hour, the week was up. She asked if she could go to see her mother in Faaone. I had promised.

She left and very sadly I installed her in the public vehicle with a few piasters in her handkerchief to pay for the ride and give her father some rum. It was like a farewell. Would she come back?

Several days later she came back.

I set to work again and bliss followed upon bliss.

Each day, at dawn, the light in my home was radiant. The gold of Tehamana's face bathed everything around it and both of us went naturally and simply, as in paradise, to a nearby stream to refresh ourselves.

Everyday life. Tehamana opens up more and more, docile, loving; the Tahitian *noa noa* makes everything fragrant. I no longer feel the passing of days and hours, I am unaware of Good and Evil: everything is beautiful, everything is good. Instinctively, when I am working, when I am dreaming, Tehamana keeps quiet. She always knows when she can talk to me without disturbing me.

Conversations about how things are done in Europe, about God, about the gods. I teach her, she teaches me. . . .

Everyday life. In bed in the evening, conversations. The stars interest her very much; she asks me what the morning star and the evening star are called in French. She has trouble understanding that the earth revolves around the sun. She in turn tells me the names of the stars in her language. . . .[18] She was never willing to accept the notion that shooting stars, which are frequently seen in this country and cross the sky slowly and full of melancholy, are not *tupapaüs.*

---

18. At this point Gauguin had inserted a passage from "Ancient Maori Religion" (see pp. 59–60, "Birth of the Stars").

One day I had to go to Papeete; I had promised to return that very evening. A carriage which was coming back in the evening left me halfway along the road; I had to walk the rest of the way home.

It was one in the morning by the time I arrived. I had very little lighting material in the house at the time, and my stock needed replenishing. The lamp had gone out and when I came home the bedroom was dark. I felt a sort of fear, and above all mistrust. Surely the bird had flown. I struck some matches and on the bed I saw [*Manao*] *Tupapaii*. [19]

The poor child came to herself again and I exerted myself to restore her confidence.

"Don't leave me alone again that way without light! What did you do in town? Did you go to see women, those who go to market to drink and dance and then sleep with the officers, the sailors, and everybody?"

I was invited to a wedding, a real legal wedding ceremony on a set day, the kind the missionaries have tried to impose on their new Christian converts.

Under a roof hastily erected by all the guests, stood a large table tastefully decorated with flowers and leaves. Relatives and friends attended, and there was the greatest luxury of foods to eat. Little pigs roasted whole on hot stones, great quantities of fish, *maiorés,* wild bananas, taro, etc.

The local schoolmistress (a girl who was almost white) was taking an authentic husband, an authentic Maori, a son of the Punaauia chief. The Protestant bishop, the girl's protector since she had left the religious schools of Papeete, insisted that she marry this young chief, and in a hurry. Out there, what the missionary wants, God wants.

After an hour, when everyone had eaten and drunk a great deal, the many speeches were delivered in orderly and methodical fashion, eloquently and spontaneously. It is an important

19. Gauguin noted here: "Description of the painting [*Manao*] *Tupapaii*" (see pp. 63–64).

matter to decide which of the two families involved will give the bride a new name, and often the discussion almost turns into a quarrel. But not that day; everything was calm, everyone was happy, joyous, and pretty drunk. My poor *vahine*, persuaded by some of the other women (I was not keeping an eye on her), ended up dead drunk, and I had a hard time bringing her home, a good girl but heavy.

Seated halfway down the table was the chief's wife, admirably dignified, decked out in a gown of orange-colored velvet: bizarre and pretentious, almost side-show garb. And yet the innate grace these people have, her awareness of her rank redeemed her getup. In the midst of all these flowers, these Tahitian dishes, her perfume was one of the most *noa noa*.

Near her was a hundred-year-old woman, a death mask made still more horrible by her rows of cannibal teeth, still intact. Tattooed on her cheek, a not very clearly shaped dark mark, like a letter. I had already seen tattoos but not like this one, which was surely European. (The missionaries, I am told, used to be very severe about lust and marked some women on the cheek as a warning of hell; this shamed them, not shame for the sin committed, but for the ridicule caused by a distinctive mark.) Then I understood the distrust Maoris feel today toward Europeans.

Many years had gone by between the time the old woman was marked by the priest and the girl was married by the priest. The mark was still there.

Five months later the young bride gave birth to a well-formed baby.

The parents were furious and wanted the couple to separate. The young man did not see things that way at all: "Since we love each other, what difference does it make! We are used to adopting other people's children. I adopt this one."

But why was the bishop at such pains to have the legal wedding take place in a hurry? Mischievous gossips say . . .[20]

We prefer to believe in the angel of the Annunciation.

20. Gauguin's ellipses. (Translator's note.)

For about two weeks the flies, scarce until then, had been appearing in great numbers and become unbearable. And all the Maoris rejoiced. The bonito and the tuna were going to come in from the open sea. And the people began to check their lines and hooks.

Women, children, everybody took a hand in dragging nets, or rather long barriers made of coconut leaves, along the shore and along the corals which line the bottom of the sea between the land and the reefs. In this way they manage to catch a type of small fish that the tuna are fond of eating.

The day came when they launched two large dugout canoes attached to each other; in the front there was a very long pole that could be raised up quickly, with two ropes reaching to the back. By this means, once the fish has bitten, it is immediately lifted out of the water and brought into the boat.

We have come beyond the reefs and go far out to sea. A turtle watches us go by.

We reach a place where the sea is very deep and which they call the tunafish hole: the place where they sleep at night, very deep down, sheltered from sharks.

A cloud of sea birds keeps a close eye on the tuna: when the fish rise to the surface, the birds drop to the sea and fly up again with a strip of flesh in their beaks. Carnage on every side.

When I asked why they didn't let a long line down into the tunafish hole, they answered that it was a sacred place. The god of the sea resides there.[21]

. . . The captain of the boat chose a man to throw the hook out of the canoe. For some time not one tuna was willing to bite. Another man was called. This time a superb fish bit, making the pole bend.

Four strong arms raised the pole and, with the ropes to the rear pulled taut, the tuna began to be brought to the surface. A shark jumped on its prey: a few bites and all we were bringing

---

21. Here Gauguin had inserted a passage from "Ancient Maori Religion" (see pp. 58–59, "Legend of Rua hatu").

into the boat was the animal's head. The fishing was off to a bad start.

My turn came; I was chosen. In a few minutes we caught a large tuna: a few blows with a stick on its head and the animal, shuddering in its death agony, shook the countless fiery spangles of its mirror-like body.

A second time fortune was with us: the Frenchman certainly brought good luck! They all shouted that I was a good man and I conceitedly did not contradict them. We continued fishing until evening.

When the supply of small fish used for bait was exhausted, the horizon was ablaze with the reddening sun. We made ready to return. Ten magnificent tuna overloaded the canoe.

While all was being put in order, I asked one young boy why there had been all that laughter and those whispers when my two tuna were being brought into the canoe. He refused to explain it to me but I insisted, knowing how little resistance the Maoris have, how weak they are when you really urge them. So he told me that when the fish is caught by the hook in the lower jaw, this means that your *vahine* has been unfaithful while you have been away fishing. I smiled, incredulous. And we came back.

The tropical night passes swiftly. Twenty-two vigorous arms drove the paddle into the sea while the men shouted in rhythm, to spur themselves on. Our wake looked like cut glass; it was phosphorescent and I felt as though we were taking part in some mad race, followed by the mysterious spirits of the ocean and the curious fish which accompanied us, whole schools leaping at the same time.

After two hours we reached the entrance to the reefs, where the waves break with all their strength. A dangerous place to go through because of the surf. This requires turning the prow of the canoe neatly to the wave; but the natives are skillful and although I watched somewhat fearfully, they carried out the maneuver very well.

Before us, the shore, lighted by flickering fires (huge

torches made of dry coconut tree branches). The sea, the land lighted by those fires, and the families waiting; some people sitting motionless; others, the children, jumping about and shrieking countless shrill cries. A vigorous thrust of the canoe, which climbed onto the sand.

Our entire haul is laid out on the sand. The captain cuts it up in pieces. Equal portions [depending on] how many people, women and children included, have taken part in the fishing, both for tuna and for the small fish. Thirty-seven portions.

Immediately afterward my *vahine* took the ax, split wood, and built a fire while I washed and put on something to fend off the coolness of the night. My portion of fish cooked. Hers raw.

A thousand questions. Things that had occurred during the fishing. Came time to go to bed. One question was eating me up. What was the use? What good would it do?

At last I asked it: "Have you been a good girl?"

"*E[ha].*"

"And was your lover today a good one?"

"*Aita.* . . . I didn't have a lover."

"You lie. The fish spoke."

Over her face came a look I had never seen before. Her expression was prayerful. I went along with her and her faith in spite of myself. There are times when warnings from on high are useful.

Contrast between the religious, superstitious faith of this race and the skepticism of our civilization.

Softly she closed the door and prayed out loud. ". . . Keep me from coming under the spell of bad behavior. . . ." That night I almost prayed.

When she had finished praying she came up to me with resignation and said, tears in her eyes: "You must beat me, strike me many times."

At sight of this resigned face, this marvelous body, I was reminded of a perfect idol. May my hands be cursed forever if they flagellated a masterpiece of creation. Seen like that, naked, she seemed to be covered by the orange-yellow garment of

purity, the yellow robe of Bhiksu.[22] Beautiful golden flower, fragrant with Tahitian *noa noa,* whom I adored both as an artist and as a man.

"Strike me, I tell you, otherwise you will be angry for a long time and you'll get sick."

I kissed her and my eyes spoke Buddha's words: Gentleness overcomes anger; good overcomes evil; truth overcomes lies.

It was a night of tropical sweetness. And morning came, radiant.

My mother-in-law brought us some fresh coconuts.

She looked questioningly at Tehamana. She knew.

Shrewdly she said to me: "You went fishing yesterday. Did all go well?"

I answered her: "I hope to go again soon."

I had to return to France: pressing family duties called me back there. Good-by, hospitable land. I was going away two years older, feeling twenty years younger and more barbarian, yet having learned more.

When I left the quay to go aboard, Tehamana, who had cried for several nights and was now weary and melancholy, was sitting on the stone; her legs dangled and her wide, sturdy feet skimmed the surface of the salty water. The flower she had been wearing at her ear had fallen, faded, into her lap.

Here and there other women too looked as in a daze at the heavy smoke from the ship that was taking us all away, ephemeral lovers. And from the ship's gangplank we could see, through our binoculars, that on their lips was this old Maori oration:

Gentle breezes from the south and the east, you who meet to play and caress one another above my head, hurry to the other island together: there you will see the man who abandoned me, sitting in the shade of his favorite tree. Tell him you have seen me in tears.

22. The saffron-colored robe of Buddhist monks; Bhiksu = Buddha.

# *"In Two Latitudes"*

On the other side of the earth, at latitude 17° S, the nights are all beautiful. The Milky Way is a streak in the great valley and worlds move slowly across the heavens; their trajectory cannot be explained, for the silence remains. They are geniuses, say the barbarians. These geniuses are not prophets, they are looking for another country.

Around the island the infinitely tiny creatures have built a gigantic barrier: the waves that batter this wall do not bring it down, but flood it with phosphorescent spray. Vaguely I watched these scrolls and curls edged with green lace, but my thoughts were far away, unaware of time: the notion of time fades into space on such nights. I also heard them orchestrate a monotonous chant into the beats of a drum. Dreaming like that I am hardly disturbed by the neighing of a rutting horse, a suffering animal. Why should I care, I'm becoming selfish.

. . . At latitude 47° N, in Paris, I think: there are no more coconut trees, sounds are no longer musical. Town houses, boulevards, hovels too, mean streets with slippery sidewalks on which prostitutes and *alphonses*[23] walk. Surely you know the Rue Rochechouart: d'Harcourt has a music hall there. D'Harcourt is a patron of the arts, I'm told. One morning, when an appoint-

23. *Alphonses:* pimps (expression borrowed from *Monsieur Alphonse,* a comedy by Alexandre Dumas fils).

ment had been arranged, I walk through a great hall with not a soul in it: bare benches, question marks, which are really double basses. And I pass under an imposing organ as I enter d'Harcourt's office. What am I going to say? I believe in art, that is enough. My very inadequate name, my not very prepossessing face, my buttonhole that has no ribbon in it;[24] this is very little. But I believe in art; this is everything. I wanted to have an opinion on a symphony written by my friend Molard, a musician in whom I have faith because he has talent, an individual talent that makes no concessions.

When I had finished naïvely reciting my little speech, I listened to Monsieur d'Harcourt:

"Is your friend famous? Has he won the Prix de Rome? Why does he not come here himself? My opinion, you see, is that you don't know how to write unless you've already worked for disreputable places, the cabarets, the dives. If you really want to know your business, you have to hear your music played by a cornet. Especially a cornet that plays off-key."

And he laughed loudly and longly. I, who do not know how to laugh, tried to smile so that I would seem able to appreciate a joke: the smile of a man who does not understand! the smile of a fool, surely. Why did Bhiksu come to my mind just then? Because he says: "You waste a century when you remain five minutes in the company of a fool." The moment was drawing near when I would have to withdraw, so as not to waste Monsieur d'Harcourt's precious time.

Before leaving I tried to utter a few silly sentences, silly because useless:

"I thought, Monsieur d'Harcourt, that in order to discover geniuses, one had to go looking for them, like Liszt imposing *Lohengrin*[25] on the entire world. But Liszt was a musician. I also thought that those who work for cabarets were born for that. On the other hand, doesn't it seem to you that those who respect

24. Allusion to the ribbon of the Legion of Honor, which opens many doors in France.
25. Liszt's piano transcription of Wagner's opera.

art are born to create works of art, always, in spite of themselves?"

Monsieur d'Harcourt wanted to have the last word. At the end he said to me: "If Wagner were to come along now, he would be a flop, and I don't have any desire to have flops with new people. It costs too much, and *Le Figaro,* the great *Figaro,* would give me a bad time, as it has already done in the past."

Out in the street, the sewers stink, and yet I breathe better: it seems to me I am different from the way I was a while ago. As I go down the boulevard I say to myself, Suppose we go once again to latitude 17°?

There, all the nights are beautiful.

—Essais d'Art libre, *May 1894*

**TO SCHUFFENECKER**  You know how my life thus far has been one of struggle, of extreme suffering that many people would not have survived. Believe me, the goal I have reached, lofty though it may seem because of my strength and my talent, is actually far below the one I had dreamed of, and I suffer as a result, though in silence. I have not had enough time or pictorial education: hence a definite obstacle in carrying out my dream. Glory! what a vain word! what a vain reward!   LETTERS

Ever since I experienced the simple life of Oceania, I can think of only one thing: living far away from other people, consequently far away from glory. As soon as possible I'll go bury my talent among the savages and no one will hear of me again. In many people's opinion that will be a crime. Why should I care! crime is often very close to virtue. To live simply, without vanity—that is what I will do, at all costs; my reason and my temperament order me to do so.

. . . I dare not tell you not to abandon painting since I am thinking of abandoning it myself so as to live in the woods and carve imaginary beings on the trees. . . . Whoever wants any consolation must seek it among the simple creatures and reject all vanity. And although I have a good brain, I hope that eventu-

ally I will be able to stop thinking and simply live, love, and rest. The Europeans are unremittingly hostile to me; those good savages will understand me.    —*July 26, 1894, Pont-Aven*

TO WILLIAM MOLARD    . . . In December I'll come back and every day I'll work at selling everything I own, either all at one "go" or partially. Once I have that capital, I'll leave for Oceania again, this time with two comrades from here, Séguin and an Irishman.[26] Don't bother lecturing me about it. Nothing will keep me from leaving, and when I leave it'll be forever. What a stupid existence Europeans live. . . .

—*Undated, September 1894, Pont-Aven*

TO MONFREID    . . . I have definitely resolved to go live forever in Oceania. I'll come back to Paris in December for the sole purpose of selling all my stuff at whatever price I can get. (Everything.) If I succeed I'll leave right away—in February. Then I'll be able to spend the rest of my life free and easy—without worrying about tomorrow and without having to struggle all the time with imbeciles. Good-by painting, except as an amusement. . . .    —*September 20, 1894*

TO AUGUST STRINDBERG    *Editor's note: Gauguin had asked the Swedish writer, who often came to his evenings at 6 Rue Vercingétorix, to write a preface to the catalogue for the sale he held at the Hôtel Drouot, on February 18, 1895, before his new departure for Oceania. Strindberg answered him with a refusal: "I cannot love your exclusively Tahitian art." In place of the habitual preface, Gauguin inserted Strindberg's letter, followed by his own reply:*

I received your letter today; your letter which is a preface for my catalogue. I thought of asking you for that preface the other day, when I saw you playing the guitar and singing in my studio. Your Nordic blue eyes looked attentively at the paintings

---

26. Ultimately, neither Armand Séguin nor the Irishman, Roderic O'Conor, went.

hanging on the walls. I felt stirrings of rebellion: a whole clash between your civilization and my barbarism.

Civilization from which you suffer. Barbarism which for me is a rejuvenation.

Seeing Eve as I choose to paint her, using shapes and harmonies of another world, your most vivid memories may have evoked a painful past. The Eve of your civilized conception makes you and almost all of us in fact misogynists. The ancient Eve who frightens you in my studio might well smile at you less bitterly one day.

. . . The Eve whom I have painted (and only she) can logically remain naked before your eyes. Your Eve, in that natural attire, would not be able to walk without immodesty, and, too beautiful (perhaps), would conjure up evil and pain.

To make my thoughts clear to you, I will no longer compare these two women directly; instead I will compare the Maori or Turanian[27] language, which my Eve speaks, with the language spoken by the woman you have chosen among all others, an inflected language, a European language.

In the languages of Oceania, with their essential elements preserved in all their primitiveness, isolated or welded together without any thought for polish, everything is naked and primeval. Whereas in inflected languages, the roots from which they sprang, as did all languages, have disappeared; daily use has worn away their ruggedness and their contours. Such a language is a perfect mosaic; you can no longer see where the more or less roughly assembled stones are joined; you merely admire a beautiful painting in stone. Only a practiced eye can discern the construction process.

Excuse this long digression on philology; I think it is necessary to explain the savage kind of drawing I have had to use in order to decorate a Turanian country and Turanian people.

—*Undated, February 5, 1895, Paris*

27. Gauguin may have confused Tourane, now known as Da Nang, in South Vietnam, with the Turanian or Ural-Altaic languages.

# *"About Sèvres and the Latest Kiln"*

. . . I see in the newspapers that they have just inaugurated a new kiln at Sèvres—another kiln! Messrs. Poincaré and Roujon were there; it was a baptism, a solemn occasion.

. . . And so Sèvres, which has done so much, has it not, for ceramic art, goes on. How many people realize that the famous porcelain works, with all its kilns, is far behind the individual porcelain-makers? How many people realize that approximately eight years ago, only Chaplet could do really successful glazes? In those days (if I may be allowed to indulge in this personal memory) I had glimpsed the possibility of giving the ceramic art new impetus through the creation of new handmade shapes. I worked to carry out this idea; Chaplet, who is a superlative artist —"the equal of the Chinese," as Bracquemond has so rightly said—understood me and found my experiments worthwhile, in spite of the inevitable groping. Carriès came to my studio at that time and examined them at length.

My goal was to transform the eternal Greek vase (which today has been complicated by Japanism and Christophle-style goldsmithing), to replace the potter at his wheel by intelligent hands which could impart the life of a face to a vase and yet remain true to the character of the material used, obeying the laws of gobine geometry.[28]

28. Gauguin used the term *"géométrie gobine,"* probably from *"gobin,"* a rarely used colloquialism meaning hunchbacked, deformed (Latin *gibbus;* Italian *gobbo*).

Albert Aurier wrote in this connection that I molded "more soul than clay," and I accepted that praise for my intention, if not for my work. Chaplet had long since opened wide his door to artists. Unfortunately, the modern sculptors' nimble fingers too often aggravated the potter's work by adding ornaments. Nudes, cherubs, garlands, and still more miniature women, as if they were being made of stone, or bronze, or pewter. Really, one could have hoped for something better, and because it lacked individuality, the production of French artists suffered by comparison with the Chinese glazes, which were mere child's play for Chaplet.

A few years later brought a sudden and excessive infatuation, originating who knows where, for high-fired works, and Carriès, Dalpayrat, and so many other Japanists triumphed at the Champ de Mars. A triumph enshrined by the Luxembourg.

Whereupon, what did Sèvres do? Sèvres went along, as people say nowadays; Sèvres imitated the initiators without acknowledging their names; Sèvres vulgarized imperfect creations, and did not create anything of its own. And that is why they are adding more and more kilns!

Ah, dear sir, what a great man Monsieur Roujon, director of the Beaux-Arts, would be if he was not content to do no more than baptize official kilns! Could he not, as director, go and visit the studios of the art industry? Should he not strive to find talent wherever it is, far from the official spheres? Now, outside those spheres, it is true, you do sometimes find revolutionaries. But what of it? In art, there are only two types of people: revolutionaries and plagiarists. And, in the end, doesn't the revolutionary's work become official, once the State takes it over?

—Le Soir, *April 25, 1895*

# "Interview with Paul Gauguin"

**by Eugène Tardieu**

Here is the fiercest of the innovators, the most intransigeant of the "misunderstood." Several of the people who discovered him have since dropped him. The majority consider him nothing but a practical joker. He meanwhile, very serenely, goes on painting orange flowers and red dogs, making his so very personal manner still more personal every day.

Powerfully built, with graying curly hair, and an energetic face with light eyes, he has his very own smile—very gentle, modest, and somewhat scoffing.

"Copying nature—what is that supposed to mean?" he asks me with an abrupt challenging gesture. "Follow the masters! But why should one follow them? The only reason they are masters is that they didn't follow anybody! Bouguereau spoke to you about women who swear rainbows, he denies blue shadows; you can deny his brown shadows, but his work doesn't sweat at all; he's the one who sweated producing it, the one who sweated to achieve a result that photographers achieve much better, and when you sweat, you stink; he stinks of platitude and impotence. Besides, who cares whether or not there are blue shadows; if some painter, tomorrow, wanted to see pink or purple shadows, no one would have a right to demand explanations from him so long as his work was harmonious and thought-provoking."

"So, what about your red dogs, your pink skies?"

"They are absolutely deliberate! They are necessary, and everything in my work is calculated, mulled over at great length. It's music, if you like! I borrow some subject or other from life or from nature, and, using it as a pretext, I arrange lines and colors so as to obtain symphonies, harmonies that do not represent a thing that is real, in the vulgar sense of the word, and do not directly express any idea, but are supposed to make you think the way music is supposed to make you think, unaided by ideas or images, simply through the mysterious affinities that exist between our brains and such arrangements of colors and lines."

"Now, that's rather new!"

"New!" cried Monsieur Gauguin, warming to his subject, "not at all! None of the great painters has ever done anything else! Raphael, Rembrandt, Velázquez, Botticelli, Cranach—they all deformed nature. Go to the Louvre, look at their paintings; no two are similar. If one of them is on the true path, then, according to your theory, all the others are wrong—or else they've all been making fools of us!

"Nature! Truth! You don't find them in Rembrandt any more than you do in Raphael, in Botticelli any more than in Bouguereau. Do you know what will soon be the ultimate in truth?—photography, once it begins to reproduce colors, and that won't be long in coming. And yet you want an intelligent man to sweat for months so as to give the illusion he can do something as well as an ingenious little machine can! It's the same thing in sculpture; perfect casts can be made from nature; a man who is clever at casting will make you a Falguière statue as easy as can be, whenever you want!"

"In other words, you do not accept being labeled a revolutionary?"

"I find that ridiculous. Monsieur Roujon pinned that label on me. My answer to him was that all the people involved in art who have done something different from what their predecessors had done deserved the same label, and it is those people who are the masters. Manet is a master, Delacroix is a master. When they first began, their works were called abominations;

people laughed their heads off over Delacroix's purple horse. I've looked everywhere in his work for that purple horse but in vain. But that's the way the public is. I am perfectly resigned to being misunderstood for a long time. If I did what has already been done, I would be a plagiarist and would consider myself unworthy; so I do something different and people call me a scoundrel. I'd rather be a scoundrel than a plagiarist!"

"Many people of sound judgment think that the Greeks having achieved ideal perfection and pure beauty in sculpture, and the Renaissance having done the same in painting, all one need do is copy those models: they even say that the plastic arts have already said everything they have to say."

"That is absolutely wrong. Beauty is eternal and can express itself in a thousand different ways. The Middle Ages had one type of beauty, Egypt had another. The Greeks were looking for the harmony of the human body. Raphael had models who were very beautiful, but it is possible to produce a very beautiful work with a thoroughly ugly model. The Louvre is full of works like that."

"Why did you go to Tahiti?"

"I had once been captivated by that virgin land and its primitive and simple race; I went back there, and I'm going to go there again. In order to produce something new, you have to return to the original source, to the childhood of mankind. Eve, as I see her, is almost an animal; and this is why she is chaste, though naked. All those Venuses on exhibit at the Salon are indecent, hatefully lascivious. . . ."

Monsieur Gauguin suddenly stopped speaking. His face, with a faint expression of ecstasy, was turned toward a canvas on the wall showing Tahitian women in a virgin forest.

"Before I leave," he went on, after a few seconds, "I am going to bring out a book, with my friend Charles Morice, that will tell about my life in Tahiti and the way I feel about art. Morice comments in verse on the works that I have brought back from there. That will explain to you why and how I went there."

"What is the book's title?"

*"Noa Noa,* which, in Tahitian, means fragrant. It will embody the scent that Tahiti gives off."

<p align="right">—L'Echo de Paris, <em>May 13, 1895</em></p>

# Second Stay in Oceania

*Editor's note: Gauguin returned to Tahiti on July 3, 1895.*

TO WILLIAM MOLARD   How I pity you for not being here. I am sitting quietly in my hut. In front of me is the sea, and Mooréa, which takes on a different aspect every quarter of an hour. A *paréo*[1] and that's all. No such thing as suffering from heat or cold. Ah, Europe! . . .

Great political activity in Tahiti at this time. As you know, or maybe you don't, since 1890 three islands had been in a state of rebellion, claiming the right to govern themselves: Huahiné, Bora-Bora, and Raiatéa. Monsieur Chessé came out here to bring the stray children back into the fold. Two of them gave in, and the warship took part in the reconciliation festivities, along with four hundred Tahitians, all the authorities, and myself. Believe me, we talked, yelled, and sang throughout four extraordinary days and four extraordinary nights of celebrations, just like Cythera. You in France can't begin to imagine what it's like. Now there remains only to conquer Raiatéa, and that's another matter, because it will be necessary to fire the cannon, to burn, and to kill. A matter of bringing civilization to them, I am told. I don't know whether I'll witness the battle, out of curiosity; I admit that I am tempted to. But, on the other hand it sickens me. . . .[2]                    —*October 1895, Tahiti*

1. The native loincloth which goes from the waist to the knee.
2. See p. 121–22.                                                              **115**

TO MONFREID    I have just received your amiable letter and at this time I have not yet so much as touched a brush, except for doing some stained glass in my studio. I had to stay in temporary quarters in Papeete while making a decision, which was, finally, to have a big Tahitian hut built out in the country. It's beautifully located, I must say, in the shade, by the side of the road, and behind me there is a gorgeous view of the mountain. Just picture a large sparrow cage made of bamboo grillwork and having a coconut-thatch roof, divided off into two parts by the curtains from my old studio. One of the two parts makes a bedroom, with very little light, so as to keep it cool. The other part, with a large window up high, is my studio. On the floor, some mats and my old Persian rug; and I've decorated the rest with fabrics, trinkets, and drawings.

As you can see, it's not such a bad life for the moment. Every night frenzied young girls invade my bed; last night I had three of them to function with. I'm going to stop leading this wild existence and install a serious woman in the house and work like mad, especially as I feel in tiptop shape and I'm sure I'm going to do better work than before.

. . . Look at what I've done with my family: I've skipped out without any warning. Let my family get out of the mess on their own, because if I'm all they've got to help them, well . . . ! I firmly intend to end my days here in my hut, altogether peacefully. Oh yes, I'm a great criminal. So what! So was Michelangelo; and I'm not Michelangelo. . . .    —*November 1895, Tahiti*

TO SCHUFFENECKER    I arrived after a rather long and tiring voyage. Now that I've just finished my hut and my studio, I can begin to take it easy, and although I haven't touched a brush in a long time, my mind and my eye have been hard at work. This period of rest, or to put it more accurately, the physical fatigue of the voyage, with my eyes staring dully at the sea, has strengthened my determination to die here and has also paved the way for my artistic work. I feel that I'm going to be able to produce something positive from now on.

Some people may say it was criminal of me to run away. Well, for a long time I argued with myself over what I should do, and always reached the same conclusion: flight, isolation. I'm getting no mail at all, not a single note, not to mention a banknote. Every time the mail boat arrives, I hope—in vain. . . .                    —*December 6, 1895, Tahiti*

TO MONFREID   . . . You must admit that my life is very cruel. During my first stay in Tahiti I made tremendous efforts. . . . And what did I arrive at? A complete defeat. Enemies and nothing else, bad luck pursuing me relentlessly all my life; the further I go, the further down I go. . . . I have just done a canvas. . . . What's the point of sending this canvas when there are so many others that don't sell and just make people howl? This one will make people howl even louder.[3]

    . . . I'm living on 100 francs a month, I and my *vahine,* a girl of thirteen and a half: that's not much, as you can see, and out of it I must pay for my tobacco, and soap, and a dress for the girl, 10 francs worth of finery every month. And you should see what I'm living in! A thatch house with a studio window; two coconut tree trunks carved like native gods, flowering shrubs, a little shed for my wagon and a horse.

    . . . Lots of people always manage to find protection because they are known to be weak and they know how to ask. No one has ever protected me because people think that I am strong and also because I have been too proud. Today I have fallen low, I am weak and half worn out by the merciless struggle that I had undertaken. I go down on my knees and put all pride aside. I am nothing but a failure. . . .       —*April 1896, Tahiti*

TO SCHUFFENECKER   . . . To youth, though I may not have taught it anything, I have given freedom, so to speak. Thanks to my audacities, everyone today dares to paint without copying na-

3. This was the painting called *Te arii vahine (The Noble Woman),* no. 542 in the Wildenstein Catalogue.

ture and they all benefit from this and they all sell their things alongside mine because, once again, everything seems comprehensible, compared with the things I do. . . .

—*April 10, 1896, Tahiti*

TO MONFREID  . . . I am writing you because an officer is going to France this month and is taking with him some of my canvases, very clumsy ones, because of the condition I'm in; but I have a temperament that makes me want to do a canvas all at one go, feverishly. Whereas working an hour a day . . . Well, such as they are, I am sending them to you. They may be good; so much suffering and anguish have gone into them that that may make up for the awkward way they were executed. Mauclair says I am revoltingly vulgar and brutal. What iniquity. . . .

—*July 13, 1896, Tahiti*

TO MONFREID  . . . Schuff. [enecker] has just got up a petition, which I think will be useless, to have the State come to my aid.[4] That is the kind of thing that offends me more than anything else. I ask friends to help me while I wait to receive the money that is due me, and to make efforts to collect it for me, but I have never had any intention of begging from the State. All my struggles to succeed outside the official channels, and the dignity that I have striven to keep all my life—all this is now meaningless. As of today I am nothing but a blatant intriguer, whereas if I had given in, why yes, I'd now be living on easy street. Really, this is one more trouble that I did not expect to have. . . .

—*August 1896, Tahiti*

TO ALFRED VALLETTE (editor of the *Mercure de France*)  I am in a colonial hospital to heal my foot, which is in very bad shape once again. From that hospital I am writing to thank you, first of all, for

---

4. It had been Schuffenecker's own idea to take the unfortunate initiative of drafting a petition to the government so that it would deign to come to Gauguin's assistance. Among those who signed it were Puvis de Chavannes, Edgar Degas, Stéphane Mallarmé, Octave Mirbeau, and Eugène Carrière.

sending me the *Mercure*. When I read your review each month I forget the isolation in which I live, and although I am not up-to-date on the gossip in political circles and on the boulevards (for which I have no use), I take great pleasure in keeping up-to-date with the work of the intellectual world.

. . . Let me make a comparison and ask you a question: What do you think of a body of work whose admirers include such men as Degas, Carrière, St.[éphane] Mallarmé, J.[ean] Dolent, Alb.[ert] Aurier, Remy de Gourmont, while its antagonists are nonentities like Camille Mauclair?

This is to tell you that between such subtle, scholarly pieces of literary criticism as those of Viélé-Griffin, de Gourmont, and others, and the art criticism of Camille, there is such a gap that I do not understand the *Mercure,* which is so enlightened in all matters. The *Mercure*'s paying readers include as many painters as men of letters. That Mauclair should write criticism for the *Revue des Deux Mondes* or the *Journal de la Mode,* that I can understand, but in the *Mercure*! I am not saying this because in every issue, at every painting exhibition, he knocks me. Oh no! as I said above, Degas's admiration and that of some others is enough for me. But because without rhyme or reason, without any of the knowledge you need in order to judge painting, he says bad things about everything that has the courage to express an idea, everything that is not official, not the "salon" type of work. . . . To hear him tell it, any writer who is not a graduate of the [Ecole] Normale is a vainglorious ignoramus, etc. But rest assured, Mauclair is there, watching over artistic security: "Who are you? Citizen, you whom the young people unjustly hail, show your passport. Are you a graduate of the Ecole? Back, you proud creature, who won't do things as others do them. . . ." Believe me, my dear Editor (and it is as a shareholder that I am saying this), Mauclair does not belong on the *Mercure.*

I must add that for me Tahiti is still charming, that my new wife is named Pahura, that she is fourteen and very debauched, but does not seem so—for want of some point of comparison

with virtue. And, finally, that I continue to paint revoltingly
vulgar pictures. . . .                                        —*July 1896, Tahiti*

TO MONFREID   . . . I am beginning to get better and have taken
advantage of that to get a lot of work done. Sculpture. I place
it everywhere, all over the grass. Clay covered with wax. First of
all a female nude, then a superb imaginary lion playing with its
cub. The natives, who have never seen wild animals, are as-
tounded.

[Now] the priest, of course, did everything he could to
make me get rid of the female nude, which doesn't have any
clothing. The law laughed in his face, and I told him in no
uncertain terms to go to hell. Ah! if I only had what is owing to
me, my life would be extraordinarily calm and happy. I'm soon
to be the father of a half-caste; my charming Dulcinea has de-
cided to lay an egg. My studio is very handsome and I can assure
you time goes by quickly. Believe you me, from six in the morn-
ing to noon I can do a lot of worthwhile work. Ah, my dear
Daniel! what a pity you have not tasted this Tahitian life; you
would never want to live any other way.

                                                    —*November 1896, Tahiti*

# A Letter to Charles Morice

. . . France has sent a ship here, the *Duguay-Trouin,* as well as a hundred and fifty men from Nouméa who came on *L'Aube,* a warship stationed there. All this so as to take the supposedly rebellious Leeward Islands[5] by force. When Tahiti was annexed, they refused to be part of the annexation. Then one fine day, the Negro, Lacascade, governor of Tahiti, decided to pull a fast one and cover himself with glory. He sent a messenger, to whom all powers had supposedly been given, who landed at Raiatéa and immediately went to find the chief and promised him the moon and the stars. Along with other chiefs, this chief yielded to reason and came down to the beach to board the warship. As soon as the natives set foot on the beach, the warship, which had orders from Governor Lacascade to take them, lowered armed boats and pointed its muffled cannon toward shore. The natives, who have very keen eyesight and are very mistrustful, figured out what was going on and beat an orderly retreat. The landing troops were greeted by rifle shots and had to return hastily to the ship. Several sailors and an ensign were left dead on the battlefield. Since then the natives have calmly continued plying their trade, but have refused to let the French move freely about the island, allotting them only a fairly narrow strip of land. . . . [In] August 1895,[6] Chessé, the general com-

5. Leeward Islands: Raiatéa, Bora-Bora, Huahiné, Tahaa. (Gauguin's note.)
6. See p. 115, the letter written to William Molard in October 1895.    **121**

missioner, came to Tahiti, having promised the French governor that he would get the better of the rebels through simple persuasion. This cost the colony, which is already overburdened with expenses, a hundred thousand francs. Chessé, a duck spreading its wings, sent messenger after messenger and gave the native women presents—red balloons, little music boxes and other toys (God's truth, I'm not making it up)—and recited a lot of nonsense from the Bible. Nothing tempted the women, despite all the lies. Chessé went away, completely defeated by savage-style diplomacy. At present, all available soldiers, plus Tahitian volunteers enrolled here, are in Raiatéa. After an ultimatum was sent on the twenty-fifth, they opened fire on January 1, 1897. This has not had much effect in the past two weeks, as the mountains can hide the inhabitants for a long time.

You could make a nice newspaper article (the idea seems original to me) out of Paul Gauguin interviewing a native before the action begins:

Q: "Why don't you want to be governed by the French laws, the way Tahiti is?"

A: "Because we have not sold out, and also because we are very happy governed the way we are, with laws suited to our nature and our land. As soon as you move in somewhere, everything belongs to you, the land and the women, whom you leave two years later with a child on their hands that you don't care about. Everywhere there are officials and gendarmes whom we constantly have to ply with little presents, or else we are harassed in countless ways. If we have to take even a short trip connected with our trade, we are forced to waste several days waiting for an incomprehensible piece of paper and going through countless formalities. And since all that is very costly, we would be burdened with taxes which the natives have not the means to pay. We have a long acquaintance with your lies, your fine promises. Fines and jail as soon as anyone sings or drinks, and all that so as to give us so-called virtues that you don't practice yourselves. We all remember how the Negro servant of Papinaud, the governor of Tahiti, used to break into homes at

night to rape the girls. And no way of taking action against him because he was the governor's servant! We like to obey a chief, but we do not like to obey all these officials."

Q: "But now if you don't give in and ask for mercy, the cannon will get the better of you. What do you hope for?"

A: "Nothing. We know that if we surrender, the most important chiefs will be sent to the penitentiary in Nouméa and since, for a Maori, it is a disgrace to die far from his own land, we prefer to die here. I am going to tell you something which will simplify everything. As long as you French and we Maoris are side by side, there will be trouble, and we do not want trouble. Therefore, you must kill all of us, then you will argue among yourselves, and that will be easy for you, with your cannons and your guns. Our only defense weapon is to flee into the mountains every day." (That was the answer that was given at the time of the ultimatum.)

My dear Morice, you can see what a neat interview this could make, the whole thing in the very simple language that a native would use.

If you manage to have the article published by a newspaper, send me a few copies. I'd like to show a few skunks over here that I've got some clout. Of course my name would have to appear, in order for it to carry some weight.

Let's get to work.[7]                              —*January 1897*

[POSTSCRIPT]

It is a pity that we don't know more results of the expedition, but it has only just begun; in any case, the hospital already harbors ten wounded soldiers who were sent on the twelfth.

Speaking of hospitals, I have just tried to enter one for some treatment. The people in charge there insulted me in every way, and after many efforts, and in exchange for the sum

7. Charles Morice polished the wording of this "interview" and inserted it right in the middle of excerpts from *Noa Noa* (rewritten by him), which he published, in the *Revue blanche* of November 1, 1897, pp. 183–84, under the simple title: "Note."

of 5 francs a day, do you know what they gave me? An entry permit with the word "Pauper" on it. You will easily understand that, although in great pain, I had to refuse to go in with a mixed lot of soldiers and servants. Besides, here, as in France, there is a faction that considers me a rebel, and, like everywhere else, in fact here more than elsewhere, a man in financial straits is ill-treated. Of course I am talking only about the Europeans in Papeete, because here in my part of the island the natives are, as always, very good to me and very respectful.

LETTERS    **TO MONFREID**  . . . Concerning canvases exhibited and the forth-coming exhibition that you mention (schism by the Independents), I would like to say that I am not at all in favor of exhibitions. That idiot Schuff. [enecker] dreams of nothing but exhibitions, publicity, etc., and doesn't realize that they have a disastrous effect. I have many enemies and I am fated always to have a good many, in fact more and more of them; and every time I exhibit my work, it arouses them and they all begin to yelp and discourage art lovers by wearing them out. When all is said and done, the best way of selling is by keeping quiet, while working on the art dealers.

. . . I do not thirst after glory and luxury, all I ask is to live in peace here in my adorable corner of the world. If ever you are free, if your mother happens to die, then I would strongly advise you to come here with an income of 200 francs a month. Life is so serene, so propitious to artistic work, that it would be folly to look for any other way of life.

*—February 14, 1897, Tahiti*

**TO MONFREID**  . . . Whatever you do, don't let Schuff. [enecker] go ahead and stick me in an exhibition along with Bernard, Denis, Ranson and Co. That would just give the critic from the *Mercure* a chance to say that it's Cézanne and van Gogh who are really the promoters of the modern movement. No, you see, exhibitions don't do me any good; I just get told off unfairly and am lumped in with anybody and everybody.

*—March 12, 1897, Tahiti*

TO MONFREID . . . I haven't a cent left and no one will give me credit any more, not even the Chinaman who sells bread. If I could walk, I'd go off for days into the mountains looking for something to eat, but no, I can't even do that! I was wrong not to die last year; that would have been better, but now it would be stupid. Yet that is what I will do if I don't receive anything in the next mail. . . . This is no way to live and it actually prevents me from getting better. . . .         —*August 1897, Tahiti*

TO MONFREID . . . Without a dealer, without anyone to find me a year's supply of grub, what's to become of me? I don't see any way out except Death, which solves all problems. . . . My trip to Tahiti was a mad adventure, but sad and miserable it has turned out to be. . . .         —*September 10, 1897, Tahiti*

TO MONFREID . . . Since my paintings are unsalable, let them go on being unsalable. A time will come when people will think I am a myth, or rather something the newspapers have made up; and they will say: "Where are those paintings?" The fact is that there are not even fifty of them in collections in France.

. . . Always keep your eye on the Persians, the Cambodians, and to a small extent the Egyptians. The big mistake is Greek art, no matter how beautiful it is. . . .   —*October 1897, Tahiti*

TO MONFREID . . . I think that everything has been said about me that should have been said and also everything that should not have been said. All I desire is silence, silence, and more silence. May I be allowed to die in peace, forgotten, and, if I must live, may I be left even more in peace and forgotten. What difference does it make whether I am Bernard's pupil or Sérusier's! If I have done beautiful things, nothing will tarnish them; if what I've done is shit, then why go and gild it, why lie to people about the quality of the goods? In any case, society will not be able to reproach me for having taken a lot of money out of its pocket through lies. . . .         —*November 1897, Tahiti*

# "Miscellaneous Things"

*Editor's note: In 1895 Gauguin had taken with him to Tahiti the illustrated manuscript of* Noa Noa, *now in the Cabinet des Dessins of the Louvre. There were still a number of blank pages in it. From time to time between 1896 and January 1898 he wrote down his thoughts on these pages. His biographers have quoted some of them, but most have never been either printed or reproduced in a facsimile edition. Thanks to an exceptional permission granted by the authorities in charge of the French National Museums, I can give some of them here.*[8]

My God, what childish things will be found in these pages, written either for personal entertainment or for the sake of classifying favorite if somewhat foolish ideas, rather than trusting a poor memory, and so many rays reaching to the vital center of my art. But if a work of art were a work of chance, all these notes would be almost useless.

I don't think it happens like that at all. I believe that the line of thought which has guided my work, or part of it, is very mysteriously linked to a thousand others, either my own or those heard from other people. For a few days my thoughts wander, I remember lengthy studies, often sterile, still more often disturbing; a black cloud comes and darkens the horizon, confusion reigns in my soul and I am incapable of making a

---

8. I have taken the liberty of shifting certain passages from "Miscellaneous Things" (Diverses choses) and inserting them in other writings, which the reader will find farther on, because they complement them.

choice. If at other times of bright sunlight, with a lucid mind, I was drawn to such-and-such a fact, such-and-such a vision, such-and-such reading, must I not step back a bit to recall it? I think man is inclined to playfulness at certain times, and childish things are far from detracting from serious work; they imbue it with gentleness, gaiety, and naïveté. In our day people begin to weary of analysis carried to an extreme; and simplicity, which is inherent in a great nobleman, cannot be understood by a bourgeois. Machines have come, art has gone; and I am far from finding that photography is auspicious for us. Since the advent of the snapshot, said one horse lover, painters have been able to understand horses, and Meissonnier, one of the glories of France, has been able to depict that noble animal from all angles. As for myself, my art goes way back, further [back] than the horses on the Parthenon—all the way to the dear old wooden horsie of my childhood. I also began to hum the sweet music from one of Schumann's children's pieces, "The Wooden Horse" [ Kinderscenen, op. 15]. And I've lingered over Corot's nymphs dancing in the woods at Ville-d'Avray. Quite naïvely and in all good faith, without ever having made a sketch of dancers at the Opera, Corot, that delightful fellow, knew how to make all those nymphs dance, and how to turn those little country houses in the Parisian suburbs into genuine pagan temples on the hazy horizon. He loved to dream, and I too dream before his paintings.[9]

Scientists, forgive the poor artists, they are still children; forgive them out of pity or at least out of love for flowers and heady scents, for they resemble them. Like flowers, they blossom forth at the least ray of sunlight and give off their scent, but they wilt upon the impure contact of the hand that sullies them. For anyone who knows how to look, a work of art is a mirror that reflects the artist's mood. When I see a portrait by Velázquez or Rembrandt, I scarcely see the features of the face he painted, whereas I have an intimate impression of the moral portrait of the painter himself. Velázquez is essen-

9. See p. 268.

tially royal. Rembrandt, the magician, is essentially a prophet.

I can't remember which English author said that one should be able to recognize the king even if he was naked in a throng of bathers. The same applies to the artist; one should be able to discern him even though he is hidden behind the flowers he has painted. Courbet, when a lady asked what he was thinking of before a landscape he was in the act of painting, gave this fine answer:

"I am not thinking, Madame; I am moved."

Yes, when a painter is in action he must be moved, but prior to that he thinks. Who can swear that something I have thought, or read, or enjoyed did not influence one of my works several years later?

Forge your souls, young artists, constantly give them wholesome nourishment, be great, strong, and noble, and verily I say unto you that your work will be the image of your soul.

. . . It is surprising that Delacroix, who was so keenly concerned about color, reasoned it out as a law of physics and a matter of imitating nature. Color! what a deep and mysterious language, the language of dreams. Which is why, throughout his work, I can see traces of a great struggle between his very dreamy character and the down-to-earth character of painting in his day. Yet his instinct rebels in spite of himself; often, at many points, he tramples on those laws of nature and yields to utter fantasy.

I like to imagine Delacroix coming into the world thirty years later and undertaking the struggle which I dared to undertake. With his good fortune and, above all, with his genius, what a Renaissance there would be today! Baron Gros, who felt a great deal of fatherly affection for Delacroix, was admiring the almost completed *Massacre of Chios* one day. Astonished by a glaring error of drawing, he pointed it out to Delacroix.

"Among such admirable things," he said to him, "how can you leave an eye seen full-face on a face seen in profile?"

"Oh, I am very upset over that!" Delacroix answered. "Several times I have drawn it in properly, but it doesn't look right. You try, perhaps it will be better." And Delacroix handed him his palette.

"Upon my word," cried Gros, after making an unsuccessful attempt, "you are right." And he rubbed out what he had just done.

It was such rebellious acts of drawing that gave Delacroix a mistaken reputation for drawing badly but being a good colorist. Yet when it came to color, Delacroix did not actually make the slightest innovation.

. . . What can I say about the shocking appearance that stems from real perspective? Defects which are perhaps less shocking in landscapes, where the parts in the foreground can be enlarged, even exaggeratedly, without the viewer being so upset by this as when the subject is human faces. In a painting you must correct that inflexible perspective, whose accuracy would distort our perception of the objects shown. When we look upon nature itself, our imagination does the painting. What makes modern art inferior is that it tries to render everything. The whole is lost amid all the details—and boredom is the result.

A given arrangement of colors, lights, and shadows produces an impression. This is what we might call the music of the painting. Often you are seized by that magical harmony before you even know what the subject of a painting is, as when you enter a cathedral and are too far away from the painting to make it out clearly. This is where painting is truly superior to the other art, for this emotion is aimed at the most intimate part of the soul.

In art, the greatness of the masters does not consist of not having mistakes. Their mistakes, or, rather, the things they forget, are not the same as those of ordinary, run-of-the-mill artists. The poetically minded, the critics, when discussing works by the great masters, always attribute to the perfection of cer-

tain secondary qualities what is actually the effect of that unique gift. They praise Raphael's skill in drawing, Rubens' coloring, Rembrandt's chiaroscuro. No, no, a thousand times no; that is not where the truth lies.

Is there a recipe for making beauty? The schools give recipes, but they do not beget works that make people exclaim: "How beautiful that is!"

. . . You will always find sustenance and vital strength in the primitive arts. (In the arts of fully developed civilizations, nothing, except repetition.) When I studied the Egyptians I always found in my brain a healthy element of something else, whereas my studies of Greek art, especially decadent Greek art, either disgusted or discouraged me, giving me a vague feeling of death without the hope of rebirth.

. . . Slyly, banteringly, but also overbearingly, the critic— the one who does not swallow anything whole, who waits until posterity has consecrated it before . . . howling—is among those who howl their admiration the way they howl their insults: don't be afraid, don't tremble (the wild beast doesn't have any nails or teeth, or even brain: it is stuffed). . . .

. . . the critic asks me: "So you are a Symbolist? I mean well and I would like to learn; why don't you explain Symbolism to me."

Timidly (I do not howl) I answer: "How nice it would be if you spoke to me in Hebrew, a language which neither you nor I understand. That would make the situation somewhat analogous to . . ."

"To what, Monsieur le Symboliste?"

Still speaking slyly, banteringly. Timidly, without being sly or bantering: "Well . . . my paintings probably speak Hebrew, which you do not understand, so there is no point in continuing the conversation."

. . . Japanese sketches,[10] Hokusai prints, Daumier lithographs, [cruel observations by] Forain, the school of Giotto, brought together in this volume [in an album], not by chance but by my [good] will, altogether intentionally.[11]

[I include a photograph of a Giotto painting.]

Because they appear to be different, I want to show how they are related. The conventional views imposed by clumsy critics or the ignorant public would classify these various types of art as caricatures or [examples of] frivolous art. But that is not so. I believe art is always serious, no matter what its subject; a caricature ceases to be a caricature as soon as it becomes art. Bouguereau's virgins are not grotesque in themselves, but since there is no art whatsoever in Bouguereau's paintings, we can say that they are grotesque, and therefore caricatures. *Candide* is not a frivolous work, and in it Voltaire proceeds the same way Daumier does. In Forain's work there is something of Louis Veuillot. [Artists do not do caricatures. Though a man may wear the clothes of a musketeer while following the fatted ox in the Mardi Gras procession, he is still a peasant. Voltaire wrote *Candide*. Daumier created Robert Macaire. In "Sagesse" (Wisdom), Gaspard does not make me laugh.[12] Louis Veuillot is disdainful. So is Forain.]

In this Hokusai warrior, don't you see the noble stance of Raphael's *Saint Michael,* the same purity of line, with the power of a Michelangelo, yet achieved with much simpler means, without the play of light and shadows? So far from nature and yet so close to it. No need to point out how nobly and honestly it is drawn; those primeval qualities are obvious to anyone who instinctively feels and loves them. And since I am speaking here, in the temple, to the discerning and to those who wish to listen

10. I have inserted here, in brackets, passages which in fact Gauguin added later, in *Avant et Après,* when he took up this text from "Miscellaneous Things" again.

11. These were reproductions of works of art that Gauguin had taken to Oceania.

12. Verlaine's poem beginning "Je suis venu pauvre orphelin . . ." (A poor orphan I came . . .) and ending "Priez pour le pauvre Gaspard" (Pray for poor Gaspard). Gauguin had inserted it in full in "Cahier pour Aline."

and not to argue about something they know nothing about, I shall discuss only briefly what is meant by honesty in drawing. [In this Hokusai warrior, Raphael's *Saint Michael* becomes Japanese—yet another version of him. There is a hint of Michelangelo . . . Michelangelo the great caricaturist! He and Rembrandt go hand in hand. Hokusai draws honestly.]

Drawing honestly does not mean affirming a thing which is true in nature [it does not mean lying to oneself], but, instead, using pictorial idioms which do not disguise one's thought. A painter who, for fear of making a mistake or fear of the public, dares not use a true color necessary to his harmony and replaces it by some other, undefined tone, is telling a lie and speaking nonsense. With the Japanese, honesty is generally obvious.

Now we come to the major item in this little exhibition, the Giotto.

One art critic said about me: this so-called great painter deliberately tramples on all the rules of perspective and all the traditions. Take away the traditions and this criticism could apply to Giotto, as seen in this canvas. Mary Magdalen and her party arrive in Marseilles in a boat which you'd think was a wedge of Dutch cheese [if, that is, a slice of calabash can look like a boat]. The angels go before them, their wings widespread. No relationship to be sought between these figures and the tiny tower which even tinier men are entering. Seemingly carved out of wood, these figures in the boat are huge [or very light, since the boat is not sinking], while in the foreground a draped and much smaller figure stands implausibly on a rock, thanks to we know not what prodigious law of equilibrium.

I saw an intelligent person smile, while standing before this canvas; then, looking at me, with the smile on his lips, he said to me: "Do you understand that?" I answered the way I still answer today: "There is nothing to understand. Just like listening to music. If all these figures were their true size, if the sea were a true sea, if the faces were true flesh, then you would understand! I don't think you would, for the laws of beauty are not to be found in all those truths; therefore, neither is understanding, and you must look elsewhere for feelings to satisfy

you." [Before this canvas I have seen modern man, always modern man, who rationalizes his feelings like the laws of nature, smile the smile of a satisfied man and say to me: "Do you understand that?" Certainly, in this painting, the laws of beauty do not reside in the truths of nature; we must look elsewhere.]

In this marvelous canvas there is no denying an enormously fertile conception. It does not matter whether the conception is natural or improbable. I see in it a tenderness and love that are altogether divine. I would like to spend my life in such decent company. Giotto had very ugly children. When someone asked him why he made such pretty faces in his paintings but such homely children in life [in real life], he replied: "My children are made at night and my paintings are made during the day." Did Giotto know the laws of perspective? I don't care whether he did or not. The ways he had of blossoming forth do not belong to us but to him; let us consider ourselves fortunate to have and to see [to be able to enjoy] his works.

It is six meters long and two meters high. Why those dimensions? Because that is the entire width of my studio, and because working up high tires me exceedingly. The canvas is already stretched, prepared, carefully smoothed, not a knot, not a crease, not a spot. Just think, it is going to be a masterpiece.

THE PAINTING I WANT TO DO[13]

In terms of geometrical composition, the lines will start from the middle, elliptical at first, then undulating, until you come to the ends. The main figure will be a woman turning into a statue, still remaining alive yet becoming an idol. The figure will stand out against a clump of trees such as do not grow on earth but only in Paradise. You see what I mean, don't you! This is not Pygmalion's statue coming alive and becoming human, but woman becoming idol. Nor is this Lot's wife being turned into a pillar of salt: great God, no!

Fragrant flowers are seen on all sides, children frolic in this garden, girls pick fruit; the fruit is heaped up in enormous baskets; robust young men in graceful poses lay them at the

13. This project was not carried out.

idol's feet. The over-all mood of the painting should be grave, like a religious incantation, melancholy and at the same time gay like the children. Ah! I almost forgot: I also want to put in some adorable little black pigs, their snouts snuffling at the good food that will be eaten, their desire shown by the way their tails tremble with eagerness.

My figures will be life-size in the foreground, but here's the hitch: the rules of perspective are going to force me to place the horizon very high up and my canvas is only two meters high, which means I will not be able fully to include the superb mango trees in my garden.

How difficult painting is! I will trample on the rules and I will be stoned to death.

To set the mood of gravity, the colors will be grave. To set the mood of gaiety, the colors will be light, melodious as sheaves of wheat. How shall I manage, a painting that is dark and light at the same time? Of course, there is the "in-between-the-two" solution that generally satisfies people but which I do not like at all.

My God, how difficult painting is when you want to express your thoughts with pictorial rather than literary means. The painting I want to do is certainly far from being done, the desire is greater than my power, my weakness is enormous (enormous and weakness, hmm!). Let us sleep. . . .

. . . ABOUT PERSPECTIVE    In an inn, a stranger who took part in a general conversation as a man interested in the fine arts, said to me:

"In a museum I saw a picture that was no bigger than this [and he held his hands about thirty centimeters apart]. Ah, what a beautiful thing it was! It showed one side of the church [Saint Peter's in Rome]. The perspective in it is admirable; you see all those columns retreating far, far away, then people who become quite tiny in the background. Really extraordinary."

Out of politeness I did not dare smile, and I nodded agreement. Then I reflected sadly that this good man who was speaking without any malice was similar in every respect to the competent people, the critics, who, on the contrary, do speak with

malice, and who influence the fate of us painters. They too admire those admirable perspectives which show distance so well—haven't they written pages and pages on perspective and the mechanics of drawing!

. . . If you want perspective emphasizing distance, then resolutely widen the space between the lines that converge on the horizon. Any child knows that—so why express astonishment and admiration? And if not, then why criticize?

In *The School of Athens,* Raphael commits the most incomprehensible errors of construction and yet the effect is right. (You bet it is!) In a large vestibule, which is reached by going up a few steps, people. In the foreground, on the steps, a group of men (Raphael is holding a portfolio), and so on, all the way to the background. This interior gives the impression of a very large and very lofty vestibule, yet you can see the limits of it coming together in the normal way (otherwise it would not be intimate, the scene would not be localized).

If he places his horizon line high up, the marble flagged floor becomes very important; consequently the columns are visible only at their base, and this hall is deprived of its rich stature. If he places his horizon line down low, the people are also lowered, and that he does not want. He wants the people to be important and the monument to be important. So he tramples on the mathematical, material, linear rules of natural perspective (which are not the same thing as the rules of art, beyond the grasp of the general public) and replaces them either by equivalents or by other more or less fabulous rules, speaking, as it were, an allegorical language, which, when the critics translate it literally, is indeed absurd, whereas when it is translated rationally it becomes a noble language. In all his groups the faces, although very close to one another because of their position as shown by the feet, very visibly decrease in size and height, which immediately creates an effect of distance.

The various groups, whether in the foreground or in the back, are of approximately the same height, but are always done on the same principle of faces touching each other and becoming smaller. Moreover, their movements are all roughly analo-

gous (one could almost say to the point of being monotonous), which accentuates the principle and the primary idea that prevails throughout this painting, from the foreground to the remotest background.

. . . At my Tahiti exhibition at Durand-Ruel's[14] (although it is a bore to have to talk about myself, I am doing it at this point so as to explain my Tahitian art, which has the reputation of being incomprehensible): at that exhibit the crowd and then the critics howled before my canvases, saying they were too dense, too nondimensional. None of their beloved perspective: no familiar vanishing point . . . The air was stifling, they complained, as at the approach of a cataclysm, etc. The painter was probably ignorant of perspective, or had poor eyesight; above all, he failed to understand the laws of nature. Well, I want to defend myself.

Did they expect me to show them some fabulous Tahiti looking just like the outskirts of Paris, everything lined up and neatly raked? What is actually the fruit of deep meditation, of deductive logic derived from within myself and not from any materialistic theories invented by the bourgeois of Paris, puts me seriously in the wrong, they believe, for I do not howl with the pack. And one of them cries out: "Do you understand Symbolism? Personally I do not understand it at all." And another, a wit (my God, what a lot of wits there are in Paris!), writes: "If you want to entertain your children, send them to the Gauguin exhibit; they will be amused by the colored pictures of quadrumanous females stretched out on billiard cloths, the whole thing adorned with words from the local language," etc.

Don't these people understand anything! Is it too ingenuous for overly witty, refined Parisians?

The island, a mountain above the horizon of the sea, surrounded by a narrow strip of land on the coral. An item of geographical information. Thick is the shadow that falls from

14. The exhibition opened on November 4, 1893.

the great tree leaning against the mountain, the great tree that masks the formidable cavern. Thick too are the forests, and deep.

Any receding perspective would be an absurdity. As I wanted to suggest a luxuriant and untamed type of nature, a tropical sun that sets aglow everything around it, I was obliged to give my figures a suitable setting.

It is indeed the out-of-door life—yet *intimate* at the same time, in the thickets and the shady streams, these women whispering in an immense palace decorated by nature itself, with all the riches that Tahiti has to offer. This is the reason behind all these fabulous colors, this subdued and silent glow.

"But none of this exists!"

"Oh yes it does, as an equivalent of the grandeur, the depth, the mystery of Tahiti, when you have to express it on a canvas measuring only one square meter."

Very subtle, very knowing in her naïveté is the Tahitian Eve.[15] The riddle hiding in the depths of her childlike eyes is still incommunicable to me.

She is not some pretty little Rarahu, listening to a pretty ballad by Pierre Loti played on the guitar (by pretty Pierre Loti as well). She is Eve after the Fall, still able to go about unclothed without being immodest, still with as much animal beauty as on the very first day. Childbearing cannot deform her, so sturdy does her body remain. The feet of a quadrumane! So be it. Like Eve, the body is still an animal thing. But the head has progressed with evolution, the thinking has acquired subtlety, love has imprinted an ironic smile on the lips, and naïvely she searches in her memory for the "why" of times past and present. Enigmatically she looks at you.

"She is of the realm of the intangible," it has been said.

All right, I accept that.

15. This would seem to refer to the painting listed by Wildenstein as no. 389 with the title *Eve exotique;* Gauguin himself wrote the date 1890 on the canvas. At that time, however, he was still in France. Hence it is more likely that the painting was done during his first stay in Tahiti and shown at the Tahitian exhibition at Durand-Ruel's, November 1893.

On the easel, a peculiar painting.[16] In an amphitheater of strange tones, like some flowing potion, diabolical or divine, who can tell? the mysterious Water[17] gushes forth for the thirsting lips of the Unknown.

On seeing this seemingly supernatural form (exhibited at Durand-Ruel's), this form which materializes a pure idea, people exclaimed: "But it's madness! Where did he ever see that?"

They should meditate on these words: "The wise man, and he alone, will seek to penetrate the mystery of the parables."

. . . The characteristic feature of nineteenth-century painting is the great struggle for form, for color. For a long time two sides fought to gain the upper hand; today there is a third faction, more bourgeois and therefore less impassioned, which settles combats of this sort by a compromise, as would a judge. Oh King Solomon, how they have travestied your wisdom.

First of all, let's look at both sides, let's see what reasons they have, good or bad.

Form, or draftsmanship, which is infinitely rich in vocables, can express everything and do so nobly, either by line alone or by using tones which shape the drawing and thereby simulate color. In another age Rembrandt's genius made people believe they saw color, while Holbein, the German, and Clouet, the Frenchman, made outstanding use of line, and line only.

In the nineteenth century, Ingres still stands out. All of them fully earned their victory.

But why not add to this fine linear work another element, color, which would complete and enrich it, making a masterpiece still more of a masterpiece? I have nothing against this, but I would like to point out that in that sense it is not another element; it is the same element; this would be colored sculpture, so to speak. Regardless of whether Michelangelo's *Moses* has one tone or several tones, the outline is always the same. Ve-

16. Quoted from an article by A[chille] Delaroche. (Note by Gauguin.)
17. This is the painting entitled *Pape Moe (Mysterious Water)*, already mentioned in *Noa Noa* (see p. 89).

lázquez, Delacroix, Manet did beautiful color work, but, once again, the only direct feelings their masterpieces give come from the drawing. They drew with colors. And Delacroix thought he was fighting . . . in favor of color, whereas, on the contrary, he was helping drawing to dominate. His poetic fervor, inspired by Shakespeare, and his impassioned soul could find expression only in drawing. His lithographs and the photographs of his paintings reveal his entire vocabulary. And when I look at his paintings I experience the same feelings as after reading something; on the other hand, if I go to a concert to hear a Beethoven quartet, I leave the hall with colored images that vibrate in the depths of my being. What happens with Delacroix is also the case with Puvis de Chavannes, and with Degas, to give examples of modern masters.

Then came the Impressionists! They studied color, and color alone, as a decorative effect, but they did so without freedom, remaining bound by the shackles of verisimilitude. For them there is no such thing as a landscape that has been dreamed, created from nothing. They looked, and they saw, harmoniously, but without any goal: they did not build their edifice on any sturdy foundation of reasoning as to why feelings are perceived through color.

They focused their efforts around the eye, not in the mysterious center of thought, and from there they slipped into scientific reasons. There are physics and metaphysics. In all events, their work was not without value, and some of them, such as Claude Monet, achieved real masterpieces of harmony. Intellect and sweet mystery were neither the pretext nor the conclusions; what they painted was the nightingale's song. They were right in beginning by studying nature in color (just as his mother's milk readies the child for the day when he will eat more solid food), the necessary evolution which took place in those days, but which should also have been a gradual matter, culminating in an ultimate development. And that they did not do; I could almost swear that they had no idea that such gradual progress was possible. Dazzled by their first triumph, their vanity made

them believe it was the be-all and the end-all. It is they who will be the official painters of tomorrow, far more dangerous than yesterday's.

The latter[18] have a glorious past behind them; they are placed in an edifice built on sturdy foundations; when one of them, no matter how weak he may be, says "we," we must bow before him. In their ranks were men like Ingres and Delacroix; today they have men such as Puvis de Chavannes, not to mention others. Then too, the art they talk about (most of them, without understanding it) stands on its own two feet, it is logical, and also it is age-old, which is a source of strength. Moreover, that art has gone all the way; it has produced and will still produce masterpieces.

But the official painters of tomorrow are in a wobbly boat, because it is a jerry-built, unfinished boat. When they say "we," who are they? How many of them are there? When they talk about their art, what exactly are they talking about? An entirely superficial art, nothing but affectation and materialism; the intellect has no place in it.

The century is coming to an end and the masses press anxiously about the scientist's door; they whisper, they frown, faces brighten. "Is it all over?" "Yes." A few minutes later: "No, not yet." "What is happening?" "Is a virgin giving birth?" "Is a pope becoming truly Christian?" "Is a hanged man being resuscitated?" Not at all; quite simply it's the question of color photography, the absorbing problem whose solution is going to make so many unsavory characters fall down with their behinds right in their . . . At last we will know who is right, Cabanel, Claude Monet, Seurat, Chevreul, Rood, Charles Henry; the painters, the chemists.

Rood and Charles Henry broke color down, decomposed it, or composed it, if you like. Delacroix naïvely left aside his

18. By "the latter," Gauguin means the *non-Impressionist* "modern masters" whom he spoke of earlier and to whom he now reverts.

worries as poet-painter to run after ladies' purple-shaded yellow hats.

Zola himself, who had so little of the painter in him, and had such a pronounced taste for an asphalt-colored world [of streetwalkers] (to put it in polite terms), is busy, in Mouret's store, the Bonheur des Dames, fashioning white bouquets combining an infinite number of shades. As you can see, everybody is concerned with color. I was about to forget Brunetière, such an educated man. At the Puvis de Chavannes banquet, we all listened, somewhat dazed, as he congratulated that great painter . . . on having made such beautiful paintings with pale tones. In your splendid garden only wisteria blooms; no deep-red roses, no scarlet geraniums, no deep-purple pansies, above all no sunflowers, no poppies; cornflowers perhaps! Like the Impressionist gardens. Then too, everyone has a preference for some specific color. Paul does not like blue, Henri hates green (spinach!), Eugène is afraid of red, Jacques feels sick when he sees yellow. Confronted with these four critics a painter does not know how to account for himself; timidly he tries to say a few words about observation of colors in nature, calling upon Chevreul, Rood, Charles Henry in support of his views, but in vain; the critics howl and then are silent.

And as easily as you let out a fart in order to get rid of someone who's a pain in the neck, Cézanne says, with his accent from the Midi: "A kilo of green is greener than half a kilo." Everyone laughs: he's crazy! The craziest person is not the one you think. His words have a meaning other than their literal meaning, and why should he explain their rational meaning to people who laugh? That would be casting pearls before swine.

The photography of colors will tell us the truth. What truth? the real color of a sky, of a tree, of all of materialized nature. What then is the real color of a centaur, or a minotaur, or a chimera, of Venus or Jupiter?

But you have a technique, people will say to me. No, I do not. Or rather, yes, I do have one, but it is very vagabond, very elastic, it depends on the mood in which I wake up in the

morning; it's a technique I apply as I like in order to express my thinking, without paying any heed to nature's truth, which is only externally apparent. It is assumed at this time that either through the work of earlier painters—their observations as formulated in their works, then transcribed by literate translators —or through the latest chemical, physical, scientific research by scholars more enamored of truth than of imaginary things: it is assumed (all of this being gathered in one great sheaf) that the last word has been said concerning painting techniques.

Well, personally, I do not think [so], and I am judging by the many observations I have made and put into practice. Yet if I believe I have found a great deal, then logically I must conclude that there still remains a great deal to be found by other painters; and they will find it.

It would be beside the point, in this slim volume, to set out all those observations; their application would be dangerous for anyone who did not understand more than half of them; you have to make a choice among them according to the mood you are in when you wake up in the morning; each subject to be handled needs a special technique, in harmony with the thinking which guides it. Nevertheless, I am going to discuss it a little for the sole purpose of showing, of sketching merely, the falsehood of truth and the truth of falsehood. I hope that the reader, who is not just anybody and who, above all, is well-meaning, will succeed, despite the sketchiness of this outline, in discovering the true, rational, and nonsupernatural meaning of the shocking things that will be stated for his benefit.

Truth is in front of our eyes, nature vouches for it. Would nature be deceiving you, by any chance? Is truth really naked, or disguised? Though your eyes cannot reason, have they the necessary perfection to discover truth?

Let's look and see, as the skeptical worker would say. The sky is blue, the sea is blue, the trees are green, their trunks are gray, the ground on which they grow is slightly indefinable. All of this, as everybody knows, is called local color, but the light comes and changes the look of every color at will. And the sea that we know to be blue, which is the pure truth, becomes yellow

and somehow seems to take on a fabulous hue that you can find only at the clothes-dyers'.[19] The shadows on the ground become purple or other colors that are complementary to the tones closest to them. And everyone peers through his opera glasses at the right color and dexterously applies to the canvas, in squares prepared in advance, the true color, the genuine color which for a few seconds is there before his eyes.

All of this toned down a little—it is better to err on the side of less than more, exaggeration is a crime (as everybody knows). But who can guarantee that his colors are true at this very hour, this minute which no one has witnessed, not even the painter who has forgotten the previous minute? Men apply their tones delicately, with utmost care, for fear of being called coarse; the women apply theirs with vigorous, bold strokes, so as to be considered masculine and jaunty, and hot-blooded (without any other adjective; in studio terms the word "hot-blooded" is enough). But where is this source of luminous strength? Indeed I see shadows that indicate that the sun must have distorted the local color, indeed I have heard the servant usher in the king, but I do not see the sun, the king.

This whole heap of accurate colors is lifeless, frozen; stupidly, with effrontery, it tells lies. Where is the sun that provides warmth, what has become of that huge Oriental rug?

When we see that little canvas, with its pretentious claim to imitate nature, we are tempted to say: "Oh man, how small you are." And also that a kilogram of green is greener than half a kilo. THE FALSEHOOD OF TRUTH

I have observed that the play of shadows and zones of light did not in any way form a colored equivalent of any light. A lamp, or the moon, or the sun can produce as much, that is, an effect; but what makes all these types of light distinct from one another? Color. The pictorial rendering of these zones of light

19. In an article in *Le Figaro*, Henri Fouquier, the great journalist, speaking of a Gauguin painting in which the sea was yellow, said: "I hear that Monsieur Gauguin has left for Tahiti. I hope that during his voyage he will encounter that famous yellow sea he is so fond of painting," etc. (Note by Gauguin.)

with the contrasting shadows becomes negative, and the values they embody become negative; it would be merely a literary translation (a signpost to indicate that here is where light, a form of light, resides). And also, since all these zones of light are indicated in the landscape in uniform fashion, mathematically, monotonously, governed by the law of radiance, and since they take over all the colors and they in turn are overtaken by that law, it follows that the wealth of harmonies and effects disappears and is imprisoned in a uniform mold. What then would be the equivalent? Pure color! and everything must be sacrificed to it. A local-color, bluish-gray tree trunk becomes pure blue, and so on for all colors. The intensity of color will indicate the nature of each color: for example, the blue sea will be of a blue more intense than the gray tree trunk which has become a pure blue, but less intense. And since a kilo of green is greener than half a kilo, then in order to achieve the equivalent (your canvas being smaller than nature) you have to use a green that is greener than the one nature uses. That is the truthfulness of falsehood. In this way your painting, illuminated by a subterfuge, a falsehood, will be true because it will give you the impression of something true (light, power, and grandeur), with harmonies as varied as you could wish. Cabaner, the musician, used to say that in order to give the impression of silence in music, he would use a brass instrument sounding one single high-pitched note rapidly and very loudly. This then would be a musical equivalent, rendering a truth by a lie. Let's not carry the subject any further; as I told you, this is merely a sketch. It can be important only to people concerned with physics. So now I'll leave that aside and talk about color solely from the standpoint of art. About color alone as the language of the listening eye, about its suggestive quality (says A. Delaroche) suited to help our imaginations soar, decorating our dream, opening a new door onto mystery and the infinite. Cimabue would have shown posterity the way into this Eden, but posterity answered, Watch out! What the Orientals, Persians, and others did, first of all, was to print a complete dictionary, so to speak, of this language of the listening eye; they made their rugs marvelously

eloquent. Ah you painters who demand a technique for color! study those rugs; in them you will find all that science can teach you, but who knows, perhaps the book is sealed and you cannot read it. And the recollection of bad traditions obstructs your understanding. For you, the result of seeing color thus determined by its own charm, yet indeterminate when it comes to designating objects perceived in nature, is a disturbing "What on earth is that all about?" which defeats your powers of analysis. So what!

Photograph a color, or several colors; that is, transpose them into black and white, and all you have left is an absurdity, the charm has disappeared. That is why a photograph of a Delacroix, a Puvis de Chavannes, etc., gives us a very rough idea of those paintings; and this proves that their qualities do not lie in their color. Delacroix, it has been said over and over again, was a great colorist but a poor draftsman. Yet you can see that the opposite is true because the charm that pervades his works has not disappeared in the photographs of them.

As best we could, we have just pointed out and then explained color as living matter; like the body of a living being. Now we must talk about its soul, that elusive fluid which by means of intelligence and the heart has created so much and stirred so much—about color that helps our imagination to soar, opening a new door onto mystery and the infinite. We cannot explain it, but perhaps indirectly, by using a comparison, we can suggest its language.

Color being enigmatic in itself, as to the sensations it gives us,[20] then to be logical we cannot use it any other way than enigmatically every time we use it, not to draw with but rather to give the musical sensations that flow from it, from its own nature, from its internal, mysterious, enigmatic power. By means of skillful harmonies we create symbols. Color which, like music, is a matter of vibrations, reaches what is most general and therefore most undefinable in nature: its inner power. . . .

20. Attempts by medical science to cure madness by means of colors. (Note by Gauguin.)

Outlined so briefly, suggested so enigmatically, this problem of color remains to be solved, you will say. But who has claimed that it could be solved by a mathematical equation or explained by literary means? It can be solved only by a pictorial work—even if that pictorial work is of an inferior quality. It is enough that the being be created, that it have an embryonic soul; whereupon the progression up to its perfected state ensures the triumph of doctrine.

The battle for painting through color, thus explained, must be joined without delay. It is all the more appealing for being difficult, for offering a limitless and virgin terrain.

Of all the arts, painting is the one which will smooth the way by resolving the paradox between the world of feeling and the world of intellect. Has this movement of painting through color been glimpsed, put into practice by someone? I will not draw any conclusions, nor name anyone. That is up to posterity.[21]

And if such a man does exist, are others following him and likewise creating? . . . I would say no. There are indeed some young painters today who are very talented, who are intelligent (possibly too intelligent), but who are not instinctive or sensitive enough. They dare not cast off their shackles (after all, one must earn a living); they illustrate a new literature with the same means as were used formerly to illustrate the old literature— without the musical powers of color. Then too, the task is cruelly difficult, easily ridiculed. They have not discovered anything by themselves and were never taught anything of what has just been said about color. No master, that is their slogan: they won't be anyone's disciples, not they! Paintings which announce the doctrine are right there before their eyes but as the prophet says: "They cannot read, the book is sealed," as Jesus says. It is offered to them only in the form of parables, so that seeing, they do not see, and hearing, they do not understand.

I have forgotten to mention the tendencies and aspirations toward this art of color shown by the English painter Turner, in his second period. Although they are cloudy, the literary

21. Gauguin is discreet enough not to name himself.

descriptions in his paintings actually prevent us from knowing whether, in his case, this art of color stemmed from instinct or from a very deliberate and definite intellectual determination. It is only fair to mention it, whatever the source may be. Because of his talent, the talent of genius, he was considered mad, and later men like Delacroix were thoroughly shaken by it. But the time had not yet come. . . .

Ugly women, very ugly women cannot stand ugly models in painting: what goes on in their minds? I have never been able to find out whether this horror of ugliness came from their horror of their own reflections in a mirror, or the opposite.

Most well-meaning souls today verbally acknowledge that beauty is very variable, relative, etc., with so many explanations that you can't understand a thing and it boils down to everything being beautiful. I who am an artist do not feel that way at all, and as a lover of the beautiful I always seek it, although it often takes a long time to find it.

Those well-meaning souls kindly allow painters their ugly models. They forgive Othello's dark color: "That devil of an Othello has a style of beauty all his own"; or "He is handsome in his own way."

I who am an artist do not believe that is true at all. The beauty of Shakespeare's work does not by any means lie in the physical beauty of an Othello and his mate but rather in its literary expression. To make sure you understand me I will use a comical comparison. The cookbook does not tell you, "To make a good jugged hare, you must stew it in a pretty jar."

For us artists, models are simply like pieces of type to the printer: they help us express ourselves.

I might add that there is more involved: a type of modesty which becomes a duty, and consists of not clothing your work in a beauty which is not rightfully its own.

. . . Without trying to make a play on words, I will say that my models are Raphael, Leonardo da Vinci, Rembrandt, etc. The masters. Not their models but themselves.

Ah, if only the good public would finally learn to understand a little, how I would love it! When I see people look at one of my works, and turn it this way and that, I am always afraid that they will finger it the way they would paw a girl's body and that my work will bear the traces of this ignoble deflowering forever after.

And over there somewhere in the throng someone yells at me: "Why do you paint, whom are you painting for (—for yourself alone—)?"

I am stumped; trembling, I beat a retreat.

The turning point of the times, in art = a mad search for individualism.

A POINT OF LAW: ARE CHILDREN RESPONSIBLE FOR THE SINS OF THEIR PARENTS? At first glance the human mind, moved by a keen feeling of justice, refuses to acknowledge that such a responsibility could exist. Yet the question is not solved by saying, "It's not their fault if . . ." Now, if the children are not responsible for those sins, then the opposite, that is, nonresponsibility for the parents' virtues, rightfully and obviously is the case.

First of all, let us look at how nature goes about it. As the child is a consequence of the parents who created him, he generally inherits physically and therefore morally from his forebears; can medical science and education overcome hereditary vices? We may say that in some cases they can, to a small extent, and in other cases they can do nothing. Nature is not unjust in its creation; it is logical. This is the way the old society understood it. As a just reward for man's work, it gave glory and fortune to him and his descendants, thinking that this was an inducement to do good, while similarly, in the opposite case, the punishment extended to the man's offspring. What moralist or legal expert would care to deny that this idea of inheritance has halted many a man who was heading toward crime?

The new society has indeed kept the old institutions, such as marriage, an institution which today engenders such great calamities, the most horrible trafficking, the prostitution which is the result, and finally, the illegitimate and adulterine children.

Where those children are concerned, society agrees, in order to safeguard morality, that they are responsible for their parents' sins! Society has also kept acquisition of fortune, when fortune there is, by inheritance, except once again where adulterine children are concerned. When the parents have made the mistake of dying poor, the children inherit the poverty and thereafter [are] responsible for their parents' mistake, an enormous mistake in our day, when gold is all-important.

It has also kept transmission of the paternal name by heredity—this, at a time when women are beginning to take an increasing part in work, in glory. Well, if modern society wants to decree once and for all that children are not responsible for their parents, it must be logical and revise the institutions which no longer fit in with its progressive tendencies.

Once the child comes of legal age he will lose the name he had as a child and he will choose the name of a man newborn into society. He will not inherit any fortune, except that which the State, which has become the sole heir, will give him, sharing all wealth equally among all men who have become its children. That is when we will be able to cry, "Long live the Social State! Long live Equality!"

Until such time as society has created this upheaval, the child who, through nature's will, inherits from his parents all of the acquired illnesses and his father's legitimate name—consequently the glory and the fortune that name carries with it, consequently the rights which glory and fortune entitle him to enjoy—that child will be responsible for the shame attaching to that name just as [for] the glory, just as for the physical ugliness or beauty of his father and mother, and, ultimately, for their poverty. All this considered as a matter of law; but if we look at it from another angle than that of pure law, the humanitarian angle, it is easy to find the corrective agent. Let us loudly and clearly acclaim goodness and glory, let us always seek men's happiness; and at the same time let us hide away shame and make the punishment lighter and lighter. And then to be just, to be consistent with its humanitarian leanings, the new society will have to set about creating institutions suited to its aims so

as to bring relief to the poor soul who is cut off from paternal honor and [from] fortune.

It is not enough to proclaim that the child is not responsible. It is also necessary to destroy the causes which place that burden of responsibility upon him, to do as the doctor does, striving to alleviate the physical defects which parents pass on to their children.

I have just said that marriage as an institution was beginning to collapse. There are two ways of defending this institution. The first is by asserting that all children would be homeless if marriage did not exist and backing up this statement by pointing to the large number of extramarital children abandoned by their fathers. It would be easy to reply that in most cases that abandonment is caused precisely by the institution of marriage itself, by the burden of shame it places on adultery, on any illegal act of procreation. It could also be said that since in modern society a woman can inherit wealth just as well as a man and has every possibility of finding a job in any career, she can easily play a big role in the children's education. Death can quickly take a father away, and yet the children manage to grow up. I who write these few words here, I myself lost my father at the age of two. And in the last resort, it amounts to a financial question to be solved, and we are in a very good position to solve it. If a wealthy young lady, like a Miss Rothschild, had a child by her coachman, a superb stallion, the child would be sturdily built and would certainly not have to be pitied for having been abandoned by his father. And since the heart does not come into the picture at all but only a matter of pecuniary advantage, let us take a look at pecuniary advantage and see if in fact it is not wronged by that noble institution. What fate awaits a girl in the year 1900? If she has no dowry,[22] one of three fates awaits her. Either her parents, in order to get rid of her, "marry her off," as they say, cleverly and by dint of nasty maneuvers, big or little, persuading some civil servant with a small

22. As is the case with half the women in our society. (Note by Gauguin)

but reliable salary, a man who is already mature, that he will be getting a real treasure; and away the girl goes, in the name of Morality, bowing her head before the maternal authority, to do as her mother and her grandmother and her great-grandmother did before her, to get married and thus be permitted to have a child, that much and no more, and be happy or unhappy as luck will have it. What does that matter? She will be an honest woman forever more.[23]

Or she will be doomed to eternal virginity, which, from the standpoint of her happiness, from the physical standpoint, from the standpoint of the role which a human being should play in society, is unhealthy and monstrous.

Or she will run away from her father's house, will take a lover or two, or three, and will be dishonored in the eyes of society and in her own eyes; and finally she will become a prostitute (necessity leaves her no choice).

From this observation it is obvious that because of financial necessities, over half of society cannot marry and can keep alive only by prostitution. In the other half of society, the wealthy half, only half of the girls get married; the others lack beauty or suitors, who indeed are becoming rarer and rarer. So this brings us down to one quarter of society. You must admit, seeing the number of divorces or of couples who, though unhappy, do not divorce, that that leaves very few happy people who can praise loudly and clearly the benefits of the noble institution of marriage.[24]

The second way of upholding the institution of marriage is fully explained in a single word: morality, mores.

Where does morality take up its headquarters? Below the navel. The mayor need only grant his entry visa and honor is

23. And what a sad prospect for the father, knowing that his daughter can legally be killed by her husband if she is caught in the act of committing adultery. That is when we can say that a child is abandoned by its parents, committed into the hands of another man. (Note by Gauguin.)

24. What are we to think of a democracy that tends increasingly to create an aristocratic sect (the aristocracy of money), the only one having the right, or the means (which amounts to the same thing) to beget children legally (another *droit de seigneur*)? (Note by Gauguin.)

safe. In the little parlor close friends take tea, the young newly-weds embrace one another, kissing and hugging everywhere, and everyone exclaiming, "Aren't the lovebirds sweet!"—the accompaniment to all the familiar sentimentality. In every piece of censored literature, in the theater, it's the same dodge. In the opposite case, outside marriage, anathema: tragedy at the Porte Saint-Martin.[25]

Yet it is necessary to look for the origins of this morality. Today it exists only in the West, or, to put it more accurately, only in the Christian world, which might lead us to believe that this imposed morality, these imposed mores, have their beginnings in an ancient philosophy, one older than Jesus Christ, but affirmed and consecrated by Jesus' doctrine, in view of the extent to which the Catholic Church and especially the Protestant Church impose it on other people: *Works of the flesh shalt thou do in marriage only.* By now, who has not encountered the confessor's handbook, with its frightening sadism? From scanning the sacred Buddhist writings or the Christian Scriptures, one can ascertain that it is never mentioned—not being an element of wisdom, and contributing neither to man's happiness nor to his improvement. This Morality, the source of all hypocrisy and of many physical evils, engenders the great traffic in flesh, the prostitution of the soul; and it would even seem to be a virus born of civilization, for among the savage races of Oceania and the black peoples of Africa there is no such thing. Moreover, as soon as Christianity makes its appearance among them, vice, which had hitherto been unknown, also appears, along with the fig leaf below the navel.

When Jesus says, *Be fruitful and multiply,* he even seems to be saying, taking the carnal meaning of his words: increase, that is, make the body healthy, improve it by means of all the exercises that are necessary to its vitality; multiply, that is, copulate,[26] a law which applies to mankind just as much as it does to the animals and plants. As for the spiritual meaning of his

25. The Porte Saint-Martin Theater was famous for its ferocious cloak-and-dagger plays; Boulevard Saint-Martin was long called "Boulevard du Crime."
26. And he does not indicate any *legal form* of copulation. (Note by Gauguin.)

words, the same law exists: improvement of the soul, creation
by means of intelligence coupled with feeling, beautiful and
wise. Farther on, in fact, he seems to find it cruel to punish
adultery, that consequence of marriage, that terrifying law
created by man, the potentate of his day, not with a view to
morals but for the sake of his own defense; and when he says
to those who are pursuing Mary Magdalen, "Let he who is
without sin cast the first stone," he seems to be saying that no
one is without sin, without this particular sin, that it must be
accepted as necessary to mankind.[27]

I am a young soldier[28] and I have just arrived in camp;
tomorrow we will fight at Austerlitz. Napoleon's finger is always
laid upon his brow of genius, they say, and Murat, handsome on
his handsome steed, prances and capers and calls us, "My gal-
lant lads." As for me, I begin to feel uneasy; I don't understand
much about all this. The cannon roars, we run, the whistling
bullets deafen my ears, and men fall next to me. I am horribly
afraid, I shoot blindly, I don't know where, I don't know
whether I am killing or whom I am killing. I no longer know
whether I am afraid. Along with the others I run forward or
backward.

The battle has been won. I think we are again being called
"my boys," "my gallant lads."

Later I take part in the Chinese campaign. I am the stand-
ard-bearer. With our bayonets we are supposed to take a small
fort surrounded by an enclosure of pointed bamboo rods. De-
spite the arrows, we gallant Frenchmen advance at the double,
we do. The Chinese cover us with projectiles, the battalion falls
back. I am afraid and I hide between the bamboo rods, and
foolishly I stick the flag in the ground. Gallantly it looks at the

27. Jesus gathers about him beautiful women who have sinned, he forgives
them; what is more, he accepts subsidies from them. (*Luke,* VIII, 3: "[They]
ministered unto him of their substance.") (Note by Gauguin.)
28. Here Gauguin is ridiculing Marshal MacMahon, Duke of Magenta, President
of the French Republic from 1873 to 1879. On May 16, 1876, MacMahon had
tried to carry out a *coup d'état* by dismissing a republican minister and replacing
him with a minister who had monarchist leanings. His attempt failed.

Chinese and does not back away one inch; neither do I; I have even closed my eyes and mumbled a Hail Mary. The battalion comes back; I have opened my eyes; I can feel the French coming up very close to me. It is good to see my fellow countrymen again, and then I gallantly carry my flag once more. China is defeated, the French flag waves over the fort. My God, how beautiful that noble emblem is! I am decorated, the most gallant of the gallant.

Intelligence, duty, gallantry, country. I am a Marshal of France, I am at Reichshoffen. The Germans surround us on all sides, our men are dropping like flies, France has definitely, definitely been defeated. Standing in the stirrups, I smoke cigarettes without flinching, I am impervious to fear. I take a supreme decision and summon the colonel of the cuirassiers, those armored hordes:

"Charge all that rabble!"

"But, Marshal, the whole regiment will be mowed down by the Prussian artillery, and to no avail."

Holding my cigarette in my hand, I point to the king of Prussia, to Bismarck, and to General von Moltke over there, in the distance.

"Show those Germans that France knows how to fight. Charge!"

And gallantly, unflinchingly, I looked through my field glass at that whole jumble of mud, blood, and metal.

In the streets of Paris there were soldiers, barricades, women, children; and I told my army:

"Put them all to the sword."

My gallant men killed everyone. Napoleon, my emperor, has been avenged; it was he who made me Marshal of France.

And I am President of this nasty Republic. But my memories speak to me; the empress weeps and her child is the son of my emperor. I am gallant, I am great-hearted, my gallant sword is at my side: the young Napoleon awaits his throne, which I, great horseman, mighty Marshal of France, Duke of Magenta, am going to restore to him. Gambetta wants me to yield.

Confound it, I don't give a damn. I've got a gallant army.

Major Labordère gives the signal for disobedience.

And I, Grand Marshal of France, I am obliged to submit, to submit my resignation.

I am left with a pension, a private income, my decorations, my ostrich-feather trimmings. . . .

. . . The *Mercure de France* has had the ingenious idea of asking many people from different walks of life what they thought of the idea of a Revenge.

, . . . They did not ask me anything and I will simply answer this way: my brothers are here, in Germany or elsewhere, everywhere. So I have no cause to make war on them.

As for the majority of the young people, among whom I do not have any relatives, I do not know them very well but I assume that in spite of their army service, they are educated enough today to be able to tell good things from bad ones. So the young people must not for a single minute wish for a disgraceful action that would be contrary to their interests.

There remains the bourgeois, ripe in years: he is someone I know, and I am sure that without meaning a word of it, he will clamor for Revenge, an attack on Berlin! Honor and country are the words which clothe him. Let us leave him this uniform; otherwise his nakedness would be altogether too repulsive.

# A Letter to Charles Morice

. . . I remember your evaluation of Renan in your book;[29] here is mine. Ernest Renan lost his faith, he admits as much. Is this confession an advance apology for his ultimate arrival at the desired goal, the Academy? Is he using his immense talent to serve himself, to serve his lay ambition?

It was his great erudition, so it seems, that made it his duty to cease believing in the Church, and he left it, rid of the seminary's imprint forever. He certainly must have been, since he wrote his *Life of Jesus*! It caused a scandal, a unanimous cry of indignation from the Catholic world, and the very authoritarian Pope Pius IX did not want to believe a bit of it at first.

Upon closer examination, this so-called revolt is no more than a minor escapade, altogether on the practical level of modern beliefs. . . . The fabulous trappings in which the Church had enveloped Jesus had made the stupid masses take a very lukewarm attitude toward him, while Renan's man-Jesus, a new illogical figure, was necessarily intended to strengthen the

29. Gauguin used part of this letter in "Miscellaneous Things," with two variants that I have added in brackets. It was in a book written in 1889, *La Littérature de tout à l'heure*, pp. 258–59, that Charles Morice analyzed Renan. "This faith in doubt, this doubt in the midst of faith, rather, this doubting faith and this believing doubt . . . a supreme doubt in which he seems to triumph."

faithful in their belief without weakening the prestige of the Church. . . .

[This strictly literary work, if we look at it carefully, has no philosophical basis and nothing which in itself could be taken as an attack on the Church. Pope Pius IX's successor, Leo XIII, so as to appear to be in step with the modern spirit, would not deny it. People had really begun to cool off; the old Jesus was just too fabulous, that's all, whereas the new Christ, whom Renan describes so well, although he was still incomprehensible, could be believed in by the Sunday amateurs, the masses.]

The Church clearly understood this later [once it had thought the matter over] and quickly forgave him for his escapade. I am thoroughly convinced that the Church was an enormous help to Ernest Renan in becoming what he has become. "See how we upraise them," the Church can say. "Still another great man who got his start in our institutions."

But a Renan who had placed his erudition, his vast intelligence, and his talent in the service of a fine cause, the real cause of God, that is, wisdom, the good of mankind, that Renan, having become a lay apostle, having rid himself of pharisaism, fighting the Church as a man familiar with its iniquity and its lies . . . a Renan such as that, taking Jesus himself as his model, would have been a dangerous man for the Church. And the Church never forgives.

And Renan would have lived a martyr's life, perhaps an obscure one; Renan preferred a life of earthly pleasures, the enjoyments of an honest citizen, and remained an obedient seminarist after all.

An unbeliever? Perhaps. A rebel? No. . . .

[And unless an unbeliever lies to himself, he cannot be submissive, cannot tacitly join causes with fraud. It's a pity.]

*—November 1897, Tahiti*

**TO CHARLES MORICE**   . . . If I have the strength, I will copy over and send to you a piece I have written lately (for six months I haven't   LETTERS

painted anything) on Art,[30] the Catholic Church, and the Modern Spirit.

From the philosophical point of view it may be what I have expressed best in my life. . . .    —*November 1897, Tahiti*

30. Where art is concerned, Gauguin is referring to "Miscellaneous Things."

# A Letter to Daniel de Monfreid

. . . As soon as the mail came, seeing that there was nothing from Chaudet and having suddenly almost recovered my health, that is, without any more chances of dying a natural death, I wanted to kill myself. I went to hide in the mountains, where my corpse would have been eaten up by ants. I didn't have a revolver but I did have arsenic that I had hoarded during the time I had eczema. Was the dose too large, or was it the fact of vomiting, which overcame the effects of the poison by getting rid of it? I know not. Finally, after suffering terribly all night, I came back home. Throughout the past month I have been plagued with throbbing temples, then dizzy spells, and nausea during my scant meals. . . .

I ought to tell you that I had made up my mind to do it in December. So before I died I wanted to paint a large canvas[31] that I had worked out in my head, and all month long I worked day and night at fever pitch. I can assure you it's nothing like a canvas by Puvis de Chavannes, with studies from nature, then a blocked-in design, etc. No, it's all done without a model, feeling my way with the tip of the brush on a piece of burlap that is full of knots and rough patches; so it looks terribly unpolished.

People will say it is slipshod, unfinished. True, it is hard for

---

31. Which Gauguin entitled *D'où venons-nous? Que sommes-nous? Où allons-nous?* (*Where Do We Come From? What Are We? Where Are We Going?*), no. 561 in the Wildenstein Catalogue.

anyone to judge his own work, but even so I do believe that not only is this painting worth more than all the previous ones but also that I will never do a better one or another like it. I was so bent on putting all my energy into it before dying, such painful passion amid terrible circumstances, and such a clear vision without corrections that the hastiness of it disappears and life bursts from it. It does not stink of models, professionalism, and the so-called rules that I have always disregarded, though sometimes not without being afraid.

The canvas is 4.50 meters long and 1.70 meters high. The two upper corners are chrome yellow, with the inscription on the left and my signature on the right, as if it were a fresco, painted on a gold-colored wall whose corners had worn away. In the bottom right, a sleeping baby, then three seated women. Two figures dressed in purple confide their thoughts to one another; another figure, seated, and deliberately outsized despite the perspective, raises one arm in the air and looks with astonishment at these two people who dare to think of their destiny. A figure in the middle picks fruit. Two cats near a child. A white she-goat. The idol, both its arms mysteriously and rhythmically uplifted, seems to point to the next world. The seated figure leaning on her right hand seems to be listening to the idol; and finally an old woman close to death seems to accept, to be resigned [to her fate]; . . . at her feet, a strange white bird holding a lizard in its claw represents the futility of vain words. All this takes place by the edge of a stream in the woods. In the background, the sea, then the mountains of the neighboring island. Although there are different shades of color, the landscape constantly has a blue and Veronese green hue from one end to the other. All of the nude figures stand out from it in a bold orangey tone. If the Beaux-Arts pupils competing for the Prix de Rome were told: "The painting you have to do will be on the theme, 'Where do we come from? What are we? Where are we going?' " what would they do? I have finished a philosophical treatise comparing that theme with the Gospel. I think it is good. If I have the strength to recopy it I will send it to you. . . .                                         —*February 1898, Tahiti*

# Against the Catholic Church

*Editor's note: Haunted by the problem of human destiny, and also, at one point, by thoughts of suicide, Gauguin attempted, early in 1897, to state in philosophical terms the question which he was to use later that year as the title of his large painting* Where Do We Come From? What Are We? Where Are We Going? *To tell the truth, he did not answer the question clearly by either the pen or the brush, despite his intentions. His canvas is valid more because of its pictorial qualities and its composition than because of the rather obscure symbols which it claimed to visualize. At the same time, since illness often prevented him from painting, Gauguin had begun to write abundantly, on the blank pages that were left at the end of his* Noa Noa *manuscript of 1894. Right in the middle of a series of meditations on artistic and biographical matters which he had entitled "Miscellaneous Things," he inserted a long essay of impassioned religious criticism, "The Catholic Church and Modern Times."*

*He had been reading a little pamphlet which had been published in French, in San Francisco, in 1896,* Le Jésus historique *(tiré de* La Nouvelle Genèse*) (The historical Jesus [taken from the New Genesis]). The author was an English poet, Gerald Massey; and the French philosopher Jules Soury added to it a "Translator's note" by merely excerpting certain passages from an enormous work (four volumes),* A Book of the Beginnings . . . *(London, 1881), followed shortly thereafter by a second part,* The Natural Genesis . . . *(1883) (which title Soury should have translated more accurately as* La Genèse naturelle*). These fragments constituted a virulent diatribe against what Massey labeled "Christolatry." The so-called revealed truths were merely* **161**

*"falsifications of old fables."* It was about time that experimental knowledge replaced faith and myths.

Gauguin drew not only on this pamphlet but also, later on, when he managed to obtain a copy, on The Natural Genesis. *It has been established that he copied, in pen and ink, an illustration from that work, and that he translated certain passages of it word for word. But he also made lengthy personal additions to it. First of all, a prolix return to the Scriptures, which he knew well from having studied Biblical literature from 1859 to 1862, while a pupil at the priests' school in Orléans, where the course was given by the bishop of Orléans in person. "Recalling certain theological studies in my youth . . ." as he explains in* Avant et Après. *But from the phraseology first used by the prophets, then by the Gospels, Gauguin came to the conclusion that it was to be taken only as a set of more or less disguised symbols or parables, whereas the Church, irrationally, had turned them into absurdities by interpreting them literally. On one hand, after having wanted to "kill God," he tried—anticipating Teilhard de Chardin—to find a synthesis between Christianity purged of its dogmatic dross and modern evolutionary science, as well as democracy. On the other, his fierce indictment of clericalism led him—and this will come as no surprise to the reader—to anarchist, antistatist conclusions, to vituperations against bourgeois morality.*

When Gauguin left Tahiti for the Marquesas, he took the manuscript of Noa Noa *along with him. In 1902, as illness made it harder and harder for him to paint and insomnia left him long stretches of time to be filled, he undertook to rewrite his manuscript of 1897–98, revising it considerably and, moreover, adding approximately fifteen new pages that were even more explosive than the earlier ones. And he found a new title for the whole work: "Catholicism and the Modern Spirit."*

*The first version remained unpublished (the manuscript is in the possession of the Cabinet des Dessins at the Louvre). The manuscript of the second version was acquired by a European residing in Tahiti, and was finally sold, after obscure transactions, to an American who donated it to the City Art Museum of St. Louis, Missouri. The virulent tone of the manuscript doubtless explains why, in a country where atheism is considered disgraceful, its present (and final) possessors have not published it, and have merely written an all too brief article on it in their newsletter. Fortunately I was entrusted with a photograph taken of the manuscript*

*before it left Polynesia for the New World, so that I am now able to offer
the reader lengthy excerpts from both versions.*

*For the cover of the second manuscript Gauguin had done a hand-
some monotype, which proves that he intended it to be published one day.*

Every form of government seems to me absurd, every creed
idolatry. While man is free to be a complete fool, his duty is to
cease being one. In the name of reason, I am a tyrant: I refuse
to grant him the right to be a fool, and when in a place of
worship I see him acting foolishly or hypocritically, then I go
away, filled with most sincere indignation.

"THE
CATHOLIC
CHURCH AND
MODERN
TIMES"
(EXCERPTS)

What must be attacked is not the fabled Christ but, higher
up, further back in history: God.

You cannot bear to see the endless mystery remain unfath-
omable, so proudly, lazily you cry, I've got it! And you have
replaced the unfathomable, which is so dear to poets and sensi-
tive souls, by a specific being, tiny and mean, wicked and unjust,
in your own image, very specifically concerned (excuse me for
saying it), concerned with the asshole of each one of his little
productions. And this God listens to your prayers, as his whim
takes him; he is often wrathful and is appeased by the beseech-
ings of one of the little creatures he brought into the world.

And thou, infinite world, your movement is subject to nu-
merous laws—which proves your reason and the existence of
reason, yet your creator, according to man, is irrational, over-
throwing his own laws upon request from one of his atoms.

. . . When the alchemist comes home from Mass he will find
his crucible filled with gold; at night, through his telescope, the
astronomer will see the moon stopped in its tracks, will see it
jeering, laughing at the astonishment of the fellows at the Ob-
servatory. Because . . . oh, I don't know—God's will, maybe?

. . . What must be killed so it will never be reborn: God. Our
souls today, gradually shaped and taught by other souls that
have come before, no longer want a God-creator who is tangible
or has become tangible through science. The unfathomable
mystery remains what it was, what it is, what it will be—unfath-
omable. God does not belong to the scientist, nor to the logi-

cian; he belongs to the poets, to the realm of dreams; he is the symbol of Beauty, Beauty itself.

To define him, to pray to him is to deny him. When my neighbor says to me: "You know what? Tomorrow I'm going on a trip, I'm going to visit the moon," he makes me laugh for a minute, if he is joking. In case he happens to be talking seriously, I go away, his insanity frightens me. And in church a man climbs into the pulpit and tells his faithful: "Listen, I am going to take you up into the sky to see and hear God." God must be killed.

. . . And the reader closes his eyes and has every right to demand that I explain my sacrilege. May he rest assured. The commentary which follows will show him that my soul is not irreligious.

If we but examine the Bible a little, we can see that, generally speaking, the doctrine it contains, particularly that concerning Christ, is set out in a symbolic form which is twofold; first of all, a form which materializes the absolute Idea so as to make it easier to grasp, feigning a preternaturalistic air—this is the literal, superficial, figurative, mysterious meaning of a parable; and second, an aspect giving the spirit of the parable. This is no longer the figurative but the representative, explicit meaning of the parable.

The wise man will seek to enter into the secret of the parables, to penetrate their mystery, to imbibe the enigmatic element in them.

. . . Christ's principle whereby all men are brothers, whereby he who wishes to be the foremost must be the servant of all, which he demonstrated in practice, in primitive, easily graspable form, by washing the feet of his apostles himself, by giving himself as the first-born of human regeneration, as the first among several brothers, carrying this sentiment, with its extension in the concept of idealism, to the point of martyrdom and of forgiving those who victimized him—is that principle not the original and most essential foundation of any social consti-

tution, of union in invigorating, conciliatory, devoted, family, patriotic, humanitarian harmony, implying all of the subsequent developments of suitable organization? Is it not the ratifying principle of free man socially established as citizen, in a sovereign democracy, with equal rights for all and government by universal suffrage, under the regime of the conciliating intelligence of arbitration by voting and parliamentary majorities and of decisions which are always temporary in recognition of the right of minorities to appeal them through new elections, so as to correspond to the views of all, to the gradual conception of ideas, of reforms, of the ideal to be achieved gradually, as it comes to be better understood, [is this not] the sentiment which inspires brotherhood? Between these principles of Christian brotherhood and modern democracy, of free citizens governed by one and the same law of equality, are there not affinities, understanding, natural agreement in the avoiding of dissidence and conflicts, a blending, an identification as complementary elements of social organization?

. . . It is up to the philosophers to define, factually and rationally, the scientifically and superlatively demonstrative, comprehensive meaning which can actually shed more and more light on, and solve, this ever-present human problem: explaining what we are, where we come from, where we are going. Now, what is there in this philosophical, universal concept of nature, stemming from ideas already expressed, accepted in modern society, combined with others that are as yet only in gestation but which adapt to them logically; what is there that is not in harmony with the Biblical doctrine or the doctrine of Christ? With its rational meaning, of course, stripped of the strictly literal, preternatural, irrational, misconstruing interpretation placed on it by the Catholic Church? Is it the doctrine of evolution compared with the text in Genesis, concerning creation? In the enlarged, logically developed meaning of this doctrine of evolution, embracing all of nature, there is an obvious concordance as to the original, generative

action of God or Being as necessary first cause in explanatory reasoning on universal life, without regard to any particular tradition: concordance as to the substance, although the form is different. But if we refer to the vocabulary customarily used in the Bible we find the idea expressed in a more perceptible materialized form, symbolizing the substance, so as to make it easier to grasp by primitive minds which were not yet very receptive to the spiritual meaning of things, almost always using parables to explain doctrine. The text of Genesis expressing the creation as a giving birth, a bringing into being of the principal living elements of nature in seven days, that is, successively and in an order which, although abridged, corresponds precisely to the successive order of the appearance of those elements as demonstrated by geological strata, to the successive order of all the formative phases which science recognizes [and] sanctions but as taking place over periods that were immensely longer and even more numerous—the text of Genesis can perfectly well be interpreted in agreement with the meaning of the doctrine of evolution. Is this also the meaning of the evolution which transforms animal souls, human souls, by metamorphosis, ascensional metempsychosis? The parable of Jacob's ladder, reaching from the earth to the sky, can perfectly well be adapted to it.

After all the insights formulated earlier, and now here, any subsequent study of Christianity cannot help but expand these affinities as to aspirations and ideas between Christianity and modern society, and bring them together in one philosophical comprehension, merge them, identify them in a single, revitalized whole, richer and more fertile. But! But, outside of the Catholic Church, which is petrified in its hypocritical pharisaism of forms draining away the truly religious substance, of pious practices, which it uses as a means of securing bondage to its oppressive theocratic propensity, its infallible, unjustified dogmatism, its irrational preternaturalism, in fact the opposite of the true doctrine of the Bible and of Christ, and, ultimately, contrary to modern society.

Given this ever-present riddle: *Where do we come from? What are we? Where are we going?*, what is our ideal, natural, rational destiny? And under what conditions can it be accomplished? or what is the law, what are the rules for accomplishing it in its individual and humanitarian meaning? A riddle which, in these modern times, the human mind does need to solve in order to see the way before it clearly, in order to stride firmly toward its future without stumbling, deviating, or taking a step backward; and this must be done without wavering from the wise principle which consists of making a tabula rasa of all earlier tradition, of subjecting everything to a comprehensive, scientific, philosophical supervision. . . . So that we do not overlook any portion of what this problem of nature and ourselves implies, we must seriously (even if only as an indication) consider this doctrine of Christ in its natural and rational meaning which, once freed of the veils that concealed and denatured it, emerges in its true simplicity but at the same time full of grandeur and shedding the intensest light on the solution to the riddle of our nature and our destiny.

. . . Today, for our modern minds, the problem *Where do we come from? What are we? Where are we going?* has been greatly clarified, by the torch of reason alone. Let the fable and the legend continue as they are, of Utmost beauty (that is undeniable); they have nothing to do with scientific reasoning.

. . . After modern society had succeeded, with infinite difficulty, in escaping from the oppressive, debasing, stultifying, theocratic regime of the priests, the sacerdotal caste that calls itself the Catholic Church, then society (there is no denying it) felt the same repulsion for Christianity itself as for the Church which claimed to be the embodiment of Christianity and its hereditary, privileged, infallible interpreter, whereas the Church was the very opposite of it in doctrinal matters and practiced Christianity the wrong way around.

. . . The Catholic Church is like a dirty stick: we really do not know by which end we should grasp it.

First of all, it is high time to point out the considerable historical error which has been perpetuated, in good faith,

<div style="text-align: right">"CATHOLICISM AND THE MODERN MIND" (EXCERPTS)</div>

down to our own day, namely, having what is called the Christian era begin with the birth of a so-called Jesus. Now, historically, there is no Jesus to be found.

Christolatry goes back to a very ancient period prior to the Christian era: the mythical Jesus become an earthly Jesus. In all probability the religious (or rather, philosophical) sect, in the story as told, was formed clandestinely, like all types of freemasonry that defy an established authority, and took as its basis a gospel that was already in circulation, wielding and transforming it to suit its needs, taking pains to make it essentially incomprehensible for anyone who did not have the key to it, and above all, unattackable by despotic legislation. Around the substance of this gospel, unceasingly reworked and revised, seeking the philosophical other world with essentially humanitarian concepts, countless precautions were woven, so that it became a labyrinth in which it was impossible for anyone who did not have Ariadne's ball of thread to find his way.

Never dreaming (good people!) that this would become the gospel of a new type of politics with immense and essentially temporal power.

. . . How did the Catholic Church manage to denature the truth from the very beginning? We cannot understand it unless we realize that the sacred books were not in circulation. Oh, there were a few scattered challenges to this, for two centuries: but the truth was hushed up, and they contrived to invent a sort of dummy, born at the same time, who also answered to the name of Jesus and whose cross was no longer the cross of the equinox but an instrument of torture. Now in those days there was no such thing, historically, as that instrument of torture with its two thieves, its Lazarus, its Pontius Pilate, etc.

That they were able to perform this bit of legerdemain is understandable, for the reasons I have just given. But today, when the truth is so obvious for all who know how to see and read, it is no longer understandable that intelligent, educated people should allow the Church to lead them along! If they are in good faith, then we must assume they are mad. What is more plausible is that it's a matter of commercial interest.

The Catholic Church—in other words, the sacerdotal guild made up of recruited priests, the new ones being recruited by the ordination of their elders—lays claim to a dogmatic and supposedly divinely inspired and infallible authority, given to it by Christ saying these words to Saint Peter: "Thou art Peter and upon this rock I will build my church; and the gates of hell shall not prevail against it."

And the Church claims to have that infallible authority to decide dogmatically, contrarily to every man's common sense, on the true meaning of all the texts of the Bible, stated once and for all, to dogmatize all religious doctrine, among others the real presence of Christ's body and soul in the Communion, the doctrine that the Virgin Mary gave birth supernaturally, the miracles of the relics, etc., so as to reprove any philosophical or seemingly scientific doctrine that does not fit in with its infallible and sovereign judgment, such as the rotation of the earth on its own axis, a doctrine which the Church, through the intervention of the Pope as the infallible representative of that dogmatic authority, forced Galileo to deny on his knees. And the Church claims to have the superior right not only to formulate this condemnation of scientific, philosophical, and religious doctrines theoretically, through a pronouncement by the synod as a body or by the Pope in person, but also to sanction it in practice (when it has the power to do so) through penal execution of the persons it reproves and labels as heretics.

For example, the sentencing . . . of Galileo, the Albigensian crusades, the tortures and burnings at the stake committed by the Inquisition, the Council of Constance ordering Jan Huss and Jerome of Prague to be burned alive.

. . . And when we think of the superabundance of rites supposedly for the purpose of worship, the number of ceremonies which drain away all substance, so that it is lost sight of, and replace it by an unimaginable swarm of pious practices which supplant the genuinely religious substance that consists of seeking and practicing what sentiment, conscience, and reason order us to do—do we not see in all this the hypocritical phari-

saism used to deceive, enslave, and exploit simple souls which even the prophets and Christ inveighed against so heavily?

. . . After all, what exactly is this teaching of the doctrines of the prophets, Christ, and the apostles which the Catholic Church professes to give? It boils down, in fact, to the pure dogmatism of the simply literal, figurative meaning of the parables, of a mysterious, secret doctrine exhibited as in a sealed book, according to Isaiah, which the Church itself does not understand, as it naïvely admits when it speaks of the holy mysteries of religion, transcending reason, so it says. . . .

This purely literal teaching of the parables, forming a doctrine imposed as dogma by the Catholic Church upon minds characterized by the *credo quia absurdum* which it has formulated, misconstrues all of Biblical doctrine and all of Christ's doctrine and instills in the mind nothing but a doctrinal preternaturalism in conflict with reason and with science. . . .

. . . The fact of concealing the substance of doctrine in the mystery of the parables seems necessary as a precaution, which would permit its revelation only to the penetration or privileged initiation of those who are worthy of it, the true disciples, and would thus shield it from exploitation by false doctors, hypocritical pharisees who, without any regard for the real meaning of things, and content to go no further than the surface because it works in favor of their self-interested aims, enclose themselves in the literal, absurdly preternaturalistic meaning of this parable and are caught in it as in a net, until the time comes to unmask them. Which is what Christ did in his day, when he drove the merchants of religion from the temple.

. . . The way in which the parables are used, that is, on the whole, with clear-sightedness, makes it easy to guess the real thought they are expressing; we need only become accustomed to it by getting the over-all spirit of the Bible clearly in mind and always drawing on the true, just, philosophical rational meaning of things, which is the heart of the Bible's genuine teachings but which is disregarded by those who exploit religion.

Aside from these mysterious, truly enigmatic passages, there are others which (although they are presented in symbolic

form) are clear enough for us to grasp their real meaning at first sight; for instance, those expressing the parable of the Last Supper, which is surely free of all ambiguity. Christ in his teaching often says: "Be ye therefore perfect, even as your Father which is in heaven is perfect." Here he is establishing himself as the true model expressing those perfections which will gradually assimilate us into divine nature. And calling himself the son of God, he says: "I am the living bread; if any man eat of this bread, he shall have life forever." And to make his meaning perfectly clear, the Bible has the apostles say: "How can this man give us his flesh to eat?" which enables him to answer, "He that eateth my flesh . . . even he shall live by me," and this clearly explains that we must take this to refer to the spirit. When he partakes of the Last Supper with his disciples, he symbolizes the bread and the wine which, eaten and drunk together in a gathering of companions, form one flesh and one blood, symbolizing that we ourselves are made of flesh, and that our soul is made of moral, intellectual, wise, divine spiritual qualities and perfections. "Eat of this as my flesh, drink of this as my blood; do this in remembrance of me." These words mean, "I shall be in you and you in me." Is not all of this outstandingly rational, intelligent? Antipreternatural?

For the first several centuries the Christian world, its most eminent and authoritative scholars, understood it this way. When some people, with a turn of mind that sees only the material, literal meaning of things, began to express that meaning, the Church as a whole, including even a pope (Pope Gelasius at the end of the fifth century)[32] stated that the bread and wine used in the paschal communion had symbolic significance only.

How has today's Catholic Church come to modify and distort so simple and comprehensive a meaning? To replace it by the irrational and absurdly preternaturalistic dogma of transubstantiation through the transubstantiating virtue of the priest? The wafer absorbed by those who take communion has changed

32. Gelasius I, pope from 492–96.

substance, has in reality become the flesh, the blood, the body, and the soul of Christ, his entire corporal and divine personality.

... When we see this irrational, dogmatic, subtle but absurd interpretation of texts which are so comprehensible in themselves, we wonder whether it stems from some inept infatuation or is motivated by a pharisaical desire to enslave warped minds.

... This irrational, dogmatic preternaturalism which, in fact, is completely outside the true doctrine of Christ and garbles and annihilates it and which the Church, without understanding it, adopts and stretches to the utmost—this preternaturalism fostered all the types of perfidy, all the abusive influences, all the pharisaic leanings toward mastery, enslavement, and exploitation of simple souls, and indeed fostered them too well not to be preserved, definitively sanctioned, and exploited to the hilt; whereupon, as pharisaism infiltrated the original Christian Church, invading and absorbing it, this dogmatic preternaturalism that overflowed with miracles was inculcated in the timorous and gullible ignorant and it developed all the superstitions in them and established the idol-worshiping cult of relics, the pharisaic cult of pious practices supplanting true and fertile internal worship by the wise man's conscience and intelligent mind, and contributed mightily to founding this Catholic theocracy made up of hypocrisy, ambition, pride, guile, ineptness, impostures, and violence. . . . This bold theocracy puts a halt to controversy by dogmatizing without rhyme or reason, by asserting itself violently, by calling itself the authorized, privileged, infallible interpreter of God.

... We might note an after-fact, a last-born characteristic of this ... perpetuation, the Jesuitism whose crafty and immoral doctrines were so thoroughly unmasked and stigmatized by Pascal in his *Provinciales,* the Jesuitism which today dominates all the clergy, even in Rome itself, and whose rule ... of obedience *sicut ac cadaver* to the superior (or confessor, a headmaster in a cassock) is taught in the seminaries, in this modern day and age ... and taught not to children but to men who as priests are to guide people's consciences, with this commentary: "Should you

object that a superior can lead us into doing evil, you must obey the superior in all things that seem to you contrary to your reason, because then you would not be responsible, but only he. . . ." And that sums up the teaching of the Catholic Church.

. . . When thinkers inspired by what is good, what is just, what is beautiful, what is true emerged from this horrible medieval darkness of abomination and desolation and moved in a new direction without once turning around and looking back, without keeping even a single form, a single vestment belonging to that pestilential Church, making a clean break with all previous tradition no matter whence it came, and determined to make everything henceforth subject to control by pure reason, comprehension, science—when they did so, they were simply instinctively following the Biblical admonition to flee into the mountains and thus basing themselves on the most outstanding principles of intelligence and science.

# Two Essays

. . . Based on all of that false morality which the Christian religion inculcated in our predecessors, the State constantly combats all the efforts of the just, acting on the strength of that iniquitous right which force confers, supposedly in the name of the Gospel. But that war tax! In whose name is it levied? Is it a brotherly measure? For the sake of country, men devour one another for base, material interests. What difference does it make to progress if the earth belongs to one flag rather than another! But what does matter is that the earth belong to all, and not just to one.

. . . And after all what are the feelings of justice which motivate the State's legislation, if not feelings of interest? After all, who are these judges who do not take responsibility for their judgment, since they apply the law, the law of might-makes-right, these so-called irreproachable judges, if not egoists, men on a salary, like the executioner himself? And yet the crime rate goes up day after day. Do we not sense that this is a defective, cruel system? What after all is the right to punish, if not the right conferred by force?[34]

33. I have supplied the title.
34. At this point a horrified Gauguin tells of the execution of a young man named Prado, which he had witnessed on December 28, 1888, in front of the Petite-Roquette Prison. The crowd had shouted, "Long live the assassin! Down with justice!"

. . . These few words are enough to explain modern society. On one side, creatures who from their infancy have borne poverty and other people's scorn, while all the priest offers them by way of consolation and compensation are absolution and happiness in paradise—both guaranteed by the State. On the other side, judges with satisfied bellies, luxury-loving executioners, and also priests. All these people go on benders, laugh at the patient's contortions, and [are] labeled "decent people" because they go to Church or say Mass. Taking over other people's goods by means of the law, which is a lesson in thievery, they reach retirement believing in the Gospel that the Church teaches, such a convenient Gospel that cancels out reason and all effort to do some hard thinking. Far from justness. Far from brotherhood. Far from charity.

. . . Without infringing on freedom, acting in fact on behalf of that very freedom, wouldn't the State be entitled to do away with the Church altogether? . . . All the sciences, when it comes to teaching or practicing them, such as medicine, for instance, are subject to State inspection so that no fraud will be perpetrated, so that the doctor whose job is to heal will not administer a poison that will kill the patient. By what right does the Church administer, from childhood on, so dangerous a poison as the superstitious belief in the absurd and a deceitful faith with all its consequences: hatred of one sect for another? And why should one sect dominate rather than another, despite the terrible historical example of blood spilled because of these superstitions? In short, why this lie authorized by the State?

But what the State does not do, common sense, which is the greatest revolutionary in the world, will do. And if we look at the matter from the practical, governmental standpoint, leaving aside any spiritualism, we come to a question of prime importance: Is the State to be or not to be? Doesn't the State feel the ever-growing danger of a police mightier than its own, namely, the confessional? A police that knows all the State secrets, uses and abuses them, and obeys only one State, Rome: a police that worms its way into all families, the absolute mistress bringing

corruption in its wake from an early age. Ah, the dogma of communion with the body of Jesus, necessitating absolution after confession—one of the seven marvels of the ecclesiastical police!

And what about this rule laid down in all religious schools: *Nunquam duo, semper tres* (never two, always three), making it a principle of virtue to denounce. To be an informer, as we would say, speaking bluntly.

Doesn't the State see that it is at the mercy of a strong conspiracy? Yes, it does see but it shows little discernment in trying to break up the religious orders, in other words, by opening the doors to the cages where the wild beasts are kept. It ought to do just the opposite, that is, it should tell them: "You want to live among yourselves, yet in our midst, to stun us with the sound of your bells and all your idolatrous ceremonies? Well, go away, all of you, group together under your leader, in one enormous community, which you will be prohibited to leave!" The insane are locked up, aren't they!

Wild beasts are locked up, aren't they! There's an end to everything, as they say. For several years, there have been all these reports of disorders in the colonies, culminating in war; no one denies their religious basis, and as these disorders spread, they provide a lesson in the danger those missions embody; an ever-growing danger that the States are powerless to avoid: China is beginning to close its doors to the missions,[35] it is slitting their throats. And a wrathful Europe will go and spill its blood in vain to support those missions! . . . Do away with the missions in China and you'll have peace immediately.

. . . [The missionaries] would willingly march . . . with the Gospel in one hand, and a rifle in the other: the Gospel for their God and the rifle on behalf of the Western civilization which they believe they represent. We could give the names of mis-

---

35. Gauguin had read an article by Pierre Nesles, "La Chine qui se ferme" (China Closes Its Doors), in the *Mercure de France* of August 1900.

sionaries who have urged officers to order that cannons be fired on populations who might resist their influence. We have even seen army officers deliberately misled by missionaries so that those missionaries could later make an even greater impression on the terrorized native populations, humbled by an act of armed force. And, on the other hand, to persuade the faithful to hand over money, the missionaries have accredited a thousand inane or barbaric legends.

. . . One of our kings said: I am the State. Today, we are the State, we meaning the people, and in the end it is always the people who get the upper hand. Whoever oppresses the people is sentencing himself not only to repression but to legal repression, repression which armed strength can delay but not prevent. Like a river when you dam it, the waves of anger rise and in time smash everything. As long as the State is the policeman and the executioner of a society, it will be at the mercy of an uprising. Like the kings, the republics that forget this are doomed.

If . . . this institution, marriage, which is nothing other than a sale, is the only one declared to be moral and acceptable for the copulation of the sexes, it follows that all who do not want or who cannot marry are excluded from that morality. There is no room left for love.

AGAINST MARRIAGE[36]

Treated this way, woman becomes abject; she is doomed either to get married if fortune permits or to remain a virgin, which is such an unnatural condition, so monstrously indecent, and unhealthy. Or else she is forced to become what is called a fallen woman. The police gets into the act and the girl becomes a prostitute, brought down in the world and penned up in specially designated districts.

If ever a society was barbaric and cruel, it is certainly today's society, our hypocritical society that, supposedly acting

36. I have supplied the title.

in the name of Christian morality, thus decides a woman's fate and thereby causes so much suffering.

. . . And we protest: woman, who is after all our mother, our daughter, our sister, has the right to earn her living.

Has the right to love whomever she chooses.

Has the right to dispose of her body, of her beauty.

Has the right to give birth to a child and to bring him up —without having to go through a priest and a notary public.

Has the right to be respected just as much as the woman who sells herself only in wedlock (as commanded by the Church) and consequently has the right to spit in the face of anyone who oppresses her.

. . . If we look at all the classes of society, we are unable to say which is the best one. At the top, society is fiercer, more grasping, more hypocritical, and less brutal; because it is better dressed, it is more appealing, and seems to be better.

At the lowest level, society has the same vices but is more pardonable; we can even say it is the only level that is excusable. There are of course exceptions on both sides. But charity and brotherhood are more developed at the lowest level of society: to understand suffering you have to suffer. As an Italian put it: "Poverty does not make war on poverty." Whereas at the top we might say, dog does not eat dog.

. . . Does marriage lead to reasonable happiness? We will leave the decision up to the reader who has lived, who knows what married life is like. At any rate, marriage creates two separate classes from the cradle onward: legitimate children and illegitimate children; the latter are doomed to eternal reprobation, victims of the transgression, the so-called transgression invented by the Church (with its commandment: "Thou shalt not sell thy body except in marriage").

. . . At this time we feel the almost insurmountable barrier between ourselves and the institution of marriage: first of all, the powerful Church, the State, the accepted mores, the notaries and the lawyers who concoct marriage contracts, the caterers, the carriage drivers, the seamstresses, etc.

. . . But even all that would be unimportant compared to the deep-rooted conventional attitude. Just as the most unbelieving people have their children baptized because that is the rule, so the most well-meaning and most intelligent people get married because it's the thing to do. My grandfather married, so did my father, so did I. We are respectable people. Otherwise, what would the neighbors say?

. . . Without marriage would paternal feelings no longer exist? And in the event that paternal feelings disappeared from this world, isn't society rich enough and intelligent enough to take care of the matter? It has already been able to institute free education, that is, spiritual nourishment; one more step forward and it will establish bodily nourishment.

Besides, regardless of whether marriage does or does not exist, the poor man's child will be poor and the rich man's child will be rich. We can carry our reasoning further and say that those who marry are entitled to say to the Church, and to the State as well: "Since you force us to get married in order to live respectable lives and since we are poor, kindly feed our children." Otherwise only the rich have a right to get married. Which is another version of the *droit du seigneur.*

. . . Let everyone look around him, without prejudice, of course. Where are there happy couples? On all sides, divorce actions in which the lawyers squabble over who will get the money, tragedies in the courts.

. . . Either you look at the errors caused by marriage, or you examine their source, that indecent settlement between the two families, the notary, and the priest, all in agreement to conclude an ignoble sale for the sake of the religious morals which the State, obeying the Church's commandment, has adopted; in either case you are forced to admit that the institution of marriage must perish, for reason demands its disappearance and morality disapproves of its existence, because it is contrary to our democratic principles of freedom and brotherhood.

And the State, understanding this, but the wrong way around, taxes bachelors! . . .[37]

**TO MONFREID** . . . My guts are not hurting me much and the throbbing at the temples is becoming less and less frequent; on the other hand, I am in such a state of exhaustion that I have not been able to hold a brush all month. I haven't done anything. Besides, for some time, my big canvas has drained away all my energy; I look at it constantly and (I must admit) I do indeed admire it. The more I see it the more I realize its enormous mathematical defects, but not for anything will I fix them; it will remain just as it is, a sketch, if you like. But at the same time this question arises and I am perplexed: where does the painting of a picture begin and where does it end? At the instant when extreme feelings are merging in the deepest core of one's being, at the instant when they burst and all one's thoughts gush forth like lava from a volcano, doesn't the suddenly created work erupt, brutally perhaps, but in a grand and apparently superhuman way? Reason's cold calculations have not led to this eruption; but who can say exactly when the work was begun in one's heart of hearts? Perhaps it is unconscious.

Have you noticed that when you recopy a sketch you are pleased with, one that you did in a minute, in a second of inspiration, all you get is an inferior version, especially if you correct its proportions, the mistakes that reason imagines it sees. I am sometimes told: the arm is too long, etc. It is and it isn't. Mostly it is not, because the more you lengthen it, the more you leave verisimilitude behind and enter the realm of fable, which is not a bad thing; of course, the whole work must be imbued with the same style, the same will. If Bouguereau

37. This diatribe against marriage was of course largely subjective. In 1896 Gauguin had sent Schuffenecker a cruel letter in which he drew conclusions from his unfortunate marital experience: ". . . A Danish woman never gives herself; she sells herself, that's all. Not for anything in the world does my wife want a husband who gets in her way and the mere sight of whom causes remorse. . . . I am supposed to go on living alone, without any affection from my family, and be a money-making machine for them. No. Let the children do as their father did (at the age of seventeen I no longer cost anyone anything). For a long time I have not meant a thing to them; from now on, they do not mean a thing to me. I have nothing more to say."

made an arm too long, ah! then what would he have left, since his entire vision, his entire artistic will consists only of that stupid accuracy of his that binds us in the bondage of material reality? . . .                                    —*March 1898, Tahiti*

TO MONFREID  . . . I am very happy that you have met Degas and that while trying to be of help to me you have also made some useful connections for yourself. Oh yes! Degas has the reputation of being ill-natured and caustic (me too, says Schuffenecker).

But Degas is not that way with people he considers worthy of his attention and esteem. He has the instinct that springs from heart and intelligence. In terms of both talent and behavior, Degas is a rare example of what an artist should be: as colleagues and admirers he has had all those who are now in power, Bonnat, Puvis, etc., Antonin Proust . . . but he has never wanted any favors. No one has ever heard or seen him commit one dirty trick, one tactless action, do one ugly thing. . . .[38]

—*August 15, 1898, Papeete*

TO MONFREID  . . . I'm getting sicker and sicker all the time. If I no longer can expect to recover, wouldn't death be a hundred times better? You have severely critized my escapade as something that was not worthy of Gauguin. If you only knew the state of my soul after these three years of suffering! If I am never to paint again, I who now love nothing else, neither wife nor children, then my heart is empty.

Is that criminal of me? I do not know.

I am sentenced to go on living yet I have lost all my moral reasons for living. . . . The only claim to fame that counts is the claim one is aware of oneself: what does it matter if others acknowledge and proclaim it. The only real satisfaction is what one feels within oneself, and at this point I am disgusted with myself.

. . . I read in the *Mercure* that Stéphane Mallarmé had died

38. Concerning Degas, see pp. 257–61.

and this has made me very sad. That makes one more man who has died a martyr to art: his life is as beautiful as his work, if not more so. . . . Society is incorrigible. You would think it deliberately underestimated people's worth during their lifetimes and took as its watchword: "Genius and integrity, they are the enemy."                                          —*December 12, 1898, Papeete*

TO MADAME CHARLES MORICE    . . . But who has been telling you that I don't believe in him [Charles Morice] and especially in his talent? If I am sometimes harsh . . . it's because I am worried about the man [I] love, instead of feeling the indifference that characterizes men in our day. Yet, God knows, I have strong reasons for being impervious to all emotion. I now read very few books. But when I want to read, without being afraid of suffering, I read more than the cover of the book, more than the chapter heading, more than all the lines.

. . . I know how much Morice is improving and how much he works. His wretched trade, earning his "miserable daily bread. . . ." I realize it and I don't blame him for it, I weep for him. Horrible society which lets little men triumph at the expense of the great—yet we must put up with it, it is the cross we bear. But then, some people would not see things through to the end if the success they deserved became easily obtainable.

. . . Another thing: the book *Noa Noa.* I beg of you, credit me with a little experience and the instinct of the civilized savage that I am. The storyteller must not be hidden from view by the poet. A book is what it is. Incomplete? All right. Yet if by telling a few stories you manage to say everything you want to say or have the reader guess, that is a great deal. Morice is expected to write verse, I know; but if there is a lot of verse in this book, then all of the storyteller's naïveté disappears and the savor of *Noa Noa* loses its originality. Also, aren't you afraid that jealous people who are awaiting this book, not friends but jealous people, will say: "Well yes, Morice has talent but no creative inspiration, and if it weren't for Gauguin he wouldn't have any ideas"? And I am sure that's what people will say if there is a lot of verse. Whereas less verse will bring things into perspec-

tive and lead the way for the fine things to come, that he has already written, as you know.

It would be far better to publish his volume immediately afterward, with *Noa Noa* having formed a good introduction for it. I have strongly urged this because I am absolutely certain I am right. You mustn't believe for a minute that I am motivated by conceit—in fact, if Morice wants to publish the poems that *Noa Noa* inspired him to write, and publish them alone without the narratives or any collaboration, I give him full permission to do so and am happy to make this little sacrifice for my friend. Together, we will say to the little manuscript: Sleep, it is nighttime. It is evening. . . .                    —*February 1899, Tahiti*

TO ANDRÉ FONTAINAS

Monsieur Fontainas,

The *Mercure de France*, January issue, two interesting articles: "Rembrandt" and "Galerie Vollard."[39] The latter article mentions me and, despite your aversion, you have tried to consider the art, or rather the work, of an artist who does not appeal to you, and to discuss it fairly.

A rare occurrence in art criticism.

I have always felt that it was a painter's duty never to answer criticism, even when it is insulting, especially when it is insulting, and neither should he answer favorable criticism; such reviews are often motivated by friendship.

This time, although I stand by my customary view, I am wildly tempted to write to you, a whim I suppose, and like all passionate people, I am not very good at resisting whims. This is not a reply, since it is personal, but merely a chat about art: your article is an inducement, a stimulus.

We painters, those of us who are doomed to live in poverty, accept the material worries of life without complaining, but they do make us suffer in that they prevent us from working. How much time is wasted in running after our daily bread! Lowly

39. Fontainas's two articles were entitled "Rembrandt at Home" (pp. 35–48) and "The Gauguin Exhibition" (pp. 235–38).

manual jobs, defective studios, and a thousand other hindrances, hence our discouragement, so that we are unable to work, and there are storms and violence. None of these considerations concerns you, and I only mention them so as to convince us both that you are right to point out many weaknesses. Violence, monotonous tones, arbitrary colors, etc.[40] Yes, I suppose all that must be there, is there. Sometimes, however, it is deliberate. These repetitions of tones, of monotonous harmonies, in the musical sense of color—haven't they an analogy with those singsong Oriental chants intoned in a shrill, twanging voice which accompany the vibrant notes heard alongside them and enrich them by contrast? Beethoven often makes use of this technique (it seems to me) in the Pathétique, for example. Delacroix, with his repeated harmonies of brown and deep purple, a dark mantle suggesting drama. You often go to the Louvre: keep what I am saying in mind as you look closely at a Cimabue. Think too of the musical importance which color will be playing in modern painting from now on. Color, which is vibration just as music is, is capable of penetrating what is most general and yet most vague in nature: its inner strength.

Here, near my hut, in utmost silence, I dream of violent harmonies in the natural scents which intoxicate me. Delight enhanced by I know not what sacred horror, some immemorial thing, which I sense.[41] Formerly, odor of joy which I inhale in the present. Animal figures rigid as statues—something indescribably ancient, august, religious in the rhythm of their gestures, in their extraordinary immobility. In the dreaming eyes, the blurred surface of some unfathomable enigma.

And night falls. Everything is resting. My eyes close and uncomprehendingly see the dream in the infinite space that

40. Fontainas had written, among other things: "Although the brutal contrasts of rich, full, vibrant tones . . . compel you to look, after throwing you off at first, there is no denying that while they are melodious, bold, and triumphal, at other times they go wide of the mark because their repetition is monotonous, because in the long run the confrontation of a brilliant red next to a vibrant green becomes irritating, etc."

41. Immemorial: going back to an era so ancient that it has been forgotten. A word borrowed doubtless from Mallarmé, who had sung of "l'ultérieur démon immémorial" ("the old urge again") in the poem entitled "Un Coup de dés."

stretches away, elusive, before me, and I can feel the plaintive progression of my hopes.

. . . The State is right not to commission me to decorate a public edifice; the decoration would offend most people, and I would be wrong to agree to do it, since I would have no alternative but to cheat or to lie to myself.

. . . After fifteen years of struggle we are finally freeing ourselves from the Ecole [des Beaux-Arts], from that whole hodgepodge of recipes outside of which there was no hope of salvation, or honor, or money. . . . The danger is over. Yes, we are free, and yet I spy a danger dawning on the horizon. . . . Criticism today—serious, full of good intentions, and learned— is trying to impose on us a method of thinking and dreaming which would be another form of slavery. Preoccupied with what concerns it, with its special territory, which is literature, it would lose sight of what concerns us, which is painting. If that were the case, I would remind you proudly of what Mallarmé said: "A critic is a gentleman who minds somebody else's business."

In memory of him, please let me give you this rapid sketch of his features, a dim recollection of a beautiful and beloved face that gazed clearly into the darkness[42]—not a gift but a renewed plea for the indulgence I need for my madness and my savage nature. *—March 1899, Tahiti*

TO MONFREID . . . What still concerns me the most is: am I on the right track, am I making progress, am I making mistakes in art? Such things as the materials, and care in the actual process of painting, and even of preparing the canvas, are the least important. They can always be fixed up, can't they? Whereas art—oh, it's a very awkward and a very awesome thing to go into deeply.

During the short time that I advised students at the Atelier Montparnasse, I used to say to them: "Don't expect me to correct you outright if an arm is too long, or too short (who knows whether it is, for that matter?), but I will correct mistakes

42. Gauguin was referring to a proof of the portrait of Mallarmé, an etching he did in 1891.

in art, mistakes in taste, etc.; you can always learn to achieve accuracy, if that's what you want; technique comes all by itself, in spite of yourself, with practice, and all the more easily when you think of something other than technique. . . ."

—*May 1899, Tahiti*

TO MAURICE DENIS   . . . I'm sorry I can't answer your letter with a yes. Of course it would be interesting to see the artists who gathered at the Café Volpini meet ten years later along with the young ones whom I admire, but my personality of ten years ago is no longer of any interest. In those days, I wanted to dare to do everything, to liberate the new generation, so to speak, and then set to work to acquire a little talent. The first part of my program has borne fruit; today you can dare to do anything you like and, what is more, no one is surprised by it.

The second part, unfortunately, has been less successful. And also I'm an old fellow now, the pupil of many in your exhibit; after my absence that would become all too obvious. Much has been written on the matter, and everyone knows that I have really "stolen" so much from Emile Bernard, my master [in] painting and sculpture, [so] that (he himself has said it in print) he has nothing left.[43] Don't you go believing that the thirty-odd canvases that I gave him and that he sold to Vollard are [by] me; they are a dreadful "plagiarism" of Bernard's paintings.

Another reason, and it's the real one, too. My work is finished. . . . As I am very sick, and obliged to do some not very intellectual work in order to have something to eat, I do not paint any more, except on Sundays and holidays; so I am not even able to provide you with new samples, which, in any case, would neither be properly framed nor fit in with the trend. My Papuan art wouldn't have any raison d'être alongside the . . . Symbolists, the Idea-ists; I'm sure your exhibit will be very successful. Since almost all of you have money, a large number

43. It was in an open letter to Camille Mauclair, published in the *Mercure de France* of June 1895, that Emile Bernard accused Gauguin of having "plagiarized" him.

of customers, and powerful friends, it would be surprising if each of you could not reap the legitimate fruit of your talent and your discoveries. I am a little bit afraid you will be ridiculed by the Rosicrucians, although that would be marvelous advertising, as I think there is no room for art in Péladan's movement. . . .                                   —*Undated, June 1899, Tahiti*

TO MONFREID   . . . I have no canvas left to paint on, and anyhow I am still too discouraged to paint, too busy every minute of the day looking after my material needs, and, besides, what's the point, if my works are just going to pile up in your house, where they must get in your way, or be sold by the lot to Vollard for practically nothing.

In fact I marvel that there are still a few people who buy paintings, when there are more and more painters around who have plenty of painterly brio and who, without doing any experimenting of their own, very quickly assimilate the results of other painters' experiments and season the whole thing to the modern taste. Commercially speaking, where anything new in art is concerned, there have to be a few people who run the risks of trying it out first, before it becomes acceptable.

                                                  —*August 1899, Tahiti*

TO ANDRÉ FONTAINAS   . . . People have said that my art is coarse art, Papuan art. I don't know whether they were right, and also whether they were right in saying it. Never mind! First of all I cannot change, either for better or for worse. My works are a far severer critic; it is they who state and will continue to state who I am, horrible or glorious. . . .

. . . Of course I read your articles, since the *Mercure* is sent to me free of charge, due to my extreme poverty, and it brings me such pleasure, for I am a great reader of literature, not because it teaches me anything—my brain is refractory when it comes to learning—but because in my loneliness

O beata solitudo!
O sola beatitudo!

as Saint Bernard says, reading allows me to be in communion with other people without having to mingle with the crowd, which always frightens me. It is one of the adornments of my solitude. Ah, Monsieur Fontainas, if instead of publishing reviews under the heading "Modern Art," you often wrote reviews entitled "Adornment of Solitude," then we would understand each other completely.

. . . Did you know that about a dozen years ago I went to Saint-Quentin purposely to get a comprehensive view of La Tour's work: I had seen it badly in the Louvre and I had a feeling I would see it quite differently in Saint-Quentin. At the Louvre, I don't know why, I always lumped him together with Gainsborough. But at Saint-Quentin, nothing of the sort. La Tour is definitely French and a gentleman, for if there is one quality I value in painting, it's that one. . . . This is not the heavy sword of a Bayard but rather the dress sword of a marquis, not the bludgeon of a Michelangelo but the stiletto of La Tour. The lines are as pure as a Raphael; the curves are always composed in a harmonious and significant way.

I had almost forgotten him, but fortunately the *Mercure* came at just the right time to revive in me a pleasure I used to feel, and also to let me share the pleasure you feel when you look at the portrait of *La Chanteuse* [*The Singer*]. Your well-written article brings before my eyes names that are dear to me: Degas, Manet, for whom I have boundless admiration. And once again I see the beautiful portrait of Samary[44] that I once saw at the "Portraits of the Century" exhibit at the Beaux-Arts.

Let me tell you a little story about that. I went to the exhibit with a man who was an enemy of Manet, Renoir, the Impressionists. When he saw that portrait he declared it was loathsome. To divert his attention from it I showed him a large portrait, *Père et mère dans une salle à manger.* [Father and Mother in the Dining Room] The signature was so tiny it was invisible. "Ah, at last!" he exclaimed. "That's what I call painting." "But

44. Renoir's portrait of *Jeanne Samary.*

it's by Manet," I told him. He was furious. We have been at swords' point ever since.

And there you have many reasons, dear Monsieur Fontainas, why I hope you will write other things of the adornment-of-solitude type. . . . —*August 1899, Tahiti*

# Le Sourire and Les Guêpes

## (1899–1900)

*Editor's note:* Le Sourire *(The Smile) was Gauguin's own newspaper, with woodcuts by him as page headings. It was published in Tahiti from August 1899 to April 1900, and never had more than approximately thirty readers.*

*In Gauguin's letters to Daniel de Monfreid we find the reasons why he launched this newspaper. "Nasty smile," as Gauguin said, "which made many people, nasty people, turn pale." He had been reduced to extreme poverty, and had had to work in a road gang for six francs a day. This appears to have put him on difficult terms with his former acquaintances. The civil servants treated him disdainfully; and whenever Gauguin was robbed, a scornful"petit procureur," the public prosecutor, Edouard Charlier, always deliberately neglected to prosecute the thieves. So Gauguin had an article fiercely libeling Charlier printed in a newspaper —expecting thereby to force the prosecutor either to fight a duel with him or to sue him. "Result?" he wrote to Daniel de Monfreid. "No reaction, neither duel nor lawsuit; what rotten people out here in our colonies. . . ." But Charlier did get back at Gauguin—or so he thought —by destroying three Gauguin canvases he had once bought for a song. In a letter written after that episode, Gauguin said: "As you have seen, I began to hold my head high again in Tahiti, and a good thing, too, because after that people began to fear me and respect me, and then, one thing led to another, and I became a journalist. I have launched a newspaper called* Le Sourire, *reproduced by the Edison process, which is all the rage; unfortunately it gets passed on from one person to another, so I sell very few."*

190

*Of course not all of the local anecdotes and satirical jokes which this
humor sheet contained were of equal interest. But Gauguin's verve as a
writer is noticeable in the passages I have selected.*

*In 1952 former Governor L.-J. Bouge published, in a limited, fac-
simile edition, a complete collection of Le Sourire. But the articles it
contained have never been printed.*

*The story of Les Guêpes (The Wasps) is somewhat different. This
monthly newspaper belonged to the leaders of the Catholic party in Tahiti
(in French Polynesia, Catholics are in the minority; Protestants form the
majority). The silent partners in this newspaper wished to campaign
against the Protestant missionaries; and in 1899–1900 they hired Gau-
guin, who had a ready pen and a flat pocketbook, to edit Les Guêpes.
Pressed by necessity, the painter was temporarily obliged to silence his
vituperations against the Catholic Church; but this self-censorship did not
prevent him from slipping a few articles of real interest into Les Guêpes.
In 1966 a complete printed collection of the issues of Les Guêpes was
brought out, in book form, by Bengt Danielsson and Patrick O'Reilly with
the title Gauguin, journaliste à Tahiti as part of the series of publica-
tions of the French Société des Océanistes, whose headquarters are at the
Musée de l'Homme in Paris.*

(THE IMAGINARY INAUGURATION OF A RAILROAD)[45]

COCONUT
FLOUR

. . . Sunday is to be a great day: the Papeete-Mataiéa Rail-
way, the work of a benevolent man, will be inaugurated. Only
the upper crust will inaugurate it; as for the ordinary people—
no money, no privileges. No matter, I go and apply for a re-
porter's card; and, believe it or not, I get it.

45. Gauguin harbored a special grudge against Auguste Goupil, an extremely
wealthy lawyer and businessman, for whom he had worked in the rather humil-
iating position of tutor to his daughters. Goupil, who owned a hundred hectares
of coconut groves, had taken a notion to set up a huge finance company in order
to carry out a long-cherished project: the building of a railroad from Papeete
to Mataiéa. The main purpose of the railroad was to have been to carry the
grated coconut that his factories produced and which he exported to bakeries
in the United States. The project was never actually carried out because, as
Gauguin said in another article that appeared in Les Guêpes some months later,
it could not help but "go bankrupt." So Gauguin had fun describing an imagi-
nary inauguration of this railroad. By an amazing coincidence, all the stations
where the train stopped were coconut-flour factories. While he was at it, Gau-
guin ridiculed the luxurious mansion that Goupil had had built at Outamaoro.

At dawn on that famous day, it was obvious that the weather would be splendid, despite an exceptionally high tide. If the tide had risen just a bit more it would have swamped the ships in the anchorage and they would have sunk. Happily, no such thing happened; but let's get back to our subject instead of getting lost among minor incidents worthy at best of *Le Figaro*—oh Villemessant!

Wherefore, consequently, subsequently, as the sergeant would say, I took the train, without any luggage but elegant and refined: fawn-colored trousers, astrakhan waistcoat, and a jacket as well cut as the inkstands of Pondicherry.[46]

Wherefore, consequently, subsequently, as the man with the gold braid on his sleeve would say, as anyone can tell you, a man always has to be well dressed in order to be intelligent. Wherefore, consequently, subsequently, the train got under way, and stopped at every station. Coconut Flour No. 1. Well, well! to think I thought it was Faaa. Very shortly afterward, another stop; this time it's Coconut Flour No. 2. "Passengers for the Nouméa line change trains here," shout the employees, who are Chinese. This becomes upsetting for my poor intellect, so, to change my train of thought, I begin to examine, as we go by, a superb estate, that must surely belong to some Croesus: at the bend of the road, a carpenter has cleverly arranged a few sardine cans in tiers to imitate a castle. Just like at Versailles, there are statues to civilize the garden; gates too, and, atop columns, admirable fake metal vases offer their hospitality to skinny aloe lilies made of zinc. As I looked out the compartment door, it seemed to me that way off in the distance I could make out hands fluttering over a guitar; I also seemed to hear a gentle refrain: "I love this money."[47] And I answered by saying this couplet by Jehan Rictus to myself:

L'enfant des pauv's, c'est nécessaire
Afin que tout un chacun s'exerce,

46. Capital of French India and seaport on the Coromandel coast.
47. In English in Gauguin's text. (Translator's note.)

Car si gn'avait pas de misère,
Ça pourrait bien ruiner le commerce.[48]

The train started up again, and stopped at every Coconut
Flour Station, going as far as No. 5. To our left, the charm,
the majesty, the luxuriance, the intoxication of the forest
draws and welcomes the pilgrim on his way to Taravao and
entwines him with its ardent, dangerous caresses. To our
right, now far away, now near, the sea: a sea enlivened by slen-
der canoes, indolently swift, which young men guide with their
paddles, and their blue-and-white loincloths and their copper-
colored chests gleam in the clear air and their teeth shine in
their laughing faces. At many points along the shore girls who
have just been swimming, and are most likely lying in voluptu-
ous positions, talk about yesterday's loves and hopes for those
of the morrow. The locomotive's whistle brings us back to re-
ality, as does the cannon which was to salute the train's arrival.
But no, nothing at all, just an oversight on the part of the train
conductor and the gun captain. (The cannon balls had been
left behind in Papeete!!!) On the other hand, they've not for-
gotten to prepare a grand luncheon for the upper crust, but I,
who am a modest reporter, paid only 4 sols, I have to go eat
at the railway-station buffet run by a Chinaman: you can have
all the coconut flour you want. When that is over, I lie down
in a little thicket in the shade of a mango tree to take a little
nap. Sleep closes my eyes, so does a dream, a jumbled dream
where things go by in my head in any old order. . . . Coconut
flour, "I love this money," etc., the railway employees, all of
them Chinese, etc., it becomes a nightmare and I wake up.
And when I awake I think to myself that many a man avoids
Mazas [prison], to end up inevitably at Charenton [asylum].
Divine justice, no doubt. Without making any stops this time,
and without accident, the train takes us back to Papeete. And

48.  Poor children there have to be
     Or things'd go from bad to worse,
     'Cause if there wasn't no poverty
     That might put an end to commerce.

I came home with a happy heart but a queasy stomach, being unable to digest coconut flour.

Often things, such as words that we have seen and heard earlier, take on a profound meaning in our declining years.

Fifteen years ago, in Martinique, when I was coming back from Saint-Pierre, I saw two Negroes on the road who looked even more stiff and formal than their umbrellas; passing very close to them, I heard one say: "He ain't civilized, he talk about money all da time."

And now, as a mature man, what do I see when I come into Papeete but the colonial prison, the colonial hospital, the colonial court of justice; and now that Negro's words ring true in my ears and their meaning goes deep. Because in my youth I was just as much in love with noble things as any other man; I too had the illusion that justice would be done me one day, that merit would be rewarded. At the colonial prison or the colonial hospital, always the same words: "How much?" Depending on how fat your wallet is, you are classified as a private, a sergeant, or an officer. You are a poor colonist, astray far from home; you are in great pain and want to know what is wrong with you, so you go to the colonial hospital, and . . . having greased the concierge's palm with 10 francs, you are allowed to enter the consulting room, and there you hear, without being told: "You ain't civilized, you ain't got no money."

Then death comes to take you, take you by surprise, and, depending on how fat your wallet is, they give you a fine white shroud, a piece of gray cloth, or a stinking rag; and again depending on how fat your wallet is, a room to yourself, a ward, or the street. Officer, sergeant, private. No complaint coming because—regulations, administration, ranks, and decorations. If I were a priest, I would say charity; if I were a tyrant, I would abolish the regulations, the administration, the ranks and the decorations, and the hospital would be called "Mankind." Alas! I am not a tyrant; Zion was built of the blood of the innocent, and Jerusalem, of the fruit of iniquity. After us will come (I certainly hope so) a barbarian horde (or so I hope). Jerusalem

will be reduced to a heap of stones and the worshipers of the golden calf will be killed.

"He ain't civilized, he talk about money all da time."

—Le Sourire, *supplement to the September 1899 issue*

FEROCIOUS REMARKS

JUSTICE AND INJUSTICE[49]

... We do not agree, the public ministry and I, when it maintains that one should not take the law into one's own hands. Yes, I know the ministry has the code of justice in its favor, but I reason from daily examples: seeing what butter costs, the poor people just can't afford justice. And I say that when a . . . vile businessman who knows how to get around the laws ruins you, you have to massacre him. If your boss, without taking your worth and your work into account, fires you so you can't make a living, and all because you haven't kissed his dirty you-know-what, then you must ruthlessly mow him down. Slaps in the face, caning, murder—all these are rightful means of warding off the riff-raff who are invading society; otherwise, if you don't watch out, you'll become a nation of flunkies, and the men will all wear petticoats. If you teach the natives French and arithmetic and all they entail, that may be all very well from the standpoint of civilization; but if you think you are going to civilize the defeated races by giving them the example of wrongdoing that always goes unpunished, the bastardization of our white race, arbitrary decisions from on high and platitudes from below, then you are wrong. In a colony, trying to walk straight ahead, proudly and without concessions, leads to misery; the natives whom you teach in your colonial schools will soon tell you so. . . .

—Le Sourire, *supplement to the September 1899 issue*

Only he who is free is happy; but only he who is what he can be, and consequently what he should be, is free. Must we, in order to live, lose the reasons that make us live?

49. I have supplied the first title.

Several sentinels lined up against the wall. Above, in black letters on the whitewashed surface, an inscription stands out: Liberté, Egalité, Fraternité. Liberty, yes. Equality, not much. Brotherhood, none at all.     —Le Sourire, *September 1899*

MENAGERIE[50]    I am strong and I make a fortune with my menagerie, the most impressive menagerie in the world. Every evening a large crowd watches me enter the big cage in the middle where Brutus, that king of the desert, vainly awaits an hour of freedom in which to run around madly. He only, at first; then other lions; finally the lioness. Brutally I goad them with the tip of my pike to make them roar and leap, those terrifying animals that people call wild, and I wallow in their odor. All the beast in me is satiated, and the crowd admires me.

The cage is now empty and the great royal tiger enters it alone; nonchalantly he seeks a caress, and makes signs to me with his whiskers and his fangs when he has been petted enough. He loves me. I dare not beat him, I am afraid and he takes advantage of my fear; I must bear his scorn in spite of myself. And that fear makes me happy, my whole being quivers with it. Is there happiness without pain?

At night, my wife seeks my caresses; she knows that I am afraid of her and she takes advantage of my fear; and both of us (wild beasts too!) live our life, with fear and derring-do, joys and pains, strength and weakness, and in the evening, in the lamplight, as we choke on the stenches of the wild beasts, we look at the stupid, cowardly crowd, craving for death and carnage, curious for the horrid sight of the chains of slavery, the whip, and the pike, constantly gorging on the patients' screams. . . .     —Le Sourire, *October 1899*

**MORE ON THE MENAGERIE**[51]    Look, there, in that cage, at the pretty panther with its black coat; slowly but surely its fangs crush and devour its food, a sheep's head; the harsh sounds that issue

---

50. This text is reproduced three times, with some variations, in *Le Sourire,* "Miscellaneous Things" and *Avant et Après.*
51. I have supplied this title.

from its throat are sufficient indication of its intense pleasure.

When I see it like that, I lick my chops, I admire this feline. When its meal is over, the trivial tamer and his pike enter the cage. He takes advantage of his power and especially of his weapon, he shows off, bullies and mocks his victim.

But then comes an instant of forgetfulness and mad fright, and the pretty, insurgent panther knocks down the trivial tamer. Now it is the panther's turn to bully and mock, mock and bully; slowly but surely its fangs crush the ugly head of the darling tamer. The harsh sounds that issue from its throat indicate its intense pleasure.

And I lick my chops, I like felines.

—Le Sourire, *supplement to the October 1899 issue*

LITERARY CRITICISM                                                      UBU ROI

Alfred Jarry has a singular mind. At the Théâtre de l'Oeuvre they are staging a little play of his called *Ubu Roi*. Ubu Roi is a filthy wood louse who, bringing up the rear behind his subjects, goes off to war and always has the most extraordinary attacks of colic. I can't say the play was a smash hit, but it hit people by horrifying them, for it is no pleasure to see the race to which you belong jeered at and disparaged to such an extent. Nonetheless, a new type of character had just been created.

Whenever any ordinary politician shows himself in a cowardly light, people say: he's an Ubu. Whenever a prosecutor, likewise ordinary, merely wipes away with his handkerchief the gobs of spit that are deposited on his snout, and his trousers are used as a urinal by anyone who lifts up his hind leg: he's an Ubu. Whenever a husband is used by his wife as a mop to clean out the chamberpots: he's an Ubu. Theoretically, any man who is a filthy, disgusting beast is a wood louse that goes crunch when you step on it: he is an Ubu.

Ubu is now included in the Academy's dictionary: the word will designate a human body with the soul of a wood louse.

Let us thank Monsieur Alfred Jarry.

—Le Sourire, *November 1899*

In 1898 I received some sad news: the death of Arthur Rimbaud (a friend).[52] Rimbaud was a poet and therefore considered by some members of society as a useless being, like all artists. The world of letters was saddened [by his death], for he was a strange poet indeed, and highly intelligent, but that was all. Nonetheless, it is important, without going into the matter in detail in so little space, to say, once and for all, that the words "the glory of a country" are used in a way that gives them the opposite of their true meaning, particularly where colonization is involved. To colonize means to cultivate a region, to make a hitherto uncultivated country produce things which are useful primarily for the happiness of the people who inhabit it; a noble goal. But to conquer that country, raise a flag over it, set up a parasitical administration, maintained at enormous cost, by and for the glory of the mother country alone—that is a barbarous folly, that is shameful!

Rimbaud the poet, the dreamer, went exploring, on his own initiative and without any encouragement or resources but his own desire for freedom and charity.

After having been a star pupil of classical education, a prizewinner in academic competitions, Arthur Rimbaud, the poet with such a precocious genius, wanted to roam the world. How many people realize that he almost always went on foot, alone, and penniless. By 1880, when he arrived in Aden, he knew English, German, Dutch, Russian, Swedish, Spanish, and Italian—all the European tongues as thoroughly as French, of which he remained one of the masters. Taking advantage of the fact that the employment he found in Aden was relatively sedentary, he rapidly assimilated not only Arabic and various Oriental dialects but also the theoretical and practical science of an engi-

---

52. We must take the word "friend" in a broad sense, for Gauguin probably never met Rimbaud. However, Verlaine and his Symbolist friends undoubtedly spoke to Gauguin about him, at their meetings in Paris, which Gauguin attended, in the winter of 1890–91. Rimbaud had died in Marseilles on November 10, 1891. News of his death, says Mallarmé, had "been reported in the newspapers." But at that time, Gauguin was in Tahiti. Is it possible that when he was back in France, from 1893 to 1895, he could still not have known that Rimbaud was dead? Jean Loize suggests that it was through Paterne Berrichon's books and articles that Gauguin finally learned of Rimbaud's death.

neer. Then, still alone, he left Aden to go and explore Africa. Without anything to help him but his condescending manner, as a superior man, he managed to gain the respect and even the adoration of savage tribes hitherto feared by travelers, and he taught them industry and dignity.

"In Obock," Rimbaud wrote in 1885, "all that the small French administration cares about is banqueting and gobbling up government money which will never bring one sou back into the coffers of this dreadful colony, colonized thus far only by a dozen freebooters or so." Cost to the mother country: approximately 570,000 francs a year; to the natives: 30,000 francs. It is to be feared that in many French possessions the situation is the same, proportionally, as it is in French Somaliland. This could be found out easily enough by going through the general budget of the Republic.

It can be stated with certainty that the pro-civilization party in Ethiopia is the work of Arthur Rimbaud; despite the vexations that the Empress Taïtou placed in his way, he decisively influenced, between 1888 and 1891, both Menelik [II] and Ras Makonnen, his friends, and his admirers.

There, in a few words, you have what one individual accomplished. J.-A. Rimbaud, a poet, a dreamer, therefore a useless individual, did this on his solitary initiative, without any fortune, without any backing from our governments.

When I began to write this article, for the sake of talking a bit about colonies and colonialization, and also about an artist (everyone knows my weak point), I expected to end it as well; but suddenly another figure rises up before me, a glorious one this time, entrusted with a mission for society, Captain Marchand. Who is this man that France is proud to claim and, above all, what has he accomplished?

I do not have the impression that Captain Marchand ever studied the humanities. Instead, it seems that it was the modern courses dispensed in the regimental school, corroborating his modest elementary education, and his obedience to superiors that enabled this volunteer soldier to become a captain in the colonial marine light infantry and capable of leading a colonial

expedition. Leading troops armed with Lebel rifles, and acting on orders from the Minister of the Colonies, the captain left for Africa. The purpose of his mission was to relieve discharged soldiers and subsequently to defend the French possessions administered by Monsieur Liotard, high commissioner for the Republic in the Congo.

This Marchand fellow being an active and adventurous officer, so they say, his conquering and patriotic zeal made him go down the Bahr el-Ghazal—leaving "occupation posts" all along the way—and thus reach the Nile, at Fashoda, then in the hands of the Mahdists.[53] It appears that hardly had he entered that city when he was attacked by a dervish flotilla, which he overcame. Then, lightheartedly believing in this little victory, which liberated the Shilluks from the tyranny of the dervishes, he apparently thought that, although he did not speak the language and hadn't even an interpreter, he could conclude a treaty with the Grand Mek [the Khalifa] to the effect that the latter place his country (these are Monsieur Marchand's own words, as written in the Yellow Book) under French protection, a treaty which was supposed to be ratified later by the French government.

Everyone knows what finally came of it all. An Anglo-Egyptian expedition, led by the sirdar Kitchener, took the Sudan back from the Mahdists. Going up the Nile after taking Khartoum, the expedition encountered the French troops at Fashoda. And the first result of this diplomatic conflict between the Republic of France and the Queen of England was that Captain Marchand was ordered to leave the country of the Shilluks and return to Metropolitan France.

These rapid biographical sketches, we believe, show the essential differences that characterized Rimbaud and Marchand and led us to choose them as two contrasting types of instruments of colonization.

---

53. Supporters of the Mahdi Mohammed Ahmed, who seized Khartoum and thus temporarily stymied Anglo-Egyptian domination in the Sudan; Mahdi means tribal chief, literally "sent by Allah."

Of the two, it is the officer, not the *poète maudit,* who is commonly held to have accomplished the most civilizing mission. Yet the truth was quite the opposite. In France, where the individuals called upon to administer the new territorial acquisitions almost always lack an enterprising spirit, colonial policy is the enemy of colonization.

Just as I am about to put an end to this overlong conversation, a third figure rises up before me; forgive me: it will be the last one. I do not remember which mail brought us the news that the conflict between France and England had ended; but at any rate I was near the church in Papeete, at about ten in the morning, when Monsieur Charlier, the government prosecutor, came up to me and said:

"My dear man, it is all up with us in France."

"Already!" I cried.

"Yes, it is all up with us, and I am ashamed to be French; I have just come from seeing Monsieur Gallet, who is thoroughly indignant about it! Cowardly France has given up everything."

I too was indignant, but for other reasons. I held my tongue; the time had not yet come to talk.

Monsieur Gallet and his protégé saw their chances to acquire glory and career advancement vanish in one fell swoop. What! All those fine defense works, that fine mansion at Fautaua —was all that to be no more than an instant's dream?[54]

I who have acquired the bad habit of thinking about things . . . I who took part in the war of 1870, who have seen dead soldiers and prisoners, and all that because of a few people's whim, I do not like war. . . .

—Les Guêpes, *no. 5, June 12, 1899*

---

54. "Gauguin is referring to preparations for war which had been made in Tahiti at that time in anticipation of a conflict with England and a takeover of the island. Apparently resistance plans had been mapped out, navy batteries had been installed to defend the pass, and in the valley of Fautaua a sort of blockhouse had been built, with a bridge (still called Fashoda Bridge) to reach it. The governor was to have taken refuge there in the event of an English invasion." (Footnote by Danielsson and O'Reilly.)

GENTLE
PROGRESS

When Cythera became Swiss,[55] it lost its lovely temple of Venus and an imitation of Genevan austerity made it cheerless and unbearable. In former times the sky of Cythera was pure, the women were adorable and adored and had the joy of living naked in the mild air, being caressed by soft grasses, bathing voluptuously. Life was a perpetual holiday, a perfect ignorance of work, which the generosities of nature made unnecessary. [What more smiling prospect than its port, with its sunlit shops and its canoes?][56]

. . . The civilized hordes arrive and run up a flag; the fertile ground becomes arid, the rivers dry up; no more perpetual holiday—instead, a struggle for survival, and constant labor. . . . The storm passes by over our heads, bowing the tops of the age-old coconut trees down to the ground. . . . They poison our land with their infected excrement . . . they sterilize the soil, deface and damage living matter. . . . Everything perishes. . . .    —Les Guêpes, *no. 12, January 12, 1900*

55. For "Cythera," read Tahiti, and for "Swiss," read Calvinist. (Footnote by Danielsson and O'Reilly.)
56. Gauguin added this last sentence to the text when he included it in *Avant et Après*.

# Gauguin and the Art Speculators

*Editor's note: We shall now see how (in 1900) two art speculators fought over Gauguin. One was a professional art dealer, Ambroise Vollard; the other was a wealthy amateur with a private income, the Rumanian prince Emmanuel de Bibesco. Both Emmanuel and his brother Antoine were friends of Marcel Proust, who was then nearing thirty. Vollard and Bibesco both proposed to guarantee Gauguin a meager yearly stipend in exchange for an agreed-upon number of canvases. Bibesco began, at the end of 1899, by slipping Gauguin the modest sum of 150 francs in a letter, so that Gauguin would send him "a little painting." In January 1900 Gauguin asked Monfreid to work out with Bibesco the choice of the painting. Whereupon Bibesco became bolder and, in March 1900, suggested to Monfreid that he should replace Vollard, to whom Gauguin was as yet bound only by a verbal agreement. Bibesco asked for twenty-four canvases a year, to be paid for at a rate of 200 to 250 francs each.*

*Ultimately Gauguin chose Vollard but did not break with Bibesco. The correspondence between Gauguin and Monfreid throughout 1900 shows Gauguin continuing, rather cleverly, to play off Bibesco against Vollard and Vollard against Bibesco. Although Vollard eventually won, Gauguin vituperated against the dealer, who was exploiting him and was later to make a fortune out of him, calling him "the lowest kind of crocodile" and "a regular pirate."*

*The following excerpts from two letters by Gauguin, one to Vollard in January 1900 and the other to Bibesco in May 1900, shed light on Gauguin's artistic activity. The first one was published in the Malingue collection but was mistakenly said to have been addressed to Bibesco. The* **203**

*second letter, unpublished until now, was in Vollard's archives and al-*
*though it bears no name, was undoubtedly written to Emmanuel Bibesco.*
*Gauguin had sent a copy of it to Monfreid, who must have passed it on*
*to Vollard to prove to him that Gauguin was in good faith and persuade*
*Vollard to be less stingy with him.*

LETTER TO AMBROISE VOLLARD    First of all I'm afraid your sheets of
Ingres paper[57] won't be of much use to me. I'm very particular
when it comes to paper. On top of that, the words "format
intégral"[58] frighten me so I can't get started. Now, no artist (if
you consider me as such, not as a machine to produce on
order) will be good at doing something he doesn't feel, and
never mind the size! I've experimented all my life, even in
Brittany; I like to experiment; but if it has to be water-colored,
pasteled, or what have you, then all my ideas evaporate, and
actually you would lose out, because the result *would make a
monotonous* show. Art lovers all have different tastes; one likes
his pictures powerful, another one likes them sweet as sugar.
Right now I have a series of experimental drawings that I am
pretty pleased with and I am sending you a very small exam-
ple; it's like an impression and yet it isn't. I use heavy ink
instead of pencil, that's all. You mention painted flowers; I
don't really know which ones, even though I do so few of
them, and that is because (as you have surely noticed) [of the
fact that] I do not paint by copying nature—nowadays less
than previously. Everything I do springs from my wild imagi-
nation. And when I am tired of painting human figures (my
favorite subject), I begin a still life, which I finish, by the way,
without a model. . . .

   If you dwell on the matter of price, you say that it's because
my painting is so different from other people's painting that no
one wants it. . . . Hard words if they are not exaggerated. I am
a bit skeptical about that. Back in about 1875 I saw Claude
Monet paintings go for 30 francs each, and I myself bought a

57. Used for pastel drawings. (Translator's note.)
58. Large sheet of paper, 50 by 65 cm. (Translator's note.)

Renoir for 30 francs. As a matter of fact, I had a collection of *all* the Impressionists that I bought at very low prices. It's in Denmark, with my brother-in-law, the famous Brandes who will not let go of them for *any* price. It includes twelve Cézannes.

And when I was in Paris myself, I sold for prices starting at 2000 francs down to 500 at the lowest. No, the truth is that it's the art dealer who decides what the price is to be, when he knows how to go about it. When he's convinced and especially when it's good painting. *Good painting always fetches a good price.*

Also I've had a letter from Maurice Denis, who is very well informed about what goes on in Paris. He tells me that Degas and Rouart are fighting over my paintings and that at the Hôtel des Ventes they bring pretty handsome prices. So when you say, "No one wants [my painting]," this is enough to astound even a man inured to being astonished.

. . . Yet, despite the fact that no one wants my painting because it is different from other people's—peculiar, crazy public that demands the greatest possible degree of originality on the painter's part and yet won't accept him unless his work resembles that of the others! By the way, I resemble those who resemble me (those who imitate me)—well, in spite of that, you want to do business with me.

. . . What I am *and what I want to go on being is this: a great artist.*

. . . So here is my *formal offer,* which can give you every assurance (my faithful word as an artist is your guarantee) that what I send you will be Art and nothing but, not stuff produced just to make money. EITHER WE AGREE ON THIS OR THERE IS NO POINT IN TALKING ABOUT IT ANY MORE.

I have always said—and [Théo] van Gogh used to think so too—that a lot of money could be earned through me, because: (1) I am fifty-one and have one of the biggest reputations in France and elsewhere; and (2) since I took up painting very late, there were *very few* paintings by me, and most of them are *considered valuable* in Denmark and Sweden. So there is no need to fear with me, as there is with the others, that there will be an endless number of paintings that will constantly have to be bought up. If my wife (even she!) didn't take everything for

herself when she sells a painting, then I'd have been able, long ago, to sell everything I do in Denmark. And once it's there, it doesn't come back to Paris. So for a dealer it's simply a matter of determination and patience and not of a big investment, as with Claude Monet. I estimate that I have done at the most three hundred canvases *since I first began to paint,* and a hundred of those don't count, since they are early things. Among the remainder you have to consider that about fifty have been successfully sold abroad and that a few have been bought by serious people in France who do not resell them. This makes a *very small total* as you can see. And it's worth taking into account, especially since a price of 200 francs is what you pay a beginner, not a man with a *well-established reputation.* I believe that this answers every point raised in your letter. . . .    —*January 1900, Tahiti*

LETTER TO MONFREID   . . . At the last minute I have received a letter from a man I do not know with 150 francs in it so that I will send him a small canvas. I'm writing him saying he should go and see you to choose another one *if* the one I send him doesn't suit him (Mr. Emmanuel Bibesco, 69 Rue de Courcelles).

—*January 1900, Tahiti*

LETTER TO EMMANUEL BIBESCO   Both of your letters have come at the same time as the one from Daniel [de Monfreid] and Vollard.

Yes of course I'd have been happy to carry out the proposed transaction with you, an art lover, instead of with Vollard, an art dealer, who has not only speculated on my poverty but has also done a lot to bring down the prices of my paintings temporarily so as to make a *clean sweep,* as they say.

But we artists can only act as artists, that is, always in good faith and as men of our word; now Vollard writes me that he agrees to everything I want in response to his proposition and has sent me 300 francs in advance, which is a beginning. So we'll have to forget your offer but believe me, I don't thank you any the less for having made it. In my letter, however, I stipulated some clauses with reservations such that at a given time I can sell either old canvases or others of my own choosing and I am

writing to tell Daniel what he should do when a collector comes
to him asking for a canvas. Here, let me digress for a moment:
Daniel sold you five paintings at 150 francs each, an exceptional
price, because he knew I was short of money, but from now on
he will not let go of any painting for less than 500 francs *mini-
mum*. . . . Besides, in view of my contract with Vollard, it would
be dishonest, awkward, and against my own interests to sell for
less than he does. He speculates, it is true, but he is running a
risk because, as I told you, this is only a minimal increase, a fair
and legal one compared with the previous increases and with my
reputation, and with the fact that I have produced so few paint-
ings.

Very cordially yours,                        —*May 1900, Tahiti*

**EXCERPTS OF LETTERS TO MONFREID ABOUT VOLLARD**  . . . What is to be-
come of me if nothing works out with Vollard within the next
three months, with nobody in Paris from now on who can look
after my affairs?

. . . If Vollard decided to put on a show of my things during
the Universal Exhibition, it would be important to choose *good*
paintings, and add drawings and engravings.

This month I am sending him ten drawings, which at 40
francs each, the price he is offering, *makes* 400 francs. . . .

—*March 1900, Tahiti*

. . . This Vollard deal! I have written you at length and by now
you have received my letter. If it doesn't go through, then I
will be more and more in the soup, deeper and deeper in debt
again; right now I place all my hopes in an arrangement with
Vollard.

. . . In my long letter about Vollard I forgot to mention one
thing to you, and I think there is still time to go into it.

If Vollard puts on a show during the Universal Exhibition,
I would like it to be done with a lot of good judgment. By this
I mean that along with the few recent canvases some of the
better old paintings should be shown. Among others, the *Ia
Orana Maria* that is at Manzi's and one or two paintings at

Degas's; and the big canvas, *"Where are we going?"* It doesn't matter if they have *already been shown,* for right now the whole world outside France is on hand and is not familiar with my works.                                                        —*April 1900, Tahiti*

. . . The 300 francs from Vollard every month will be amply sufficient to let me work without having to worry. . . . Once I've begun working again I don't want to have to sell anything dirt cheap, except to Vollard. It is in my interest to make sure I reap my share of benefit from rising prices. So you must hide all my canvases; the ones that *supposedly* can't find buyers will find them one day.

. . . As for the new paintings I sent you, I don't see why Vollard should have first choice of one or another canvas, since as I said to you in my letter those paintings are not to be included in the Vollard deal *at that price.*  —*May 1900, Tahiti*

. . . Any day now I'll get rid of Vollard if he keeps on playing tricks on me. . . .                                      —*November 1900, Tahiti*

. . . Vollard has the nerve to send me 200 francs *intending* to send me 400 francs next month, which means that next month he *will owe* me 600 francs. I am sure you will agree that I cannot go on working under those conditions. . . .  —*November 1900, Tahiti*

. . . Yes, undeniably, Vollard wants to make a fat profit off me and that's why I would so like to be ahead instead of behind so that I could tighten the screw on him good and proper. . . . You see, he asks me how much I want for my big painting; I tell him 2000 francs; he immediately goes to see clients and finds an offer of 10,000. Naturally he writes me to say he'll accept my price of 2000 francs and there is no doubt he is robbing me.

. . . You say that Vollard will take my canvases at 250 francs. He hasn't mentioned it, so I'm lying low, but it *proves* once again how interested he is in having my paintings and how easy it will be, when the time comes, to make the price go up. If only I were ahead in my output! I would write to him right away—and coolly I would say, especially since he is often late and so doesn't keep

his word: "Sir, you have paid me so much in advances, here is your money back. Our contract has come to an end. . . ."

*—December 1900, Tahiti*

. . . Vollard has sent me the balance of what he owed me and was late in paying; it *now seems* to me that he is really afraid I will drop him, which proves he *is very interested* in this deal. As always, he doesn't offer much explanation; for instance, he says he has received ten paintings from you and is very satisfied with them, but he does not tell me whether he has *put them down to my credit* and at what price, 200 francs or 250 francs, which he says he should pay me *from now on.* Please try to get to the bottom of the matter but be discreet about it. . . .

*—February 25, 1901, Tahiti*

. . . If it all works out in a year from now and I have a few thousand-franc notes to my name, I'll see to it that Vollard raises the price of my paintings, or else the hell with him.

*—1901, Tahiti*

*Editor's note: Letters from Gauguin to Vollard, excerpted from the original French text of the correspondence as preserved by John Rewald and published by him in a luxury edition (printing of 500 copies) in San Francisco, in 1943, entitled,* Letters to Ambroise Vollard and André Fontainas. *N.B. The letters from Gauguin to Fontainas had already been published in Paris in 1921 (31 pages, in-16).*

By now I don't understand a thing about your way of doing business and, to be perfectly frank, I am very sorry not to be dealing with Mr. Bibesco. If I gave you what you wanted at such *ludicrous* prices! (you know they were), that was because I was temporarily hard up. *—December 1900, Tahiti*

If this goes on [the rise in prices in Tahiti], the cost of living will be so high that I will be forced to go to the Marquesas, which in the long run would not be such a bad thing, since it would give me completely *new* material for my paintings.

*—April 1901*

Yes, I've decided to go to the Marquesas. . . . It would be to your advantage as well as mine since I have overused Tahiti to some extent and out there I will find a completely new atmosphere that will make me do good work.                                —*May 1901*

. . . I'll have to go to Tahiti to defend myself by appealing a case (I've been sentenced to three months in jail and a fine of 500 francs). I *am sure* of winning but even so, paying for the trip and the legal costs is going to get me deeper into debt. . . .
—*April 1903, Marquesas*

LETTERS    TO MONFREID    . . . My paintings and sculptures should be kept safe.

Speaking of sculptures, I would like the very few I have done not to be scattered. . . . The large pottery figure[59] which has not found a buyer—whereas Delaherche's ugly pots sell for high prices and go to museums—I would like to have it to put on my tomb in Tahiti, and before that, as the ornament of my garden. Which means that I would like you to send it to me, carefully packed. . . .                    —*October 1900, Tahiti*

TO MONFREID    . . . In the Marquesas, where it is so easy to get models (something which is becoming harder and harder in Tahiti) and there are open landscapes, in short, completely new and wilder elements, I think I will do some fine things. Here my imagination was beginning to go cold, and also the public was getting too used to Tahiti. People are so stupid that when they *are shown* canvases containing new and terrifying elements, Tahiti will become comprehensible and charming. My Breton canvases have become rose water because of Tahiti; [those of] Tahiti will become cologne water because of the Marquesas.
—*June 1901, Tahiti*

TO CHARLES MORICE    . . . Today I've hit bottom, defeated by poverty and, above all, the illness of an altogether premature old

---

59. This is *Oviri* (savage) with which Gauguin identified personally.

age. Will I have any respite in which to finish my work? I dare not hope so; at any rate, I will be making a last effort next month by going to live at Fatu Hiva, one of the Marquesan islands where there is still some cannibalism. I think that there, the altogether wild element, the complete solitude will give me a last burst of enthusiasm which will rejuvenate my imagination and lead to the fulfillment of my talent before I die. . . .

*—July 1901, Tahiti*

TO MONFREID . . . I have always said, or if not said, at least thought, that a painter's literary poetry is special, and not the illustration or the translation, through shapes, of something written. In other words, what you should try for in painting is suggestion rather than description, just as in music. I am sometimes reproached with being incomprehensible precisely because people look for an explanatory meaning in my paintings, whereas there isn't any. We could talk about this at length without coming to any positive result; so much the better, I say; the critics talk nonsense and we rejoice over it if we have a legitimate feeling of superiority and the satisfaction of duty done. Bunch of blockheads who want to analyze our pleasures. Or do they actually suppose that we are obliged to make them feel pleasure? . . . *—August 1901, Tahiti*

TO MONFREID . . . I feel happier and happier about my decision, and I guarantee you that from the standpoint of painting, it's admirable. Such models! Marvelous, and I have already begun working.

. . . How right you are about the notoriety to be gained from the press! A clear conscience first of all, and the esteem of a few people, the aristocrats who understand: beyond that, there is nothing.

You know my views on all these false notions of Symbolist or other types of literature in painting, so I don't need to repeat them; besides, you and I agree on this subject, and so does posterity, since the works that are sound and healthy last in spite of everything and all the critico-literary maunderings in the

world cannot change that. Perhaps I am overvain when I congratulate myself on not having fallen into all the traps which praise from the press would have led me into, as it has so many others, Denis, for instance, and perhaps Redon as well. And although I was vexed I smiled when I read so many critics who had not understood me.

Besides, in my isolation here, a man really gets a fresh start. Here poetry is created all by itself, and all you need do in order to suggest it is give way to your dreams while you paint. All I ask is two years of decent health and not too many financial worries, which have too strong a grip at this point on my nerves, and I will achieve a certain maturity in my art. I feel that where art is concerned I am right, but will I have the strength to express it affirmatively? At any rate I will have done my duty, and even if my works do not last, there will always be the memory of a painter who freed painting from many of its former academic failings and Symbolist failings (another type of sentimentalism). . . .    —*November 1901, Hiva Oa, Marquesas Islands*

TO MONFREID . . . For two months I have been filled with one mortal fear: that I am not the Gauguin I used to be. These past few years which have been terribly hard and my health, which I am slow in recovering, have made me extremely impressionable, and being in that condition I have no energy whatsoever (and no one to comfort or console me), utter isolation.

. . . What you say about Morice's collaboration on *Noa Noa* does not displease me. As far as I was concerned, that collaboration had two purposes. It is not like other cases of collaboration, that is, two authors working jointly. The idea had occurred to me, when speaking about noncivilized people, to bring out their character alongside our own, and I thought it would be rather original for me to write (quite simply, like a savage) and next to that have the style of a civilized man, which is what Morice is. So I thought of our collaboration and arranged it to that end; then too, writing is not my line of work, as they say, which of us two was the better: the naïve and rough-spoken savage or the man rotted by civilization? Morice decided to publish the book

anyhow and at an inappropriate time; that does not dishonor me, after all.                —*May 1902, Hiva Oa, Marquesas Islands*

TO ANDRE FONTAINAS   I am sending you this little manuscript written in haste, so that once you have read it (and if you approve of it) you can ask the *Mercure de France,* on my behalf, to publish it. I have two reasons for not sending it directly to the *Mercure.*

The first reason is that you are the *Mercure*'s art critic and you might think I was acting out of spite, whereas I would be doing no such thing.

The second is that I receive the *Mercure* free of charge. Being poor, perhaps it is better for me to keep quiet.

What I write does not have any literary pretensions, but it does express a profound conviction, and I want to share it. . . . All my work from the beginning down to this very day (as can be seen) is a single body of work, with all the gradations that the education of an artist implies. On all that I have kept mum and will continue to do so, as I am convinced that it is not polemics but all the paintings a man has done which bring out the truth. Besides, the fact that I live utterly cut off from society is enough to show that I do not run after fleeting glory. My pleasure is to see talent in other people.

I'm writing you all this because I value your esteem; I would not want you to misunderstand my manuscript, to think I intended it as a means of getting publicity. No. . . . Only, I feel secretly angry when I see a man like Pissarro maltreated. I wonder whose turn it will be tomorrow.

When I am maltreated, that is something else again; it doesn't bother me. I say to myself: Well well, maybe I am something!                —*September 1902, Atuona*

TO MONFREID   . . . By the time you receive this letter you will probably already have read, if the *Mercure* published it, the article of countercriticism which I sent in. I think it will be to your liking, for I did my best to prove that in no case do painters need the support and didactics of men of letters.

I also tried to do battle with the parties which, in every era,

lay down dogmas and baffle not only painters but also the art-loving public. . . . You have long known what I have tried to establish: the right to dare everything; yet the difficulty I have had finding enough money to live on has been too great, and my capacities have not produced a very big result but the mechanism has got under way nevertheless. The public does not owe me anything because the pictorial work I have done is only relatively good, but the painters who benefit from that freedom today do owe me something.

It is true that many people suppose it all came about of itself. Anyhow I don't ask them for anything and my conscience is enough reward.        —*October 1902, Marquesas Islands*

TO MONFREID   . . . I have had a letter from Fontainas saying that the *Mercure* has refused my article. I had a feeling that would happen. They're all the same; they want to criticize painters all right, but they don't like it when the painters come along and prove how stupid they are. . . .        —*February 1903*

TO ANDRÉ FONTAINAS   . . . Your kind letter does not surprise me where the *Mercure*'s rejection is concerned: I had a feeling that would happen. On the *Mercure* there are men like Mauclair, whom you can't so much as lay a finger on. That's more the real reason than my article not being topical. . . .

—*February 1903, Atuona*

# *"Racontars de Rapin"*

## (Excerpts)

*Editor's note: The 1902 article which was sent to, and refused by, the* Mercure de France *was published much later—in 1951—thanks to* Mme. Joly-Segalen, *with the title "Racontars de Rapin" (Dauber's Gossip).*

I am going to try to talk about painting, not as a man of letters but as a painter. . . . There will be much, possibly too much, about criticism, but it will be up to the critics and the public to take into account the exaggerations of an unruly mind.

. . . Plastic art calls for too much thorough knowledge: it demands the whole lifetime of a superior artist—especially when instead of being general it becomes particular, individual —and has to take into account the specific nature of the person devoting himself to art, the milieu in which he lives, and the upbringing he has had. An artist must look to the future, whereas the so-called learned critic has learned only from the past. And what does he generally remember about the past except names in catalogues?

No matter how precocious a critic may be intellectually, no matter how diligently he goes through the museums, he cannot in so short a time acquire a profound knowledge of the ancients, when we who have special gifts, for whom this is our goal, our reason for living, we ourselves barely succeed in penetrating the secrets of the masters.

Did Giotto know perspective? If so, why didn't he use it? **215**

We wonder why Velázquez' *Infanta* (La Caze Gallery)[60] has shoulders that are merely artificial and why her head does not fit onto them. And the effect is good. Whereas a head by Bonnat fits onto real shoulders; and the effect is bad!

Meanwhile Velázquez is still a master, although Carolus-Duran corrects him.

The plastic arts do not easily give away their secrets; in order to guess them you must scrutinize those arts unceasingly while inwardly scrutinizing yourself. Complex arts if ever there were any. They include everything—literature, observation, virtuosity (I did not say dexterity), visual gifts, music.

. . . In our day and age, the critics are educated, talented men who criticize conscientiously, unselfishly, devotedly, with conviction, with feeling even. But this is nothing new! Just as a reminder, let's mention two from the past: Taine and Saint-Victor.

The former talked about everything except painting (read *Essai de critique,* by Albert Aurier).

The latter, more affirmative, talked chiefly about painters. Marchal, the great Marchal, he used to say. Poor painter hoisted up onto a gigantic pedestal that made him dizzy, and he killed himself. Who has ever heard of him today? Whereas Millet, on the other hand, was labeled vulgar, was accused of delighting in dung, and Saint-Victor buried him in a coffin. Thank God, Millet has got out of it; yet back in 1872, he had trouble finding someone to pay him 50 francs for some drawings so that he could pay the midwife.[61] Probably the sacred words spoken by Monsieur de Saint-Victor were the cause of all this destitution.

Don't these examples give us pause? Don't they suggest that mistakes can be made in any day and age?

. . . Does anyone remember the Puvis de Chavannes banquet? All the cities, the guilds, and the State sent representa-

60. In the Louvre. (Translator's note.)

61. Gauguin had already noted this in "Miscellaneous Things": "In 1872, when Millet's wife was about to give birth, he went up and down the whole of the Rue Laffitte trying to sell three drawings at any price. He finally got 50 francs for the lot. . . ." (Louvre manuscript, p. 372.) Also, see above, p. 34–36, the article written in 1889, "Who Is Being Deceived Here?"

tives who were to make speeches. Monsieur Brunetière, who was already signed up, represented art criticism. Now, everybody knows that Monsieur Brunetière is a remarkable and learned man, a writer, a logician, etc., a man whose words carry weight in elite society. He spoke:

"Monsieur Puvis" (in speaking of Puvis the word "monsieur" was funny), "Monsieur Puvis, I must congratulate you on having produced great painting with pastel tones, without being carried away and using gaudy colors." That was all but it was enough. I was there and I protested.

The word "Impressionism" was not spoken, but it was there, between the lines. Do you notice the dogma of light-toned painting without colors? Monsieur Brunetière does not like rubies and emeralds, only pearls! I see the pearl, but also the shell.

Perhaps Monsieur Brunetière will read this. He will smile disdainfully and will say: "Monsieur Gauguin must attend the Ecole Normale first, and then we will talk." Will he be right? First, government by men of arms; now, government by men of letters.

I often read: "No one knew better than he how to paint the mushroom's poison. No one knew better than he how to catch woman's fleeting grace. No one . . ." All the jobs have been filled, you see; there is nothing left for us.

The critic teaches us to think; gratefully, we would like to teach him something. Impossible: he knows everything.

. . . Knowing how to draw does not mean drawing well. Let's have a look at that much-vaunted science of drawing. But it's a science that all the Prix de Rome winners have mastered, as have even the contestants who came out last; a science that all of them, without exception, have mastered in a few years. . . .

One painter who has never known how to draw but who draws well is Renoir. . . . In Renoir's work, nothing is in its rightful place; don't look for line, there is none; as if by magic, a pretty spot of color, a caressing light are eloquent enough. A light down ripples on the cheeks as it does on a peach, stirred

by the breeze of love that whispers its music to the ears. You'd like to bite into the cherry that expresses the mouth, the laughing mouth that reveals one sharp little white pearl of a tooth. Be careful, it bites cruelly; it is a woman's tooth. Divine Renoir, who does not know how to draw.

. . . If we look at Pissarro's art as a whole, despite its fluctuations—Vautrin is always Vautrin, despite his many incarnations[62]—we find not only an enormous artistic determination which never wavers but, in addition, an essentially intuitive thoroughbred art. No matter how far away the haystack is, over there on the slope, Pissarro takes the trouble of going there, walking all around it, examining it. He has looked at everyone, you say! Why not? Everyone has looked at him too but disowns him. He was one of my masters and I do not disown him.

In a display case, a charming fan by Pissarro. A simple gate, half-open, separates two very green (Pissarro green) meadows; a troop of geese files through it, their eyes on the alert, asking one another anxiously, "Are we going to Seurat's or Millet's?" Finally they all go to Pissarro's.

. . . Mr. Critic, you can't claim to have discovered Cézanne. Today you admire him. Admiring him (which calls for understanding), you say: "Cézanne is monochromatic." You could have said polychromatic or even polyphonic. You must have an eye and also an ear! "Cézanne doesn't have antecedents; he is content to be Cézanne!" There you are mistaken, otherwise he would not be the painter he is. Unlike Loti, he has read; he knows Virgil; he has looked with understanding at Rembrandt and Poussin.

. . . Farther on, our dear critic gives advice, in his pedantic manner. "Take care," he says to Carrière; "another step and you will trip and fall into obscurity. Yet we loved you and we

62. Allusion to the former convict with the many metamorphoses, a character whom Balzac used in several of his novels, particularly in *Splendeurs et Misères des Courtisanes (A Harlot High and Low)*, the last part of which is entitled, "Vautrin's Last Incarnation."

admired you. Now there are only apparitions which it is almost impossible for us to make out."[63]

I do not know and I do not need to know what is going on in Carrière's soul. His soul belongs to him. Perhaps Carrière, tired of talking to deaf people, now wants to talk only to those loyal to him, saying to them: "Set the seal on what I tell you." I will be among those who do.

. . . At an exhibition in London, one sagacious critic wrote: "Monsieur Degas seems a good pupil of Nittis!" Doesn't this reflect that mania which men of letters have for squabbling in court over who had a given idea first? And the mania spreads to painters who take great care of their originality, as women do of their beauty. And then too, it's so convenient to complain: "Ah! Thingumbob has reaped the fruit of my efforts, he has stolen everything from me and I have nothing left."

. . . No, no, a thousand times no; an artist is not born as such all at once. If he adds one new link to the chain that has already been begun, that in itself is a great deal.

. . . I read what gets written. Reading in the wild woods is not the same thing as reading in Paris. Reading so far away, I was astonished that the men of letters had refused Rodin's *Balzac*, a statue which I have not seen and cannot judge. But to think of Rodin, who, if not the greatest sculptor, is at least one of the few great sculptors of our day, rejected by the men of letters! That frightens me more than the catastrophe in Martinique. Did Rodin forget to consult the critics to make the comparison between the literary art and the plastic arts?

. . . What did Delacroix mean when he talked about the music of a painting? Make no mistake about it, Bonnard, Vuillard, and Sérusier, to mention a few of the young painters, are musicians, and you can be sure that colored painting has entered a musical phase. Cézanne, to mention an "old" painter, seems to be a pupil of César Franck; he is constantly playing the

---

63. In "Miscellaneous Things" Gauguin had noted: "A painting by Carrière: The beautiful colors exist and are indistinctly seen."

organ, which is what made me say that he was polyphonic.

. . . Our feelings, when we see or read a work of art, are due
to a number of things. . . . If a critic wants to accomplish his real
task as a critic, then, above all, he must mistrust himself instead
of trying to find himself in the work.

My neighbor in the bush is an old man whom death seems
to spurn. His tattoos and his thinness make him frightening.
Once upon a time he was punished for cannibalism; then he was
brought back before his sentence had ended. A prankish Italian
captain, who wanted to do me a favor, told the man that it was
I, formerly all-powerful, who had interceded in his favor. I did
not deny it, and this proved useful to me. For the old man,
whom no one has ever been able to baptize as a Christian, is still
looked on by all as a witch; and he has designated my person
and my house as taboo: in other words, I am sacred.

Although the people have learned from the missionaries all
the superstitions that the men of religion have taught them, they
still keep their ancient traditions alive.

This old man and I are friends and I give him tobacco,
which does not surprise him. Sometimes I ask him if human
flesh is good to eat; that is when his face lights up with an infinite
gentleness (a very special gentleness that savages have) and he
shows me a fearsome set of teeth. One day, out of curiosity, I
gave him a can of sardines. It didn't take long: with his teeth he
opened the can without hurting himself and he ate the whole
thing, down to the last morsel. As you can see, the older I get,
the less civilized I get.

One more story; it will be the last one. Very shortly after
my arrival in Fatu Hiva, I had a simple bamboo hut, a bit of bush
cleared away, a path.

The sun had just disappeared, its red glow outlining the
mountain. Seated on a stone I was smoking a cigarette, thinking
of I don't know what, or rather, not thinking of anything, as
people do when they are tired. Before me the bush had just
parted to let through a shapeless creature preceded by a stick.

Walking slowly, its ass very close to the ground, it was coming straight toward me.

Was it fear or something else that chilled me through? Without saying a word I held my breath. These few minutes seemed to me a quarter of an hour. I grabbed the stick as it explored and deliberately said, "Boo!" in a voice like a low moan.

At last I could make out a completely naked body, skinny, shriveled, and tattooed all over, which made it look like a toad.

Then, without uttering a word, her hand examined me. First my face and then my body (I too was naked; except for a *paréo* at the waist), I felt a dusty hand, cold with the cold that is peculiar to reptiles. Terrifying feeling of disgust. When it came to the navel, the hand parted the cloth and attentively touched my sex. *"Pupa"* ("European"), she exclaimed in a sort of grunt, then she went away, still in the same position, toward the bush in the other direction.

You must realize that when the native males reach adulthood, they undergo, by way of circumcision, a veritable mutilation; the scar it leaves is an enormous fold of flesh, conducive to exquisite moments.

The very next day I made inquiries and learned that for a very long time this blind madwoman had been living like that in the bush, eating what the pigs left. God in his infinite goodness let her live. She could tell the time of day and of night and could not bear to wear the slightest article of clothing, except for a flower necklace that she knew how to make very well herself. Everything else she tore into shreds.

For two weeks the obsessive vision remained with me, and all my work at the easel was impregnated with it in spite of myself. Everything around me took on a barbaric, savage, fierce look. Coarse, Papuan art.

The events of the Revolution put an end to eighteenth-century art. Then came the many years of destruction, the soldiers, the bureaucracy. Throughout this whole period the arts came to a complete standstill; mental activity was directed elsewhere.

I don't want to speak ill of the new lords, generals of humble origin who account for much of French glory; but it is obvious that those new lords, and in fact the entire nation, were receptive only to politics, to the idea of country. Napoleon I, who is supposed to have reconstituted everything, reconstituted art as well in the form of a code. There were no more painters, only professors.

Thanks to this system there were well-tended schools harboring plaster statues of David, just as we find our Presidents of the Republic in public monuments. Whereas until then there had been a language in each province, mindful of fine traditions, now there was a sort of "Volapük"[64] of tried and true recipes. It was an iron rod as well. Nothing was overlooked in the campaign to hustle things along. Courses in drawing from antiquity, anatomy, perspective, history, etc.: a single language.

When the State backs something, it does it thoroughly. Everywhere, patented professors guaranteeing perfection, and enormous mediocrity. And this Volapük is still spoken, and its word is law! What can you do with such a language, such infamous jargon? Although it was convenient for the mediocre, on the other hand it was a terrible torment for men of genius.

Among them, Delacroix, always in conflict with the schools and their attitude: how could such vile drawing be married to so beautiful a fiancée as the use of color he had begun to glimpse? Hence this maxim they still intone at the Ecole des Beaux-Arts: "Delacroix is a great colorist but he does not know how to draw."

At about the same time, the obstinate and strong-willed Ingres, likewise realizing the incoherence of such a language, simply set about reconstructing a logical and beautiful language for his own use, keeping one eye on the Greeks and the other on nature.

Since in Ingres's work drawing was a matter of line, people

64. Alias: Esperanto. (Note by Gauguin.) Volapük was actually supplanted by Esperanto. A supposedly universal language, Volapük was devised in 1879 by Johann Martin Schleyer, but the preference went to Esperanto, invented by Dr. Lazarus Ludwig Zamenhof ca. 1887.

did not notice the change so much. Yet he took a considerable step. No one in his entourage understood this, not even his pupil Flandrin, who never spoke anything but Volapük and who, for that very reason, was looked upon as the master while Ingres was relegated to the background—from which he emerges today, resplendent.

Ingres and Cimabue have points in common, among them the ridiculous, the beautifully ridiculous, the kind of thing that would make you say: "Nothing looks more like a bit of daubing than a masterpiece." And vice versa. Cimabue's virgins, because of their ridiculous aspect, are closer to the phenomenon become dogma (Jesus as the offspring of a Virgin and the Holy Ghost) than any other ordinary run-of-the-mill maiden.

. . . A shoulder, Ingres would tell his pupils furiously, is not a tortoise's shell. Anatomy is an old acquaintance, but not a friend. In spite of his official status, Ingres was certainly the most misunderstood painter of his day; possibly it was for that very reason that he was the official painter. People did not see the revolutionary in him, the reconstructor; in that very respect the Ecole did not follow him. Ingres died, and must have been badly buried, for today he is on his own two feet again, not as an official painter but altogether differently. He could not be the man of the majorities.

. . . After the events of 1870, the number of people at the opening of the Salon was tremendous.

Defeated soldiers filled with hate for the Prussians, and proud of their vile reprisals against the Commune. Serenely, without shame, the great Bonnat was little Thiers's painter. After Thiers, MacMahon, the killer of cuirassiers, reviewed the troops, so to speak, at the opening of the Salon. French painters, salute! Here is your commander ordering you, "Atten*tion!* Forward, march!" And everybody fell into step. Behind him, Meissonier, colonel of the national guard, also ordered: "Forward, march!" Meissonier, the painter of those armored hordes where everything looked like iron—except the armor.

Everyone became involved—the State, for one thing, with all its fake luxury, its decorations and purchases. . . . For an-

other, the Press and high finance: speculation. And also the large number of artists, and the amount of women's influence.

. . . Zola ushered in trivial naturalism and pornography, the pornography of things read between the lines. So many portraits of distinguished women looking like infamous whores. Semi-nudity. In the journalistic spirit, painting became a matter of minor news items, puns, serialized romances. Photography made it a matter of haste, easy effects, and accurate drawing. Again, Ingres was knocked over.

. . . And that, in brief, is where art stood twenty-five years ago, in spite of exceptions. A huge prison, but also a compulsory brothel. The kings have their tombs in Saint-Denis. The painters have theirs in the Luxembourg.

With the permission of the director of the Beaux-Arts and of the Council of State, donors and inspectors introduced, within the space of a few years, selections from Daumier, Puvis de Chavannes, Manet, and from the Caillebotte collection. I understand their good intentions but I cannot agree with them.

The Luxembourg was a house of prostitution.[65] Either the people in charge blushed for shame and wanted to wipe away that ugly blot; in which case they should have destroyed it from top to bottom, rather than bringing in decent citizens and mixing them with the others. Or else they wanted (which is probable) to honor unknown, decent citizens. A funny way of doing honor to decent girls—taking them to the brothel and telling them: "Now you are at the public's service; you do as the madam and her assistant tell you."

. . . Where things become interesting, where they become a page out of the history of end-of-the-century art, is when you go to the Panthéon. Unconsciously, no doubt, the State has brought all the official top people face to face with a single man. Everything the critics may say and everything I have just said becomes useless when you are at the Panthéon.

Attila's defeated hordes charmed by little Geneviève are

---

65. For many years the Luxembourg Museum was supposed to be devoted to modern art.

not in the paintings. The barbarians are the painters themselves. Saint Geneviève is Puvis de Chavannes, who drives them away from Paris forever. What finer lesson for the painters and the critics could there be than that?

I wouldn't swear it, but I think that the first exhibit by a little group, since called "Impressionists," took place in 1872. Where did these bohemians come from? From the wolves undoubtedly, since they had no collars. Although almost classic and very simple, their paintings seemed odd: no one ever knew why.

People laughed uncontrollably. Surely it wasn't meant to be taken seriously; surely it was an escapade, a joke. A few experts on insanity were called in but as no provision had ever been made for such a case, they did not dare say it was madness. A few oculists hesitantly suggested color blindness.

Yet it was meant seriously and the Salon did not realize it; otherwise it would have opened its doors wide so as to lose the Impressionists in the crowd and (perhaps) appease them by giving them a little bone to gnaw on. However that may be, the official Salon did not see any cause for worry, and matters became serious indeed, very serious. I will not go into their history; everybody knows it. I point it out only as a way of noting one of the most influential efforts ever made in France, only a handful of men, with only one weapon, their talent, successfully doing battle against a fearsome power made up of Officialdom, the Press, and Money.

But it was merely the pictorial triumph of a certain type of painting—which by now has more or less cleverly fallen into the public domain—and is exploited abroad, exploited by a few dealers, and by a few collectors-cum-speculators.

But it is also a school (one more school, with all the slavery that that implies). Yet another dogma. There are people who like dogma: the neo-Impressionists who followed later tried another and possibly more redoubtable dogma, for this one is scientific and leads straight to color photography. I am talking about the dogma and not the neo-Impressionist painters, who have a good deal of talent. They ought to remember that it is not method that constitutes genius.

So it was necessary, with due consideration for the efforts made and for all the research, even if it was scientific, to attempt complete liberation, to smash windows, even at the risk of cutting one's fingers, and leave it up to the next generation, independent henceforth, free of all hindrance, to solve the problem brilliantly.

I will not say "definitively," for what we are talking about is actually an endless art: it uses a wealth of different techniques and is capable of rendering all natural and human emotions, fitting itself to the joys and sufferings of each individual and each era.

This meant giving oneself over body and soul to the struggle, fighting against all the schools (all of them, indiscriminately), not by denigrating them but in another way—by tackling not only what is officially recognized but also the Impressionists, the neo-Impressionists, the old public and the new. Not having a wife any more, or children who disown you — Disregarding insults, disregarding poverty. . . . Doing everything that is forbidden, and then rebuilding more or less successfully without being afraid to exaggerate—exaggerating, in fact. Learning anew, then, once that has been assimilated, learning again; overcoming all bashfulness, regardless of the ridicule which that brings you. When a painter stands before his easel, he is a slave neither to the past nor to the present, neither to nature nor to his neighbor.

. . . This effort I'm talking about was made about twenty years ago; it was made secretly, in ignorance, but with determination, and it became gradually stronger.

Let everyone claim credit for what has been achieved! It doesn't matter. What does matter is what exists today and what will pave the way for the art of the twentieth century. Nothing happens by accident. It was no accident that, at a given time, alongside floundering officialdom, a whole new generation of surprising intelligence and varied art emerged and seemed, with each new day, to solve all the problems to which no one had given any thought earlier. The Bastille had awed people but it had been demolished, and the open air was good to breathe.

All doors were open to them; in fact they were made welcome from the very beginning. Today, boldness is no longer blackballed; it is snobbish to be bold. All the obstacles put up by ridicule have been hurdled. When they want to exhibit their work, the painters choose the day, the hour, the hall that suits them. They are free. There are no juries. Now it is not MacMahon but, instead, admirers who know about art and who say to them: "Forward, march!" This is more encouraging and also more noble than a medal of honor.

. . . In this way we have conquered all of Europe, which should console us for the loss of two provinces, and, above all, in recent times we have created the freedom of the plastic arts.
—*September 1902, Atuona*

TO MONFREID   . . . Lately, during my long sleepless nights, I have   LETTERS
been setting down in writing what I have seen, heard, and thought during my lifetime. It includes things that are very harsh for some people, especially for my wife's behavior and for the Danes. . . .   —*February 1903, Marquesas Islands*

TO ANDRÉ FONTAINAS   I have just written a whole volume of childhood memories, the reasons for my instincts, for my intellectual development; also what I have seen and heard (including criticism of men and of things), my art, other people's art, the things and people I admire, also those I hate. This is no literary work deliberately cast in a chosen mold. It is something else: the civilized man and the barbarian face to face. The style has to be in keeping, laid bare, showing the whole man, often shocking. That comes easily enough. I am not a writer.

I will send you the manuscript by the next mail; on reading it you will understand, between the lines, that I have nasty and personal reasons for wanting this book to be published. It must be published, even if only in a very plain edition; I am not anxious to have it read by many people, just by a few.

But why am I entrusting this to you, a man I do not know intimately? Once again that strange nature of mine, my instinct. Although far away, I trust you blindly. So I am burdening you

with responsibility for a serious matter, a toilsome task. Because of it I am writing to a friend . . . telling him[66] to sacrifice everything I showed in my first Tahiti exhibit (to sell it at any price he can get so as to find the money that will be needed to publish this book).

If then you are willing to take on the task, and I am sure you won't want to disillusion me and make me very unhappy, please take what was written for the *Mercure* and insert it into the book wherever seems suitable to you.

The drawings are like the style, very unusual, sometimes offending. I would be very grateful to you (whatever happens) if you kept the manuscript and its sketches as a souvenir of me in some corner somewhere, as a savage curio, and not in a drawer where you collect precious objects. This is not by way of payment, or barter *(troki-troka)*. We natives of the Marquesas do not deal that way; but we do know when to hold out our hands in a friendly gesture. Our hands are never gloved.

In your gracious letter, you say to me: "Why don't we see any of your works any more? Do you despise yourself to that extent?" No, I do not despise myself, on the contrary; but here's the thing: for several years I have had eczema on my feet and halfway up my legs, and especially in the past year it has been so painful that it is impossible for me to do any sustained work; I sometimes go two months at a time without even picking up a brush. . . . If I succeed in getting over it, or at least if it gives me less pain, then the harm will not have been too serious, for my brain continues to function and I'll get back to work and try to find a sound conclusion to the work I have begun.

In fact, in the most desperate moments this is the only reason that prevents me from blowing my brains out. My faith is invincible. You can see, dear Monsieur Fontainas, that I do not despise myself. I am afraid of one thing, of going blind. . . . If that happens, then I will be defeated.

—*February 1903, Atuona*

66. Monfreid.

## *Avant et Après*

*Editor's note: Rearranged in a more coherent order, and with subtitles that I have added, here are extensive passages from the "scattered notes" that Gauguin wrote a few months before his death in the Marquesas on May 8, 1903. The length of the manuscript makes it a real book, although Gauguin denied it ("This is not a book," he says in it time and again). An uneven but often admirable compendium of what Gauguin had "seen, heard, and thought" during his lifetime, it frequently rises to the level of an autobiography and a testament. It was not published until long after its author had died: first of all, Kurt Wolff, in Munich (1914), brought out a facsimile of the original manuscript, with its handsome black-and-white monotypes. But it was not until 1923 that the book was printed, by the publisher Georges Crès in Paris. In 1948 Paul Carin Andersen, publisher in Copenhagen, reproduced the facsimile edition.*

**DEDICATION**  To Monsieur Fontainas, all this, all that, prompted by an unconscious feeling, born amid isolation and wildness. . . .

. . . Small preface . . . I believe . . . that far too much is written these days. Let's be clear about it.

Many many people know how to write, that is undeniable; but very few, terribly few, have any idea of what constitutes literary art, which is a very difficult art. The same is true of the plastic arts, and yet everyone dabbles in them. It is every person's duty to try his hand, to exert himself. Alongside art, very pure art, there are also, given the richness of human intelligence

and of all its faculties, many things to be said and they must be said.

And there you have my preface. I did not want to write a book that would bear the slightest resemblance to a work of art (I would not know how); but as a man who is very well informed on many things that he has seen, read, and heard all over the world, the civilized world and the barbarian world, I wanted to strip completely naked, without fear and without shame, and write . . . about it all.

It is my right to do so. And no critic can prevent it from being my right, infamous as it may be.

. . . I'm not a professional. I would like to write the way I do my paintings, that is, as fantasy takes me, as the moon dictates, and come up with a title long afterward.

Memories! That means history. That means a date. Everything in it is interesting—except the author. And you have to tell who you are and where you come from. Making a confession—ever since Jean-Jacques Rousseau, that has been no slight affair. If I tell you that by the female line I descend from a Borgia of Aragon, viceroy of Peru,[67] you will say that it is not true and I am pretentious. But if I tell you that the family is a family of sewer cleaners, you will hold me in contempt.

If I tell you that on my father's side they were all named Gauguin, you will say that that is unbelievably naïve; and if I explain what I mean, that I am not a bastard, skeptically you smile.

The best thing would be to keep quiet, but keeping quiet when you feel like talking is an imposition. Some people have a goal in life, others do not. For a long time people have harped at me about virtue: I know virtue, but I do not like it.

. . . Even so I am not one of those who speak badly of life. One suffers, but one also experiences pleasure and,

67. Don Pio de Tristan Morosco, a Spaniard from Aragon, great-uncle of Gauguin's mother, was an interim viceroy of Peru.

however little it may have been, that is what one remembers.

. . . Scattered notes, unconnected, like dreams; like life, made of bits and pieces. . . . This is not a book. . . . Various episodes, countless thoughts, certain jokes all come into these pages from who knows where, converging and separating; a child's toy, shapes in a kaleidoscope. Sometimes serious, often playful, at the whim of frivolous nature; they say man drags his self around with him. . . . I remember having lived; I also remember not having lived. To daydream is roughly the same as to dream asleep. The sleeping dream is often bolder, sometimes a little more logical.

. . . We already know it, you will say, but it is a good idea to say it again, incessantly, always: like a flood, morality crushes us, stifling freedom, hating brotherhood. Asshole morality, religious morality, patriotic morality, the soldier's and the gendarme's morality. Duty in the performance of one's duty, the military code, pro-Dreyfus or anti-Dreyfus.

Drumont's morality, Déroulède's morality.

The morality of public education, of censorship.

Aesthetic morality; certainly the critic's morality.

The morality of the magistrature, etc.

These pages will not change anything but . . . it's a relief to write them.

. . . The evasive use of words, the tricks of style—brilliant dodges that sometimes suit me as an artist, but do not suit my barbarian's heart, so tough, so loving. One understands them and practices wielding them; luxury that agrees with civilization and whose beauties I do not disdain.

Let us learn how to use and delight in them, but freely; soft music which at times I like to hear, until my heart seeks silence.

There are savages who sometimes get dressed.

My grandmother was quite a woman. Her name was Flora Tristan. Proudhon said she had genius. Not knowing anything about it, I rely on Proudhon.

MEMORIES OF YOUTH

She created a whole lot of socialist things, among others the Union ouvrière. The grateful workers erected a monument to her in the cemetery in Bordeaux.

She probably did not know how to cook—a socialist blue-stocking, an anarchist. Father Enfantin and people generally credit her with starting Compagnonnage,[68] and with founding a certain religion, the Mapa religion, in which Enfantin is said to have been the god Ma and she the goddess Pa.

Where the truth ends and the fable starts, I can't begin to say and I am telling you this for what it is worth. She died in 1844; many delegations followed her coffin.

What I can be sure of, however, is that Flora Tristan was a very lovely and noble lady. She was a close friend of Mme. Desbordes-Valmore. I also know that she used her whole fortune in support of the workers' cause and traveled constantly. At one point she went to Peru to see her uncle, the citizen Don Pio de Tristan Morosco (Aragon family).

Her daughter, who was my mother, was brought up in a boarding school, the Pension Bascans, an essentially republican establishment.

It was there that my father, Clovis Gauguin, met her. At the time my father was a political reporter for Le National, the newspaper of Thiers and Armand Marrast.

After the events of 1848 (I was born on June 7, 1848), did my father foresee the coup d'état of 1852? I do not know. Be that as it may, he conceived the idea of going to Lima, where he intended to found a newspaper. The young couple had a little money.

Unfortunately the captain of their ship was a dreadful man; this did my father terrible harm as he suffered from severe heart disease. As a result, when he was about to go ashore at Port

---

68. System of itinerant apprenticeship. [Translator's note.] If Father Enfantin (mistakenly) attributed the founding of the already old Compagnonnage system to Flora Tristan, it was doubtless because of her travels throughout France, for the purpose of visiting workers. (See Biographical Index, Flora Tristan's *Tour de France.*)

Famine, in the Straits of Magellan, he collapsed in the whale-boat. He was dead of a ruptured aneurysm.

This is not a book, and it is not a collection of memoirs either; I just happen to be telling you about them because right now my head is full of recollections of my childhood.

The old man, the very old uncle, Don Pio, positively fell in love with his niece, who was so pretty and looked so much like his beloved brother, Don Mariano. Don Pio had remarried at the age of eighty and from this new marriage he had several children, including Echenique, who was to be for a long time President of the Republic of Peru.[69]

All this made for a large family, and in its midst my mother was as petted and spoiled as a child.

I have a remarkable visual memory, and I remember that period, our house, and a lot of things that happened; I remember the President's monument, the church whose dome, entirely carved out of wood, had been added on afterward.

I can still see our little Negro girl, she who, according to custom, must carry to church the little rug one kneels on. I can also recall our Chinese servant who ironed so well. It was he, in fact, who found me in a grocery store, where I was sitting between two barrels of molasses and sucking sugar cane, while my weeping mother was having them look for me everywhere. I always had a fondness for running away; in Orléans, when I was nine years old, I took it into my head to run away into the forest of Bondy with a handkerchief filled with sand on the end of a stick I carried over my shoulder.

I had seen a picture which appealed to me, showing a vaga-bond with his stick and his bundle over his shoulder.[70] Watch out for pictures. Luckily, the butcher took me by the hand as I was walking along the road and, saying I was a naughty boy, led me back to my mother's house. As a very noble Spanish lady, my mother had a violent nature, and her little hand, flexible as

69. Gauguin was mistaken: Echenique had married Don Pio's eldest daughter and was his son-in-law.
70. It was probably a picture of the Wandering Jew.

India rubber, gave me several slaps. It is true that a few minutes later, my mother was crying, hugging and petting me.

But let's not get ahead of the story; let's go back to the city of Lima. In Lima in those days, in that delightful country where it never rains, the roof was really a terrace and the owner of each house had to pay an insanity tax—that is, on each terrace a madman was attached by a chain to a ring, and the owner or the tenant was required to feed him with the simplest kind of food. I remember that one day my sister, the little Negro girl, and I were sleeping in my room, the door of which gave onto an inner courtyard; we were awakened, and right across from us we could see the madman coming down the ladder. The courtyard was bathed in moonlight. Not one of us dared say a word. I saw, and I can still see, the madman come into our room, look at us, then quietly climb back up to his terrace.

Another time I was wakened in the middle of the night and saw the superb portrait of the uncle hanging in the room. He was staring at us and he was moving. It was an earthquake. No matter how brave and even clever you may be, when the earth quakes you quake too. That's a feeling that's common to everybody and that no one denies having felt.

I realized that later when, from a ship outside the harbor of Iquique, I saw part of the city collapse and the sea play with the ships like balls being bounced about by a racket.

I have never wanted to be a Freemason, not wishing to belong to any society, either out of an instinctive desire for freedom or lack of sociability. However, I do recognize the usefulness of that institution where sailors are concerned; for in this very same spot near Iquique I saw a trading brig being driven on the rocks by a very strong tidal wave. She hoisted her Freemason's pennant to the top of the mast, and immediately a great many of the neighboring ships sent out boats to tow her in by the bowline. As a result she was saved.

My mother was fond of telling about the tricks she played at the President's house and elsewhere.

A high-ranking army officer, who had Indian blood in his veins, had boasted of being very fond of red peppers. My

mother, at a dinner to which this officer was invited, went to the
kitchen and ordered two dishes of peppers. One was ordinary
and the other extraordinary, seasoned to the hilt with hot pep-
pers. At dinner my mother had arranged to have herself seated
next to him, and while the ordinary dish was served to everyone
else, our officer was served from the extraordinary dish. He
suspected nothing, especially since he had taken an enormous
portion, but at the first mouthful he felt the blood rush to his
face. And my mother asked him very seriously:

"Is the dish badly seasoned? Do you not find it hot
enough?"

"On the contrary, madam, this dish is excellent!"

And the poor man had the courage to eat his entire portion,
down to the last mouthful.

How graceful and pretty my mother was when she wore the
local costume, the silk mantilla covering her face and leaving
only one eye visible, such a soft and imperious eye, so pure and
caressing.

I can still see our street, where the *gallinacos*[71] came to eat
the rubbish. Lima in those days was not the great, sumptuous
city it is today.

Four years went by in this way, but one fine day urgent
letters arrived from France. We had to go back to settle my
paternal grandfather's estate. My mother, who had so little
practical business sense, came back to France, to Orléans. She
was wrong, for the following year, 1856, the old uncle, tired of
having successfully teased Madame la Mort,[72] let her catch
him.

Don Pio de Tristan Morosco was no more. He was a hun-
dred and thirteen years old.[73] In memory of his beloved brother
he had left my mother an income of 5000 piasters, which meant
a little over 25,000 francs. At his deathbed, the family managed
to get around the old man's wishes and seized this immense

71. Urubus, South American vultures which eat carrion.
72. Title of a play by Rachilde, published in her *Théâtre* (1891), with a frontis-
piece by Gauguin depicting a veiled woman.
73. Gauguin is mistaken; Don Pio died at the age of eighty-seven.

fortune, which was swallowed up in a spending spree in Paris. Today one very wealthy female cousin is still living in Lima, a near-mummy. The Peruvian mummies are famous.

The following year Echenique offered to come to an understanding with my mother, who, proud as ever, answered: "All or nothing." The outcome was—nothing. Henceforth, although we were not poverty-stricken, we lived in utmost simplicity.

Much later, in 1880 I believe, Echenique came back to Paris, this time as the ambassador and responsible for arranging with the Comptoir d'Escompte [Discount Bank] for the guarantee of the Peruvian bond issue (the guano business). He stayed with his sister, who had a splendid town house in the Rue de Chaillot and, being a discreet ambassador, he told her that all was going well. My cousin, a gambler like all Peruvian women, hastened to the Dreyfus bank to speculate on a rise in the Peruvian shares.

The opposite happened, and a few days later the Peruvian stock was unmarketable. Her loss came to several millions.

*"Caro mio!"* she said to me, "I em rooined; I now have only eight horses left in the stables. What is to become of me?"

She had two admirably beautiful daughters. I remember one of them, a child my age, whom it appears I had tried to rape. I was six years old at the time. The rape can't have amounted to much, and probably both of us together thought up the idea of those innocent games.

As you can see, my life has always been very restless and uneven. In me, a great many mixtures. Coarse sailor. So be it. But there is also blue blood, or, to put it better, two kinds of blood, two races.

. . . My teacher was an old man named Baudoin, a grenadier who had survived Waterloo. He was admirable at seasoning a Jean Nicot.[74] In the dormitory, with our nightshirts raised, we

---

74. Humorous name for a pipe, because of Jean Nicot, who had introduced tobacco into France; hence the word nicotine.

would say, disrespectfully: "Attention! Shoulder arms!" And with tears in his eyes the old man would remember the great Napoleon. The great Napoleon knew how to make them die; he also knew how to make them live. "There are no soldiers left any more," old Baudoin used to say.

. . . When telling you, a little while ago, about my childhood in Lima, I forgot to tell you something that has to do with Spanish pride. It may interest you.

In Lima there used to be a cemetery of the Indian type: pigeonholes, and in those pigeonholes, coffins; inscriptions of all kinds. A French industrialist named Maury had the idea of looking up the richer families and offering them carved marble tombs. It was an instant success. So-and-so was a general, so-and-so a great captain, and so on. All heroes. He had provided himself with photographs of monuments carved in Italy. He was wildly successful. For several years numerous ships arrived filled with pieces of marble that had been carved in Italy, very cheaply, and they were very impressive.

It was he who had a carved wooden dome made to measure for the church; the pieces needed only to be assembled and put in place on top of the old dome. My mother, who had learned to draw at boarding school, made an admirable, that is to say atrocious, ink drawing of this church and its fenced garden. As a child I found this drawing very pretty; but then it was by my mother: I am sure you will understand me.

In Paris I saw Maury again, a very old man looked after by two nieces, his sole heirs. He owned a very beautiful collection of vases (Inca pottery) and many pieces of pure gold jewelry made by the Indians. What became of all that? My mother had also kept a few Peruvian vases and above, all, quite a number of figurines made of solid silver, just as it comes out of the mines. Everything disappeared in the Saint-Cloud fire—set by the Prussians—a fairly big library and almost all our family papers.

The mere sight of the binding bearing Lamartine's name

reminds me of my adorable mother, who never lost an opportunity to read his *Jocelyn*.

. . . My good uncle in Orléans, who was called Zizi because his name was Isidore and he was very small, told me that when we arrived from Peru we lived in my grandfather's house. I was seven years old. Sometimes I could be seen in the garden stamping my feet and throwing sand all around. "Well well, my little Paul, what's the matter?" I stamped all the harder and said: "Baby is naughty."

Even as a child I passed judgment on myself and felt the need to make people know it. At other times they could see me stand motionless, in silent ecstasy, under a hazelnut tree which, along with a fig tree, decorated one corner of the garden.

"What are you doing, my little Paul?"

"Waiting for the hazelnuts to fall."

At that time I was beginning to speak French and, doubtless because I was accustomed to Spanish, I pronounced all the letters with affectation.

A little later on I whittled and carved dagger handles— without the dagger; a lot of little dreams that grownups couldn't understand. An old lady who was a family friend exclaimed admiringly: "He will be a great sculptor." Unfortunately this lady was not a prophet.

I became a day pupil in a boarding school in Orléans. The teacher said: "This child will either be an idiot or a genius." I became neither the one nor the other.

One day I came home with a few colored-glass marbles. Furious, my mother asked me where I had gotten them. I lowered my head and said that I had exchanged them for my rubber ball.

"What, you, my son engaging in trade?"

That word, "trade," in my mother's mind was a despicable thing. Poor mother! She was wrong, and at the same time right, in that already, as a child, my intuition told me there are a lot of things that are not for sale.

At eleven I went to a secondary school run by priests, and

there I made very rapid progress. In the *Mercure* I read the views of several literary men on the value of this seminarian schooling, from which they later had to disentangle themselves. I will not say, like Henri de Régnier, that this education contributed nothing to my intellectual development; on the contrary, I believe it did me a great deal of good.[75]

As for the rest, I think it was there that I learned very early on to hate hypocrisy, false virtues, informing on others *(Semper tres)*;[76] to mistrust everything that was contrary to my instincts, my heart, and my reason. It was there too that I picked up a little of that casuistic spirit which is not to be sneezed at, I must say, as an asset in the struggle. It was there I became accustomed to withdrawing within myself, constantly observing what my teachers were up to, making my own amusements, and my own sorrows too, with all the responsibilities that that implies.

. . . One story leads to another. I remember one evening in Le Havre (I was a sailor in the merchant marine in those days) when I had had a bit to drink, and at midnight I was coming down some street on my way home. I nearly broke my nose on a half-open shutter that was protruding. "Swine!" I shouted, and pounded on the shutter, which would not close. Believe you me, there must have been a hanged man there that didn't want it to. This time I let matters be and continued on my way (I'd had a little too much to drink), saying to myself out loud as I went: "The swine! Don't give a damn about people going by, 'snough to break a man's head open."

. . . My first voyage as an apprentice was aboard the *Luzitano* (Union des Chargeurs, voyage from Le Havre to Rio de Janeiro).

. . . The ship is anchored in the anchorage at Rio de Janeiro.

---

75. The teaching dispensed at the *petit séminaire* in Orléans was actually quite varied and extensive. It gave Gauguin a considerable background of general culture.
76. See p. 176, the rule laid down in religious schools: *Nunquam duo, semper tres* (never two, always three), which encouraged pupils to inform on one another.

Fine night, intense heat. Everyone is looking for a little cool air. The sailors are sleeping on the forecastle. Aft, the officers chat before trying to get some sleep.

Suddenly a cry: "Man overboard!" It was the cabin boy, a mere child. Involuntarily—no doubt he had been dreaming—he lost his balance, and now the current is carrying him aft of the ship.

The child does not know how to swim. We all watch, as if at the theater. The cook, a Negro, belatedly awakes and out of curiosity comes to look. He understands and shouts:

*"Oui, fout, sagué touné, il va se noyé!"*[77]

Without a moment's hesitation he jumps into the water and brings the boy to the aft ladder. Then everyone grabs a rope to throw to the child, who has already climbed up. Fear and stupidity reside in us. One brave and intelligent man comes along, and then everyone becomes brave and intelligent. . . .

. . . A few days before we left Le Havre for Rio de Janeiro, a young man came to see me, saying: "You are my successor as apprentice. Look, be so kind as to take this little box and a letter to this address." I read, "Madame Aimée Rua d'Ovidor."

"You will see a charming woman," he said, "to whom I am giving you a very special recommendation. She is from Bordeaux, like myself."

I will spare you, reader, a description of our sea voyage; it would only bore you. I will just tell you that Captain Tombarel, who was one-quarter Negro, was altogether charming, that the *Luzitano* was a pretty 1200-ton ship and very well fit out for passengers, and that with a favorable wind she clipped along at 12 knots an hour. We made a very fine crossing, without any storms.

As you can imagine, the first thing I did was to take the little box and the letter to the address I'd been given. Joy awaited me.

"Isn't he nice to have thought of me. And you, my pet, let me have a look at you. How handsome you are!"

---

77. *"Oui, faut, sacré tonnerre . . ."* "Yes, I must, damn it all, he's drowning."

I was very short in those days and, although I was seventeen and a half, I looked fifteen. In spite of this, I had sinned for the first time, in Le Havre, before going on board, and my heart was now beating like a drum. The month that followed was altogether delightful.

Although she was thirty, the charming Aimée was very alluring, and played the leading roles in Offenbach's operas. I can still see her, richly attired, driving away in her brougham harnessed to a mettlesome mule. Everyone paid court to her. . . . And Aimée made my virtue tumble. The flesh must have been willing, for I became very naughty.

On the return voyage we had several women passengers, among them a very plump Prussian woman. This time it was the captain's turn to be smitten, and he certainly turned on the heat, but to no avail. The Prussian woman and I had found a charming hideaway in the sail locker, the door of which communicated with the cabin near the stairs. . . .

. . . I hate Denmark—its climate and its inhabitants—profoundly.[78]

Oh, there are some good things in Denmark, that is undeniable. In Denmark they do a lot for education, science, and especially medicine. The hospital in Copenhagen can be considered one of the handsomest establishments of its kind, because of its size and above all for its cleanliness, which is first-class.

Let's pay that much tribute to them, especially since aside from that I can't see any but negative things. I beg your pardon, I was about to forget one thing: the houses are admirably built and equipped either to keep out the cold or for ventilation in summer, and the city is pretty. I must also add that receptions in Denmark are generally held in the dining room, where one eats admirably. That's something anyhow, and it helps to pass the time. But don't let yourself be too bored by this monoto-

78. Gauguin had lived in Copenhagen with his family in 1884–85.

nous kind of conversation: "You, a powerful country, must find that we are far behind. We are so small. What do you think of Copenhagen, our museum, etc.? It's nothing very much." All this is said so that you will say exactly the opposite; and you say it, of course, out of politeness.

That museum of theirs! To tell the truth it does not contain a collection of paintings, just a few paintings from the old Danish school, Meissonier-type landscapes, and views of little boats. Let's hope things have changed today. There is a monument built expressly for their great sculptor Thorvaldsen, a Dane who lived and died in Italy. I saw it, saw it very clearly, and my head buzzed. Greek mythology that had become Scandinavian and then had been coated over with Protestantism. The Venuses lower their gaze and modestly cover themselves with wet drapery. The nymphs dance a jig. Yes, gentlemen, they dance a jig: look at their feet.

In Europe they call him "the great Thorvaldsen," but they haven't seen him. His famous lion, the only one that travelers in Switzerland can see: a stuffed Great Dane.[79] When I say this I know that in Denmark they're going to burn sugar in every corner to clear the air of all the unflattering things I have said about their greatest sculptor.

. . . Let me show you into a salon such as one rarely sees nowadays. The salon of a count, very high in the Danish nobility: a vast square room; two enormous German tapestry panels, done specially for the family, and just as marvelous as you can possibly imagine; above two doors, paintings of Venice by Turner; carved wood furniture with the family arms, inlaid tables; period fabrics—everything an artistic marvel.

You are shown in and you are greeted. You sit on an ottoman, a spiral of red velvet, and on the marvelous table are a doily worth a few francs bought at the Bon Marché, a photograph album, and flower vases of similar quality.

---

79. This probably refers to Thorvaldsen's *Lion of Lucerne.*

Next to the salon, a very pretty museum room. The collection of paintings; portrait of an ancestor by Rembrandt, etc. Everything smells moldy. No one goes in there. The family prefers the Protestant church, where the Bible is read and where everything petrifies you.

I must say that in Denmark the system of getting engaged is a good thing in that it doesn't commit you to anything (people change fiancés the way they change handkerchiefs), and, in addition, it has every appearance of love, liberty, and morality. You are engaged; so you can go out for a walk—even go traveling—the mantle of engagement covers everything. You can fool around with "going-almost-all-the-way-but-not-quite," which has the advantage, for both parties, of teaching them not to be careless and get into trouble. With each engagement the bird loses a lot of little feathers that grow back without anybody noticing. Very practical, the Danes. Have a taste, but don't get too enthusiastic, or you might regret it. Remember that the Danish woman is the most practical woman there is. Don't get me wrong: it's a small country, so they have to be prudent. Even the children are taught to say: "Papa, we've got to have some dough; otherwise my poor father, you're out on your ear." I've known such cases.

. . . In those scales of theirs up north, the biggest heart in the world cannot outweigh a coin worth a hundred sous. I too have observed the north, and the best thing I found up there was certainly not my mother-in-law but the game she cooked so admirably well. The fish is excellent too. Before you are married everything is nice and cozy, but afterward, watch out, brother; things turn to vinegar.

. . . In Ibsen's play *An Enemy of the People,* the wife becomes (but only at the end) worthy of her husband. As commonplace and self-centered as the great majority of people, if not more so, all her life long, she has just one minute that melts all the ice of the north that she has in her. . . . I know another enemy of the people whose wife not only did not follow her husband but, what's more, brought up the children so well that they do not

know their father; and that father, who is still in the land of the wolves, has never heard a voice murmur in his ear: "Dear Father." If he leaves anything to inherit when he dies, they'll be there, all right.

. . . Do not get the notion of reading Edgar [Allan] Poe except in some very reassuring place. Although very brave, but not really being so (as Verlaine says), you'd be sorry for it. And, especially, do not try to go to sleep within sight of an Odilon Redon.

Let me tell you a true story. My wife and I were both reading in front of the fireplace. Outdoors it was cold. My wife was reading Poe's *The Black Cat,* and I *Le Bonheur dans le crime,* by Barbey d'Aurevilly.

The fire was about to go out and the weather was cold. It was time to go and fetch some coal. My wife went down to the cellar of the little house we had sublet from the painter Jobbé-Duval.[80]

On the steps a black cat gave a frightened jump. So did my wife. But after a moment of hesitation she continued on her way. Two shovelfuls of coal—and a skull emerged from the heap of coal. Shivering with fright my wife left everything in the cellar, raced back up the stairs, and finally fainted in the bedroom. I went down in turn, and as I shoveled more coal I brought an entire skeleton to light. It was an old wired skeleton that Jobbé-Duval had used and then, when it had gone out of joint, had thrown away in the cellar.

As you can see, it was all extremely simple, and yet the coincidence was peculiar. Beware of Edgar [Allan] Poe. I myself resumed reading and, remembering the black cat, caught myself thinking of the black panther which serves as prelude to that extraordinary story by Barbey d'Aurevilly, *Le Bonheur dans le crime.*

80. This was in 1880, and the house, with studio and garden, was at 8 Rue Carcel, in Vaugirard, a Parisian suburb.

I sometimes went to the Tuesday receptions given by that admirable man and poet named Stéphane Mallarmé. On one of those Tuesdays, talk turned to the Commune; I talked about it too.

Coming home from the Stock Exchange some time after the events of the Commune, I went into the Café Mazarin. At one of the tables a military-looking gentleman was seated; he reminded me very strongly of a former classmate and, as I was staring at him, he said to me haughtily, pulling at his mustache as he did so: "Do I owe you something?"

"Excuse me," I replied, "but weren't you at Loriol's?[81] My name is Paul Gauguin."

And he answered: "Mine is Denneboude."

We recognized one another immediately, and each of us told the other what had happened to him since. He, an officer trained at Saint-Cyr, had been taken prisoner by the Prussians and, when the Versailles troops entered Paris, he was in command of a battalion. Reaching the Place de la Concorde by way of the Champs-Elysées, then advancing to the Gare Saint-Lazare, he overcame a barricade and took prisoners. Among them was a gallant Paris lad aged about thirteen, who had his rifle in his hand when he was made prisoner.

"Excuse me, Captain," the lad cried, "but before I die I would like to go and say good-by to my poor grandmother who lives up in that attic you see over there; but don't worry, I won't be long."

"Move fast, then!"

I was about to shake hands with this good Denneboude, a childhood comrade; but I did not.

He continued: "We went up the street as far as the Clichy toll gate, but, before we reached it, the lad came up to us all out of breath shouting, 'Here I am, Captain.' "

And I, Gauguin, anxiously asked: "What did you do with him?"

---

81. From 1862 to 1864, Gauguin had been a boarder at a private secondary school, run by a Mr. Loriol, at 49 Rue d'Enfer in Paris.

"Well," he said, "I shot him! My duty as a soldier, you know . . ."

From that very moment I felt I knew what was meant [by] that precious notion of a soldier's conscience and, as the waiter was coming my way, I paid for our beers without saying a word and I left *pronto, illico,* my heart in a tumult.

Stéphane Mallarmé took down a superb volume of Victor Hugo and, with that magician's voice of his that he used so dramatically, he began to read the story I have just told; only at the end, Hugo, too respectful of human life, does not have the young hero shot.[82]

YELLOWS

*Editor's note: I have inserted two fragments—one taken from "Miscella- neous Things" and the other from an article in* Essais d'Art libre *of January 1894—to complete the recollections of van Gogh given in* Avant et Après.

CONCERNING
VINCENT
VAN GOGH

. . . I went to Arles to join Vincent van Gogh after he had asked me a number of times to come. He said he wanted to found the Atelier du Midi, and I would be its leader. This poor Dutchman was all ardor and enthusiasm. From reading *Tartarin de Tarascon* he had conceived an extraordinary idea of the Midi, to be expressed in bursts of flame.

And on his canvas the chrome yellows did burst out; their sunlight flooded the *mas*[83] and the entire plain of the Camargue.

. . . In my yellow room, sunflowers with purple eyes stand out against a yellow background; the ends of their stalks bathe in a yellow pot on a yellow table. In one corner of the painting, the painter's signature: Vincent. And the yellow sun, coming

82. This episode was reported in *Le Figaro* of June 3, 1871; the end of the article said that the officer had sent the adolescent home to his family with a kick in the seat. From this incident Victor Hugo drew his famous poem, in the volume called *L'Année terrible,* which ended with these words, ". . . et l'officier fit grâce [and the officer reprieved him]." In 1905, however, Charles Vérecque, a poet

through the yellow curtains of my room, floods all this flowering with gold, and in the morning, when I wake up in my bed, I have the impression that it all smells very good.

Oh yes! he loved yellow, did good Vincent, the painter from Holland, gleams of sunlight warming his soul, which detested fog. A craving for warmth.

When the two of us were together in Arles, both of us insane, and constantly at war over beautiful colors, I adored red; where could I find a perfect vermilion? He, taking his yellowest brush, wrote on the suddenly purple wall:

Je suis sain d'Esprit,
Je suis Saint-Esprit.[84]

In my yellow room, a small still life; a purple one. Two enormous, worn-out, shapeless shoes. Vincent's shoes. The ones he took one fine morning, when they were new, to go on foot from Holland to Belgium. The young parson (he had just completed his theological studies, so as to be a pastor, like his father) was setting out to see those whom he called his brothers, the miners. As he had seen them in the Bible—simple people, oppressed, working for the luxury of the high and mighty.

Contrary to what his teachers, wise Dutchmen, had told him, Vincent had believed in a Jesus who loved the poor, and his soul, brimming with charity, desired both consoling words and sacrifice, desired to combat the strong for the sake of the weak. Beyond the shadow of a doubt, Vincent was already a madman.

The way he taught the Bible in the mines was, I believe, beneficial to the miners down below, disagreeable to the au-

---

and militant socialist, wrote a verse piece in which the adolescent was indeed executed. Whom are we to believe?

83. Low farmhouse in southern France. (Translator's note.)

84. I am of sound mind, I am the Holy Ghost. (Translator's note.)

thorities on high, above ground. He was soon called back, dismissed; a family council gathered and decided he was insane, should be shut up in an asylum. He was not interned, however, thanks to his brother Théo.

One day the dark, black mine was flooded with chrome yellow, the terrible flash of fire damp, the dynamite of the rich that never fails to explode. The creatures that were crawling on their bellies in the filthy coal at that moment said good-by to life that day, good-by to mankind, without blaspheming.

One of the miners, a terribly mutilated man, his face burned, was taken in by Vincent. "And yet he's done for," said the company doctor, "unless a miracle happens or he receives the most intensive motherly care. No, it's folly to look after him."

Vincent believed in miracles, in motherliness.

The madman (beyond the shadow of a doubt he was mad) watched for forty days at the dying man's bedside; he vigilantly prevented air from reaching the man's wounds and paid for medicines. A parson bringing consolation (beyond the shadow of a doubt he was mad), he talked. His mad enterprise made a dead man, a Christian, live again.

When the wounded man was out of danger at last and went back down into the mine to carry on his work, then, said Vincent, you could have seen the head of the martyred Jesus, the forehead bearing the halo, the zigzags of the crown of thorns, red scars on the ashen yellow of a miner's forehead. . . .

Beyond the shadow of a doubt, that man was mad.

THE PINK CRAYFISH[85]

*Before winter, 1886*    The snow is beginning to fall [there], it is winter, I'll spare you the shroud, it's simply snow. The poor people are suffering. Often landlords do not understand that.

Now this particular December, in the Rue Lepic, in our good city of Paris, the pedestrians are hurrying more than usual

---

85. As Gauguin had already inserted this text in "Miscellaneous Things," the passages in brackets indicate variants.

and have no desire to linger. Among them a shivering and bizarrely dressed [individual] hastens toward the outer boulevard. He is wrapped up in a goatskin, wears a fur cap, rabbit no doubt, has a bristling red beard [everything bristles—coat, cap, and beard]. The garb of a drover.

Don't give him just a careless glance, and despite the cold don't continue on your way without looking attentively at the white and harmonious hand, the blue eyes that are so clear, so childlike [so keen, so intelligent]. Surely a poor vagabond [but he is not a drover, he is a painter].

His name is Vincent van Gogh. [Van Gogh is his name.]

Hastily he enters the shop of a dealer in primitive arrows, rusty metal objects, and cheap oil paintings. Poor artist! You put a part of your soul into the painting of this canvas that you have come to sell.

It's a small still life, pink crayfish on pink paper.

"Can you give me a little money in exchange for this canvas, to help me pay my rent? [the rent is due soon]."

"Well, my friend, the customers are becoming difficult; they ask me for cheap Millets. And another thing," the dealer added, "your painting is not very gay, you know; today the Renaissance is on the Boulevard. However, they say you have talent and I want to do something for you. Here, take a hundred sous."

And the coin rang on the counter. Van Gogh took it without a word of protest, thanked the dealer, and went out. He trudged back up the Rue Lepic. When he had almost reached his lodgings, a poor woman, released from Saint-Lazare Prison, smiled at the painter, desiring his custom. The handsome white hand emerged from under the great-coat; van Gogh was fond of reading, he thought of *La Fille Elisa*,[86] and his 5-franc piece became the property of the unhappy woman [of the whore]. Rapidly, as if ashamed of his charity, he fled, his stomach empty.

---

86. A novel by Edmond de Goncourt.

[*After*] *winter 1894*   The day will come, and I can see it as if it had already come. I enter room no. 9 at the auction rooms; the auctioneer is selling off a collection of paintings. I go in. "Four hundred francs for *The Pink Crayfish,* four hundred fifty, five hundred. Come come, gentlemen, it's worth more than that."

No one says a word. Sold, *The Pink Crayfish* by Vincent van Gogh. [Sold. Pensively, I went away. I was thinking of *La Fille Elisa,* of van Gogh.]

. . . For a long time now I've been wanting to write about van Gogh and I will surely do it one day when I am in the mood; for the time being I am going to tell about certain things concerning him, or rather concerning us, which should put an end to a false rumor that has been going around in some circles.

It is surely a coincidence that, during my lifetime, several men who have frequently been in my company and conversed with me have gone crazy.

This is true of the two van Gogh brothers, and some people have, either maliciously or naïvely, blamed their insanity on me. Doubtless some people can have a greater or lesser degree of influence on their friends, but that's a far cry from causing them to go mad. Long after the catastrophe, Vincent wrote me from the sanitarium where he was being treated. He told me: "How lucky you are to be in Paris! After all, that is where the top people are, and you certainly ought to consult a specialist who could cure your madness. Are we not all mad?"

This was good advice; which is why I did not follow it, out of contrariness, no doubt.

Readers of the *Mercure* have seen, in a letter by Vincent which was published a few years ago, how much he insisted that I should come to Arles to found a studio according to his ideas and be its director.

At that time I was working in Pont-Aven in Brittany, and either because the studies I had begun there made me want to stay or because some vague instinct gave me a presentiment of something abnormal, I held out for a long time; but one day, overcome by Vincent's impulsive friendship, I set out for Arles.

I arrived late at night and waited for daybreak in an all-night café. The owner looked at me and exclaimed: "So you're his chum! I recognize you."

A self-portrait that I had sent to Vincent is enough to explain the café-owner's exclamation. Showing him my portrait, Vincent had explained that it showed a pal of his who would be coming shortly.

Not too early and not too late, I went to awaken Vincent. The day was devoted to my moving in, to a great deal of talking, to strolling about so that I could admire the beauties of Arles and the Arlésiennes, about whom, by the way, I could not work up any enthusiasm.

The very next day we set to work—he continuing things already begun and I making a new start. I must tell you that I have never had the mental capacities that others find, without torment, right at the tip of their brushes. People like that get off the train, take out their palettes, and, in no time they've tossed off a sunlight effect. When it's dry, it goes to the Luxembourg, and it's signed Carolus-Duran.

I do not admire the painting but I admire the man.

He so assured, so calm.

I so uncertain, so anxious.

In every country I have to go through a period of incubation; each time I have to learn to recognize the various species of plants and trees, of all nature, so varied and so capricious, never willing to give away its secrets, to yield itself up.

So it was not until I had been there several weeks that I clearly perceived the harsh savor of Arles and its environs. All the same, we worked hard, especially Vincent. Between two human beings, he and myself, the one like a volcano and the other boiling too, but inwardly, there was a battle in store, so to speak.

First of all, everything was in such a mess that I was shocked. The paint box was barely big enough to contain all the tubes that had been squeezed but never recapped, and yet, in spite of the chaos and the mess, his canvases glowed; so did his words. Daudet, de Goncourt, the Bible were burning up this

Dutchman's brain. For him, the wharves, bridges, and boats of Arles, the entire Midi became Holland. He even forgot to write in Dutch and, as shown by the publication of his letters to his brother, he always wrote in French only, and wrote it admirably, too, with expressions like *"tant que," "quant à,"* in abundance.

Despite my efforts to discern, in that chaotic brain, some logical reason for his critical views, I was unable to account for all the contradictions between his painting and his opinions. For instance, he felt boundless admiration for Meissonier and profoundly hated Ingres. Degas was his despair, and Cézanne was nothing but a humbug. The thought of Monticelli made him cry.

One thing that made him angry was having to acknowledge that I was very intelligent, for my forehead was too low, a sign of stupidity. And amid all this, a great tenderness, or rather, a Gospel-like altruism.

From the very first month I saw that our joint finances were becoming equally messy. What should we do? It was an awkward situation; the till was modestly filled by his brother, who worked in the Goupil firm; my share was paid in exchange for paintings. The matter had to be broached, at the risk of offending his excessive sensitivity. So very cautiously and with coaxing, quite out of character for me, I brought up the matter. I must admit that I succeeded much more easily than I had expected.

In a box, we put so much for nocturnal, hygienic outings, so much for tobacco, and so much for impromptu expenses, including rent. With it, a piece of paper and a pencil for writing down honestly what each of us took out of this cashbox. In another box, the remainder of our resources, divided into four parts, for the cost of our food each week. We stopped going to our little restaurant, and I did the cooking on a little gas stove while Vincent did the marketing, without going very far from the house. One day, however, Vincent wanted to make a soup; I don't know how he mixed the ingredients—probably the way he mixed the colors in his paintings. Anyhow, we couldn't eat

it. And my Vincent burst out laughing and exclaimed: *"Taras-con! La casquette au père Daudet."*[87]

... How long did we stay together? I couldn't begin to say, as I have completely forgotten. Although the catastrophe happened very quickly, and although I'd begun to work feverishly, that period seemed like a century to me.

Unbeknownst to the public, two men accomplished in that period a colossal amount of work, useful to both of them. Perhaps to others as well? Some things bear fruit.

When I arrived in Arles, Vincent was plunged into the neo-Impressionist school, and he was floundering a good deal, which was painful to him; not that that school, like all schools, was bad, but because it did not correspond to his nature, which was so impatient and independent.

With all his combinations of yellow on purple, all his random work in complementary colors, all he achieved were soft, incomplete, monotonous harmonies: the clarion call was missing.

I undertook to enlighten him, which was easy enough, for I found rich and fertile soil. Like all independent natures that bear the stamp of personality, Vincent was not the least bit afraid of what people would say, nor the least bit stubborn.

From that day on my friend van Gogh made astonishing progress; he seemed to glimpse all that he had in him, hence that whole series of sun after sun after sun, throbbing with sun.[88]

It would be beside the point to go into technical details

87. Van Gogh was referring to the novel *Tartarin de Tarascon* by Alphonse Daudet (1840–97).

88. In a letter to André Fontainas, written in September 1902, Gauguin was more explicit on the nature of his contribution. "Look closely at van Gogh's painting before and after I stayed with him in Arles. Influenced by the neo-Impressionist experiments, van Gogh's method was always to use strong contrasts between complementary tones, yellow on purple, etc. Whereas later, following my advice and my teaching, he worked altogether differently. He did yellow suns on yellow backgrounds, etc., and learned to orchestrate a color, using all its derivatives. And then all the customary clutter of still-life objects in a landscape, a necessity in the old days, was replaced by resonant chords of strong colors, recalling the over-all harmony."

here. My aim is simply to inform you that van Gogh, without losing an iota of his originality, received most helpful instruction from me. And every day he was grateful to me for it. And that is what he meant when he wrote to Monsieur Aurier that he owes a great deal to Paul Gauguin.

When I arrived in Arles, Vincent was still feeling his way, whereas I, much older, was already a mature man. Yet along with the knowledge that I helped Vincent, I in turn owe something else to him: for that experience helped me to consolidate my own earlier ideas on painting; and even in the most trying periods, I can remember that some people are unhappier still.

. . . Toward the end of my stay, Vincent became excessively abrupt and noisy, then silent. Several times, at night, Vincent got up and stood over my bed.

How is it that I happened to wake up just then?

Whatever the reason, all I had to do was say to him very gravely: "What is the matter with you, Vincent?" Without a word, he would go back to bed and sleep like a log.

I decided to do a portrait of him in the act of painting the still life he liked so much, sunflowers. When the portrait was finished, he said to me: "That is me, all right, but me gone mad."

That same evening we went to the café. He ordered a light absinthe. Suddenly he flung the glass and its contents in my face. I managed to duck and grab him, take him out of the café and across the Place Victor-Hugo. A few minutes later Vincent was in his own bed and in a matter of seconds had fallen asleep, not to awaken till morning.

When he awoke he was perfectly calm and said to me: "My dear Gauguin, I have a dim recollection that I offended you last night."

Reply: "I forgive you gladly and with all my heart, but yesterday's scene might recur, and if I were to be struck, I might lose my self-control and strangle you. Allow me, therefore, to write to your brother to tell him I am coming back."

My God, what a day! When evening came I ate a scant dinner and felt the need to go out alone for a stroll amid the

scent of blossoming laurel. I had got almost to the other side of the Place Victor-Hugo when I heard a well-known little step behind me, quick and jerky. I turned around just as Vincent rushed at me with an open razor in his hand. The look in my eyes at that moment must have been very powerful, for he stopped, lowered his head and ran back toward the house.

Was I cowardly at the time? Ought I to have disarmed him and tried to calm him down? I have often questioned my conscience on this score but have found nothing to reproach myself with. Let him who will cast stones at me. I went straight to a good hotel in Arles and, after inquiring what time it was, took a room and went to bed. I was so upset that I was unable to fall asleep until nearly three in the morning and woke up rather late, about half past seven.

Reaching the square, I saw that a large crowd had gathered. Near our house were some gendarmes, and a little man in a bowler hat who was the chief of police.

This is what had happened: Van Gogh went back to the house and immediately cut off his ear, very close to his head. It must have taken him some time to stanch the flow of blood, for next day a number of wet towels lay on the stone floor of the two ground-floor rooms. The blood had soiled both rooms and the little stairway which led up to our bedroom.

When he was well enough to go out, with a Basque beret pulled way down over his head, he went straight to a house where, if you can't find a girl from your hometown, you can at least find someone to talk to, and he gave his ear, carefully washed, and sealed in an envelope, to the man on duty. "Here," he said, "in remembrance of me." Then he fled, went home and to bed, and fell asleep; but first he took the trouble of closing the shutters and placing a lighted lamp on a table near the window.

Within ten minutes the whole street reserved for prostitutes was in an uproar and people gossiped about what had happened.

I was far from suspecting any of this when I reached the doorstep of our house, and the man in the bowler hat said to

me point-blank and very harshly: "Well, sir, what have you done to your comrade?"

"I don't know . . ."

"But you do . . . you know perfectly well . . . he is dead."

I would not wish such an instant on anyone, and it took me several minutes before I could think and overcome the pounding of my heart.

I was choking with anger, indignation, and pain, and also the shame of all those people's eyes tearing into me. I stammered, "Very well, sir, let us go upstairs and discuss it up there."

Vincent lay curled up in bed, completely covered by the sheet, and appeared lifeless. Gently, very gently I touched his body; its warmth assured me he was alive. I felt as if all my intelligence and energy had been given a new lease on life.

In a near-whisper I said to the chief of police; "Sir, kindly wake this man up as carefully as you know how, and if he asks for me, tell him I've left for Paris; the sight of me could be fatal to him."

I must say that from that moment on, the chief of police was as polite as could be and wise enough to send for a doctor and a carriage.

As soon as he was awake, Vincent inquired after his comrade, asked for his pipe and tobacco, and even thought of asking for the box that was downstairs and contained our money. Doubtless, he suspected me—I who was already armed against all suffering!

Vincent was taken to the hospital and there his mind immediately began to wander again. All the rest is already known to people who can be interested by it and there would be no point in discussing it but for the extreme suffering of a man in a madhouse who regained his reason every month enough to understand his condition and, in a frenzy, paint those admirable pictures of his.

The last letter I received was written from Auvers, near Pontoise. He told me he had hoped to be sufficiently cured to come and join me in Brittany, but that today he was forced to

recognize that a cure was impossible. "Dear Master" (the only time he ever used that word), "it is more worthy, after having known you and caused you some sorrow, to die in a sound state of mind than in a degrading state."

And he shot himself in the belly, and it was not until several hours later that, lying in his bed and smoking his pipe, he died, with his mind fully alert, with love for his art, without hatred for mankind.

In *Les Monstres,* Jean Dolent writes: "When Gauguin says, 'Vincent,' his voice is gentle." Without knowing it, he guessed it. Jean Dolent is right. You can see why.

Who knows Degas? It would be an exaggeration to say that no one does. Only a few people. Know him well, I mean. Even his name is unknown to the millions of readers of the daily newspapers. Only painters admire Degas, many out of fear, the others out of respect. Do they really understand him? <span style="float:right">CONCERNING<br>EDGAR DEGAS</span>

Degas was born . . . I don't know when, but so long ago that he is as old as Methuselah. I say Methuselah because I imagine that Methuselah at the age of a hundred must have been like a man of thirty in our own day. As a matter of fact, Degas is still young.

He respects Ingres, which means that he respects himself. When you see him, wearing his silk hat and his blue eyeglasses, he looks exactly like a notary public, a bourgeois from the days of Louis-Philippe, right down to the umbrella.

If ever there was a man who did not try to look like an artist, it is Degas; he is so much of an artist. And he detests all kinds of livery, even that one. He is a very good man but, being witty, he has the reputation of being nasty. Spiteful and nasty. Is it the same thing?

One young critic, who has the quirk of expressing an opinion the way oracles utter their pronouncements, has said of him: "Degas, a benevolent bear!" Degas a bear! Degas, who has the bearing of an ambassador at court whenever he is out walking. Benevolent! That's very trivial tribute. He is better than that.

. . . Ah, I see what they mean! A bear. Degas backs off from

interviews. Painters seek his approval, ask for his verdict, and he the bear, the ill-natured man, so as to avoid saying what he thinks, very amiably says to you: "Excuse me but I do not see clearly, my eyes . . ."

On the other hand, he does not wait until you have become well known. Among the young painters, he senses which ones have talent, and he, the scholar, never speaks of a lack of knowledge. He says to himself: Surely, in due time, he will know; and to you he says, the way a father would, the way he said to me in the beginning: "You're off to a good start."

Among the master painters, not one can rival him.

. . . Degas scorns theories on art. He is not in the least concerned with technique.

At my last exhibit at Durand-Ruel's, Tahitian Works [18]91–92, two well-meaning young men were unable to understand my painting. As respectful friends of Degas, and wishing to be enlightened, they asked him what he felt about it.

With that kind, fatherly smile of his, he who was so young, he recited the fable of "The Dog and the Wolf," adding: "Gauguin is the wolf, you see."[89]

So much for Degas the man. What about Degas the painter?

One of Degas's first known paintings shows a cotton exchange [in New Orleans]. Why describe it? The best thing to do is to look at it, and especially to look at it carefully, and above all don't come and tell us: "No one was able to render cotton better than he." That painting has nothing to do with cotton, not even with cotton plants.

He knew it so well himself that he went on to other kinds of exercises. . . . It was apparent that even as a young painter, he was already a master. Already a bear. The tenderness of intelligent hearts is not very visible.

Brought up in elegant society, he dared to go into raptures

89. One of the two young men was a son of Henri Rouart whom Degas had brought to the exhibit. The wolf in La Fontaine's fable is described as "lean and collarless."

over the milliners' shops in the Rue de la Paix, the pretty laces, the famous knack our Parisian seamstresses have for whipping up an extravagant hat. To see them again at the races, pluckily set atop chignons, and on top of all that, or rather, glimpsed amid all that, the sauciest little nose you can imagine.

And to go off to the Opera in the evening to rest from the day's occupations. There, Degas said to himself, Everything is false—the light, the stage setting, the ballerinas' chignons, their corsets, their smiles. The only things that are true are the effects that these things create, the human frame, the bone structure, the way it is set in motion, arabesques of all kinds. How strong, lithe, and graceful! At one point the male enters the picture with [a] series of entrechats, and supports the ballerina as she swoons. Yes, she swoons, and that is the only time she does swoon. All of you who dream of going to bed with a ballerina must not hope for a single minute that she will swoon with pleasure in your arms. No such thing: a ballerina swoons only onstage.

. . . Lines of the parquet flooring stretching away to the vanishing point over there, very far away, very high up, a line of ballerinas crossing those lines, advancing with rhythmical, mannered, well-rehearsed steps.

. . . Degas's ballerinas are not women. They are machines in motion with graceful and prodigiously well-balanced lines. Arranged like a hat in the Rue de la Paix, with all the artifice that makes them so pretty. The diaphanous gauze floats up and you do not think of seeing what is underneath, not even one black to mar the white.

The arms are too long, says the gentleman who, with measuring tape in hand, calculates proportions so neatly. I know they would be, if they were meant to be still lifes. Stage backdrops are not landscapes, they are backdrops. De Nittis did some too and they were much better.

Racehorses, jockeys in Degas's landscapes. Very often, old nags ridden by monkeys.

There is no motif in all this; only the life of the lines themselves, lines and more lines. He is his style.

Why does he sign his paintings? No one has less need to sign than he.

Recently he did a great many nudes. The critics generally saw "woman." Degas sees "woman. . . ." But these paintings have nothing to do with women, no more than the earlier ones had to do with ballerinas; at most, certain phases of life revealed through indiscretion. What does this mean? The art of drawing was very low. It had to be put back on its feet again, and when I see these nudes I say to myself, Now it can stand again.

Everything concerning Degas the man as well as Degas the painter sets an example. Degas is one of the few masters who could have had awards, honors, fortune if he had only stopped to gather them but who, without rancor and without jealousy, has declined to do so. He goes among the crowd so simply! His old Dutch housekeeper is dead; otherwise she would say: "It's certainly not for you that they'd ring the bells like that."

One of the painters who, like so many others, belongs to the Independents, so that he can call himself independent, said to Degas: "Well, Monsieur Degas, are we not to have the pleasure of seeing you join the Independents one day?"

Degas smiled pleasantly . . . and you say he's a bear!

. . . People borrow a great deal from Degas and he does not complain. There is so much in his bag of tricks that one pebble more or less doesn't matter to him.

. . . There are people who say: "Rembrandt and Michelangelo are vulgar; I prefer Chaplin." One very homely woman tells me: "I don't like Degas because he paints ugly women." Then she adds: "Have you seen my portrait by Gervex at the Salon?"

A fully clothed woman by Carolus-Duran is smutty. A nude by Degas is chaste. But his women wash in tubs! That is precisely the reason why they are clean. But you can see the bidet, the douche, the washbasin! Just the way it is at home.

. . . In a restaurant some very important painters were arguing endlessly, and they asked Degas for his opinion:

"It all depends," he said, "on how the painting is hung."

I remember Manet too. Another artist whom no one could rival. Once upon a time, having seen one of my (early) paintings, he told me it was very good; whereupon I answered the master respectfully; "Oh, I'm only an amateur." In those days I worked for a broker, and I studied art only evenings and holidays.

"Indeed you are not," said Manet . . . "The only amateurs are the people who do bad paintings."

Those words were sweet to my ears.

CONCERNING ART

. . . In an exhibition on the Boulevard des Italiens I saw a strange head. I do not know why something happened inside of me, why, standing in front of a painting, I heard strange melodies. A doctor's head, very pale, with eyes that do not look at you, that do not see but listen.

In the catalogue I read, *Wagner,* by Renoir. This speaks for itself.

THREE CARICATURISTS

Gavarni, elegantly pleasing;
Daumier, sculptor of irony;
Forain distills vindictiveness.

Gérôme said to me: "You see, the big thing in sculpture is to calculate your inner framework well. . . ." What do you say to that, Rodin?

. . . Old man Corot at Ville-d'Avray:
"Well, Mathieu old fellow, do you like this painting?"
"Oh yes indeed, the rocks really look like rocks."
The rocks were cows.

Cézanne paints a gleaming landscape; backgrounds of ultramarine, heavy greens, shimmering ocher tones; the trees

stand in line, the branches intertwine but through them we glimpse the house of his friend Zola, its vermilion shutters given an orange hue by the chromes that sparkle on the whitewashed walls.

The bursting Veronese greens highlight the refined verdure of the garden, and the grave and contrasting sound of the purplish-blue nettles in the foreground orchestrates the simple poem. The place is Médan.

A pretentious passerby, horrified by what he takes to be a pitiful waste of colors by some rank amateur, assumes a smiling, professorial manner, and says to Cézanne: "So, you're a painter."

"Yes indeed, but only in a small way . . ."

"Yes, yes, I see. Look, I used to be a pupil of Corot's, and if you'll allow me, with a few judicious strokes, I will straighten everything out. Tonal values, tonal values—that's what counts."

And the vandal impudently spreads some blunders over the gleaming canvas. Dirty grays cover the Oriental silks.

Cézanne exclaims: "Sir, you are a lucky man, and when you do a portrait you doubtless paint in the shiny spots on the end of the nose, as if on the rung of a chair."

Cézanne takes back his palette and with his knife scrapes off all the messes the man made.

Then, after keeping silent for some time, he lets out a tremendous fart, turns to the man and says: "Ah, that feels better!"

X, a pointillist. Ah yes! the one who makes such nice round dots.

Along converging paths rustic figures, devoid of thought, go looking for who knows what. It could be by Pissarro.

At the seashore, a well: several Parisian figures in striped and motley dress, throats dry with ambition no doubt, seek in this dry well the water that could assuage their thirst. The whole thing made of confetti.

It could be by Signac.

Beautiful colors exist, though we do not realize it, and are glimpsed behind the veil that modesty has drawn over them. The little girls, children of love, bring tenderness to mind: hands seize and caress. Unhesitatingly I say it is by Carrière. The female scavenger, the cheap wine, the house of the hanged man. Impossible to describe. Do better than that: go and see them.

The ripe grapes spill over the edge of a fruit stand; on the cloth, apple-green apples and plum-red apples blend. The whites are blue and the blues are white. One hell of a painter, this Cézanne.

Crossing the Pont des Arts, he meets a fellow painter who has become famous, coming in the opposite direction:

"Well well, Cézanne, where are you going?"

"As you can see, I am going to Montmartre, and you, to the Institute."

A young Hungarian told me he was Bonnat's pupil.

"Congratulations," I answered, "your master has just won the postage-stamp competition with his painting at the Salon."[90]

The compliment got around; you can imagine how pleased Bonnat was, and the next day the young Hungarian nearly beat me up.

Inquiry into the German influence. Numerous replies, which I read attentively, and suddenly I begin to laugh. Brunetière!

What? The *Mercure de France* dared to speak to the *Revue des Deux Mondes,* to question it?

Brunetière, who takes so long to make up his mind that he still does not know whom to commission to do his statue. Rodin.

90. Allusion to the *Portrait of Madame Pasca* that Léon Bonnat exhibited at the Salon of 1875.

Perhaps! Yet his *Balzac* was so unpolished, and his *Bourgeois de Calais* so unscholarly.

And he says: "Today, everyone talks about everything without having learned anything." Now there it seems the *Mercure* is taking a pot shot at everyone. Poor Rodin and Bartholomé, who thought they had learned how to sculpture. Poor Remy de Gourmont, who thought he had learned something about literature.

And we, the poor public, who thought there were other artists besides Monsieur Brunetière. . . . It's a good thing I wasn't questioned, because I who haven't learned anything would have been tempted to answer boldly that Corot and Mallarmé were quite French. And in that case I would be extremely mortified today. . . .

CATHEDRALS[91]

I look at all those saints and, being a skeptic, do not see them alive. In the niches of cathedrals they have some meaning, and there only. Gargoyles too, unforgettable monsters; without fear my eye follows the contours of these bizarre creatures.

The graceful arch alleviates the weightiness of the monument; the great steps invite curious passers-by to look inside. The bell tower: the cross from above. The great transept: the cross from within.

The priest in his pulpit splutters on about Hell; the ladies on their chairs chatter about the latest fashions. . . .

. . . Roujon, man of letters, director of the Beaux-Arts. I am granted a hearing and am shown in.

Two years earlier I had been shown in to this same office with Ary Renan, as I was supposed to go and study in Tahiti; and so as to facilitate my studies, the Minister of Public Education had granted me a mission. In that office I was told:

"This mission is unpaid, but as is our custom, and as we did

91. I have supplied the title.

for the painter Dumoulin's mission to Japan, we will make it up to you when you come back by purchasing some paintings. Rest assured, Monsieur Gauguin, when you come back, write to us, and we will send enough to cover your travel expenses."

Words, words. . . .

So here I am in the office of the august Roujon, director of the Beaux-Arts.

He said to me exquisitely: "It is out of the question for me to encourage your art, which I find revolting and do not understand; your art is too revolutionary not to cause a scandal in *our* Beaux-Arts, of which I am the director, seconded by the inspectors."

The curtain twitched and I thought I saw Bouguereau, another director (perhaps he's the real one, who knows?). Undoubtedly he was not there, but I have a wayward imagination, and as far as I was concerned he was there.

What! I a revolutionary, I who adore and respect Raphael? What is a revolutionary art? When does it cease being revolutionary? If the fact of not obeying Bouguereau or Roujon constitutes a revolution, then I confess I am the [Auguste] Blanqui of painting.

And the excellent director of the Beaux-Arts (a man politically situated right of center) asked me, concerning his predecessor's promises: "Do you have anything in writing?"

Can it be that the directors of Beaux-Arts are still lower than the humblest inhabitants of the lowest strata of Paris, so that even when they have given their word in front of witnesses, it is valid only when accompanied by their signature? Anyone who has the slightest sense of human dignity can do only one thing, and that is, withdraw. This I immediately did, and came away no richer than before.

A year after my departure for Tahiti (second voyage), this very amiable and tactful director, having learned from some naïve person, no doubt, that my admirer still believed in good deeds, that in Tahiti I was immobilized by illness and horribly poor, very officially sent me the sum of 200 francs, "to encour-

age me." As you can imagine, the 200 francs were returned to the director's office.[92]

You owe money to someone and you say to him: "Look, here's a small sum of money I am giving you as a present, to encourage you."

What is drawing? Don't expect me to deliver a lecture on the subject. The critics probably mean a lot of things done on paper with a pencil, doubtless supposing that that is where you can recognize whether or not a man knows how to draw. Knowing how to draw is not the same thing as drawing well. Does this critic, this competent man, realize that tracing the outlines of a painted face produces a drawing that looks entirely different? In Rembrandt's portrait of the traveler (La Caze Gallery), the head is square. Trace its outline and you will see that the head is twice as high as it is wide.

I remember the days when the public judged the way Puvis de Chavannes's cartoons were drawn and decreed that although he was very gifted when it came to composition, Puvis did not know how to draw. What was their astonishment, when one fine day, at Durand-Ruel's, he put on an exhibit made up exclusively of black-pencil and red-chalk preparatory drawings.

Well, well, this charming public said to itself, so Puvis does know how to draw like everybody else; he knows about anatomy, proportions, etc. But then, why is it he doesn't know how to draw when he paints?

In any crowd there is always one person who is smarter than the others. And this know-it-all said: "Don't you see that Puvis is making fools out of you? Just another painter who wants to be eccentric and not do what everybody else does."

Good Lord, what is to become of us? That is probably what one critic wanted to understand when he asked me for my draw-

92. A letter which Gauguin wrote to Charles Morice—unpublished until it appeared in *Burlington Magazine* in March 1956—confirms that approximately one year after Gauguin had returned to Tahiti, that is, in about July 1896, the governor transmitted to Gauguin a money order from Roujon for 200 francs. He actually did send a letter of refusal (but not until he had taken care to inform his friend William Molard of its wording).

ings, saying to himself, Let's just look and see if he knows how to draw. He needn't worry. I am going to tell him. I have never been able to do a drawing properly, never learned how to handle a stump[93] and a piece of dough.[94] I always feel that something is missing: color.

Before me, the face of a Tahitian woman. The blank paper bothers me.

Carolus-Duran complains of the Impressionists, especially of the palette they use. It is so simple, says he: "Look at Velázquez. A white, a black."

As simple as that, Velázquez' whites and blacks!

I like to hear people like that. On those dreadful days when you think you're good for nothing, when you throw down your brushes, you remember those people and hope is reborn.

Why is it that today, as I recall everything from the past up to the present moment, I am obliged to see (it is so obvious) that almost all the artists I have known—especially the young ones to whom I most recently gave advice and support—fail to recognize me?

. . . At the age of ten, twenty, a hundred, very young, a little older, and very old, an artist is always an artist.

Isn't he better at some times, some moments, than at others? Never impeccable, since he is a living, human being? One critic tells him: "North is that way"; another says: "North is south"—blowing on the artist as if on a weathervane.

The artist dies, his heirs pounce on his work; they get the copyrights, the auction rooms, the unpublished works, and all the rest of it, until he is completely undressed.

With that in mind, I undress myself beforehand; it makes me feel better.

---

93. A rolled paper cone used for highlights. (Translator's note.)
94. Used as an eraser. (Translator's note)

Criticism undresses. But in such a different way. A critic who comes to my house sees my paintings and, breathing hard, asks to see my drawings. My drawings! Not on your life. They are my letters, my secrets. The public man, the private man. You want to know who I am: are my works not enough for you? Even right now, as I write, I show only what I want to show. But you often see me naked: that's not what matters, it's what's inside that you have to see. Besides, I myself do not always see myself very clearly.

. . . *Ces nymphes, je les veux perpétuer,*[95] and the adorable Mallarmé did perpetuate them—gay and vigilant with love, flesh, and life at Ville d'Avray, near the ivy which entwines Corot's great oak trees, with pervasive golden hues, animal odors; tropical savors here as elsewhere, of all ages, unto eternity.

. . . I have worked and put my life to good use, even intelligent, courageous use. Without crying. Without tearing anything, though I had very good teeth.

. . . I believe that life hasn't any meaning unless you live it voluntarily. . . . To put yourself into your creator's hands is to nullify yourself and die.

. . . No one is good, no one is wicked; everyone is, similarly and differently.

. . . A man's life is such a little thing, and yet there is time to do great things, pieces of the joint achievement.

. . . I have been good sometimes; I do not pride myself on it. I have often been wicked; I do not repent of it.

---

95. First line of *L'Après-midi d'un faune (The Afternoon of a Fawn):* "I would perpetuate these nymphs." (In *Modern French Poetry,* edited and translated by Patricia Terry and Serge Gavronsky, Columbia University Press, New York, 1975.)

Civilized people! You are proud of not eating human flesh. On a raft you would eat it. . . . On the other hand, every day you eat your neighbor's heart.

. . . Reading the *Journal des Voyages,* a man thinks of leaving Paris, a civilization that obsesses him; he takes the train, then at Marseilles the boat, a sumptuous vessel. Aboard ship, a few days out to sea and already he begins to know this colonial world whose existence he had not suspected.

IN TAHITI AND THE MARQUESAS

Every day glittering banquets, a long table of succulent dishes. An officer presides over the table. "Steward! What's this? Do you suppose I am used to eating such food? The government is paying, and I want my money's worth."

At home the clerk lunches on two sous' worth of figs and a sou's worth of radishes. On Sundays, some salad and a bit of bread dipped in garlic-flavored vinegar. On board, things are different; he is on holiday and wants to gobble and grumble at government expense.

The delicate palates of a ruffian, often a complaisant husband; scads of pimply, scrofulous children, the spitting images of their parents, already stamped with the seal of mediocrity— the blessings of compulsory public education.

Somewhere on the wide ocean a ship has just touched land, and it is a tiny island that is not shown on the map. Yet it has a population of three: a governor, a process-server, and a tobacconist licensed to sell postage stamps. Already!

. . . Arrival in Tahiti. Every newcomer must pay a visit: the opera hat, the governor, and the streetsweepers too are indescribable. Whispering. At last, but graciously, you are asked: "Have you any money?"

. . . Don't take it into your head to make the acquaintance of a French public prosecutor. Like me, you would be sorry for it. . . .[96] Everyone, even the commanding officer of the warship,

96. Allusion to a quarrel in 1899 between Gauguin and the French prosecutor, Édouard Charlier, over a series of petty thefts of which Gauguin had been the victim; he lodged a complaint, but Charlier did not deign to follow it up. It was indeed this incident which made Gauguin launch into polemical journalism (cf.

tried to discourage me from getting involved in such an escapade.

"You have no idea what a governor is or what a public prosecutor is, in the colonies," they said to me. "You might as well try to stop a comet by putting a grain of salt on its tail."

That is how I became a journalist, a polemicist if you prefer. But it is no easy matter to navigate among those reefs without coming to grief on them. I had to study the ins and outs, so as not to get myself sent to prison.

At 17° south,[97] as elsewhere, councillors, judges, officials, gendarmes, and a governor.

. . . A fat prosecutor, public prosecutor; after questioning two young thieves, he pays me a visit. In my hut there are things which are bizarre, because not usually seen: Japanese prints, photographs of paintings, Manet, Puvis de Chavannes, Degas, Rembrandt, Raphael, Michelangelo, Holbein. [After those names, nothing of mine (I dare not).]

The fat prosecutor (an amateur who is very clever with a pencil, they say) [who draws very well, they say, and is clever with a pencil] looks at them, and before a portrait of a woman by Holbein, from the Dresden Museum, he says to me: "It's taken from a piece of sculpture . . . isn't it?"

"No, it's a painting by Holbein, the German school."

"Well, that doesn't make any difference, I don't dislike it [I like it], it's nice."

Holbein! nice?

His carriage awaits him, and he goes farther on, where there is a view of Orohena, to have a nice lunch on the grass, surrounded by a nice landscape.

. . . On the veranda a pleasant nap, all is at rest. My eyes gaze uncomprehendingly at the space before me, and I have an inkling of the neverendingness of which I am the beginning.

Mooréa on the horizon; the sun is nearing it. Uncom-

---

B. Danielsson and P. O'Reilly, *Gauguin journaliste à Tahiti*, 1966).

97. Gauguin had already inserted this text in "Miscellaneous Things." The passages in brackets are variants.

prehendingly I follow its plaintive progress. I have an impression of movement that is perpetual from now on, an all-embracing life that never will be extinguished. . . .

. . . Let me tell you about a cliché that circulates here and has a way of annoying me: the Maoris come from the Malay Archipelago. On the boats that ply the Pacific Ocean, and when their passengers disembark at Tahiti, the officials, who always know so much, tell you: "Monsieur, the Maoris are an export from the Malay Archipelago."

"But why so?" you exclaim.

There is no "why." It's a cliché, adopted and regurgitated by all the photographers. Only the Malay Archipelago has supplied men. The very idea of the ancient land of Oceania churning out men!

In what era did men begin to exist on this globe of ours? Never mind, since, as I said before, only the Malay Archipelago . . .

In what era did thought, emerging from its animal nature, acquire a few rudimentary elements and consequently the beginnings of language, whose initial elements were provided by the first uncouth sounds that came out of the human gullet?

Come to think of it, doesn't it seem reasonable to suppose that the first thought pattern and the first language pattern were the same, roughly the same? There's nothing at all surprising about the fact that even later, much later, the few generic words that primitive man's gullet allowed him to pronounce, and the same thought pattern, are found in the Malay Archipelago, Oceania, Africa, etc.

What man sees, what he touches, and what he smells are what man must have thought about, above and beyond all else, from the beginning; then came the desire to take . . . and the means of taking, that is, the hand.

Hence the word *rima* or *lima*, meaning hand, which you find in almost every language, in the Malay Archipelago, just as everywhere else, more or less transformed by differences in pronunciation. Doesn't the Latin word *rama* resemble it? The

same holds true for the number 5, which represents one hand, and 10, two hands. As far back in time as man's memory has been able to record, savages have used their arm span as a unit of measure; the foot as well.

. . . This matter of language was one of the major reasons why this Malay-Maori cliché was adopted.

It's better not to know than to know mistakenly.

And I would say that as far as I am concerned, the Maoris are not Malays. . . .

. . . Jean-Jacques Rousseau makes his confession. It is not so much a need as an idea. The man of the people is dirty but capable of cleansing himself. People did not want to believe it and yet they were forced to. It is not the same thing as Voltaire saying to the noble caste: You are ridiculous, we are ridiculous, let us remain ridiculous.

*Candide* is a naïve child; there have to be some. Let us remain as we are.

*Jacques le Fataliste*[98] is fated to remain the servant.

Jean-Jacques Rousseau is something else again.

The education of *Emile*! the one that upsets so many decent people. It is still the heaviest chain that ever a man tried to break. I myself dare not think of it in my own country. Here, now that I am enlightened, I look at things with detachment. I have seen a native chief who, had it not been for French domination, would have become king, ask a white colonial—married to a white woman—for one of his children. Had he adopted it, he would have given its father almost all his land and 500 piasters out of his savings, as payment.

Here, everyone looks on a child as nature's greatest blessing and people vie with one another to adopt one. That's how savage the Maoris are. This kind of savagery I adopt.

All my doubts have been dispelled. I am and shall remain a savage.

Christianity here doesn't understand a thing. Luckily, in

98. A novel by Denis Diderot (1713–84).

spite of all its efforts, coupled with the civilized laws on inheritance, marriage is no more than a ceremony for the fun of it. As in the past, the bastard, the adulterine child will be the imaginary monsters of our civilization.

Here, *Emile*'s education is carried out in full, clarifying sunlight; he is voluntarily adopted by someone and adopted by the whole society.

The smiling young girls can freely bring into the world as many Emiles as they like.

. . . At the cost of a little small change my body is satisfied and my mind remains at peace.

And so I am described to the public as an animal devoid of all sentiment, incapable of selling his soul for a Marguerite. I have not been Werther, I shall not be Faust. Who knows? perhaps the syphilitics and the alcoholics will be tomorrow's leaders. Like science and everything else, it looks to me as though morality is heading toward an entirely new kind of morality which may be the opposite of today's. Marriage, family, and a heap of other good things they keep dinning in my ears seem to me to be traveling a pretty fair distance in a high-speed locomotive.

And you want me to be on your side, you bunch of bourgeois?[99]

. . . In Port Said I had bought a few photographs. The sin having been committed . . . without beating around the bush, I hung them up in the alcove. The men, the women, the children laughed—just about everybody, in fact, but only for a moment, then they stopped thinking about them. Only the people who call themselves "proper" did not come to see me, and only they thought about them all year long.

At confession, in many places, the priest elicited information; several nuns even became paler and paler and acquired dark rings under their eyes. Meditate on this, and nail up some

99. Gauguin crossed out these words *("tas de bourgeois")* in his manuscript.

indecency in plain sight, on your door; from then on you will be rid of "proper people," the most unbearable creatures God has ever made.

. . . I said to myself the time had come to clear out and go to a simpler country with fewer officials. And I thought of packing my trunks and moving to the Marquesas. The promised land, more land than they knew what to do with, meat, fowl, and, to guide you here and there, a gendarme as gentle as a lamb.

Straightaway, with my heart at ease, as trusting as an obstructed virgin, I took the boat and arrived calmly in Atuona, county seat of Hiva Oa.

I certainly had to shed a good many illusions. The ant is no lender, that is its least failing; and I must have seemed like a cricket that had spent the whole summer singing.[100]

First of all, the news that greeted me on arrival was that there was no land for rent or for sale, except from the mission, if that. The bishop was away, and I had to wait a month; my trunks and a load of building wood remained on the beach.

During that month, as you can imagine, I went to Mass every Sunday, as I was forced to play the role of a true Catholic and anti-Protestant polemicist. This gave me a good reputation, and without suspecting my hypocrisy, Monsignor consented (as a favor to me) to sell me a small plot of stony land covered with bush, for 650 francs. I set to work courageously, and also thanks to a few men recommended by the bishop, I was installed as nicely as could be. Hypocrisy has its advantages.

Once my hut was finished, I hadn't the slightest desire to make war on the Protestant pastor, who, for that matter, is a courteous and very liberal-minded young man; nor had I the slightest intention of returning to the Church.

A chick came along and the hostilities began.

---

100. Reference to "La Cigale et la Fourmi," a fable by Jean de La Fontaine (1621–95).

When I say a chick, I'm being modest; actually, all the chicks came without having been invited.

. . . Here, in this country, marriage is beginning to catch on; it regularizes the situation. Exported Christians going about their singular task tooth and nail.

The gendarme doubles as mayor. Two couples converted to the matrimonial notions and all dressed up in new clothes listen while the matrimonial laws are read aloud. Having answered "yes," they are married. As they come out one of the two males says to the other: "Suppose we exchange?" And very gaily each one goes off with a new wife to the church, where the bells fill the air with gladness.

With the eloquence that characterizes missionaries, Monsignor inveighed against adulterers and blessed the new union which was already, in this holy place, beginning to indulge in adultery.

Another time, as they came out the church door, the bridegroom said to the bridesmaid: "How beautiful you are." And the bride said to the best man: "How handsome you are." In no time one new couple went off to the right and the other to the left, deep into the bush in the shade of the banana trees, and there, before God Almighty, two marriages took place instead of one. Monsignor is content and says: "We bring civilization."

On some tiny island, whose name and latitude I have forgotten, a bishop went about his business of Christian moralization. He is quite a buck, they say. Despite the austerity of his heart and his senses, he loves a little girl from the mission school with a pure, paternal love. Unfortunately the devil sometimes minds things that are none of his business, and one fine day our bishop was walking through the woods when he caught sight of his beloved child, naked in the river, who was washing her chemise.

*Petite Thérèse le long d'un ruisseau*
*Lavait sa chemise au courant de l'eau,*

*Elle était tachée par un accident*
*Qui arrive aux fillettes douze fois par an.* [101]

Why, she's ripe, he said to himself.

You bet she was ripe! Just ask the fifteen vigorous young men who had first go at her that very evening. When the sixteenth young man's turn came, she became reluctant.

The adorable child was married to a beadle who lived in the mission. Brisk and tidy, she swept Monsignor's room and sorted the perfumes. At divine service, the husband held the candle.

How wicked the world is. The gossips' tongues wagged, wrongly no doubt, and in fact I became altogether convinced of this when one day an ultra-Catholic woman said to me: "Don't you see" (and meanwhile she drained her glass of rum without even blinking), "don't you see, my dear, it's all just a joke; Monsignor is not sleeping with Teresa, he just hears her confession so as to try and still his craving."

Theresa is the bean queen. Don't try to understand what I am going to explain to you.

On Twelfth Night, Monsignor had had the Chinaman bake a superb cake. Teresa's share contained a bean and so she became the queen; Monsignor was the king. From that day on, Teresa went on being queen, and the beadle, the queen's husband—you get my meaning.

But alas, the precious bean grew older, and our buck was clever enough to find a new bean a few miles away. Just imagine a Chinese bean, as plump as could be, plump enough to eat. You, the painter looking for graceful subjects, take up your brushes and immortalize the scene. Dark chestnut steed with the episcopal seal on its trappings. Our buck sitting upright in the saddle, and his bean, whose curves both fore and aft would be enough to bring a pope's *castrato* back to life. Still another

---

101. Little Teresa was washing her chemise
 In the flowing water of a brook,
 It was stained by an accident
 That befalls little girls twelve times each year.

girl whose chemise . . . you know what I mean . . . no need to
repeat. Four times they dismounted. . . .

. . . Monsignor is a buck, whereas I am an old cock, very
tough and pretty hoarse. If I said it was the buck who began, I
would be speaking the truth. Trying to sentence me to a vow of
chastity! That's too much. Nothing doing, Lisette.[102]

Cutting two superb pieces of rosewood and carving them
in the Marquesan fashion was child's play for me. One showed
a horned devil *(Le Père Paillard).*[103] The other, a charming
woman, with flowers in her hair.

. . . Before me I see coconut palms and banana trees; every-
thing is green. To make Signac happy, I'll tell you that little red
dots (the complementary color) are scattered through the
green. In spite of which, and this is going to annoy Signac, I
certify that large blotches of blue are visible in all that green.
Make no mistake; it's not the blue sky, only the mountain in the
distance.

What can I say to all these coconut trees? And yet, I need
to chat; so instead of talking I write.

Well! there's little Vaitauni going down to the river. . . .
This bisexual creature is not like everybody else, and that kin-
dles your senses when you're feeling impotent, like a weary
hiker. She has the roundest and most charming breasts you can
imagine. I watch that golden, near-naked body moving toward
the cool water. Take care, my dear child; the hairy gendarme,
the guardian of morals but secretly a satyr, is spying on you.
Once his eyes are satisfied, he will give you a fine in order to get
even with you for having aroused his senses and therefore com-
mitted an outrage against public morals. . . .

Ah, good people of continental France, you don't realize

---

102. Name usually given to the soubrette; in popular nineteenth-century French
songs, typifies the gay and flirtatious working-class girl.
103. *Father Debauchery,* the carved caricature of Monsignor Joseph Martin, Cath-
olic bishop of the Marquesas.

what it is to be a gendarme in the colonies. Come out and see, and you'll find a type of filthy rubbish such as you wouldn't believe.

. . . God, whom I have often offended, has spared me this time: as I write these lines, an altogether exceptional storm has just caused terrible damage.

The day before yesterday, in the afternoon, the nasty weather that had been building up for several days took on threatening proportions. By eight in the evening the storm broke. Alone in my hut, I expected it to collapse at any moment. In the tropics, the enormous trees have few roots, and the soil loses all consistency once it is soaked. Now, all around me, those trees were splitting and crashing to the ground with a heavy thud. Especially the *maioré* (breadfruit trees have very brittle wood). The gusts of wind shook my light roof of coconut leaves and blew in from all sides, so that I could not keep the lamp lighted. If my house were demolished, along with all my drawings—all the material I had been accumulating for twenty years —it would be my ruination.

At about ten o'clock a continuous noise, as if a stone building were collapsing, caught my attention. I had to go and see, and I went out of my hut. Immediately my feet were in water. The moon had just risen; in its pale light I saw that I was quite simply in the midst of a rushing torrent, carrying with it rocks that came slamming into the wooden pillars of my house. All I could do was await the decisions of Providence, and I resigned myself to do so. It was a long night.

As soon as dawn came I looked outside. What a strange sight—the sheet of water, those blocks of granite, those enormous trees from heaven knows where. The road that went by my land had been cut in two, which meant that I was hemmed in on an island, less pleasantly than the devil in a basin of holy water.

I ought to tell you that what they call the Valley of Atuona is a very narrow gorge in certain places, where the mountain rises like a wall. When a big storm occurs, all the waters of the

upland plateaux fall directly into the stream. Instead of making it easier for flood waters to run off, the administration, never very intelligent . . . did exactly the opposite, barring the way on all sides by heaping up stones. And not only that but on the banks and in the middle of the stream, it let trees grow; they are naturally uprooted by floods and become so many demolition agents, knocking over everything they encounter. In these hot, poor countries, the houses are flimsily constructed and the slightest thing brings them down: so many elements making for disaster. Reason is obviously not held in any account, since it is trampled on in this way; already they intend to do nothing more than hastily fill up the holes caused by the flood. But what about bridges! Where is the money? The eternal question, where is the money?

. . . My hut withstood the storm and gradually we are going to try to repair the damage. But what about the next flood?

. . . The flood and the thunderstorm are barely over, everyone is managing as best as he can, cutting the uprooted trees, building little footbridges everywhere so as to be able to visit his neighbors. We await mail which does not arrive, and supposing we have an enormous stroke of luck, we hope that in a year the government will be willing to compensate for our disasters and send us a little money.

. . . At my window here in the Marquesas, in Atuona, everything grows dark, the dances are over, the soft melodies have died away. But they are not replaced by silence. Crescendo, the wind zigzags in the branches, the great dance begins; the cyclone is in full swing. Olympus enters the game; Jupiter sends us all his thunderbolts, the Titans roll the rocks, the river overflows.

The huge *maioré* trees are toppled, the coconut palms bow low and their hair skims the earth. Everything flees—the rocks, the trees, the cadavers whirled toward the sea. Thrilling orgy of the wrathful gods.

The sun returns, the lofty coconut palms raise their plumes, and so does man.

. . . I want to talk to you about the Marquesans, which will be fairly difficult in this day and age. Nothing picturesque to get our teeth into. Not even the language, which is spoiled now by all the mispronounced French words—a horse, *chevalé;* a glass, *verra;* etc.

People in Europe do not seem to realize that both the Maoris of New Zealand and the Marquesans had evolved a very advanced type of decorative art. Mr. Know-it-all-Critic is wrong when he dismisses it all as "Papuan art!"

The Marquesans especially have an extraordinary sense of decoration. Give a Marquesan an object of any geometric shape, even hump-backed, rounded geometry,[104] and he will manage to make everything harmonious without leaving any shocking and disparate empty place. The basis of this art is the human body or face. The face especially. You're astonished to find a face where you thought there was a strange geometrical figure. Always the same thing and yet never the same thing.

Today, even if you offered their weight in gold, you would not find any more of those beautiful objects that they used to make out of bone, tortoise shell, or ironwood. The gendarmerie has filched everything and sold these objects to collectors, and yet the administration never once thought of doing what would have been so easy for it: creating a museum in Tahiti of all Oceanic art.

None of those people who claim to be so educated had any idea of the value of the Marquesan artists. There was not one official's wife who did not exclaim, on seeing examples of that art: "But it's dreadful! It's just plain barbaric!" Barbaric! That's their favorite word.

With their outdated fashions, their bread-loaf figures from head to toe, vulgar hips, corsets squeezing their guts, fake jewelry, elbows either threateningly sharp or sausage-fat, the sight of them mars any feast in this country. But they are white, and potbellied.

---

104. Gauguin again uses the term *"géométrie gobine";* see p. 106.

The nonwhite population is altogether elegant. . . . One man says: "They're Papuans"; another says: "They're Negresses. . . ." Let's call them the Maori race. . . . I repeat, altogether elegant. Any of the women can make her own dress, plait her hat, bedeck it with ribbons in a way that outdoes any milliner in Paris, and arrange bouquets with as much taste as on the Boulevard de la Madeleine. Their beautiful bodies, without any whalebone to deform them, move with sinuous grace under their lace and muslin chemises. From the sleeves emerge essentially aristocratic hands. Their feet, on the contrary, which are wide and sturdy, and wear no laced boots, offend us but only at first, for later it is the sight of laced boots that would offend us. Another thing about the Marquesas which upsets prudish people is that all these girls smoke pipes, and the people who see "savages" everywhere have no doubt they are peace pipes.

However that may be, in spite of everything, no Maori woman could appear badly dressed and ridiculous, even if she wanted to; she has the innate sense of decorative beauty that I admire in Marquesan art now that I have studied it. But is that all there is to it? Is it nothing but a pretty mouth which shows such lovely teeth when it smiles? . . . And those pretty breasts with their golden nipples, so unamenable to corsets? What makes the Maori woman different from all other women, and often makes her resemble a man, are her bodily proportions. Diana the huntress with broad shoulders and narrow hips.

. . . In Maori women, the entire leg from hip to foot forms an attractive straight line. The thigh is very heavy, but not widthwise, and the heaviness makes it very round and avoids that gap between the thighs that makes some women in our countries remind us of a pair of tweezers.

Their skin is golden yellow; that's a fact and some people find it ugly, but is all the rest, especially when it's nude, really so ugly? And it's to be had for almost nothing.

There is, however, one thing about the Marquesans that bothers me, and that is their excessive liking for perfume; the storekeeper sells them a horrible mixture of musk and patchouli. When there are many of them in a church, all these per-

fumes become unbearable. But, here again, the fault lies with the Europeans. You won't smell any lavender water, for the natives, to whom it is forbidden to sell a drop of alcohol, drink it as soon as they can get their hands on it.

Let's get back to Marquesan art. It has disappeared, thanks to the missionaries. The missionaries looked on carving and decorating as fetishism, offensive to the Christian God. That's the crux of the matter, and the poor wretches gave in. From the cradle onward, the new generation sings hymns in incomprehensible French and recites the catechism. . . . If a girl has picked flowers and artistically makes a pretty wreath of them and places it on her head, Monsignor becomes angry!

Soon the Marquesan natives will be incapable of climbing up coconut trees, incapable of going into the mountains to look for the wild bananas that can provide them with food. The children are kept in school, deprived of physical exercise, their bodies always clothed (for decency's sake); so they become frail, unable to spend the night in the mountains. They have all begun to wear shoes, and their feet, being sensitive from now on, will not be able to run along the rugged paths, or cross streams by stepping from stone to stone.

So what we are witnessing is the sad sight of a race becoming extinct; most of them are consumptive, their loins are sterile, and their ovaries have been destroyed by mercury.

. . . When you arrive in the Marquesas and see all the tattoos that cover body and face entirely, you say to yourself: They are terrifying fellows. And they used to be cannibals.

You are completely mistaken.

The Marquesan native is not a terrifying fellow; on the contrary, he is even an intelligent man and altogether incapable of concocting any wickedness. Gentle to the point of stupidity and timorous toward anyone in a position of authority. You say he used to be a cannibal and you suppose that that's all over: you are wrong. He is still a cannibal, but not a fierce one; he likes human flesh the way a Russian likes caviar, the way a cossack likes a tallow candle. Ask a drowsing old man if he likes human

flesh; this time, he will wake up, and with gleaming eyes and infinite gentleness, he will answer: "Oh, it's so good!"

Right now the sergeant of the gendarmerie is doing his best to persuade the natives that he, and not Monsieur Gauguin, is in charge. . . . He and Pandora make a fine couple.

Little Taia, who does his laundry, is no fool. When she wants to wangle 10 sous from him, she tells him: "You know very much things," and he gives them to her.

"I'm the one who's in charge, not Monsieur Gauguin."

What do you think of little Taia? I find that she is a typical Marquesan girl. Big round eyes, a fish's mouth, and a row of teeth that could open a can of sardines. Don't leave it near her for very long, or else she'll eat it. At any rate, she already knows all there is to know about that sergeant of hers.

. . . He's the one in charge, not Monsieur Gauguin. On his chest, the medals gleam as brightly as they can. On his rubicund face, alcohol gleams dully.

"In witness whereof, consequently, subsequently, we have delivered his identity certificate, followed by a description of him."

. . . For some time now, three whaling vessels have been navigating in our waters and the gendarmerie is worn out. Why all the commotion, all this veiled hostility? Whalers!

. . . It is the practice of whalers not to carry hard cash on them, as they know full well that while at sea you cannot eat cash, and that on land there are philosophers who disdain base metal.

And so, imbued with these false ideas, they came to the Marquesas, particularly Tahuata. There, they expected to take on a supply of water and exchange trinkets and light flannel cloth for bananas, cattle, and other victuals.

What! put ashore goods on which no duty has been paid? Out of the question! But the natives, only too happy to exchange produce they do not know what to do with for objects

that appeal to them, really wonder whether we wish them good or will. But three or four nobodies, dealers in codfish, complain that this is "unfair competition."

When all was said and done, the gendarme was out of breath and the ship, by night, was entirely relieved of its merchandise. Well stocked, it put out to sea again.

The island of Tahuata is the richer by a few European products. Where is the harm in that? Why all this outcry?

At the time, the island of Tahuata was ravaged by a frightful tidal wave which threw up enormous hunks of coral and a great many shells for collectors. Out of the coral they will make lime. When the whalers, who are terrific sailors, saw their barometer playing tricks they knew what was coming and left—but not without leaving the gendarme some very pretty presents. Bribes? Tut tut tut, presents (with invoices)!

Well, after all, the captains said, smugglers must always be on good terms with the gendarmes.   *—January–February 1903*

AN AMERICAN
ROBBED . . .
AND EATEN

Another story, this time much more recent.

A young American got off his ship and, probably captivated by the women, stayed in the Marquesas, settling in a district of Hiva Oa. To make a living, he tried to do a little trading on other people's behalf. One day he had the unfortunate idea of coming back from Atuona with a bag of piasters visibly tied to the pommel of his saddle. It was evening; he disappeared.

A Chinaman was suspected immediately and since the gendarme is a shrewd fellow in every respect, he said, "It's him," and that was enough. It wasn't until three months later, that is, three mail deliveries later, that a judge came back to Papeete with the Chinaman and a few witnesses. Naturally the Chinaman was acquitted right away.

The word "naturally" calls for some explanation.

In fact that is the rule in the Marquesas whenever a crime has been committed. The gendarme, empty-headed and always on the wrong track, carries out his investigation, heedless of warnings from the intelligent men around him. The examining

magistrate comes along much much later and his opinion immediately coincides exactly with the gendarme's. Actually, being fair is no easy matter in the Marquesas.

The natives' rule is to behave the way their fear of the bad men dictates. If one of them did not abide by that rule he would be sentenced to death. When the crime has been committed, everybody knows this; but when time comes to appear before the judge, nobody knows anything.

The witnesses get the matter all tangled up, mere child's play for them since the interpreter always translates their language all wrong. Also, with their remarkable intelligence and imperturbable presence of mind, they gloss over every contradiction. "But why did you say one thing a minute ago and the very opposite just now?"

"Because being in court frightens me, and when I'm frightened I don't know what I'm saying."

There are two of them; they accuse each other mutually, and each one invariably answers: "I accuse my neighbor because otherwise the judge will say I did it!"

I remember the naïveté of a presiding judge in the court at Papeete.

"Interpreter, tell this man that he answers every one of my questions very intelligently. This means that he thought them all over before having heard them."

Answer: "The man says he doesn't understand why he's being asked this and he's answering as best he can."

Now, to get back to our Chinaman: as soon as that precious bag of piasters hove into sight in the district near his hut it was noticed, and our vigorous and determined young American, as trusting as young people generally are, did not bother to hide it. He was killed, they say, by a vigorous blow on the neck, the cudgel acting just like a guillotine. It took two people, the Chinaman and his son-in-law, who then fought each other, they say, over dividing up the piasters.

After which, they say, the son-in-law and two other natives gave themselves over to gluttony: the American was eaten.

—Avant et Après, *1903*

# Last Writings

*Editor's note: In the two years that he had been living in the Marquesas, the gendarmes had come to hate Gauguin, as the previous pages indicate. They accused him of stirring up the natives against the established authorities, encouraging them to refuse to pay their taxes, and to stop sending their children to school. And in addition, there were virtuous complaints about the sexual liberties that Gauguin was said to have encouraged from his hut, dubbed the "House of Pleasure." Weren't his morals "those of a disciple of Epicure, which the Marquesans scarcely need to know" (letter dated August 28, 1902, from Police Sergeant Charpillet)? Didn't he "defend all of the natives' vices," and when, "completely naked," they gathered to get drunk on orange wine, didn't he look on those "savage scenes" that turned into orgies as "nothing more than mere amusement necessary to the natives' well-being"? (Report by Inspector Salles to the Ministry of the Colonies, April 4, 1903.)*

*Things went sour in early February 1903, when Gauguin wrote to François Picquenot, administrator of the Marquesas, asking that an inquiry be made concerning Etienne Guichenay, the gendarme on the neighboring island of Tahuata; he was rumored to have accepted bribes from American whaling captains, who had supposedly sold quantities of goods to the natives unlawfully, thus hurting local trade. Picquenot sent Guichenay a written request for explanations. Guichenay hastened to pass on the administrator's letter to Claverie, his colleague at Hiva Oa, who decided to sue Gauguin for "slandering a gendarme in the performance of his duty." The result was that on March 31, 1903, a judge sentenced*

286

*Gauguin to three months in prison and a fine of 500 francs, an irregular*
*application of the 1881 law concerning to the press!*

*Below are excerpts from the letters that Gauguin sent to Governor*
*Edouard Petit and to colonial inspectors who happened to be in the*
*Marquesas at the time, as well as from those he sent, after he had been*
*sentenced, to the administrator of the Marquesas, to Brault, his lawyer,*
*and to the resident lieutenant of the gendarmerie in Tahiti.*

*The last four letters in this book were written at most a month before*
*Gauguin's death.*

TO MONSIEUR EDOUARD PETIT,

GOVERNOR OF THE FRENCH SETTLEMENTS IN OCEANIA, TAHITI                    LETTERS

Dear Governor,   Like a tourist in a hurry to go around the
world in eighty days, you have visited the Marquesas. And
a formal visit it was too, since a French warship, resplendent
with our national colors, was assigned as your yacht, with
all the customary pomp.

There was every reason to hope, even to assume, that you
were coming in order to be brought up-to-date on the state of
our affairs and thereafter to govern the colony soundly and
make as many of the ardently desired improvements as possible.
This colony is entirely in your hands, having no representative
on the Conseil général, and therefore it is impossible for it to
express its hopes and proclaim its rights, except in the person
of an individual, well-meaning colonist.

Both our hopes and our expectations were wafted away in
the warship's smoke. You went to call upon the bishop at his
residence, and then went to government house, there to be
saluted yourself by the gendarme.

No doubt fatigued by this extraordinary chore, you rested
by taking photographs. Beautiful girls with firm breasts and
smooth bellies frolicking in the stream—fine subjects for your
superb collection, and just the thing to interest the school of
naturalism; but not the slightest trace of a desire to go about the
business of colonization.

What would have been interesting and worthwhile was this:
if you had dropped the haughty manner you adopted the minute

you arrived in Tahiti (in order, no doubt, to make all conversation between the colonists and yourself impossible) and had consulted the only people capable of giving you information, those who live in the Marquesas and are trying to colonize, through their intelligence, their capital, and their activity, but in vain.

Then you would have learned that we are not your stable boys (as your conduct toward us would seem to indicate that you believe); you would also have learned a good many things that you pretend not to know or do not wish to know.

Those things are of interest to everyone, here and in France, since what is at stake is the prosperity or the ruin of a colony belonging to France, and France, believing in your abilities and your good will, has made you responsible for that colony.

It is also a matter of humanity. You alone seem to understand nothing about it and take no interest in it. Judging from the superb photographs you took in the Marquesas, it is obviously a delightful land where everything betokens beauty and *joie de vivre,* and the vegetation is luxuriant.

The good seeds fall on the good soil, and the gentle breeze does the rest; the miracle is accomplished and the harvest need only go on board good strong ships in regular service—once the export duty has been paid on it.

But, on the other hand, leaving photography aside, if you look at the figures, and if, seeking to do good, you consult the experienced wise men, the sky darkens over and you find nothing but disappointment.

First of all, you would have found out that for lack of labor (especially if one is not a fervent Catholic), it would be impossible for two or three farmers to harvest five hectares of coffee or vanilla. But why talk about agriculture if almost all of the good land is owned by a handful of people, almost half of it in fact by the bishop?

So the only resource left to a colonist is to find a few scraps of land where he can build a hut and do some trading, but on

a very limited scale; for a small capitalist like that has to compete with a big concern (the Société Commerciale) which has long been equipped to take over all trade.

Or else cattle breeding, which necessitates great expenditure for grazing land, pens, transportation, and also for workers, who have become harder and harder to find. Considering the problems that plague cattle breeding—selling at low prices, difficulty of shipment, and, finally, export duty—it will inevitably be abandoned.

Which, when you come right down to it (an extremely simplified summary of the economic situation), leaves only two products, one of them being cattle, which is almost necessary, and the other, the real one, being copra.[105] On both of these products, export duty has to be paid in advance.

. . . [The work contribution] is an unduly high tax.[106] Not only is it unjustified, since, to tell the truth, there are nothing but mule tracks and they are never kept up, but it also has the disadvantage of costing more than it brings in because, to enforce it, many gendarmes are needed to do the abundant paperwork involved, whereas just one gendarme would be enough to take care of the birth and marriage and death certificates. As for crime, it is virtually nonexistent in these islands, where the natives are as gentle and timid as can be, so there is no need for a corps of armed men.

Not once since September 1901 has a judge come to Atuona to try a single case, so it must be admitted that this can scarcely be called an item of expenditure. Even if one were to come, all he could rule on would be a few ridiculous mis-

---

105. Copra is coconut meat which, when ground up, yields an edible oil.

106. A tax theoretically earmarked for maintenance of the local roads and payable in money or in kind (work contribution). Gauguin sometimes asked the administration to postpone the date when the Marquesan natives would have to do that work, so that they could first harvest their food crops; sometimes he personally paid in cash the amount owed by his "native servant"—but in vain, as the gendarme summoned the "servant" to appear before the judge, as "accused of having refused to perform his work contribution." In Gauguin's final letter to his lawyer in Tahiti, Léonce Brault, dated April 27, 1903, he expressed indignation at the gendarme's trying to "force" the natives to produce copra.

demeanors—such as bathing without a fig leaf in the more secluded parts of the river.

So what can the enormous sum which the Marquesan taxpayer pays in the form of tolls, tithes, etc., possibly be used for?

. . . "But there is no money!" What? All those enormous taxes we pay, in exchange for nothing at all, and you have no money?

. . . This may matter little to you, Monsieur le gouverneur, but it matters to us colonists, the only element of any vitality in a colony. Indignant at such treatment, we think it also matters to raise our voices in protest. And I protest vigorously, Monsieur Edouard Petit, both here and in France, where people know how to listen. Perhaps a more powerful man than yourself will say to you, like MacMahon: "You must either submit or resign."          —*November 1902, Hiva Oa, Marquesas Islands*

TO THE COLONIAL INSPECTORS, IN THE MARQUESAS AT THIS TIME    . . . I simply want to ask you to consider for yourselves what the natives are like here in our colony of the Marquesas, and how the gendarmes behave toward them; and here is the reason why. In order to save money, a judge is sent to us only about once in every eighteen months. Consequently that judge is in a hurry to hear cases and knows nothing at all about what a native can be like. When he sees a tattooed face in front of him, he says to himself: Here's a cannibal ruffian—especially when the gendarme concerned declares that it is so.

. . . So the judge arrives and deliberately chooses to put up at the gendarmerie and take his meals there, and sees nobody but the sergeant who submits the files to him along with his comments: "So-and-So, So-and-So, all a bunch of scoundrels, etc. You see, Judge, if you're not strict with these people, we'll all be assassinated." And the judge is convinced.

. . . In court, the defendant is questioned through an interpreter who does not know any of the subtleties of the language, nor, especially, of the language of magistrates, which is very difficult to interpret in this primitive tongue, except with a good deal of circumlocution.

A native defendant is asked, for instance, if he had been drinking. He answers no, and the interpreter says: "He says he has never had a drink." And the judge exclaims; "But he has already been sentenced for drunkenness!"

A native, who by nature is very timid in front of a European, who seems to him to know more and be his superior, and remembering too the cannon of the old days, appears, when in court, to be terrified of the gendarme, of the previous judges, etc., and he prefers to admit to being guilty even when he is innocent, for he knows that if he denies it, his punishment will be much worse. The regime of terror.

. . . On the opposite side of the fence, so to speak, are gendarmes who occupy posts endowed with absolute power; their word is law in any legal proceedings, they are not immediately answerable to anyone, and they are out to make their fortunes by living off the poor but generous natives. The gendarme frowns and the native gives him hens, eggs, pigs, etc.; otherwise the native will have a fine to pay.

. . . The gendarme here is coarse, ignorant, corrupt, and ferocious in the performance of his duty; yet he is very clever at covering his tracks. For instance, if he receives a bribe, you may be sure that he has the corresponding invoices in hand.

. . . Generally speaking, the population is very mild, so the only resource is fines [for] misdemeanors involving drunkenness. As the natives have nothing, but absolutely nothing, by way of amusement, their one and only joy is the type of drink that nature provides gratis, that is, the juice of oranges, coconut flowers, bananas, etc., that has fermented for several days and is less harmful than our European alcohols.

Since the very recent ban on drinking, which does away with a trade that had been profitable for the colonists, the native can now think of only one thing: drinking, and therefore he flees the towns and goes to hide somewhere else, which is why it is impossible to find workers. Might as well tell them to go back to living like savages.

. . . The gendarme is in his element. Manhunting.

. . . If, on one hand, you pass special laws that prevent them

from drinking, whereas the Europeans and the Negroes can drink, and if, on the other hand, their words, their statements in court become worthless, then it is inconceivable that they should be told that they are French voters, and that schools and other religious twaddle be imposed on them.

The singular irony of this hypocritical version of *"Liberté, Egalité, Fraternité"* beneath a French flag compared with the disgusting spectacle of men who are nothing but tax fodder (taxes of all sorts) or fodder for the arbitrary gendarme. And yet they are made to shout: *"Vive monsieur le gouverneur, vive la République!"*    —*Undated, late 1902, Hiva Oa, Marquesas Islands*

TO THE ADMINISTRATOR[107]    . . . Having examined the file on me, it happens that Gendarme Guichenay sent his lieutenant a copy of the letter which I had sent you and concerning which you answered me on March 17, 1903. With the governor's approval, the lieutenant has decided that that letter is libelous.

. . . I intend to appeal the sentence handed down on me which appears strange from every point of view; among other things, the law of July 1881 concerns the press or words spoken in public, and does not concern writings which are private or even secret.    —*March 31, 1903, Hiva Oa, Marquesas Islands*

TO MONSIEUR LÉONCE BRAULT    (lawyer, Papeete, Tahiti)    . . . So please tell me by return mail what I should do and whether I should embark immediately. I am very sick and do not wish to stay in Papeete very long. . . .

—*April 1903, Hiva Oa, Marquesas Islands*

TO THE LIEUTENANT OF THE GENDARMERIE    (Papeete)    *There are two versions of this letter, a first draft and the final version. The first paragraph of the first draft, which Jean Loize published in* Les Amitiés de Monfreid *(1951), as no. 344, does not reappear in the final letter. In the second*

---

107. François Picquenot, administrator of the Marquesas at Taiohae (town on Nuku Hiva), had written Gauguin expressing his surprise that Claverie, a gendarme, "had threatened to sue him on the strength of a letter which had accidentally fallen into his hands."

*paragraph, Gauguin added to the first draft the words that come after "misery." The third paragraph of the final letter stops before "who come by to say hello" and the word "Europeans" is replaced by "people." The paragraphs after these do not appear in the first draft. Loize summarized the beginning of the first draft as follows: "Gauguin acknowledges that he was immediately recognized here as a* refractory *individual, such as had* never been seen in the Marquesas."

. . . Out of a perfectly honorable desire for justice, I also made a whole series of complaints, all of them justified, choosing to say nothing about a lot of things because I hadn't any material proof concerning them—although they are obvious to everyone here.

. . . In the present case, the natives are not rebelling—they are far too gentle and too timid to do that—but they are dismayed and discouraged, every day wondering where the gendarme is going to take them and every day expecting some new misery, for they are the kind of people who panic easily.

. . . My life in the Marquesas is that of a recluse living far from the road, disabled and working away at my art, speaking not one word of the Marquesan language, and only very rarely seeing a few Europeans who come by to say hello. Often, it's true, the women come to see me for a minute, but because they're curious about the photographs and drawings hung on the walls and especially because they want to try to play my harmonium.

. . . Disabled as I am, life becomes intolerable for me, a struggle like the one Balzac describes in *Les Paysans*.

. . . It is a good thing I am the natives' protector. . . . I am accused of defending defenseless wretches! Yet there is a society for the prevention of cruelty to animals.

. . . I want you to know that I will go to Tahiti to defend myself, and that my counsel will have a great deal to say . . . and that even if sentenced to prison, which I would consider a dishonor (in our family we are not accustomed to such a thing), I will always hold my head high, proud of my rightfully earned reputation. . . .    —*Late April 1903, Hiva Oa, Marquesas Islands*

TO CHARLES MORICE . . . As predicted in the essay on the gendarmerie of the Marquesas which I sent to you, I have just been caught in a trap set by that very same gendarmerie; and in fact I have been sentenced. This will ruin me, and when I appeal, the decision may be the same. In any case, I must be ready for anything and make the first move.

You see how right I was, in my last letter, when I urged you to act energetically and fast. If we are victorious, the fight will have been a good one and I will have accomplished something great in the Marquesas. Many iniquities will be abolished, and that is worth suffering for.

I am down, but not yet defeated. Is the Indian who smiles under torture defeated? No doubt about it, the savage is certainly better than we are. You were mistaken one day when you said I was wrong to say that I am a savage. For it is true: I am a savage. And civilized people suspect this, for in my works there is nothing so surprising and baffling as this "savage-in-spite-of-myself" aspect. That is why it is inimitable.

. . . In art, we have just undergone a very long period of aberration due to physics, mechanical chemistry, and nature study. Artists have lost all their savagery, all their instincts, one might say their imagination, and so they have wandered down every kind of path in order to find the productive elements they hadn't the strength to create; as a result, they act only as undisciplined crowds and feel frightened, lost as it were, when they are alone. That is why solitude is not to be recommended to everyone, for you have to be strong in order to bear it and act alone. Everything I learned from other people merely stood in my way. Thus I can say: no one taught me anything. On the other hand, it is true that I know so little! But I prefer that little, which is of my own creation. And who knows whether that little, when put to use by others, will not become something big? . . .

—*April 1903, Atuona, Marquesas Islands*

TO MONFREID[108]   . . . I have just been caught in the most horrible trap. After scandalous incidents had occurred in the Marquesas, I had written to the administrator to ask him to have an inquiry carried out. I had not stopped to think that the gendarmes all connive with one another, that the administrator is on the governor's side, etc. At any rate, the lieutenant decided to sue me, and a rogue of a judge, obeying orders from the governor and the little prosecutor whom I had bullied, has sentenced me (under the law [of] July [18]81 on the press), because of a private letter, to three months in prison and a 1000-franc fine. To appeal the case I have to go to Tahiti. What with the trip, my living expenses, and especially the lawyer's fees, how much is it going to cost me? I will be ruined and my health completely destroyed.

. . . All these worries are killing me.

—*April 1903, Atuona, Marquesas Islands*

108. By the time Monfreid received this letter, Gauguin had already died, suddenly, on May 8, 1903. Monfreid, however, was not notified of Gauguin's death until August 23.

# "The Empire of Death" [109]

. . . No later than last night I dreamed I was dead and, oddly enough, it was the true instant when I was living happily.

. . . I have begun to think, to dream rather, about that instant when everything was absorbed, asleep, overwhelmed, in the original slumber, in potentiality. Invisible, indefinite, unobservable principles all, at that time, because of the primeval inertia of their virtuality, without one perceptible or perceiving act, without any reality, either active or passive, therefore incoherent, all of course sharing only one characteristic, that of nature in its entirety but lifeless, expressionless, dissolved, reduced to nothing, engulfed in the immensity of space which, as it was utterly formless and void, and as night and silence penetrated to its remotest depths, must have been like a nameless abyss. It was the chaos, the primeval nothingness, not of Being but of Life, which afterward is called the Empire of Death, when the life which had flowed from it returns to it.

. . . And in my dream an angel with white wings came to me, smiling. Behind him, an old man holding an hourglass in his hand:

"It's no use questioning me," the angel said, "I know what you are thinking. . . . Ask the old man to lead you later to infinity

109. I have borrowed this "title" from the image Gauguin describes in this fragment.

and you will see what God wants to do with you and you will feel that today you are remarkably incomplete. What would the Creator's work be if it were done in but one day? God never rests."

The old man disappeared and, awaking, I raised my eyes to the heavens and saw the angel with the white wings ascending toward the stars. His long blond hair seemed to leave a trail of light in the firmament.

—Avant et Après, *January–February 1903*

# Biographical Index

*Anquetin, Louis* (1861–1932):
painter, friend of Toulouse-Lautrec
and especially of Emile Bernard; with
the latter, in 1887–88, he created a
style called *cloisonnisme*.

*Aubé, Jean-Paul* (1837–1920):
sculptor, ceramicist, and goldsmith;
Gauguin lodged with him and did his
portrait in 1882.

*Aurier, G. Albert* (1865–92): critic
of Symbolist art, died of typhoid
fever; one of the founders of the
*Mercure de France,* in which he praised
Gauguin in 1891.

*Bamboccio, Il* (Pieter van Laar,
called Il Bamboccio, 1592–1642): did
rustic genre painting *("bambochades")*.

*Barbey d'Aurevilly, Jules* (1808–89):
called the "High Constable of
Letters," a brilliant writer who
combined Catholicism with a taste
for the demoniacal.

*Bastien-Lepage, Jules* (1848–84):
painter of peasant scenes.

*Bernard, Emile* (1868–1941):
painter; friend and admirer, then
rival of Gauguin; one of the
Pont-Aven group; writer and poet.

*Berrichon, Paterne*: author of *Vie de
Jean-Arthur Rimbaud* (*Mercure de France,*
1897).

*Bianchi-Ferrari, Francesco*
(?1460–1510): Italian painter whom
Huysmans studied.

*Björnson, Björnstierne* (1832–1910):
Norwegian poet, novelist, playwright,
and politician.

*Bonnat, Léon* (1833–1922): official
portrait painter, director of the Ecole
des Beaux-Arts in 1905.

*Bouguereau, William-Adolphe*
(1825–1905): official painter who
used insipid colors.

*Bouillot, Ernest*: sculptor in marble,
Gauguin's neighbor in 1877; taught
Gauguin the art of stonecarving.

*Bracquemond, Félix* (1833–1914):
painter and etcher.

*Brandes, Georg* (1842–1927):
Danish literary critic; Gauguin's
brother-in-law.

*Brault, Léonce* (1858–1933):
Gauguin's lawyer in Tahiti, 1903.

*Brunetière, Ferdinand* (1849–1906):
dogmatic and reactionary critic;
director of *La Revue des Deux Mondes.*

*Cabanel, Alexandre* (1823–89):
official painter; historical subjects and
portraits.

*Cabaner* (pseudonym of François
Auguste Matt, died 1888): writer of
operettas and popular songs.

*Fouquier, Henry* (1838–1901): politician and brilliant journalist.

*Gallet, Gustave* (born 1850); Governor of the French Settlement in Oceania, 1895–1901.

*Gauguin, Mette* (née Gad, 1850–1920): Danish wife of Paul Gauguin.

*Gauguin, Clovis* (1814–49): journalist; father of Paul Gauguin.

*Gauguin, Clovis* (1879–1900): son of Paul Gauguin.

*Gavarni* (alias of Sulpice-Guillaume Chevalier, 1804–66): caustic caricaturist of bourgeois society in the reign of Louis-Philippe; contributed drawings to the satirical journal *Charivari*.

*Gérôme, Jean-Léon* (1824–1904): official painter in the "neo-Pompeian" style; sculptor.

*Gervex, Henri* (1852–1929): Realist official painter.

*Gogh, Théodore van* (called Théo, 1857–91): brother of Vincent van Gogh; director of the Boussod and Valadon gallery, where, against his employer's wishes, he struggled to show the new painters; went insane, after his brother, and was placed in an asylum in 1890.

*Goupil, Adolphe* (born 1806): in 1827 started an art gallery and printing shop, whose successors in 1875 were Boussod and Valadon; father-in-law of the painter Gérôme.

*Goupil, Auguste* (1847–1921): extremely wealthy lawyer and businessman in Tahiti.

*Gourmont, Remy de* (1858–1915): essayist and literary critic, with a rich and opulent style.

*Gros, Baron Antoine-Jean* (1771–1835): precursor of Delacroix and Romantic painting.

*Guillaumin, Armand* (1841–1927): painter of "landscapes of light."

*Harcourt, Eugène d'* (1860–1918): composer, orchestra conductor; music critic on *Le Figaro*.

*Henry, Charles* (1859–1926): wrote a treatise on scientific aesthetics and other works on optics, acoustics, painting, and music.

*Hokusai* (1760–1849): Japanese; drawings and engravings full of bold life and humor.

*Huss, Jan* (1369–1415): Czech precursor of the Protestant Reform; sentenced by the Council of Constance to be burned at the stake.

*Huysmans, Joris-Karl* (1848–1907): novelist (first realistic, then Catholic); occasionally an art critic.

*Jarry, Alfred* (1873–1907): author of *Ubu Roi*, whose main character was a whopping, facetious caricature of the bourgeois; wrote three poems on canvases by Gauguin.

*Jerome of Prague* (?1360–1416): disciple of Jan Huss and, like him, sentenced by the Council of Constance to be burned at the stake.

*Jobbé-Duval, Félix* (1821–89): pupil of Ingres; in 1880 Gauguin sublet a house from him in Paris.

*Kitchener, Herbert* (1850–1916): English commander in chief of the Egyptian Army; took part in most of the British Empire's colonial expeditions.

*Lacascade, Dr. Etienne*: native of Guadeloupe, Governor of the French Settlements in Oceania, 1886–93.

*La Caze, Louis* (1799–1869): bequeathed his collection to the Louvre.

*La Tour, Maurice Quentin de* (1704–88): famous for his portraits done in pastels.

*Loti, Pierre* (pseudonym of Julien Viaud, 1850–1923): navy officer who

spent some time in Tahiti in 1872;
his novel *Rarahu* (1879, later known
as *Le Mariage de Loti*) made Tahiti
known to the French public of his
day.

**MacMahon, Patrice de** (1808–93):
marshal of the French army; fought
in the Crimea, Italy, Algeria;
commander in chief of the Versailles
forces against the Commune of 1871.
(See n. 28, p. 153.) President of the
French republic, attempted
(unsuccessfully) to bring back the
monarchy by a *coup d'état* on May 16,
1876.

**Makonnen** (1862–1906): The Ras
(political leader) of Ethiopia.

**Manzi, Maurice** (1849–1915):
director of art reproductions for the
publisher Goupil; in 1893, with
Maurice Joyant, opened an art gallery
which bore both their names.

**Marchal, Charles** (1825–77): official
painter; especially fond of Alsatian
scenes.

**Marchand, Jean-Baptiste**
(1863–1934): military adventurer
who, in 1898, occupied the Sudanese
city of Fashoda on the right bank of
the Nile, but had to retreat when
England bared its teeth.

**Marrast, Armand** (1801–52):
republican journalist; member of the
1848 provisional government, later
Mayor of Paris, then president of the
National Assembly.

**Massey, Gerald** (1828–1907):
English poet of working-class origin,
Christian Socialist; wrote works of
vehement religious criticism.

**Mauclair, Camille** (1872–1945):
poet, novelist, critic, and art
historian; one of Gauguin's bêtes
noires.

**Meissonier, Ernest** (1815–91):
official painter of the historic battles
of the Napoleonic wars.

**Mek, le Grand**: sultan of the
Shilluks in the Egyptian Sudan; in
1898 he signed with Marchand what
proved to be a short-lived treaty
making the Sudan a French
protectorate.

**Menelik II** (1842–1913): Negus
(emperor) of Ethiopia from 1889
until his death.

**Molard, William** (1862–1936):
composer of avant-garde music;
Gauguin's friend and neighbor at 6
Rue Vercingétorix, 1894–95.

**Monfreid, Georges-Daniel de**
(1856–1929): painter and navigator;
Gauguin's most faithful friend,
perpetuated his memory.

**Monticelli, Adolphe-Joseph Thomas**
(1824–86). painter from Marseilles,
used exuberant colors in his
landscapes of Provence; died insane.

**Moreau, Gustave** (1826–98):
Symbolist painter; strange poetry and
brilliant colors pervade his canvases.

**Morice, Charles** (1861–1919):
writer, Symbolist poet, and art critic;
friend of Gauguin.

**Nicot, Jean** (1530–1600): French
ambassador to Portugal; imported
tobacco into France, where it was
originally used for medicinal
purposes.

**Nittis, Giuseppe de** (1846–84):
Italian painter and engraver, Italian
landscapes and the outskirts of
Paris.

**O'Conor, Roderic** (1860–1940): Irish
painter and collector who, after
exhibiting at the Salon des
Indépendants, became friendly with
Gauguin at Pont-Aven in 1894.

**Papinaud, Pierre-Louis-Clovis** (born
1846): Governor of the French
Settlements in Oceania, 1894–96; in
1895 he tried to put down the revolt

of the Leeward Islands by using military force.

*Péladan, Joseph-Aimé* (alias Joséphin, then "le Sar," 1858–1928). a leader of the mystical Rosicrucian movement.

*Picquenot, François* (1861–1907): temporary resident in the Marquesas Islands, 1902–1903.

*Poincaré, Raymond* (1860–1934): in 1895 he was Minister of Public Education; President of the French Republic, 1913–20.

*Pomare V* (1839–91): last king of Tahiti before the island came under total colonization by the French; son of Queen Pomare (1813–77), who had reigned for half a century.

*Proust, Antonin* (1832–1905): journalist and politician, minister of fine arts, 1881–82; high commissioner in charge of the Exposition Universelle of 1889.

*Puvis de Chavannes, Pierre* (1824–98), muralist, decorative painter.

*Rachilde* (1860–1953): wife of Alfred Vallette, who edited the *Mercure de France,* and, in her own right, audacious novelist of the Naturalist school.

*Raffaelli, Jean-François* (1850–1924): painted landscapes in the Parisian suburbs and scenes from lower-middle-class life.

*Redon, Odilon* (1840–1916): one of the most original of the Symbolist painters.

*Régnier, Henri de* (1864–1936): poet; one of the leaders of the Symbolist school.

*Renan, Ary* (1858–1900): son of Ernest Renan; painter, disciple of Puvis de Chavannes.

*Rictus, Jehan* (pseudonym of Gabriel Rardon de Saint-Amand,

1867–1933): author of *Soliloques du pauvre.*

*Rochefort, Henri* (1830–1913): journalist, violent pamphleteer.

*Rood, Ogden N.* (1831–1902), American scientist; studies of photography, color, etc.

*Rouart, Henri* (1833–1912): painter and mainly a collector with very sure taste.

*Roujon, Henri* (1853–1914): director of the Beaux-Arts; then perpetual secretary of the Académie des Beaux-Arts and member of the Académie française.

*Rousseau, Théodore* (1812–67): Realist painter and colorist; known for his forest of Fontainebleau landscapes.

*Saint-Victor, Paul de* (1827–81): literary critic and, occasionally, reactionary art critic.

*Schuffenecker, Emile* (1851–1934): Impressionist painter, one of the founders of the Salon des Indépendants; faithful friend of Gauguin.

*Sérusier, Paul* (1863–1927): Breton painter and art theorist; named one branch of the Pont-Aven school the "Nabis" (from the Hebrew *nebïim,* prophet) and propagated a new "gospel" in art.

*Seurat, Georges* (1859–91): creator of Pointillism and one of the forerunners of Cubism.

*Signac, Paul* (1863–1935): Pointillist painter in Gauguin's day; friend and disciple of Seurat.

*Soury, Jules* (1842–1915): antireligious philosopher.

*Strindberg, August* (1849–1912): Swedish playwright and novelist.

*Taine, Hippolyte* (1828–93): art philosopher, historian, and reactionary critic.

*Thorvaldsen, Bertel* (1768–1844): Danish sculptor; a museum in Copenhagen is dedicated to his works.

*Tristan, Flora* (1803–44): Gauguin's grandmother, who came to France from Peru as a young girl; early advocate of working-class socialism; wrote *Pérégrinations d'un paria* (1833), *Les Promenades dans Londres* (1840), *L'Union ouvrière* (1843), "Le Tour de France 1843–1844," an unpublished journal which was brought to light in 1973; also various articles or texts on art.

*Tristan Moscoso*, Don Pio de (1769–1856): Gauguin's great-great-uncle; took part in the Peruvian war for independence and was interim viceroy of Peru.

*Turner, Joseph* (1775–1851): English painter who sometimes portrayed mythological subjects and sometimes landscapes, with remarkable effects of light.

*Vallette, Alfred* (1858–1935): editor of the *Mercure de France* from its founding in 1889; influenced the Symbolist writers.

*Veene, Théophile van der* (1843–85): from Papeete; in 1884, gave a lecture on Tahiti to the Société des Etudes coloniales et maritimes, in Paris.

*Veuillot, Louis* (1813–83): reactionary Catholic writer and journalist.

*Vielé-Griffin, Francis* (1864–1937): Symbolist poet and literary critic.

*Villemessant, Auguste Cartier de* (1812–79): founder of *Le Figaro.*

*Vollard, Ambroise* (1868–1939): famous art dealer whose flair brought him a fortune through Gauguin, Cézanne, and others.

*Vuillard, Edouard* (1868–1940): post-Impressionist, intimist painter, used delicate colors.

*Willumsen, Jens-Ferdinand* (1863–1958): Danish Symbolist painter.

*Wolff, Albert* (1835–91): journalist and art critic, another of Gauguin's bêtes noires.

*Ziem, Félix* (1821–1911): painted scenes of Venice and the Orient that were highly colored but conventional.